SUCCESSFUL COLOUR
PHOTOGRAPHY

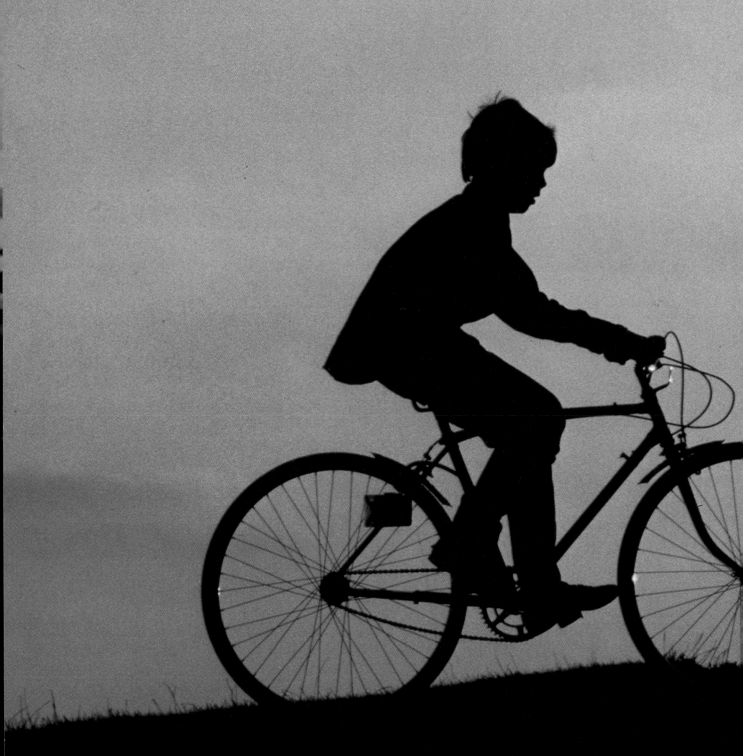

SUCCESSFUL COLOUR
PHOTOGRAPHY

The complete guide to seeing and taking better pictures

Consultant Editor Christopher Angeloglou

Collins

Book Editor: Caroline Ollard
Editors: Christopher Angeloglou, Jack Schofield
Art Director: Carol Collins
Copy Editors: Mundy Ellis, Suzanne Walker
Contributing Editors: John Bell, David Brown,
Michael Busselle, Laurence Esher, Richard
Greenhill, David Kilpatrick, Ken Kirkwood, Barry
Lewis, David Pratt, David Reed, Ekhart Van
Houten, Suzanne Walker

Published in 1981 by
William Collins Sons & Co Ltd
London · Glasgow · Sydney · Auckland ·
Johannesburg

Reprinted in 1982

Designed and produced for
William Collins Sons & Co Ltd
by Eaglemoss Publications Limited

Most of this material first published in *You and
Your Camera*
©1981 by Eaglemoss Publications Limited

ISBN 0 00 411682 8

Printed in Great Britain by Severn Valley Press

CONTENTS

9 Introduction

10 Why take the picture?

16 Composing the picture

18 Composing in the viewfinder
22 Where to put the horizon
26 Using the background
30 The foreground
34 Where to put the subject
40 The edges of the picture
44 Frame within a frame

50 Perspective and viewpoint

52 Giving pictures scale and depth
58 Creating depth
64 Choosing your viewpoint
68 Bird's-eye view
72 Worm's-eye view
76 Balance: diagonal composition

82 The details that count

84 Awareness of line and shape
88 Discovering pattern
94 Emphasizing texture
100 Tone and contrast
104 Images in silhouette
110 The picture essay

116 The excitement of colour

118 Colour awareness
120 Colour as the subject

126 Colour contrast
130 Colour harmony
134 Accent colour
138 Muted colour
142 Successful multi-coloured pictures
146 Colour and the camera
150 Seeing in black and white

154 Lighting for better pictures

156 Introducing light: the source
160 Lighting different surfaces
164 Positioning the light source
170 Small source lighting
176 Large source lighting
182 Medium source lighting
186 Photographing into the light
192 Dawn till dusk
198 Night photography

210 Movement and multiple exposures

212 Expressing movement
218 Using movement
222 Zooming
224 Techniques in movement
230 Pictures from a moving vehicle
234 Double and multiple exposures
240 Multiple images: movement and light

246 Using your camera

252 Glossary

254 Index

INTRODUCTION

It is not enough to know how the camera works and which lens gives which result. To be really successful the photographer has to be able to 'see' the finished picture in the viewfinder. And usually it's more than just seeing—it's a question of 'arranging' the picture, knowing when to exclude a foreground, knowing when to include a splash of colour, a person at the edge of the frame or a line of trees at the top of the picture. . . in short, discovering how to compose the picture more effectively. Successful colour photography also means learning to see with the eye of a camera. The human eye tends to be selective but the camera is ruthlessly objective; an unnoticed telegraph wire can become a major distraction and ruin a peaceful landscape, or the arresting colours of a butterfly can be lost against a confused background.

You, the photographer, must be clear why you want to take the picture in the first place. Is it the distant landscape that attracts your attention, or is it the mass of coloured foliage in the foreground? Each may well be worth photographing, but together they may detract from each other and the final photograph may fail because of this. It is this ability to see the photograph in the viewfinder that makes the difference between taking snaps and creating exciting photographs.

This book aims to explain the elements of successful picture making: how to position the horizon, how to handle backgrounds and foregrounds, where to position the subject in the frame, and how to deal with colour, lighting and movement. Each component of a photograph—viewpoint, perspective, contrast, texture and pattern—is taken in turn, carefully explained and illustrated with photographs and diagrams. By encouraging a photographer to *think* before exposing the next frame this book will have achieved its aim.

Why take the picture?

One of the main reasons that people are often disappointed with their pictures is simply because they don't ask themselves why they wanted to take them in the first place.

Before taking any picture it is important to know why you want to record the scene and what exactly it is about the subject that attracts you. If the subject is a landscape, for example, is it the cloud formation or line of distant hills that pleases you? Or perhaps the sunlight on the trees? Until you become aware of exactly what is attracting your attention you cannot begin to know how to go about photographing it.

You also need to consider your reason for wanting to record it. Is it the mood of the situation you wish to capture or the geographical details of the landscape? If you wanted to take a picture of your house to help sell it you would almost certainly approach the problem in a quite different way from that of a picture which was going to support a claim for a reduction in your rates. The same sort of reasoning should lie behind every picture you take.

Seeing the subject

Having established your reasons for shooting the picture you need to decide which of the components of the scene will help produce the most effective result. To do this you have to look objectively at your subject. You must, in fact, learn to be able to see like a camera.

While the human eye is an incredible piece of optical equipment, other senses override what the eye registers and the impression formed is seldom objective. Your general impression is just as likely to be influenced by your mood and by sounds and smells, and even memories, as it is by purely visual information. The camera lens, on the other hand, will record the scene quite objectively.

In a landscape scene, for example, not only will the camera fail to record the smell of newly mown hay and the warmth of the sun, but it will also seek out unpleasant things like barbed wire fences and rusty tin sheds which your eyes have glossed over. In fact, the whole scene may well appear quite differently from the impression you at first gained. It is vital, therefore, that you learn to use your eyes as objectively as a camera lens.

One way of training your eyes is to place a frame around the subject before taking the picture. You can either use your hands to form the frame or cut a rectangular hole in a piece of black card and view the scene through this using only one eye. This technique will help you exclude extraneous detail and concentrate your attention on the objects within the frame.

Analysing the subject

First identify the main components in the scene. Then consider the relationship between the various elements in terms of their shapes and sizes. It may be that the main appeal of the subject is the contrast between two or more different shapes. In which case you will want to make this the focus of attention in the photographs.

You must then determine which of the other elements such as colour, texture and lighting will contribute to the picture and which might detract from the final image.

A common fault with many photographs is that they are taken too far away from the subject and from the wrong angle. Often, too, the background becomes confused with the main subject. All these criticisms apply to the photograph below. The flamingo has its back turned and the background is neither sharp enough to show detail nor blurred enough to be unobtrusive. A much stronger shot would have been a close-up, like that on the right, taken with a longer focus lens. If you don't have a long lens, spend more time choosing your viewpoint for an overall shot. Compare the picture below with that far right, where selective focusing and careful choice of viewpoint have made a bold, simple image.

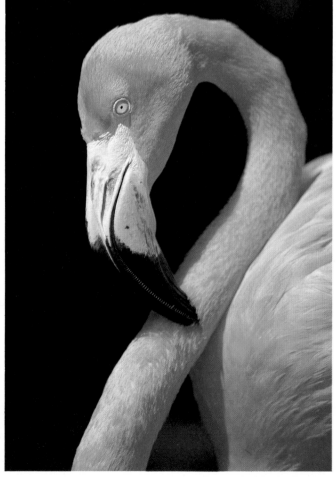

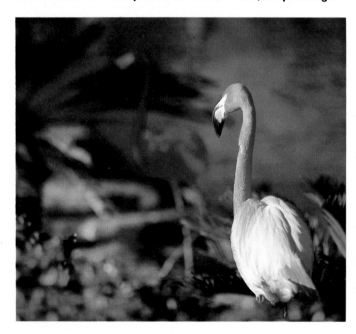

How we react to colour

Another reason for taking photographs is to capture on film the wealth of colour around us. The way colour is used greatly influences the mood of a picture and is an important element of composition.

Colour plays a large part in our feelings towards what we see. Most of our reactions towards individual colours stem originally from their use in nature. Learning about colour is therefore really only a question of looking around.

You will notice, for example, that red stands out and commands attention in much the same way as a strong highlight in a black and white photograph. This is because red is an aggressive colour, and is used in nature either to attract attention or to signify danger. Blue and green, however, are more subdued. They are the predominant colours in a summer landscape and are associated with feelings of peace.

Similarly, most people regard colours as being either hot or cold. Orange, yellow and red are associated with fire, the sun and hot weather and are therefore thought of as hot colours, while blue tends to be associated with water, snow and ice and is considered chilly.

Another factor affecting the mood evoked is the strength of a colour. Soft colours evoke the feeling of romance, while dark colours are sombre and mysterious.

Colour to emphasize mood

The more you actually look at colour, rather than just accepting it as part of the scenery, the greater will be your understanding of the response it produces. You can then use it to emphasize the mood of your pictures. The dreariness of grey city buildings can be heightened by a bright flower poking out of a crack in the pavement. However, a larger area of bright colour would

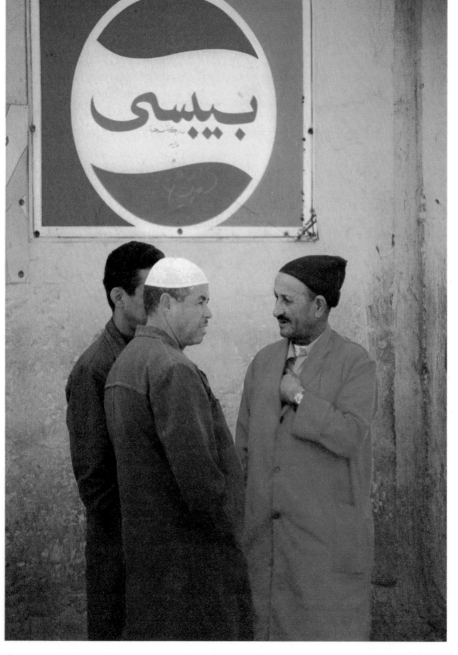

◀ In this scene *Michael Busselle* was attracted by the group of figures and the relationship between the colours of their clothing and those of the poster above. By going in close he has managed to convey this quite clearly. The picture below, however, leaves some doubt as to the main area of interest. To create impact it is usually best to keep the image simple.

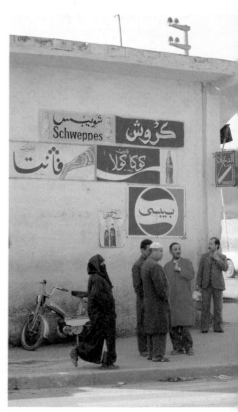

▶ An attractive scene is often not enough to make a really striking photograph. The picture on the right is pretty, but unexceptional. The picture below works much better because the splash of red is so unexpected compared with the gentleness of the rest of the composition.

detract from the overall mood.

So it is vital to look carefully at the colours in the scene you wish to photograph. Single out each of the colours, be aware of where each is in relation to the others and judge which contribute most to the mood you want to capture or evoke and which detract. The overall colour impression of the scene is very important.

There are also artificial ways of creating mood. Slight over-exposure makes colours appear weaker, and soft focusing and fog filters subdue strong colours, lending an air of dreaminess to your subject. Extra control can be exercised by using colour filters. These and other methods are covered in the chapter on colour.

▶ **Many of our reactions towards colour stem originally from how it is used in nature. Red, orange and yellow are generally regarded as being hot, and we feel the heat of a picture when these colours are included. In nature they are the colours of the sun and are beautifully captured here by** *Alex Langley,* **conveying the tropical atmosphere surrounding a mosque in Borneo.**

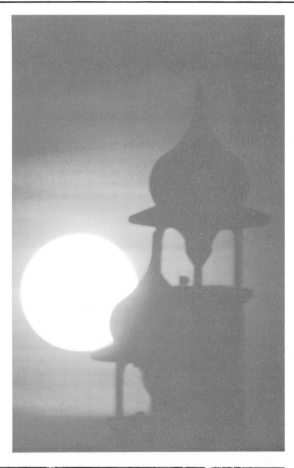

▲ The blue cast in the shadow areas of this picture has been caused by reflections from a blue sky. Snow and ice frequently have this quality and it is because of these wintry associations that we regard blue as a cold colour. Using 64 ASA film, the exposure of 1/125 at f11 was calculated to retain detail in the high-light areas. *Ernst Haas*

◀ Careful selection of viewpoint has ensured that distracting areas of colour, which might have disturbed the gentle mood, have been excluded from this picture.

▶ A conflict of mood has resulted in this picture, taken by *Suzanne Hill* on a lake in Kashmir. Although the gaiety of the flowers dominates the composition, the darkness of the water has a more sombre feeling. You can almost imagine a coffin in the boat.

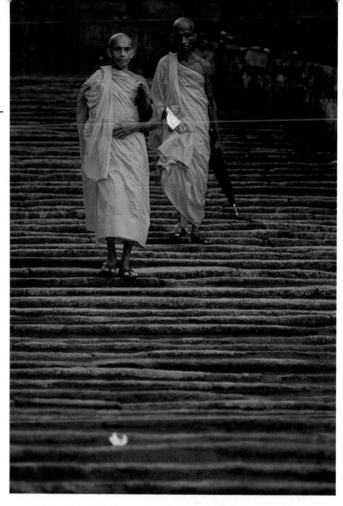

▲ To create the appropriate mood for this picture, *John Garrett* has kept plenty of space around the subject. Slight under-exposure has brightened the colour of the robes, but the grey impression of the background dominates the mood.

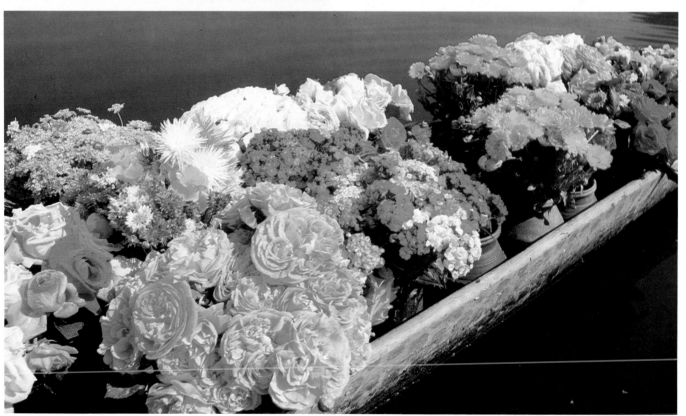

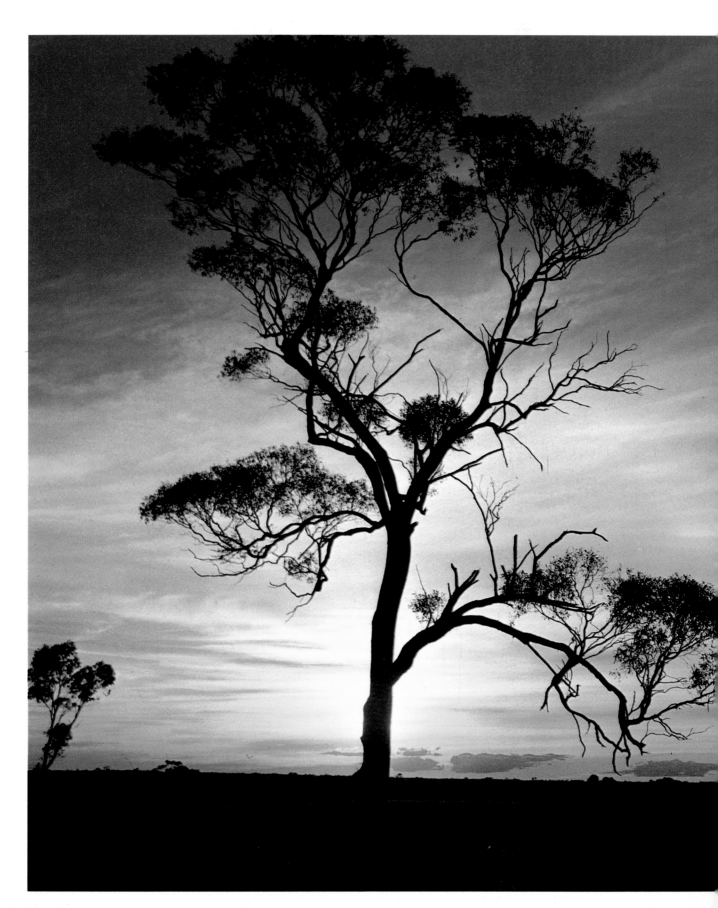

COMPOSING THE PICTURE

There is nothing difficult about composing good pictures—all that is required is a little care. Good composition is a skill, and like any skill, it can be learned, and improved with practice.

This chapter teaches you, step by step, how to compose a picture. You don't even need to have a camera with you to start off, because the first stage lies in seeing potential pictures in any scene that you look at, whether it is a woodland glade or a city street.

A major stumbling block for many photographers lies in deciding where to put each picture element within the frame. The centre of interest doesn't have to be in the centre of the frame, and the horizon doesn't always have to divide the photograph into two equal parts. This chapter shows you how to decide on the best location for both these features of the picture.

It is easy to ignore the background, and this often results in photographs where it distracts attention from more interesting areas. Both the background and the foreground can contribute a lot to the success of a photograph, and here you are shown how to use them to best effect.

The end of the chapter deals with the edges of the picture and how to use natural frames within a photograph to draw attention to the main subject.

Composing in the viewfinder

The panoramic view on the right is very much as the eye sees it—but the eye will subconsciously focus on certain details as it moves across the landscape. What each person notices is very much a personal choice—it may be the form of a particular tree, the pattern made by branches or the position of a figure.

When you take a photograph you make two decisions: *what* you are going to include and *when* to press the button. In both instances you need to consider how to show the subject in the most effective way.

Good composition may mean simplifying your photograph by changing viewpoint—moving higher, lower, more to one side. It certainly means thinking about the direction and quality of the lighting. This can make all the difference between a photograph which is muddled or boring, and one which looks right.

How to 'see' better pictures

Some people have a natural ability to see a composition right away—but most of us have to keep looking, experimenting, and looking again, until we start seeing well composed photographs. But remember, this is something anyone can do, no matter how simple or elaborate their camera.

Photography is concerned with seeing the world in terms of how it appears in a rectangular (or square) shape on a flat piece of paper. The question is, which parts of what you see should the camera include . . . or leave out? This depends not only on the main centre of interest but also on the visual appeal of shapes, colours, patterns, and textures. Moving around, looking through the viewfinder, helps you emphasize important aspects and isolate them from the overall view. Look also at the way objects may be cut by the edges of your picture. The hard lines at the edges of the viewfinder give a definite border to what you select. You might cut off a vital part of the subject by mistake—or use this border to contain the picture. This is another difference between seeing the scene as the human eye sees it and composing it into a photograph.

To become more aware of composition it is helpful to make a cardboard viewing frame. Look through it at familiar objects, parts of your home, people's faces or landscapes. It is surprising how, by imposing this frame on what you see, you start to discover interesting 'pictures' where you may not have noticed them before.

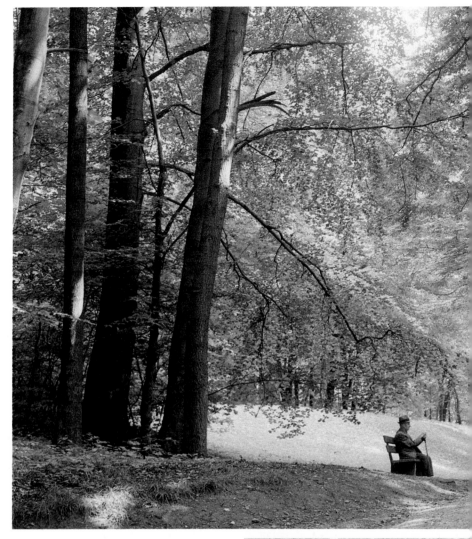

▶ With a camera the photographer can choose which part of the general view becomes the subject and a static scene, such as a landscape, gives time for careful composition in the viewfinder. Experiment by changing the camera position and moving in closer on parts of the scene to find out how this affects what you see in the viewfinder. Introducing figures into a landscape gives an immediate sense of scale and often contributes to the balance and interest of the composition.

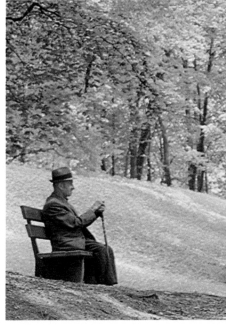

▶ Centre: picking out a detail may say as much about a scene as the larger view. In a woodland the fresh green of leaves in spring create an unforgettable image, so why not go right in and capture that quality by filling the viewfinder entirely. The skill comes in *seeing* the detail and then isolating it from the overall view.

▼ Tall, slim trees just ask for a vertical format. By moving in close this picture emphasizes the soaring quality of the trees; patterns of light and shade; rough texture of bark against a lacy canopy of leaves. You can strengthen the vertical shape later by cutting the print—known as cropping—to make a narrower shape than the film format.

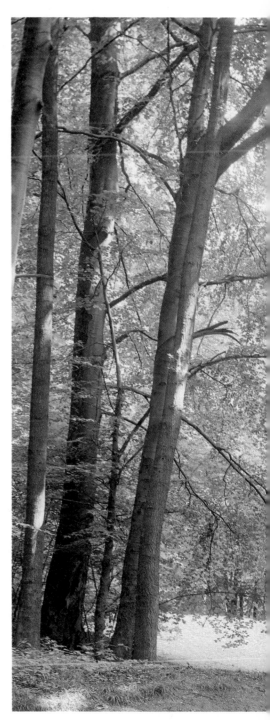

Using a viewfinder

Some people find the camera view-finder rather awkward and inhibiting—a mechanical block between them and the subject. This is where a cardboard viewing frame is useful. It helps to train the eye to see and compose successful pictures.

Whether you use a frame, or the camera itself, this section is concerned with exploring the effects of changing viewpoint. Even though you will usually be composing far more complicated pictures of groups of people, interiors, or landscapes it is well worth starting by looking at just one simple object and *seeing* it. Here you are dealing with three main elements: a) the subject, b) the rectangle or square imposed by the picture format, and c) the spaces around the subject.

As you look at the subject, notice how important the spaces around it are—both the shapes they make and the way the shadow falls. The strength, position and shape of the shadow help to define the subject's three–dimensional form.

What subject to choose?

This will depend on how close your camera lens can get to the subject—check the minimum focusing distance of your camera, then pick something that fills the viewfinder. If you can get as close as 45cm you might choose a china cup and saucer. If your minimum distance is about 90cm then choose something larger with an interesting shape, such as a chair or a watering can.

LONG VIEW
Start by looking at the subject from as far away as possible. Now move in, seeing how the subject looks on the right of the viewing frame, then on the left. In each case, is your eye led into, or out of, the frame?

CLOSE UP
Move in close until the subject fills the frame (try this out with both formats). The closer you get the more you become aware of the shape of the background, and how light and shadow give form to the subject.

DETAIL
Even if your camera lens does not let you get closer than 90cm, take a look at details through the viewing frame—the close–up view may be more intriguing and interesting lines, textures and patterns may emerge.

If you try this out using film, aim to have a neutral background, which does not interfere with the shape of the subject. You may be able to isolate the subject from distracting surroundings on a large piece of paper, in an empty room or passage, on a white sheet, or in the middle of a lawn. Position the subject and yourself so that the daylight lights the subject from the side. (Don't use flash as you cannot be sure what effect it will create.) With a simple subject like a chair, you have two choices—either to move the subject, or to move the camera. It's a good idea to get into the habit of moving the camera rather than the subject so that when you come to an immovable object, such as a tree you are used to moving around to find the best viewpoint.

The viewing frame

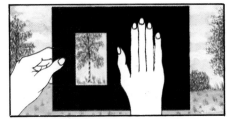

A colour–slide mount will do, but a larger, black cardboard frame helps to isolate the subject far better. You need a steel ruler, a sheet of matt black cardboard, about 30 x 23cm, a craft knife and a pencil.
Draw a rectangle in the proportion of 2:3, such as 4 x 6cm, and a square about 2 x 2cm, and cut out. Work on the black side to keep the edges crisp.

With the black side facing you, close one eye and look through the frame. Move it towards and away from you until the subject is framed in a pleasing way. Everyday objects can make effective pictures when they are cleverly positioned and background clutter is cut out.

Using the format

Basically, there are two photographic formats: square and rectangular. The size of the rectangle varies, but the proportion of 2:3 is generally appropriate for 110 and 35mm film. With a viewing frame in both shapes you can compare the effect of using the two formats—a useful point to consider when you buy a new camera. Some people are devoted to one format and find it hard to work with the other. Start by looking at the subject from the same viewpoint through one and then the other format and, of course, try the rectangle both horizontally and vertically.

LOW LEVEL VIEW
Now try a lower viewpoint: does the subject look most effective from ground level, or a little higher? Is the subject identifiable, or do you need to move around to find a better vantage point?

FROM ABOVE
With a plan view of the subject the shapes of the horizontal parts become important and the surface it stands on forms the background. A truly 'over the top' view often simplifies shapes and lines.

SILHOUETTE
Move directly opposite the light source, then adjust the viewing height until you achieve the most satisfactory silhouette. For a clear, clean shape the horizontal lines of the subject should suggest the correct height.

Where to put the horizon

In photography, as in painting, deciding where to place the horizon is an important way to give emphasis to your subject and to balance the picture as a whole. The horizon also gives a sense of scale to a landscape, whether it is a towering mountain range or a billiard table sea. The way you balance your composition adds to the visual impact of what you are trying to convey.

Horizontal or vertical ?

Most cameras take photographs on a rectangular format. This gives you the choice between composing horizontal or vertical pictures.

Horizontal photographs, with the horizon running right across the picture, tend to emphasize the space from left to right. The viewer's gaze follows along the horizon in much the same way as when scanning words on a page. Using this format gives photographs a sense of 'wide open spaces', but you need to think about including some foreground

objects as a way of giving a feeling of scale and perspective to the picture.

Vertical photographs can convey an immense feeling of depth depending on how the horizon is handled. The eye tends to 'read' the scene from foreground back and up to the sky. With a high viewpoint a great deal of detail can normally be included in this type of composition as the landscape appears to extend from the viewer's feet right up to the horizon and the sky.

When photographing a landscape, always keep training yourself to try composing both horizontally and vertically through the viewfinder or a viewing frame.

Where to put the horizon

The classic 'comfortable' position for the horizon is a third of the way down the frame. But if you want to create a more dramatic effect, consider positioning the skyline higher, much lower, or in the middle.

The classic solution

Most Western painters from the Renaissance, when they 'discovered' perspective, up to the end of the 19th century have been preoccupied with breaking down landscapes into foreground, middle distance, background, and sky. One of the formulas painters evolved, based on one-third sky to two-thirds land, is still useful in composing photographs. No one quite knows why, but the human eye finds that this proportion gives a harmonious, satisfying balance to most pictures. Whenever you break away from this classic formula, you probably—either consciously or unconsciously—intend to create a more emphatic picture.

▶ Putting the horizon two-thirds of the way up the picture gives a comfortable, but rather predictable, result.

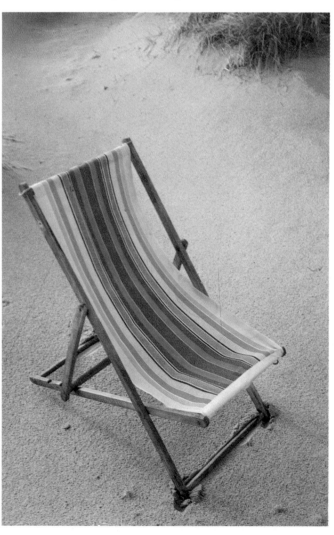

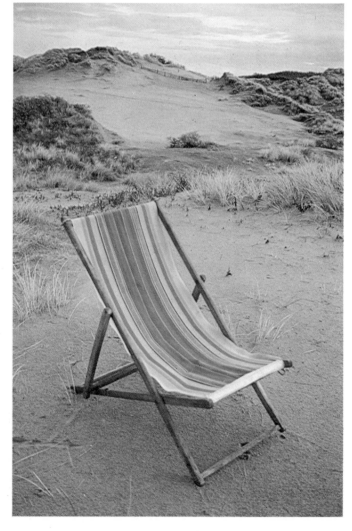

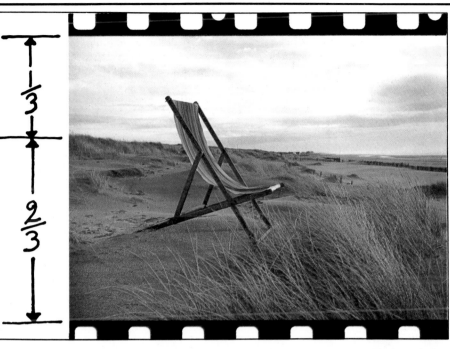

The four pictures at the bottom of the page show the effects of moving the horizon. From left to right:

With no horizon the subject is isolated and given prominence.

By moving the horizon lower the subject is placed in its setting.

The larger sky area is often dramatic, but this halfway split can be an uneasy compromise.

The low horizon makes full use of the sky's dramatic potential without detracting from the subject.

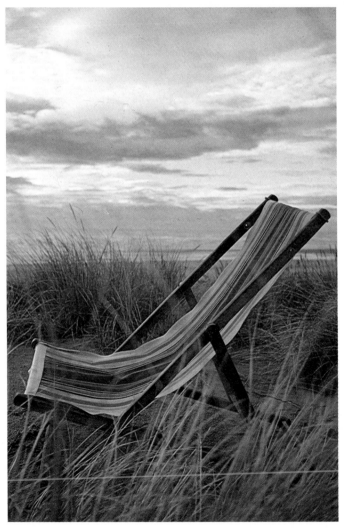

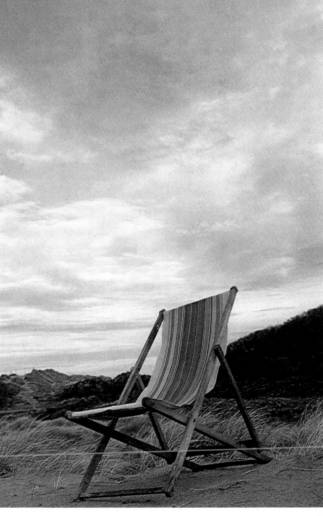

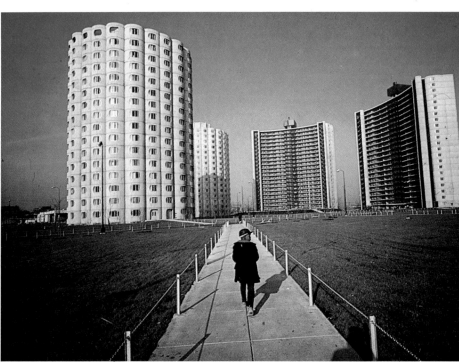

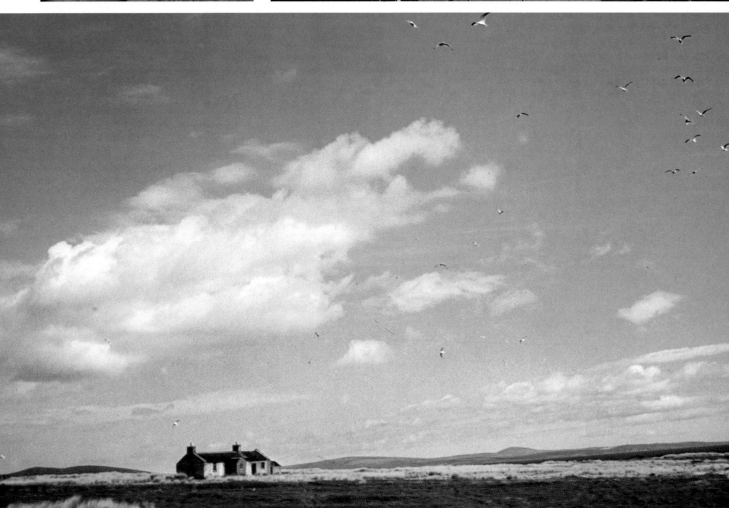

◄ Far left: central subject, classic horizon, but emphasis would differ with a lower horizon. *Spike Powell*

◄ The centrally placed horizon combines with bold vertical and horizontal lines to give balance to this urban landscape. *John Bulmer*

► Here foreground is the subject; the horizon simply acts as the end of the picture. *Barry Lewis*

▼ In this Orkney landscape the low horizon places the emphasis on the sky. The house is balanced by the cloud mass. *John Bulmer*

Using the background

Many people starting photography concentrate all their attention on the subject with hardly a thought for what is going on in the background. Yet the background can be of vital importance, and a cluttered or intrusive one could ruin a perfectly good picture. Equally, when the background adds something to the subject, it can lift a photograph out of the ordinary into something special.

There are three main points about the background to watch for: a) false attachments; b) competitive backgrounds; c) intrusive light or colour.

False attachments

These are the sort of unhappy effects where people appear to have lamp posts sprouting from their heads, or branches growing out of their ears. It is easy to miss this clumsy placing of subject and background when looking through the viewfinder. If you do notice it, try moving the camera position slightly until the 'attachment' separates from the subject.

Competitive backgrounds

These include the kind of general muddle that good planning may be

◄ The small shot at the bottom of the opposite page shows what can happen if the background is left to take care of itself—the girl disappears into the muddle and the photographer has inadvertently included his own reflection in the mirror. In the larger picture *Homer Sykes* moves the toymaker away from the messy part of the background and asks him to stand, so that his head is clear of the paraphernalia on the shelf.

► If you are working with a wide depth of field, look carefully at the background. Here the chimney coming out of the subject's head is typical of the false attachments hidden in many backgrounds. A slight sideways shift of camera position would have avoided this.

▼ Subjects with complicated patterns or shapes can easily become confused and merge into a patterned background. Put the wallpaper out of focus by using a wide aperture, and the flowers stand out from the background. Check the depth of field scale to make sure you have the area of sharpness you need.
Colin Barker

able to rearrange. If you cannot re-arrange the background, of course, you will have to move the subject if this is possible. But there are many cases where you cannot have this control over your subject—in candid photography or when you are photographing something immoveable like a statue or a building. In this case try altering the viewpoint, which may also help to sort out the tonal differences, such as when a statue seems to merge into the trees

▼ The two pictures below show how an intrusive spot of colour in the background distracts the eye from the subject. Remove the splash of yellow and the eye goes straight to

behind it instead of standing out.

Intrusive light or colour

These can also distract from the main subject. There might be a strong light source in the picture that draws your eye to it—and away from the main subject. Or maybe an area of strong colour, such as a bright curtain, dominates the picture when the subject of your photograph is wearing muted, delicate colours. Here again, the answer may be

the subject. Although the background is intentionally out of focus, the spot of unsharp colour is enough to distract the eye from the statue.
Homer Sykes

to move either the subject or the camera. Alternatively, if you have inter-changeable lenses, put the background out of focus by reducing the depth of field.

Aim to train yourself to notice these distractions in the background, whether it is muddle or that distracting red car in the distance which will register as a splash of colour just where you don't need it, *before* you take the picture. To handle backgrounds successfully so that they contribute to the overall effect of the photograph, consider them as part of the picture you are putting together in the viewfinder. The background should not be an after-thought, but part of the composition.

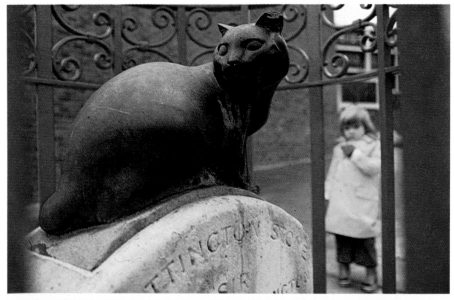

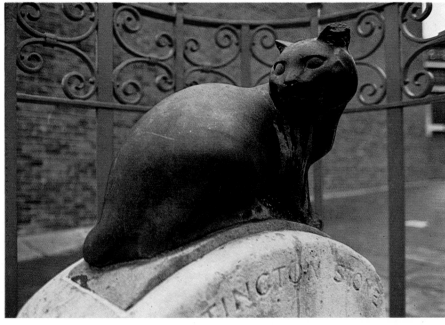

◀ The combination of a grey subject and poor lighting conditions means that the subject merges into the background. Contrast is too low to separate the buildings from the sky.

▼ As in the top picture, poor lighting has caused the subject to disappear into the background in this picture of the New York skyline. However, in the middle of the picture the sunlight has highlighted the buildings and lifted them out of the monotone of the background. *Tomas Sennett*

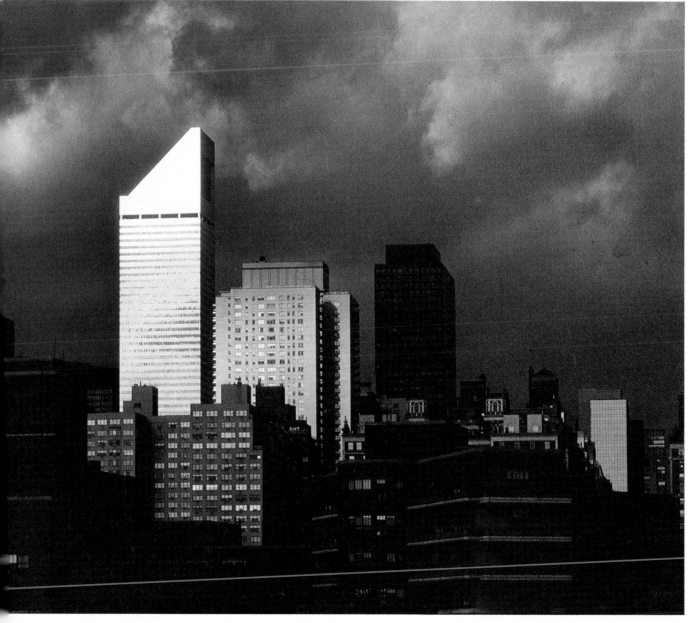

The foreground

It is all too easy to think carefully about the background before taking a picture, but leave the foreground to take care of itself. The result is often that distracting foreground objects seem to appear from nowhere and upset the balance of the picture. The photographer has to decide whether or not to include the foreground and, if so, how much of it. Many successful photographs have no foregrounds, but these are usually of subjects that are fairly close to the camera.

Using the foreground

Constructive use of the foreground is an important part of composition. It can add emphasis and balance, and tell more about the subject. If the perfect foreground for a picture is not immediately obvious, it may simply be a question of moving to a different viewpoint to include a wall or a hedge, or some shape close to the camera. Foreground can also be used to give more information about the subject, especially when photographing people. This technique may range from including pots of plants and flowers in the foreground of a picture of a flower seller, to a heap of books in a picture of an author.

Creating depth

Use of foreground also introduces an impression of depth and scale to photographs. This is especially important in landscape photography, where foreground makes the picture start right at your feet, rather than away in the middle distance. If you include a ridge of grass at the front of the scene —before the eye gets to the sea and then to the distant fishing boat—you subconsciously relate one to the other and imagine distance and relative size.

▶ Not just any shopkeeper, but very definitely a sweet seller. Here the sharp foreground tells a story, and builds up the striking pattern of shapes and colours.
Patrick Thurston

▶ Far right: instead of choosing to point the camera at the distant hills, the photographer directed it down to include the foreground and emphasize the sense of distance. The extreme depth of field also contributes to this impression
Jon Gardey

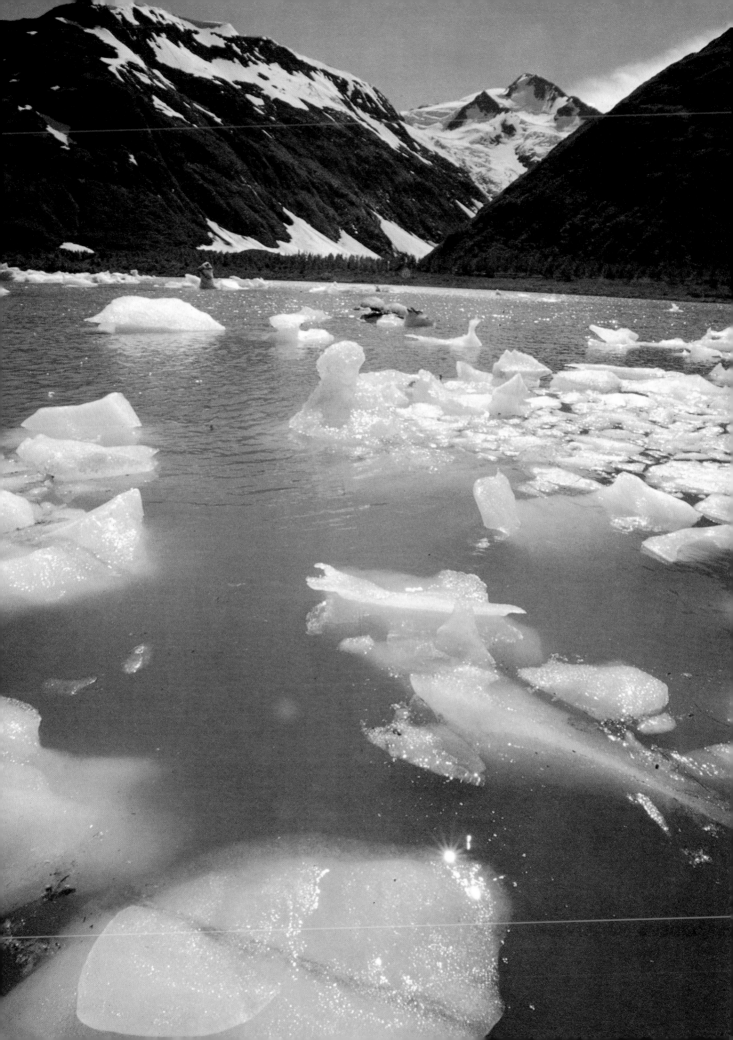

Framing with foreground

Foreground is not always confined to the bottom of the picture, but can form a complete or partial frame to your subject. A doorway, an arch or a window are obvious foreground frames. Outdoors, a branch or a pattern of leaves at the top of a picture may help to 'clothe' large expanses of uninteresting sky. Often these are more effective as silhouettes—just the shape with no detail or texture. Depth of field is no problem as this foreground treatment works well when the frame is partially, or wholly, out of focus. This prevents the foreground from dominating the picture.

Losing the foreground

There is always the danger that a prominent foreground will take over the picture and become distracting because objects close to the camera appear more defined—and larger—than distant objects. If you include a boat in the foreground of the photograph of the ice-filled lake on the previous page it might take over and become the subject. So always be quite clear in your own mind exactly what you are aiming to photograph.

There are three ways to 'lose' the foreground:
a) change camera position;
b) use a lens of longer focal length that takes in less of the subject;
c) reduce depth of field to put the foreground out of focus.

If something in the foreground threatens to become a distraction, you may choose to let it go out of focus by using a larger aperture, rather than leave it out of the picture altogether. But take care that it does not turn into a distracting blur. With many SLR cameras you can see the precise effect of foreground sharpness by using the depth of field preview button.

▶ **Out-of-focus foliage in the foreground acts as a frame and adds colour. This device can be effective when photographing people, houses, and even views, when the subject might otherwise look isolated.**
John Bulmer

▶ **Centre: imagine this scene without the arch—just a dull expanse of stone. Archways, doorways, foliage all make simple but interesting frames to 'fill' the empty top of a picture.**
Robin Laurance

 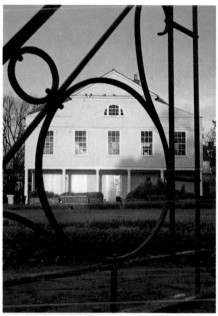 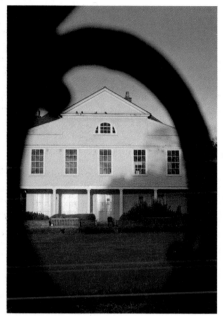

▲ Any clearly shaped object—a gate, a window frame, rigging on a boat—can be used to frame a view. Here, the house on its own looks rather bare and boring. In the central picture the gate becomes too distracting. On the right, the simple, slightly out of focus shape does not interfere with the view of the house.
Barry Lewis

▼ If the wall had been left out of this picture the scene would have been dominated by the stretch of grass in the foreground. Including the soft colours of the lichen-covered wall makes a more effective starting point for the picture without overwhelming the horse and the view. *John Bulmer*

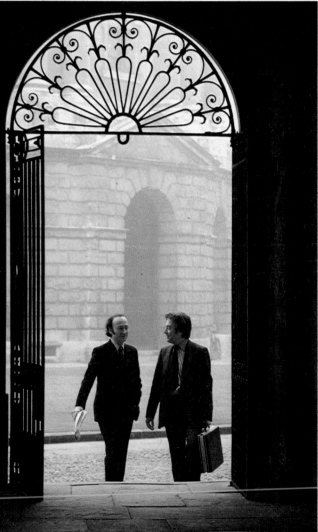

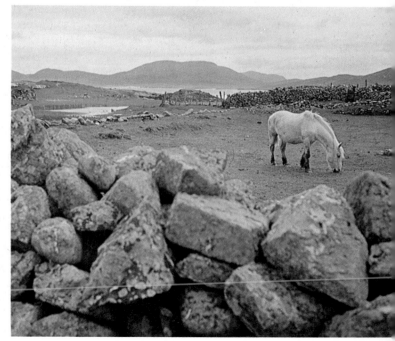

Where to put the subject

To many experienced photographers deciding where to put the subject in the viewfinder is instinctive. But for the beginner it needs as much attention as the horizon, the background or the foreground. Guidelines are useful for beginners, but you should soon start to let yourself react to the subject and not feel inhibited by rules.

The most obvious placing for the subject is in the centre of the frame: that way there is no danger of cutting off the tops of heads, or other important parts of the scene.

But a centrally placed subject often results in a dull picture. It also means that the photographer may not be filling the frame enough, with the all-too-common result that the subject is too small in the final print and becomes absorbed in a background which adds little to the picture.

However, a centrally placed subject can work particularly well when the picture has strong geometric lines that the photographer wants to capture. This can be especially true when photographing architecture where the geometric balance is important.

Most people find they prefer to look at a point just above the geometric centre, so consider positioning the most important part of the subject just above mid-centre. Then see the effect of moving this part to the geometric centre, to the top half of the picture and then below, and see which is most effective for the particular subject.

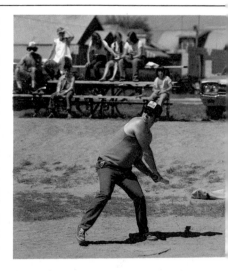

▼ The middle of the frame is often the most satisfactory place for a round subject. Here, background would be a distraction from the minute, precise detail. *Eric Crichton*

▶ A strongly geometric composition: oblong door, triangular ladder and the man dead centre, with just the position of his hand and swinging foot to add a touch of vitality. *Martin Parr*

▲ Putting the subject dead centre tends to make it static, while moving it a bit to one side gives the whole picture a more dynamic sense of movement. *Robert Estall*

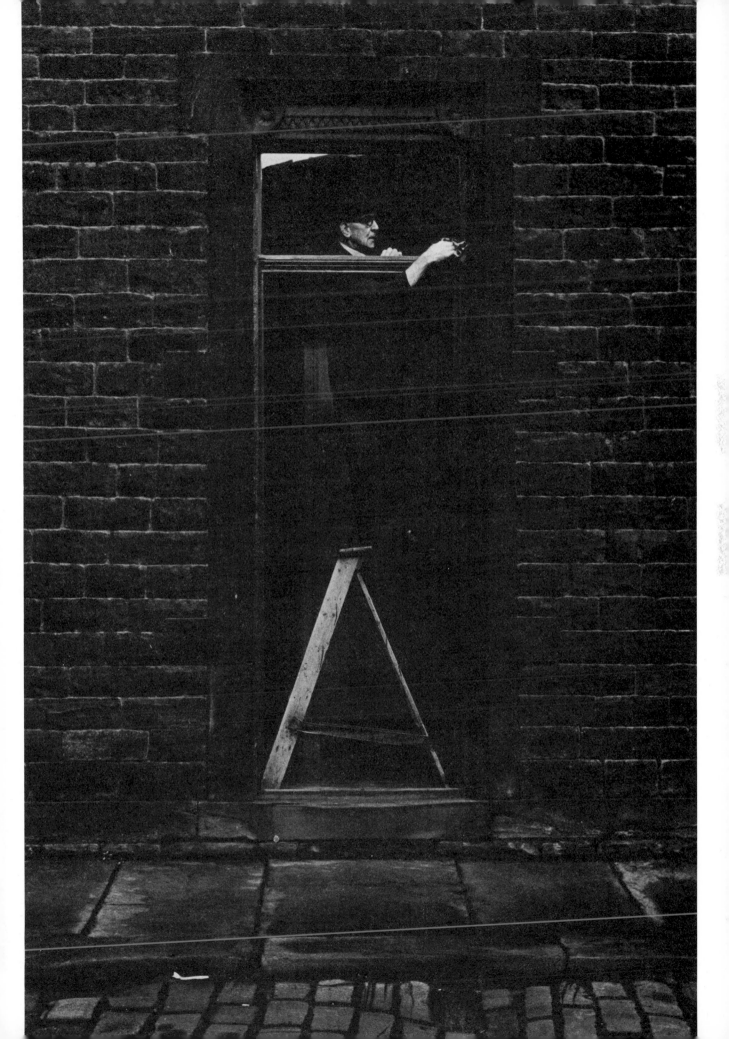

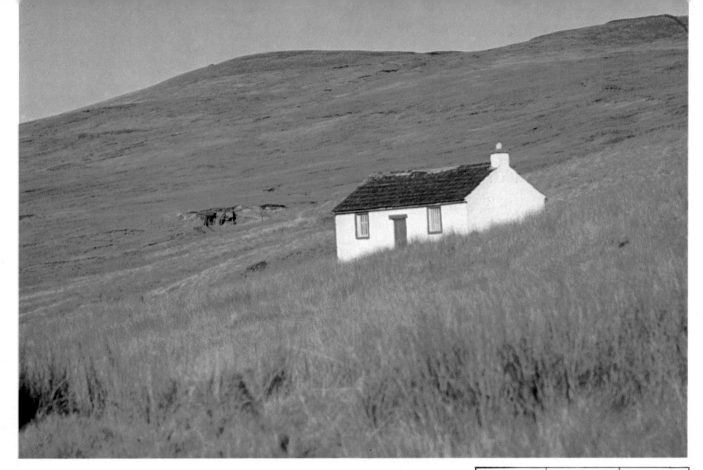

The intersection of thirds

The traditional way to produce a balanced, satisfying composition is to use the 'intersection of the thirds'. Painters have used this formula for centuries and some photographers find it helpful too. But take care not to apply this rule rigidly to every picture or you will soon find the results boring and repetitive.

If you have a subject such as a tree, or a person, or a chair, start by positioning it on one of the two vertical third lines. This position often gives a more satisfactory composition than a central one. (Compare this with the section on where to put the horizon.)

Next, imagine that the scene is divided into thirds, both horizontally and vertically. The intersection of the thirds produces four 'ideal' points on which to position the subject.

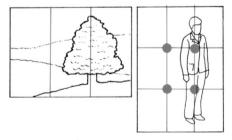

Above left: a diagram showing the positions of the vertical thirds.
Above right: a diagram showing the four 'intersections of thirds'.

▲ All the photographs on these pages are balanced differently to suit either the shape or mood of the particular subjects. Landscapes are the easiest subjects to experiment with because they do not move. This cottage is shown positioned on a vertical third: now consider how the picture would look with the cottage a little higher, or lower, positioned on one of the intersections. *John Bulmer*

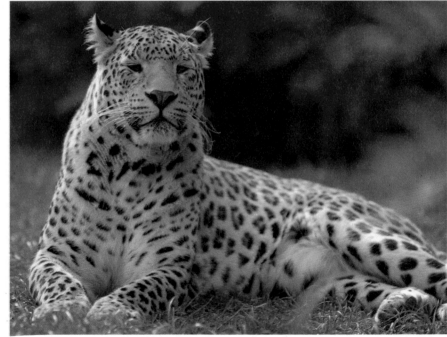

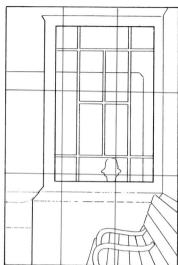

▶ When you are arranging the picture in the viewfinder try altering the camera position. The photographer used the strong rectangular shape of the window to dominate the picture, and the placing of the head—to which the eye is immediately drawn—is balanced by the bench at the bottom of the picture. With a still subject take more than one picture and try arranging the composition differently. *Bryn Campbell*

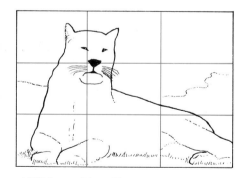

◀ With a subject like a wild cat it is less easy to move the camera. Here, the head and shoulders of the animal dominate the composition. A lower placing of the head would have meant cutting off the bottom of the body— making a weaker picture. *Eric Stoye*

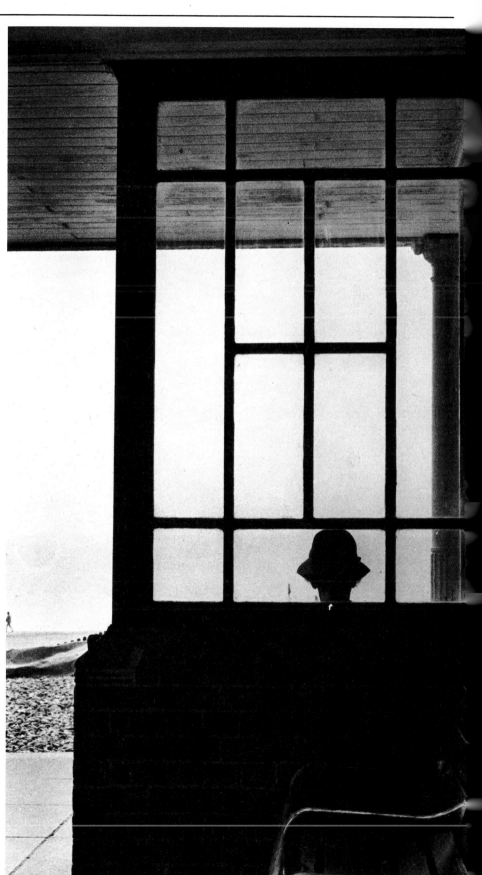

Emphatic alternatives

Placing a subject off-centre in any direction is one of the many ways of creating emphasis in a photograph, making the eye go straight to the subject. At first glance the family group by Tomas Sennett (far right) might seem unbalanced, with the figures squashed right over to the side of the frame. But in fact the group is carefully balanced by the expanse of sea, which also places them in their seaboard surroundings.

Similarly, Roland Michaud's picture of the Tibetan monk—placed firmly to one side of the frame—is a satisfying, well-balanced composition because the face is looking *into* the picture. By closing in on the head, the photographer leaves no doubt where the centre of interest lies.

If you place a subject off centre, what happens to the 'space' created? In many cases, like the two pictures just mentioned, the space becomes a balancing factor in the composition. The photographer can also use the space to add information about the subject.

Room to move

But there is another important reason for not composing certain pictures too tightly. A moving subject seldom looks right if placed in the middle of the frame. Patrick Ward's picture of the man on the bicycle needs the space on the right of the frame. It is not only a question of balance but also that a moving subject needs space to 'move into'. This is especially worth remembering in sports photography, although often difficult to achieve as all one's attention is on the action.

Another effect of leaving plenty of space around the subject is to emphasize loneliness or isolation. Here the space around the subject is as vital as the subject itself. The photograph of the tractor ploughing would have been less effective if it had been taken close to—the space emphasizes the scale of the open landscape.

Try it another way

All this is not to say that every subject should be placed off-centre. The important thing is to try various alternatives before taking the picture. If you can't move the subject move the camera and, if there is time, take more than one picture, varying the camera viewpoint to change the placing of the subject. If you can't move yourself or the subject but can change lenses to alter the angle of view, try using a lens of different focal length.

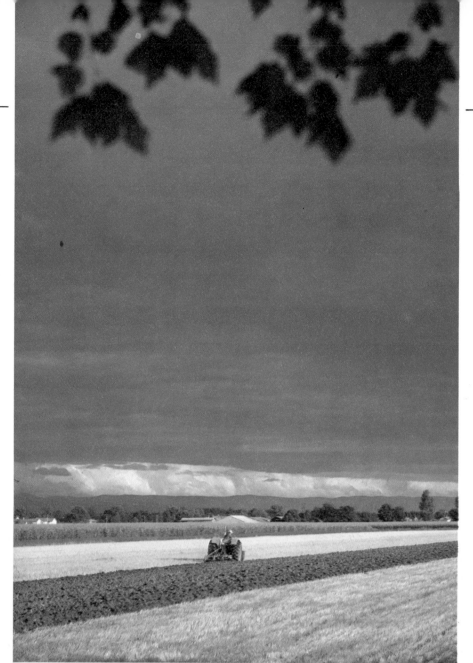

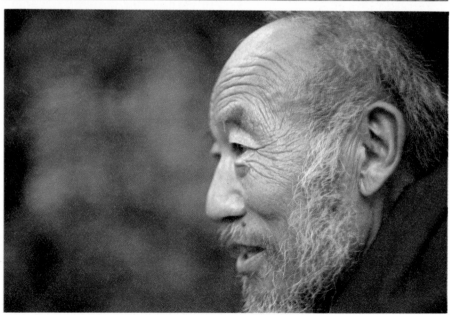

Emphasis is a way of making people notice a picture they might otherwise not have looked at. There are various ways of achieving this—by the way the picture is composed or by the way shapes, pattern and colour are used. Where the subject is placed is one of the most obvious ways of drawing attention to it. All the photographs on these two pages seem to break the obvious rules—but all succeed in holding our attention.

◀ Emphasizing the sense of wide-open space with a vast sky.

◀ Emphasizing the monk's gaze by leaving space in front of him.

▶ Emphasizing the importance of the sea in these people's lives.

▼ Emphasizing movement by leaving space for the bicycle to 'move into'.

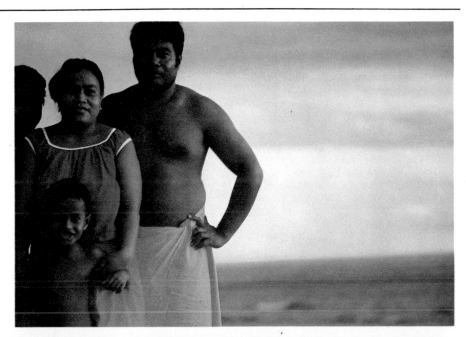

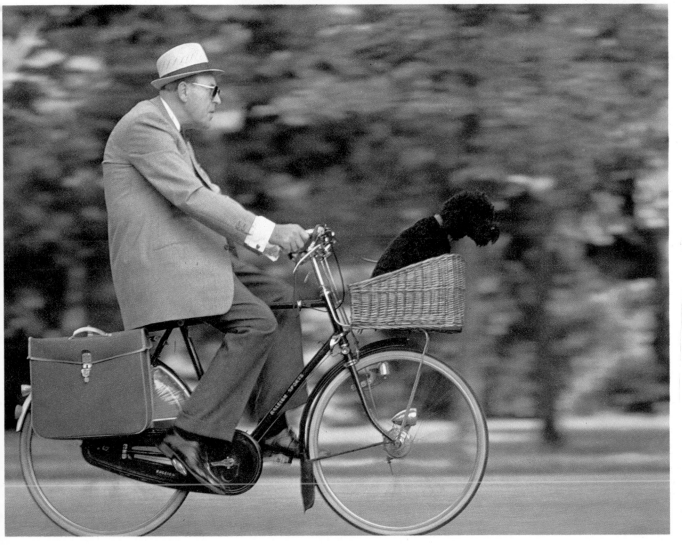

The edges of the picture

Once he has decided where to place the subject, the photographer must plan how the contents of the picture will relate to the edges of the frame. This involves more than just glancing at the edges of the picture in the viewfinder to make sure the picture is correctly framed. It is a common mistake to cut off the heads or feet of people you are photographing and this is often the result of having to take the picture too quickly, or being too close to the subject. But apart from such elementary mistakes, how should you decide where to crop the picture in the viewfinder?

A good way to discover the different ways of cropping a picture is to use a pair of right-angled strips of card when looking at pictures. Place them over a print and vary the borders of the composition. To re-create the same effect in the camera, move the camera closer or further away from the subject. The best way to test this method is to choose a static subject such as a landscape or a building, where you can easily assess the merits of adding or removing parts of the picture. Always bear in mind that the simpler the picture, the more likely it is to be strong and effective.

Looking at the same picture cropped in three different ways shows that this is another way of giving emphasis to the subject. A very tight cropping round a portrait will concentrate the eye on the face, or even part of the face, and can strengthen a weak or uninteresting picture. It is a way of leading the eye straight to the essential point the photographer was trying to make, or of excluding confusing foreground or background detail to make the photograph more explicit and clearcut.

Use the edges

There is no hard and fast rule of composition which says that the edge of the frame must not 'cut' into your subject, and often a detail from what you are photographing can be as strong a way of portraying it as showing the entire subject. As in placing the subject, it is a question of the emphasis you want to achieve. But there are dangers in going in too close on some subjects. For example, a building may look uncomfortable close to; move back and allow a little more space around the edges and it looks better. Move back further and the distracting elements on either side begin to compete with the subject so the picture ends up with no clear centre of interest.

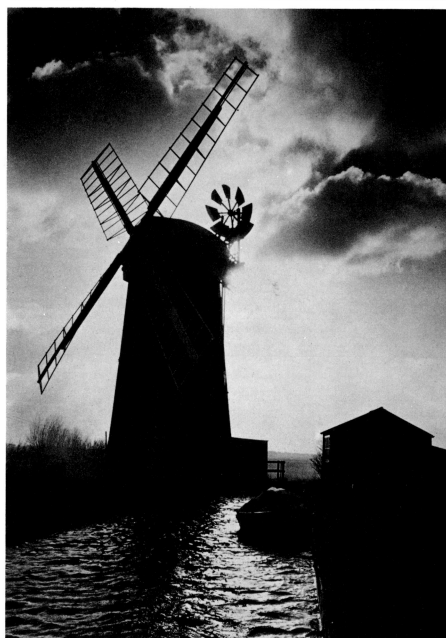

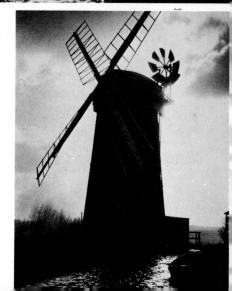

AT THE TOP
Cutting off someone's head is an obvious error—but cutting off the top of a building can be equally unfortunate. The picture on the right shows a windmill taken so close in that the top sail is cut off. Now compare it with the picture above which completes the shape, giving 'breathing space' to the mill and including just enough of the canal in front and the shed on the right to balance the weight of the building. Think of the same points when photographing any building—be it a church, a factory or a skyscraper.
Bill Coleman

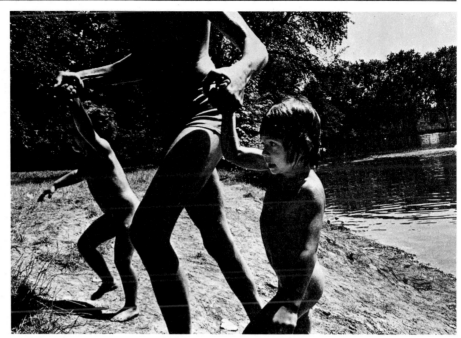

▲ If you are going to cut into a subject, it is often more effective to do so emphatically. *Tomas Sennett* used a telephoto lens to avoid distortion and yet get close enough to the subject for the effect he wanted.

▲ Ask yourself *what* you really want to emphasize. Here *William Wise* homes in on the children: if he had included the father full length the children would have become less significant instead of being the subjects.

▼ Obviously *Thomas Höpker* was amused by the way each lifeguard is standing with his hands held the same way (except for the one on the right). Cutting off the heads intentionally draws attention to the point.

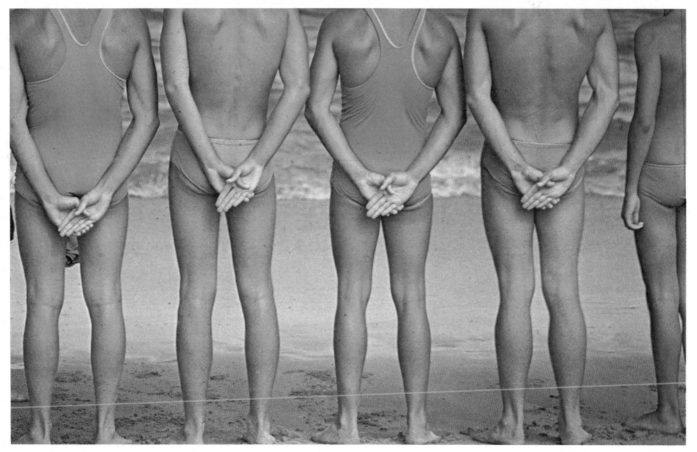

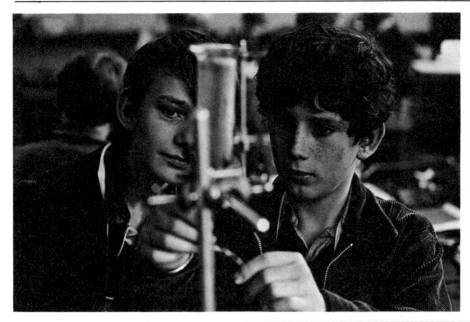

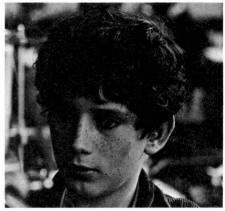

CHANGING THE MEANING
Cropping excludes distracting detail, but it can also produce a misleading picture. The boy looks in a day-dream in the close-up view: in context, he is actually absorbed in an experiment.

Making a point

How the photographer crops the picture can alter the meaning or make the picture accentuate a different point. A close crop round the face of the boy shows simply that—a boy's face, out of any context—whereas the longer view places the subject in his appropriate surroundings, at work in a school laboratory, absorbed in an experiment. So the emphasis of the picture is changed from a straightforward portrait to one which tells more of a story.

SIDES OF THE PICTURE
One of the hardest decisions is how much to leave in at the sides. The maxim 'when in doubt, leave it out' doesn't always apply, as in this picture of two sailing barges. The bank on the right tells you clearly that this is a river, not a sea, view.

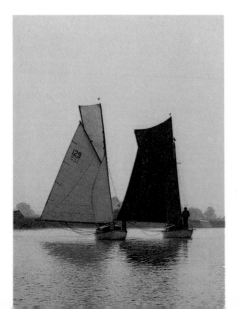

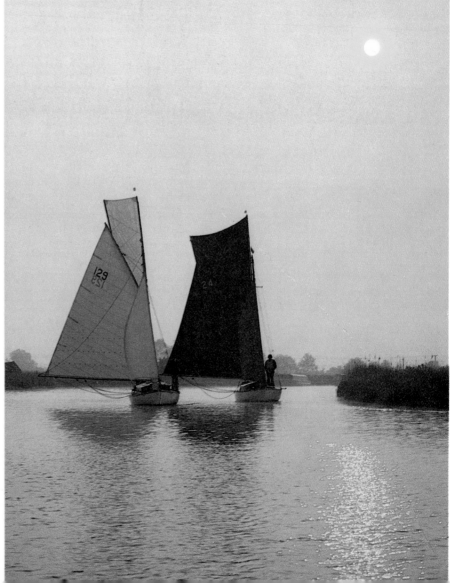

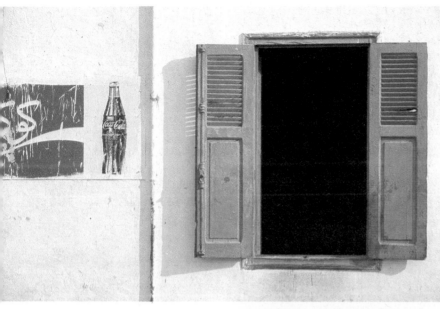

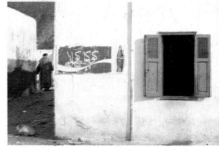

LOOK AT THE EDGES
Once again, it all depends on what you want to emphasize. The small picture above shows a dusty Arab street corner where the viewer hardly knows whether to focus on the Coca Cola ad, the window or the figure round the corner. Next *Michael Busselle* decided to leave out the figure and dwell on the pattern, colour and East-meets-West juxtaposition.

Emphasis in printing
It takes practice, luck, experience or an intuitive eye to master the various possibilities of composition when the picture is taken. But if you get it wrong at this stage the balance or emphasis of your photographs can sometimes be improved at the enlarging stage. Some photographers prefer not to interfere with the picture at this stage, feeling that the way it was 'seen' at the moment it was taken is all important. But for the beginner it gives the chance to experiment and vary the balance of a composition. If you don't do your own printing, simply mark the area you wish to be printed on the en-print and tell the printer what size you would like it blown up to.

Cropping the finished print
Alternatively, the finished picture can be cropped by trimming. For example, a picture in which the subject is long and thin benefits from being trimmed to this shape. Look at finished pictures and see how often they can be improved by more imaginative cropping —often simply removing a disturbing background. A photograph does not have to fit the exact rectangle of the manufacturer's paper size any more than the subject must sit in the middle of the picture for good composition.

LOOK AT THE BOTTOM
Take a sheet of paper and slide it up the photograph of the two men. How do the figures look with their feet cut off; cut off at the knees, or just below jacket level?

Frame within a frame

It is not always possible to fill the frame with the main subject of your photograph. Perhaps it is too far away and you have no lens long enough to do away with the empty foreground and blank area of sky behind. Unless you do your own printing and can enlarge the important part of the photograph, it will lose its impact.

One solution to this is to find a viewpoint which gives the subject its own 'frame within a frame'. Not only does this mask the empty foreground and background—or any ugly features that would detract from the picture—but it also has the positive effect of focusing attention on the main point of interest.

Frames for buildings

Photographs of buildings often suffer from this problem. Getting far enough away from the building to include a high turret or to avoid converging verticals may leave you with bleak, unused areas at the edges of the frame. Or your subject may be a beautiful old building surrounded by incongruous modern office blocks which would destroy the character of the shot. In many cases the best 'frame within a frame' for a building is part of another building. Arches, doorways or windows are ideal for the purpose, with shapes that make a positive contribution to the foreground of your shot.

If you are using a doorway or an arch to frame your subject, you will often be photographing from the inside looking out. The interior will be dark compared to the view outside and the frame will appear in silhouette. Areas of strong black in the foreground will

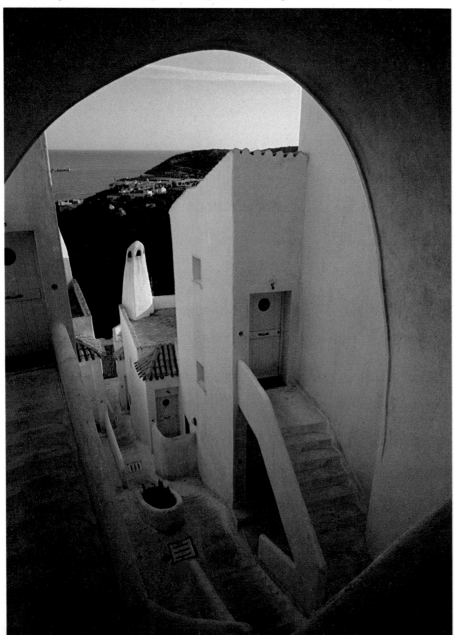

FRAMES FOR BUILDINGS

▲ Though the gold roof of the mosque is effective against the deep blue sky, its shape did not make a strong picture. *A. Evans* solved the problem by moving back and using an arch in the foreground to frame the subject. It echoes the dome of the mosque nicely.

◀ Here the arch leads the eye into the alley, and gives it a secretive, rather mysterious atmosphere. It also adds to the sense of depth. *Malcolm Aird* needed a 35mm wide-angle lens to get it all in. Costa Smeralda, Sardinia.

▶ *Patrick Thurston* found a doorway to frame his shot of Exeter Cathedral. It allowed him to 'lose' unwanted detail and focus attention on the tower. The apparent tilt of the building is matched by the angle of the frame.

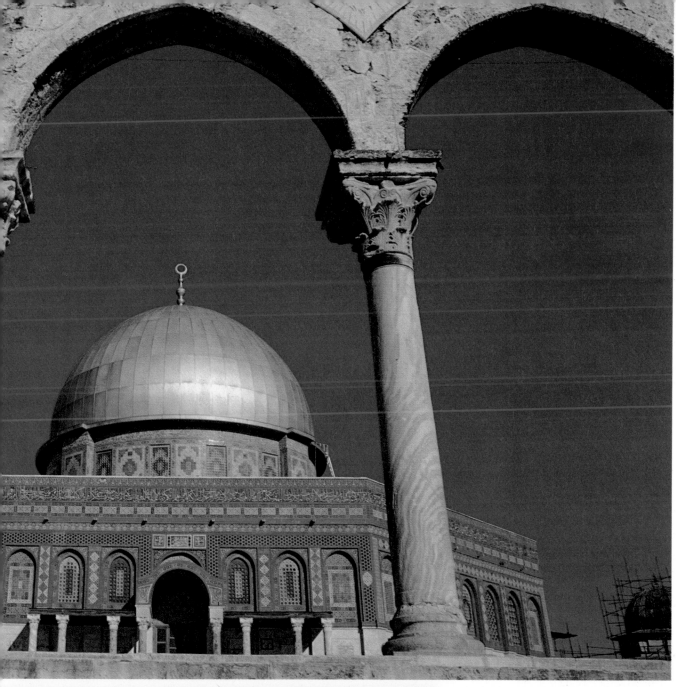

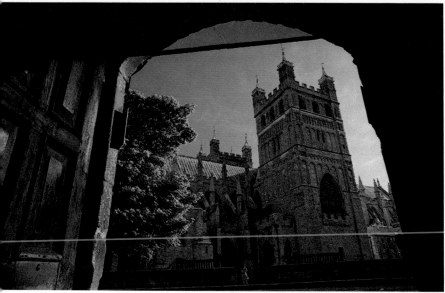

intensify the colours within the frame, but the shape of the frame you choose will be all the more important.

Unless you want a very dramatic 'keyhole' effect, a silhouetted frame should occupy only a small area of the picture. But even this small area of black will affect the exposure reading of an averaging TTL meter. So, to make sure of the right effect you should always take your reading from the main subject and then return to the viewpoint that gives you your silhouetted frame. If your camera sets its own exposure automatically, use the manual override or the memory lock.

Trees, wrought iron gates, even statues and or fountains offer frames that can provide foreground interest in a picture of a distant building. Remember, though, that if the frame is not in silhouette, too much bright colour or

complicated detail may draw attention away from the main subject. Single colours and simple, predictable shapes are best. If possible choose something that adds to the character of the building.

Frames for people

The 35mm frame is not always best suited to photographing people, particularly when used horizontally. The square format is often worse, with the figure looking dwarfed by the empty areas on either side. Here again, doorways (designed to fit the human form!)

and windows make useful frames within frames, modifying the rectangular shape of the frame with another rectangle of different proportions.

If you position the camera square on to the door or window, the symmetrical area around it will give the portrait a rather formal 'border' effect, emphasizing the figure even more. For shots like this choose a frame that fits in with the mood of the picture. You can also help your subject to pose by asking him or her to use the frame as a prop, with a hand on the doorknob or window catch

for example.

Look around for frames that will und line the character of the person yc want to photograph. Foreground flowe and foliage for a romantic picture even if you leave them slightly out focus, making use of the colours alone or a circular rubber tyre if you are ph tographing a mechanic at work. Th actions or expression of your subje may be no different, but you have adde to the viewer's impression of him her by filling the otherwise redundal area of the frame with extra informatio

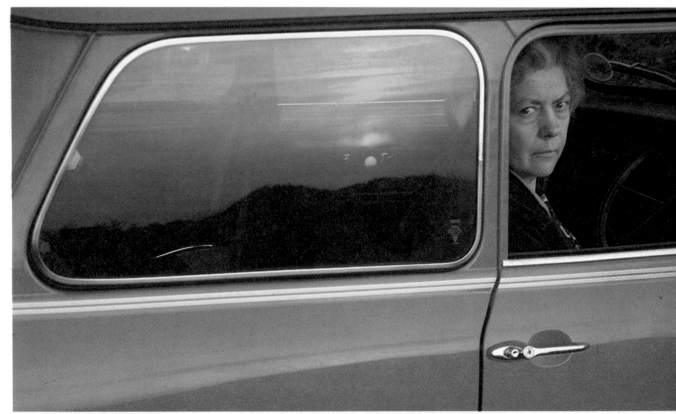

FRAMES FOR PEOPLE
▲ With one car window op and one closed, *Lawrence Lawry* could put his subject in a frame and at the same time reflect the sunset she was watching.

◀ As well as improving the proportions, each of these doorways suggested a different pose for the portrait. *Anne Conway*

▶ Both man and cat have a frame of their own here, though they are linked by the dilapidated fence. *Wilf Woodhead*

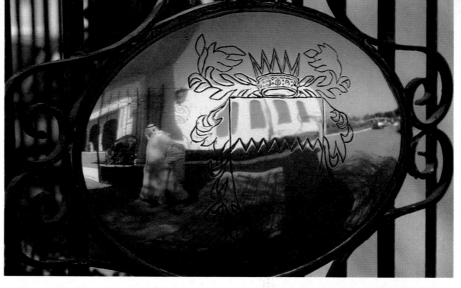

Unusual frames

As well as complementing your subject by your choice of frame, you can also create a strong effect by finding a frame that contrasts with the subject. Old against new, rusty metal against shining steel, a brand-new skyscraper viewed through the broken structure of a derelict building, or an elegant sailing boat framed by the girders of a dockside crane.

When using this approach, a wide angle lens will give you two major advantages. The contrast will work best if the frame is at least partially recognizable, and a wide angle will allow you a greater depth of field to keep both frame and subject in sharp focus. It will also allow you to approach closer to the framing object and incorporate a wider angle of view of the scene beyond.

Mirrors make unusual frames within frames and can create an arresting contrast between the reflection itself and the mirror's surroundings. Try using a mirror with an interesting frame for a portrait of a person or even a curious animal. Or find an angle that will give a surprise view or extra information about the subject—green fields reflected in a factory window, for example.

You can also play tricks with mirrors. If you take a mirror out into the countryside, you can—by hiding the edges of the mirror behind foliage—take pictures of disembodied faces appearing in trees, or hands picking roses from a briar. If you have a reflex camera focusing is no problem. If not, remember that the focusing point is the distance from the camera to the mirror *plus* the distance from the mirror surface to the object reflected.

To sum up

If you look through your viewfinder and discover that, although the subject itself is interesting, the area around it looks blank and unexciting, search around for a 'frame within a frame' to add foreground interest. Frames to watch out for are:
- doors, windows and other architectural structures;
- leaves, branches and flowers;
- fences, gates, statues or fountains;
- industrial machinery;
- mirrors or other reflective surfaces.

▶ **Moving in closer to these chickens would have shown more detail, but by including the whole door above them, *John Garrett* put them in an interesting frame. The symmetrical composition has a decorative appeal.**

▲ **Any reflecting object can be a frame. Here the plaque in one gate also reflects the other. *Ed Mullis* took the picture outside a palace in Bahrain.**

▶ ***Caroline Arber* focused on the image in the mirror to frame her subject like a beautiful cameo. The out-of-focus foreground objects add to the romance.**

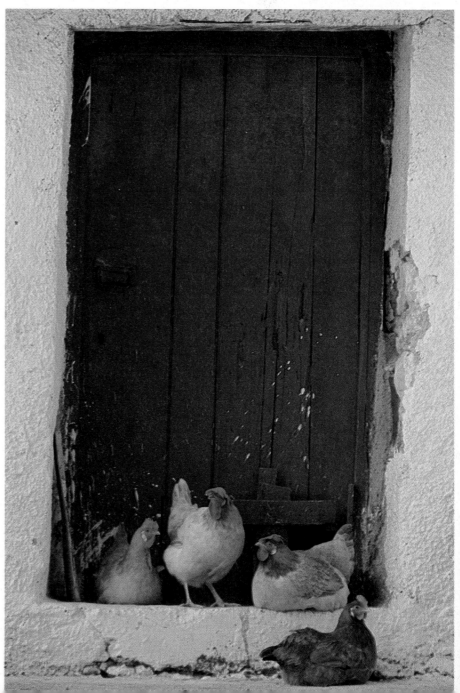

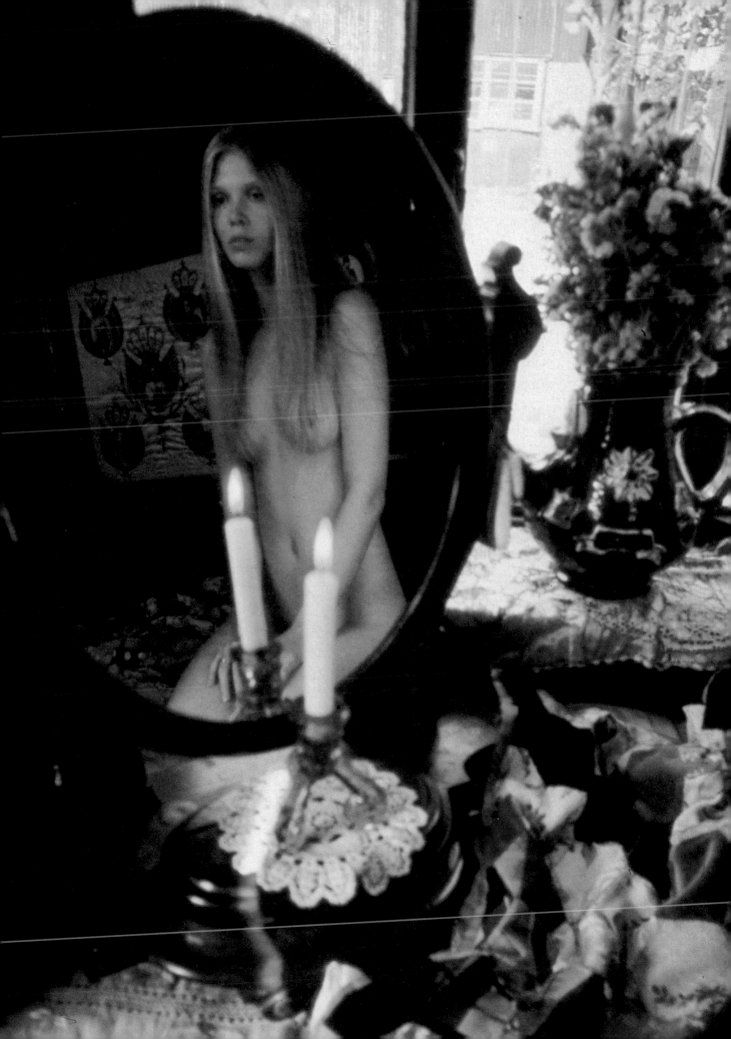

PERSPECTIVE & VIEWPOINT

Every photograph contains clues that help the viewer to visualize the size and shape of the objects in the original scene, and the distance between them. It is perspective that gives this impression of a third dimension. To emphasize those qualities which give form and depth to a picture it helps to understand how perspective works. Equally, you can deliberately eliminate form to give an abstract pattern of flat shapes or colours.

This chapter begins with a description of exactly what perspective is, and how it appears to give depth to a flat piece of paper—a photograph. It explains how you can use perspective to draw the viewer's eye into the picture, and increase the illusion of depth. Perspective is greatly affected by viewpoint, so the correct choice of viewpoint becomes very important. This chapter explains how to position yourself to advantage and also shows how lighting or a change of lens can completely alter a picture.

Unusual viewpoints can produce images that have a lot of impact. Examples show how shooting from ground level, or looking down on a subject from above can give a dramatic view of what would otherwise be a mundane subject. The last section looks at the way a diagonal composition can provide depth and movement, and prevent a picture from looking flat and uninteresting.

Giving pictures scale and depth

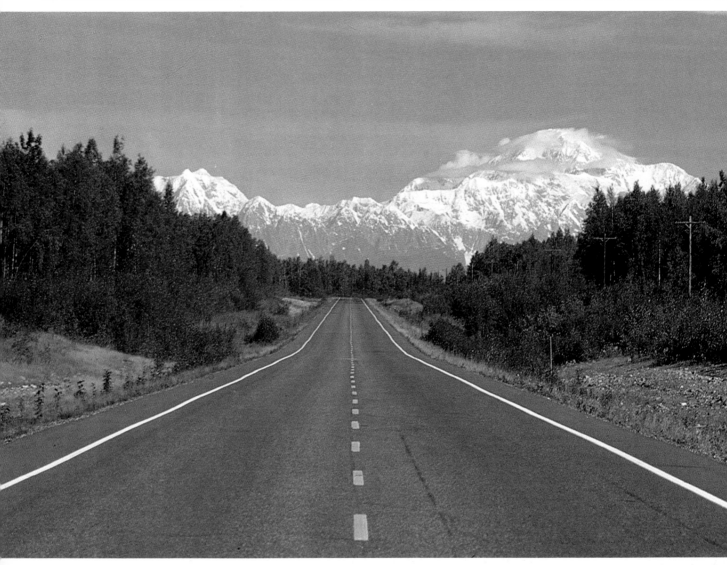

One of the greatest limitations of photography is that it has to show a three-dimensional subject by using a two-dimensional medium—a piece of photographic paper or film. However, when you look at a photograph you don't usually experience too much difficulty in assessing the depth and form of the objects contained within the picture. This is because there are clues to help you, and one of the most important of these is perspective, and more particularly linear perspective.

It is linear perspective that governs the shape and size of objects in relation to their distance from the point at which they are seen—the viewpoint.

Another aspect of perspective is that which governs the tonal quality of an object in relation to viewpoint. This is known as aerial or atmospheric perspective. However, for the purpose of this chapter, perspective is used to mean

linear perspective.

As a photographer, the more you learn about the tricks of perspective and how to use them the more you can create a sense of dramatic 3-D depth to suit the subject of your pictures.

Converging lines

Everyone knows that if you look down a railway track the rails appear to converge. They get closer and closer together until, at a considerable distance away, they appear to touch. The sleepers also appear to get smaller and closer together. Yet, if you were able to walk along the track with a measure, you would find that the rails were the same distance apart and that the space between the sleepers remained constant, however far down the line you walked. This apparent convergence is due to an effect called perspective—the fact that objects nearest to us always

▲ The use of converging lines, which the eye accepts as indicating distance, is one of the most simple and effective ways of giving a picture a feeling of depth. By standing in the middle of the road to take this picture *Steve Herr* has further dramatized the effect.

appear larger than identical objects placed further away.

A railway track is a simple and obvious example because we know that the lines are the same distance apart, but the effects of perspective are with us all the time. The buildings seen when looking down a street, even if they are not all identical, appear proportionally narrower and proportionally less deep (smaller) the further they are from the viewer. The brain, however, because it uses previous knowledge and experience, modifies the eyes' accurate image and tells us that the buildings are

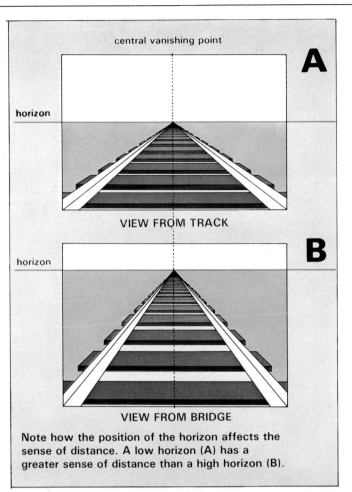

central vanishing point

A

horizon

VIEW FROM TRACK

B

horizon

VIEW FROM BRIDGE

Note how the position of the horizon affects the sense of distance. A low horizon (A) has a greater sense of distance than a high horizon (B).

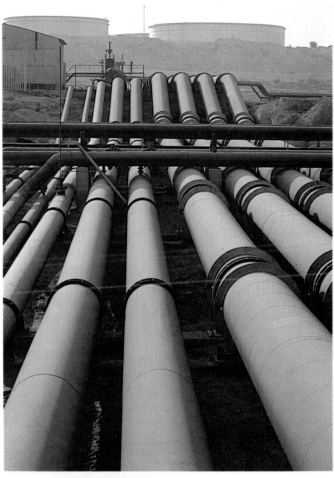

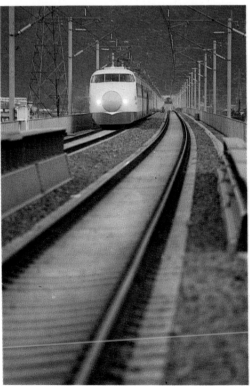

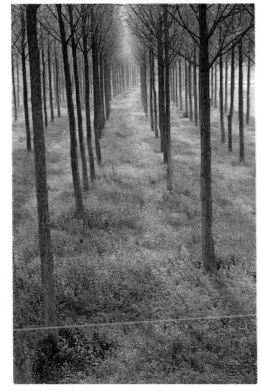

Including parallel lines which appear to meet in the distance is not in itself enough to make a good picture with plenty of depth. You have to choose a viewpoint from which this aspect of perspective can be best exploited to reflect the mood you wish to convey. *Paolo Koch* chose a low, central viewpoint for the picture of oil pipes in Iran (above), exactly right for a feeling of power and industry. *Lisa Mackson* used a high viewpoint to draw the eye down into the quiet seclusion of the woodland scene (left). *John Bulmer* stood slightly to one side to lead the eye from the front of the picture to the train (far left), while making the most of the curve at the end of the track.

the same size along the entire length of the street. You may *know* this to be true, but it is not the image received by your eye. Your brain has translated the information and decided to ignore perspective.

So, having established that your brain has been tricking you all your life, as a photographer you must now start trying to see what your eyes actually register. Because the camera does not have a brain, it will not ignore perspective. So learn to rely more upon your eyes and less on previous experience.

Vanishing points

Vanishing points and the horizon are two essential elements of perspective. Taking the railway track as an example again, you can see that the lines appear to converge at a point which is as far as the eye can see, and then disappear. This is the *vanishing point*.

In any one scene there may be more than one vanishing point. If you stand between the rails and look along the track you will see that there is only one, central, vanishing point (see diagram A). However, if you turn your head and look at a building from a corner (diagrams C, D, E and F) there are two, one on either side. Whatever their number, however, and whichever direction you look in, from the same viewpoint all vanishing points are on the same horizontal line, beyond which you cannot see. This line is the *horizon*.

Viewpoint

The position of the horizon, and of all the vanishing points along it, depends entirely on your viewpoint. By changing your viewpoint you change the position of the horizon, and so alter the perspective.

The 'normal' position of the horizon is at eye level (see diagram A) but, by moving higher up—on to a bridge, for example (diagram B)—you extend your area of vision and the horizon changes. The higher your viewpoint, the higher the horizon.

If you lower your viewpoint, objects appear to grow. A building appears larger because it towers above your normal eye level, indicating that it is very tall in relation to your viewpoint. Conversely, if you get much higher the building appears to become a scaled-down model of itself.

So changing your viewpoint affects the position of the horizon and alters perspective, which, in its turn, governs the

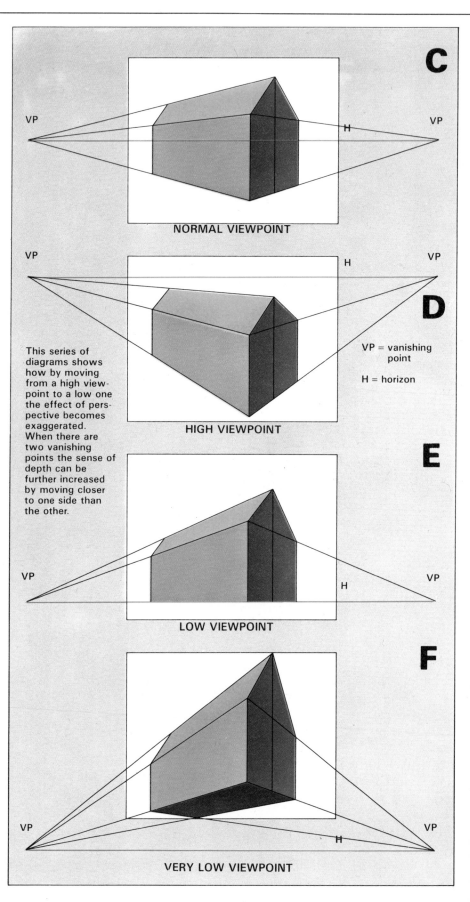

C

VP H VP

NORMAL VIEWPOINT

D

VP H VP

This series of diagrams shows how by moving from a high view-point to a low one the effect of perspective becomes exaggerated. When there are two vanishing points the sense of depth can be further increased by moving closer to one side than the other.

VP = vanishing point

H = horizon

HIGH VIEWPOINT

E

VP H VP

LOW VIEWPOINT

F

VP H VP

VERY LOW VIEWPOINT

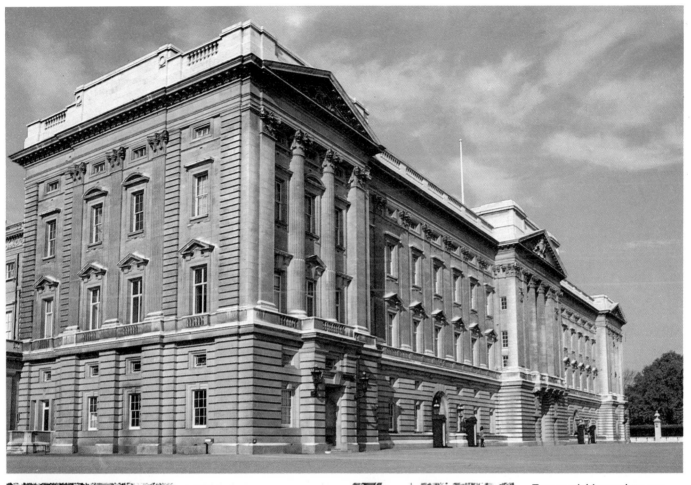

Two vanishing points are better than one! Especially when it comes to emphasizing the three-dimensional quality of a subject. Take a building, for example—it has two surfaces which meet at right angles to each other so there are two vanishing points, one from each surface. You may not be able to get both, or even one, of these in the shot. But, by positioning yourself in the front of the point where the walls meet, so that both are seen at an angle (above), you can suggest the vanishing points outside the edges of the picture. This will give a greater sense of depth than a shot from head on to just one surface (left).

visual impression of scale. It follows, therefore, that with a very high viewpoint, such as from a helicopter, you could photograph a building as tall as the United Nations Center in New York so that it would assume the scale of a king-size cigarette packet in the resulting print. Your brain, however, would adjust this image, primarily because it would recognize it as being a building, but also because everything else would be in proportion. The building would still stand out and tower above its environment.

Similarly, you could photograph a king-size cigarette packet from a very low viewpoint so that it appeared to tower up like a skyscraper.

Using perspective

Choose a photograph from a newspaper or magazine and draw a carefully measured grid over it. Better still, draw 5mm or 10mm squares on a transparent material or tracing paper. You can then use the grid on any picture without damaging it. With the aid of this grid you will quickly learn how perspective works.

You will be able to see—because your grid has constant, equal squares—how objects steadily appear both narrower and less deep (smaller) as they stretch into the distance. You should also find where the horizon is situated, and thus be able to plot vanishing points.

This will help you notice the way three-dimensional scenes are depicted on the flat surface of a photograph or drawing. Try making better use of perspective as an element of design and composition in your pictures. The next section outlines a number of elements which will help you to create a sense of depth.

Incidentally, if you find yourself able to see the effect of perspective on the print but not through the camera, you might consider, if your camera has interchangeable focusing screens, using one with a squared grid. It may take a little time to get used to it, but you should see a big improvement in your pictures. If you revert to your original screen later, this improvement should remain.

▶ For this picture *Adam Woolfitt* has taken the trouble to find an unusual viewpoint which uses the effect of perspective to its greatest advantage. The flatness of the head-on view against the dynamic lines disappearing into the distance makes a striking contrast, emphasizing both elements.

The essential part that perspective plays in giving a picture a sense of depth and distance is immediately obvious when looking at the print or transparency. It is not so easy to judge through the viewfinder. Placing a grid over printed photographs is one way of getting used to a squared focusing screen, which should help you over the problem. Even if you can't change the focusing screen on your camera you may find that this practice makes you think more carefully before you take your next picture.
Michael Busselle

Creating depth

A feeling of depth is not an essential requirement of every good photograph. A telephoto lens, for instance, compresses distance and can make an impressive two-dimensional picture which is immediately arresting because of its flatness—with the subject appearing to be on the *surface* of the photograph like a flat, drawn design instead of the usual 'window' on to a three-dimensional scene.

There are many subjects, however, where a flat image would be disappointing and where it is vital to create an impression of depth. Landscapes, for example, often appear to come to life only when the eye is drawn into and around the scenery, exploring the picture. Look at any number of successful photographs—still-lifes, landscapes or people—and notice how each composition benefits from having this strong 3-D effect.

So, one of the first decisions to consider every time you take a picture is: do you want to create a flat design or a 3-D effect?

There are a number of basic elements which can combine to give a sense of depth in a photograph: subject qualities such as scale, contour (i.e. overlapping forms), tone and texture. In addition there is the use of camera controls such as selective focusing. No matter whether you have a 110 or an SLR, you can exploit most of these to your own advantage. Start by looking for each individual element (described on the next four pages) in photographs in magazines and books. Then see if you can take shots based on one or several of these elements. As with other areas of composition the first step is to look carefully at the subject and recognize the opportunities.

► **There are times, generally when the scene would otherwise be boring, when a flat, diagrammatic representation of a landscape can look very impressive. The strength of this picture, however, lies in its tremendous feeling of depth. The countryside seems to stretch on and on into the distance.** *Kenneth Griffiths* **has carefully composed the picture so that the eye is drawn from the foreground on the left, where every blade of grass is pin sharp, to the main subject on the right. The lines of the road then lead you into the middle distance, almost in the centre of the scene, and then on to the horizon. Including the low layer of cloud almost as a ceiling has further increased the sensation of depth.**

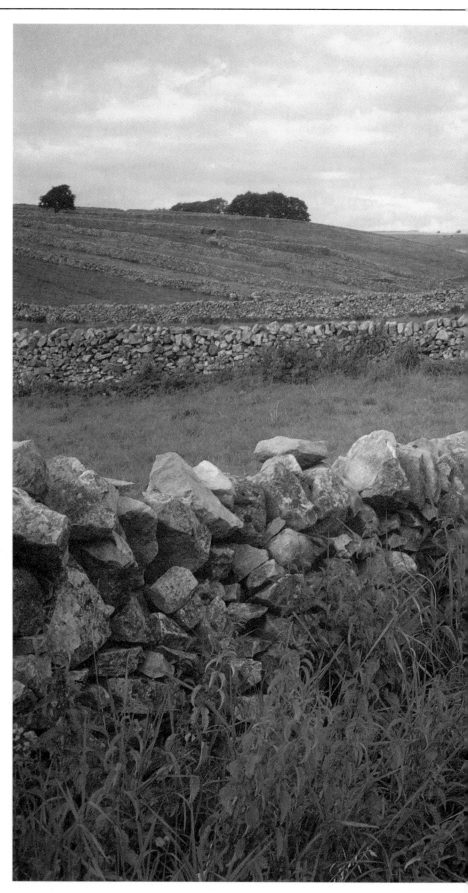

► SCALE: a picture which gives little indication of the scale of the elements within it can be very deceptive. Mountains, for example, may only look like small hills unless there is something in the picture to compare them with. Notice how the sense of distance in this picture depends to a great extent on the Eiffel Tower in relation to the figure in the foreground. When the tower is removed (see above) much of the feeling of depth goes with it. *Bryn Campbell*

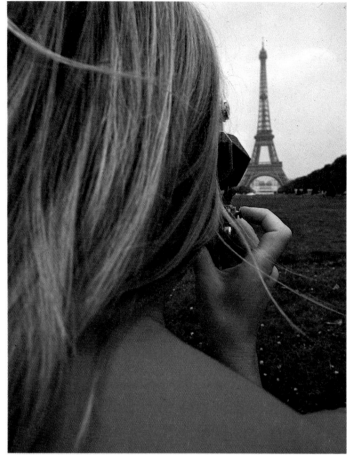

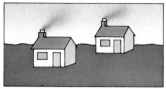

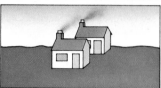

► OVERLAPPING FORMS: when one element in the picture partially obscures another the overall impression of depth is far greater than if the two were some distance apart (this is illustrated by the simple diagrams above). The picture of the old abbey shows how the principle works in practice. Had the photographer moved closer, so that all of the abbey could be seen through the gap in the wall, the final picture would have lost depth and appear to be much flatter. *Clay Perry*

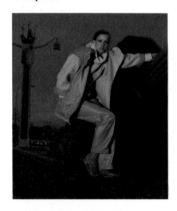

► LEAD-IN LINES: lines which draw the eye from the front of the picture into or around the main subject are a useful compositional device for inducing a feeling of depth. They can come from the bottom, the sides or, as in this picture, from the top. Compare this effect with that above where most of the railing has been cropped away. *Tino Tedaldi*

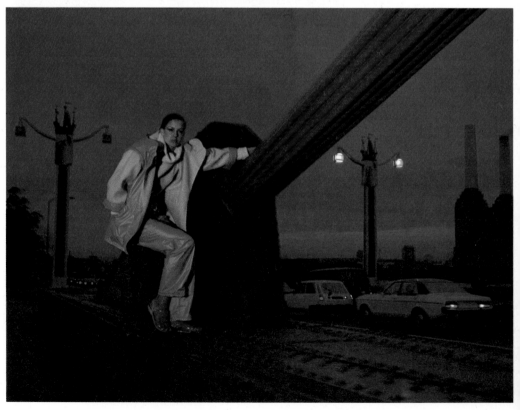

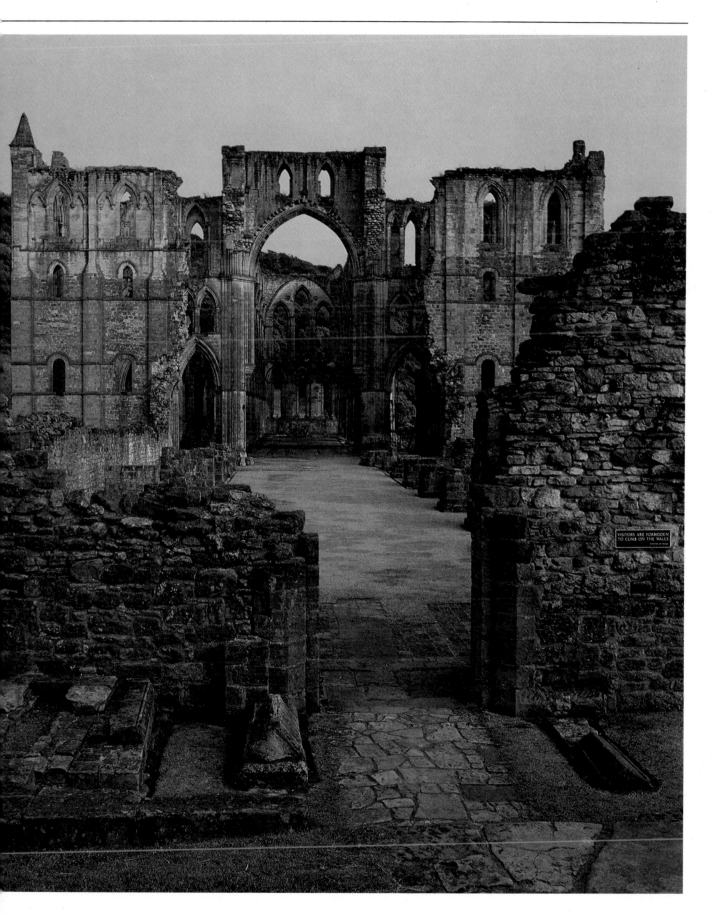

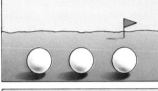

▶ DIMINISHING SHAPES: objects of the same or similar size appear to become smaller as they get further away (see diagrams above). *Robert Estall* has emphasized this for a greater feeling of depth in his picture by using a wide angle lens.

▲ FILLING THE MID-GROUND: choosing a viewpoint which places the main subject in the middle distance is an effective way of drawing the eye into a picture, so strengthening the feeling of depth. *John Goldblatt*

▲ TEXTURE: exaggerating the texture of foreground objects in contrast to the lack of detail in the distance is another method of adding to the feeling of depth in a photograph. Here it is obviously the converging lines of linear perspective which give the greatest sense of depth, but emphasizing the texture of the foreground by using a low viewpoint has also added to the effect. *Lisa Mackson*

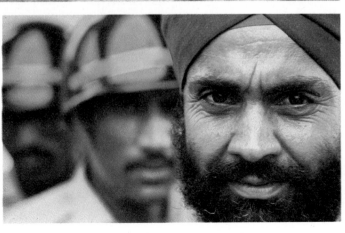

◀ SELECTIVE FOCUS: this technique is especially useful for producing depth in close-up shots and in subjects with a confused background. By throwing the background out of focus the sharp main subject stands out from the rest of the picture. The lack of detail in the background makes it seem to be further away from the main subject than it actually is, giving the illusion of depth.

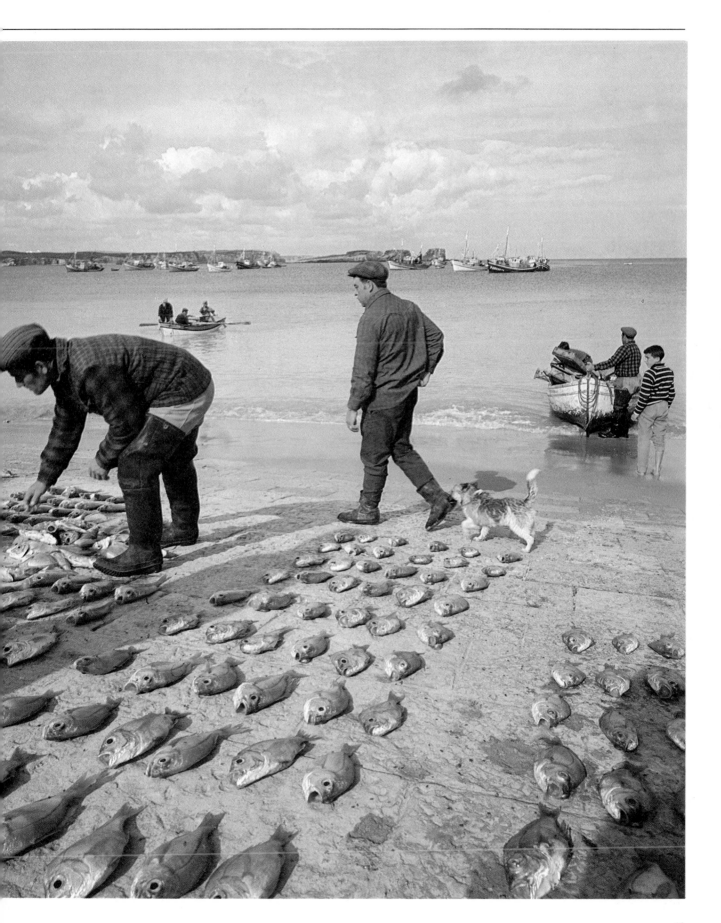

Choosing your viewpoint

Your choice of viewpoint, or camera position can make or break a picture, yet many people hardly give it a thought. The viewpoint has the greatest single influence on the picture. If you were going to hang a picture on your wall you would first examine the room carefully, looking for the position which would best complement both the room and the picture. The same amount of consideration should be given to taking a photograph. Just as you wouldn't dream of hanging your picture on the first spot on the wall that happened to catch your eye, so the best viewpoint is unlikely to be the first place from which you saw the subject.

Explore the subject

There are some occasions when the most immediately obvious viewpoint is the best possible place from which to take a picture. Generally this is not so, however, and the first thing you should do after deciding to take a photograph is literally to walk around the subject. See how it looks from the left and right, farther and closer, higher and lower.

You should in fact learn to explore your subject, to 'see' the full picture possibilities.

It is a very useful exercise to photograph a suitable subject from every conceivable viewpoint. You will be surprised just how much variety of composition and emphasis can be obtained from even the most basic situation or subject.

Lighting

It is important to remember that the camera position affects not only the

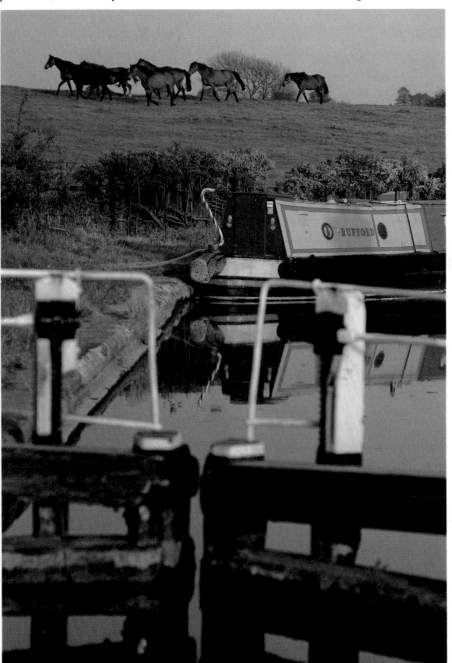

▲ The advantage of a close viewpoint is that the composition can be reduced to essentials, usually resulting in a simple design. Because it is simple, however, the smallest detail plays an important part in the picture and so must be carefully considered. For this picture *Patrick Thurston* positioned himself very precisely so that the tiller just appears in the sky area above the bank, while the reflection just misses being cut into by the edge of the pathway.

◄ A very different picture is created by moving to a more distant viewpoint. The barge is seen in its setting and there are more points of interest. The height of the camera is important here as it controls the overlap between the foreground, subject and background. Any lower and the lock gates, barge and field would have been mixed up.

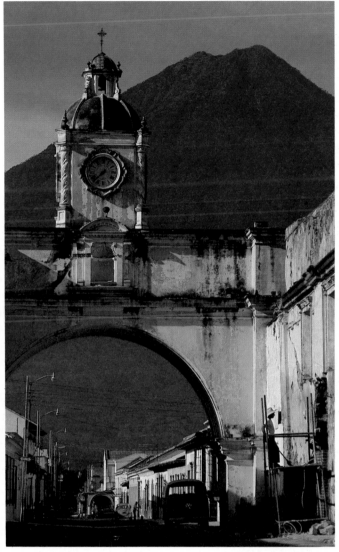

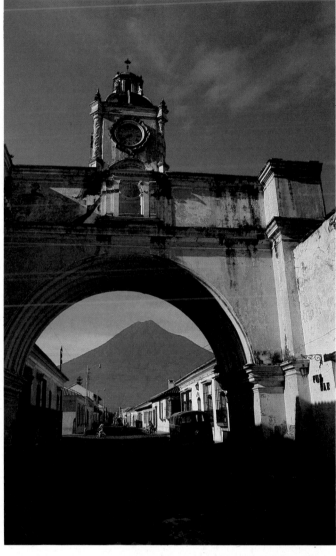

composition of the image but in most cases also the lighting.

Study the effect of the light on your subject and see how the lighting quality can be changed simply by moving the camera. A good example of this is the difference that shooting a subject against the light can make to the image, as opposed to conventional over–the–photographer's–shoulder lighting. Or you may need to move the camera so that part of the subject hides the sun to prevent flare.

Where the texture of a subject is important in a picture the direction of the lighting is a crucial factor. In this instance a shot head–on to the subject will rarely make the most of the texture, while shooting into the light would destroy detail completely. It is important, therefore, to look at the effect of the lighting when choosing your viewpoint.

Perspective

Another aspect of photography which depends totally on viewpoint is the effect of perspective. By changing viewpoint you change the relationship between the size and proportion of the various elements in the picture area.

You can learn a great deal about perspective simply by observing what happens to the apparent sizes of objects as you move closer or farther away from your subject. Take a person standing in front of a building as an example. From a distance the figure is overshadowed by the prominence of the building. As you move closer, however, the figure becomes proportionately more dominant and the prominence of the building is diminished.

Generally speaking a low, close viewpoint will exaggerate perspective, while a distant viewpoint will lessen it.

▲ A new viewpoint combined with a change of lens can make a spectacular difference to perspective and scale. For the picture on the left *Anne Conway* used a 135mm lens. By moving about 30 metres closer and changing to a 28mm lens the archway appears to grow and now dominates the volcano.

Changing lenses

To be able to change the focal length of your lens is a considerable advantage when choosing your viewpoint. Indeed, changing lenses will often encourage you to change your viewpoint. A longer lens, for example, enables you to use a more distant camera position but still obtain an image of adequate size. With a portrait, for instance, the perspective effect on a face is very unflattering when a standard lens is used closer than about 1·5 metres. A longer lens enables you

to shoot at twice that distance and still get an image that fills the viewfinder, but without the apparent distortion.

A wide angle lens (shorter than normal focal length) enables you to include more of a scene without having to move farther away. This is a particular advantage when taking pictures in a confined space, and it also enables objects quite close to the camera to be included in the foreground. This can also be useful in landscape photography to produce an impression of depth and distance.

One of the unexpected bonuses of using a lens of a different focal length is that it encourages you to take a new look at your subjects and to try some new viewpoints.

Framing

Finally, having decided on a general position for your camera, you should consider *slight* changes of viewpoint. Maybe one step to the left to exclude an intrusive colour, or a fraction lower so that you include an interesting piece of foreground, will make all the difference to the final result.

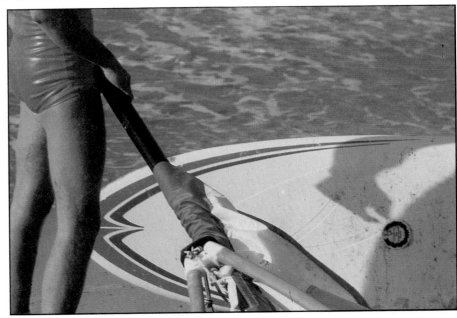

▲ *Tessa Harris* has used a very close viewpoint to emphasize the graphic quality of the strong colours and shapes of this windsurfer as he dismantles his craft on the beach.

▼ When the figure moved the shapes became much simpler, so Tessa lowered her viewpoint very slightly to include waves rolling into the beach as a more interesting background.

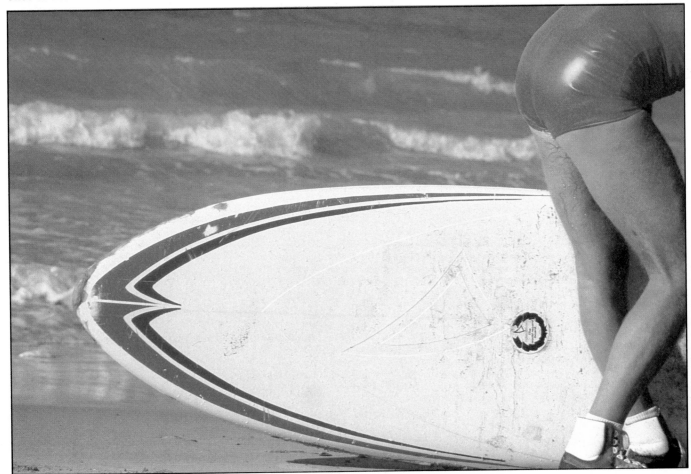

Write a check list

Ask yourself when was the last time you took a picture from ground level? Or from the top of a building? Or even from a chair? When was the last time you focused your camera at less than three metres? It is surprising how easily one can lapse into a routine and forget to explore the full possibilities of a subject.

You might even consider writing yourself a check list of possible viewpoints:

- From left and right
- From behind
- From a high viewpoint
- From close up
- From far off
- Including foreground interest
- Using a foreground object to frame the subject
- Directly into the light
- Lying on the ground, either facing forwards or on your back
- Directly above the subject.

These pictures were all taken from the balcony of St Mark's Basilica in Venice. They show how by careful choice of viewpoint the photographer can control exactly what is included in the picture, and in this way place personal interpretation on the subject. For the picture above left *Van Phillips* chose a viewpoint which accurately reflects what the horses look like. But with the other four shots, *Malcolm Crowthers* was trying to convey the sentiments of Petrarch, for whom these horses seemed 'to neigh and paw the ground with their hooves'. For the picture below left he actually lay on his back, hanging over the balcony slightly, to capture the descending hoof. The lifelike impression is helped by the fact that from this viewpoint all reference to the building is excluded.

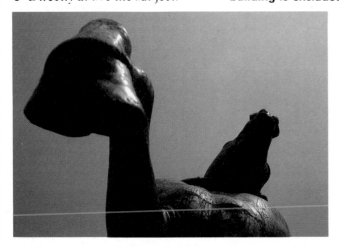

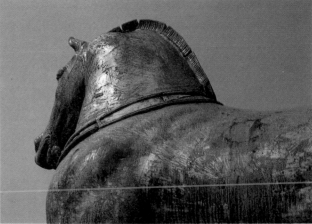

Bird's-eye view

Looking down from a great height is fascinating. People climb hills and mountains just to see the world rolled out like a map in front of them. A high viewpoint separates the viewer from his surroundings—gives a feeling of objectivity while reducing the significance of what he sees. One of the most memorable examples of this was the first picture of our earth as seen from a spacecraft.

Because most photographs are taken with the camera aimed at the subject from the same level—eye-level, from which we are used to seeing our surroundings—even a slightly higher viewpoint creates a degree of surprise. Simply climbing a few steps to take a photograph can show the scene in a different light, making a far more striking image.

Practical applications

Apart from its dramatic impact, a high viewpoint can often be very useful in separating the planes of your picture.

Imagine taking a shot of a queue of people. If you are standing at the front of the queue looking back, from street level you see only the first two or three people and the rest are lost behind them. From a height of a metre or so, however, you see the heads and shoulders of the entire queue. From a first floor window you can see even more of everybody. Your bird's-eye view has separated the planes in a sort of visual stretching process.

Getting higher is often the only way to cope with a subject that is too crowded and confusing from a normal viewpoint. Even still lifes and close ups can benefit from the technique, which—as well as removing unwanted background clutter—can give a stronger feeling of design with simpler lines and shapes.

A change of perspective

The effect of a high viewpoint is difficult to anticipate. It is usually a question of getting up there to see. The effect is often more startling when the subject is quite close to the camera. With a head and shoulders portrait, for example, you only need to raise the camera slightly to see a significant change, whereas a distant skyline might look much the same from several metres higher.

The effect on perspective is the most immediately noticeable aspect of the bird's-eye viewpoint. We are used to seeing the view stretching away to 'infinity', or at least to the horizon. Objects in view are normally progressively further from the camera, and appear to decrease in size correspondingly. This is largely responsible for giving a picture the illusion of depth.

With a true bird's-eye viewpoint there is no infinity and usually no horizon. The subject itself is on a single plane of focus. With no foreground, mid-ground or background the image tends to have a graphic quality with no depth or perspective.

Shots like this—whether they show a city layout from an aircraft or a chess board from directly overhead—concentrate attention on the two-dimensional *patterns* of the subject.

CHANGING YOUR VIEWPOINT
▼ **A bird's-eye view from as close as this creates an unusual perspective.** *Ashvin Gatha's* **over-the-shoulder glimpse of what the boy is doing also emphasizes the size of his smooth head.**

To retain a sense of depth you have to include some indication of foreground, by including the parapet of a tall building, for example. This restores an element of perspective, and adds impact from the high viewpoint.

The effect of lighting

In most photographs the chief concern is with the way light affects the vertical surfaces in the picture. But with bird's-eye shots it is the way that the horizontal surfaces are affected that is important. Shadows cast by people, buildings or even clouds can easily become the most

CREATING PATTERN

▶ From further away, a bird's-eye view becomes more two-dimensional. There is no infinity and, with no foreground, little perspective. The subject appears on one narrow focal plane, and pattern—of both line and colour—becomes all the more important. *Timothy Badow*

▼ Because it is so unfamiliar, a high viewpoint holds a special fascination. Displayed on one horizontal plane, a landscape which from the ground appears as a jumble of features can reveal an ordered pattern. *Bob Davis*

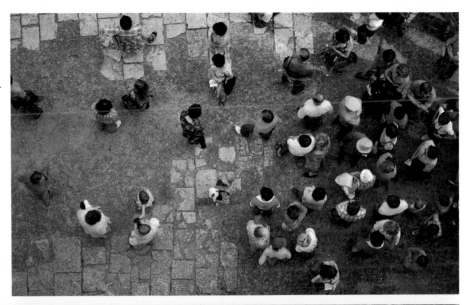

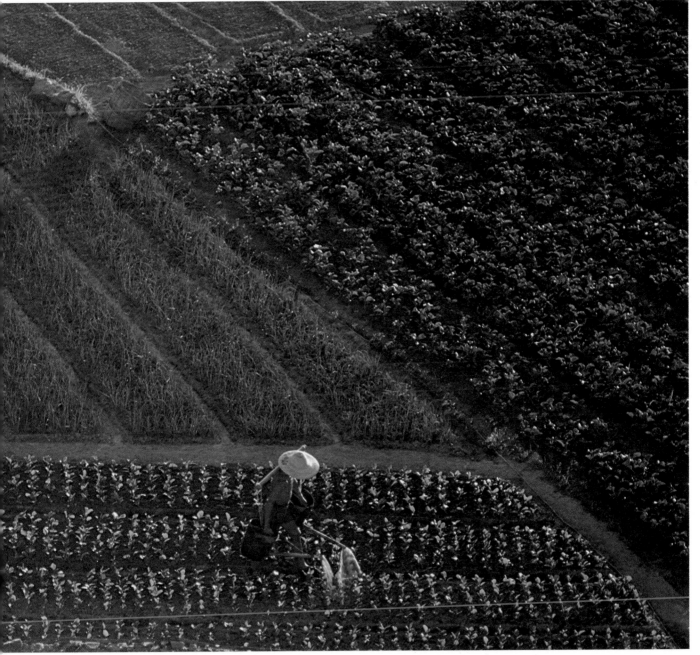

dominant element—shadows which from street level would go unnoticed.

Angle of light: For outdoor shots, then, the time of day becomes a very important factor. From above, a crowd of people strolling on the piazza will make a more interesting image when the low evening sun throws long shadows than on a dull, shadowless, morning.

With the light directly overhead, the lack of shadows reinforces the already two-dimensional appearance of a bird's-eye picture, abstracting it even further from our normal view of the subject. The picture will thus depend far more on the colour and pattern in the subject.

Quality of light: From high up you can see further, but you are photographing through more atmosphere, and so atmospheric conditions will have more effect. Even a slight amount of haze can destroy the crisp quality such pictures usually require.

A UV or haze filter can help a little with colour film, although they will not penetrate a really dense haze.

A polarizing filter will reduce much of the reflected light which is scattered indiscriminately by the haze, producing greater clarity and colour saturation.

In addition to haze, the blue cast which an excessive amount of ultra-violet light creates can also be a problem in high-view shots. A UV filter may not be strong enough, and it is often better to use a warm filter like an 81A or even stronger.

With black and white pictures an orange

HEIGHT AND PERSPECTIVE

The huge panorama you see when you point your camera at the horizon from the top of a high building seems to dwarf the height of your vantage point so that the perspective from foreground to background is not very different from a normal view. But point your camera down onto the ground beneath you and you begin to get a more dramatic bird's-eye effect. *Michael Busselle* took the general overview here with a 20mm wide angle lens, keeping the camera almost level. Then he homed in on selected details (ringed in the large picture) with his 70-210mm zoom lens.

A) First he chose an area where the bird's eye view showed several levels (the river, the streets and the railway bridge) justaposed in an unusual way. He took the first of these shots with the zoom lens around 135mm.

B) Then he shot the scene with the lens at around 180mm. Without the context of the surrounding cityscape, the relative positions of the boat and the trains appear all the more peculiar and difficult to decipher.

C) With the zoom lens fully extended at 210mm, the perspective seems even more flattened. In fact, if you compare all three shots you will find that the relationship of one object to another remains consistent.

D, E, F) Keeping the lens at 210mm, Busselle had a wealth of detail to pick out from his high viewpoint. The more directly downwards he pointed his camera (as in E), the more two dimensional the effect. With no perspective, pattern becomes all the more important in these shots.

A

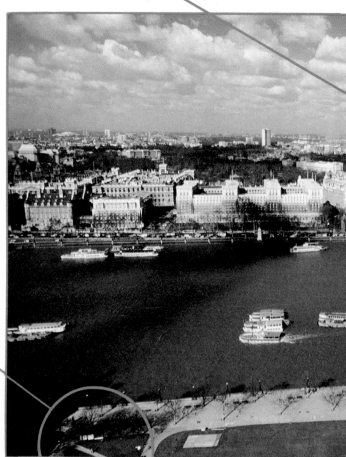

F

or a red filter is very effective in penetrating haze.

Lenses and viewpoints

From the top of a tall building you can obtain a variety of different effects just by changing lenses.

A wide angle lens aimed towards the ground can include part of the structure you are standing on, and perhaps the horizon as well. Still a bird's-eye view, it provides the missing element of perspective. The foreground details con-siderably increase the impression of height. With a wide angle, exaggerated perspective makes a camera height of only a metre effective for close ups.

A telephoto lens has the opposite effect. Pointed directly down so that the subject is on a single plane, the fore-shortening effect of the lens reduces perspective even further. Isolating small areas from above can juxtapose normally separate objects. Boats on a river can appear to be on a collision course with trains on a bridge above.

Safety

From a height you may feel that you can see as a bird does, but remember that you can't fly like one—and neither can your camera.

It is very important to hold the camera firmly on it's neck-strap at all times, both for your sake and for those below.

You will feel that from a high vantage point you can 'see everything'. This is not quite true, but you can see things in a new and different way, and prob-ably take better pictures, too.

B

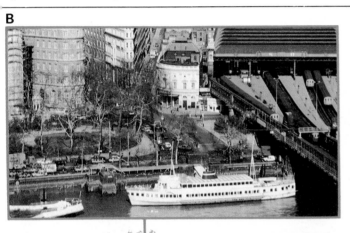

C

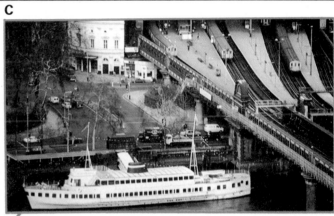

D

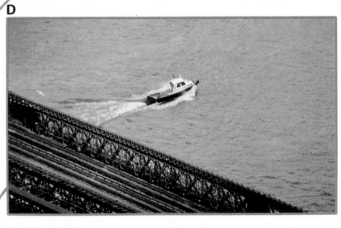

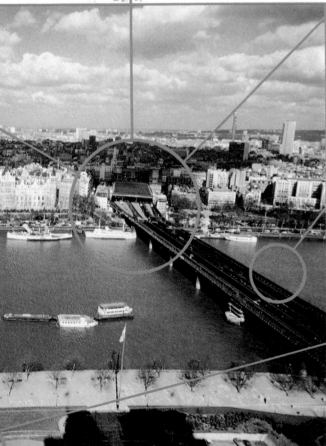

E

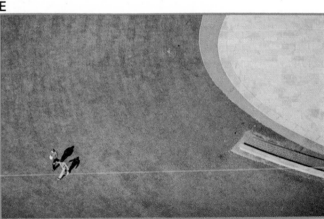

Worm's-eye view

Have you ever taken a picture from ground level? The world can seem dramatically different from a worm's-eye viewpoint. Of course it has its disadvantages. To see things from that point of view is often far from comfortable or convenient. But the rewards of seeing things in a different way—of taking a distinctly different approach—make the effort well worth while.

Getting down to it

The effect of an unfamiliar viewpoint and the resulting perspective will be much more noticeable with objects which are quite close to the camera. A low viewpoint would produce little change from the normal view with a tall building, for example. If your subject is a person, however, the effect can be quite startling.

A waist level camera such as a twin lens reflex makes it possible to adopt a fairly dignified position for a worm's-eye view. With an eye level camera there are several things you can do.

● Lie full length on the ground.
● With some SLRs—usually the more expensive ones you can remove the pentaprism and fit a waist level finder.
● Fit a right-angle viewfinder attachment to the pentaprism eyepiece so that you can look down into it.

Choice of lens

The maximum effect of a low viewpoint comes from photographing objects between ground level and the normal camera height of 1½-2 metres. Few telephoto lenses are capable of this, but most standard and nearly all wide angle lenses can focus this close.

A wide angle lens will further emphasize the low viewpoint and exaggerate the unfamiliar perspective as it includes far closer foreground details. With a 24mm or 28mm lens (on a 35mm camera) it is possible to include the feet of a standing figure from ground level quite close by.

Tilting the camera upwards has a powerful effect on the composition of the shot. The diagonal lines of perspective give a typically pyramid shape to the subject and make it appear more vigorous and dramatic.

Using silhouettes

Since you will often be shooting upwards against the sky, the shape or out-

▶ With the sun in your shot, a small aperture gives a starburst effect. As it has no multicoating, *D. Kilpatrick's* lens also gave flare spots which he incorporated into the picture.

▲ With a wide angle lens from ground level you can include most of a standing figure. With a fish-eye you can take in most of the surrounding scene as well. Notice that this shot has no 'right way up'. *Paolo Koch*

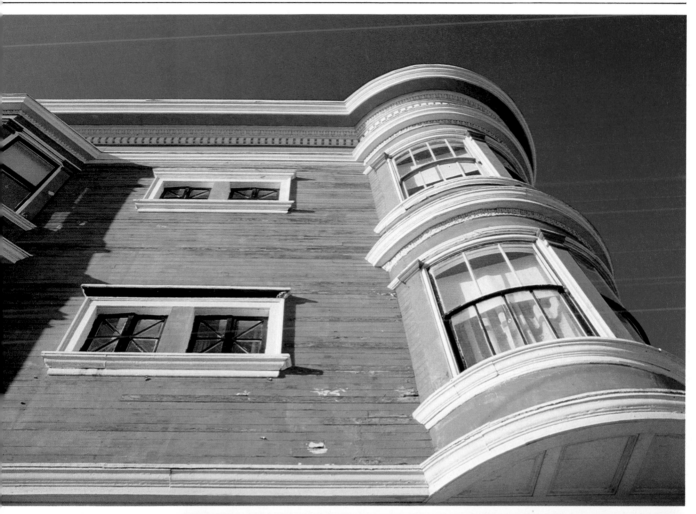

▲ From a worm's-eye view you can make good use of the sky as a contrasting background. *Anne Conway* used a polarizing filter and framed the shot to get the best colour balance.

▶ For this worm's-eye close up *Suzanne Hill* used extension tubes, placing her camera on the ground.

73

line of the subject will be very important. By exposing for the background you can allow the subject to become a silhouette. This is particularly effective when you include the sun in the picture. A wide angle lens at a small aperture will give a natural starburst from the sun.

You will need to take extra care with exposures for this kind of shot. If you *do not* want your subject as a silhouette, it is best to take your TTL or meter reading from close to the subject before taking the picture.

With black and white pictures a deep red filter can add to the effect. It records the sky as a much darker tone and any white clouds will be emphasized. With colour film a polarizing filter will do this without adding a colour cast. Graduated effect filters can also be used to darken or colour the sky.

Choosing subjects

Small subjects—such as toddlers and pets—are seldom photographed from their own level. By going down to, or

▲ **A low viewpoint gives a more sympathetic view of a small child.** *Michael Busselle* used a standard lens at minimum focusing distance to leave both foreground and background blurred.

below, their level you can get a far more intimate, personal view. From ground level, a picture of a toddler or a domestic cat towering above you is a reversal of the normal state of affairs and can produce a very dramatic effect.

Small subjects also have the advantage that you can cheat a little by sitting them on a bench or a table. This makes it easier to get your low viewpoint while keeping your subject firmly in one place.

Action pictures are particularly dramatic when shot from a low viewpoint. Goal-mouth pictures are often taken this way at football matches. There are many startling shots of horses going over a jump taken with a remote-controlled, motorized camera positioned directly underneath the fence and pointing towards the sky. Not every photographer would want to risk his

camera in this way but the same technique can be used in more controlled circumstances. Get your children to jump over you as you lie on the ground, for example or creep just out of range under the arc of a child's swing.

Justify your viewpoint

Any subject can be approached from a worm's-eye view for a novel perspective. You may want to be blatant about your unusual angle, making it the dominating factor in the shot. Or you may simply want to use the viewpoint as an integral part of the picture.

Look for a setting that makes sense of your viewpoint without seeming contrived or gimmicky. A portrait of a child climbing a tree, for example, or of a man cleaning a window.

An interesting photograph is just as often the result of the way the photographer looked at his subject as it is due to the subject itself. Often an otherwise commonplace situation can make a dramatic picture simply because the viewpoint is unfamiliar.

▲ The worm's-eye view makes it difficult to see what is the subject of this almost abstract shot. It is in fact a wet street at night lit by neon signs. *Robin Bath*

◄ Photographing an aquarium, *Jane Burton* took a low viewpoint to show this frog above and below the waterline, making a point of how light is refracted differently in water and in air. The head seems to have slipped sideways.

▼ Shoulder-deep in water, *John Garrett* used an underwater Nikonos camera set at 1/500 to catch the action here.

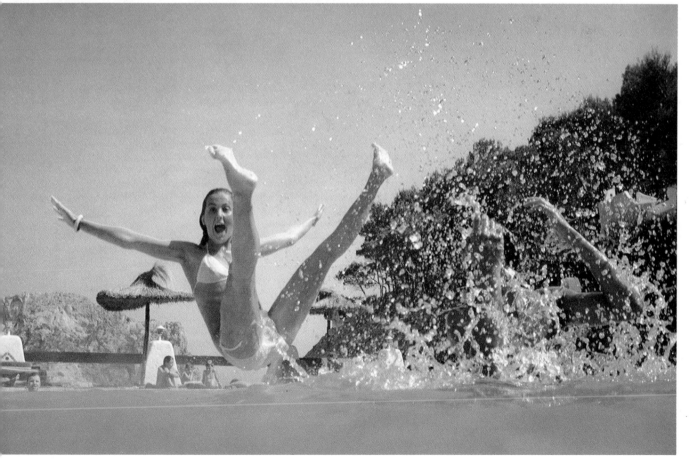

Balance: diagonal composition

Most cameras produce rectangular or square pictures. When trying to make a balanced composition, therefore, it is natural to think first of how the horizontal and vertical lines in the picture relate to the sides of the frame. The position of the horizon is often the first consideration. Many objects—trees, buildings and people, for example— are normally vertical and this, in conjunction with the horizon, makes rectangular composition the norm.

Images in which the strongest shapes and lines cut the frame diagonally, however, require a different kind of composition. Whether or not the diagonal runs precisely from one corner of the picture to the other, the *impression* is that the image is divided into two triangles.

The principles of balancing a composition remain the same: a strong colour on one side of the dividing line can counteract a complicated shape on the other; or the silhouette of a human figure will balance the strong attraction of the sun setting like a fireball on the other. But with diagonal compositions, the problem is now to contain these visual 'weights' within their opposing triangles.

Diagonal compositions fall mainly into two categories:
● those that are essentially flat pictures, relying on two dimensional pattern, colour and shape for their impact;
● those where the diagonal is related to lines of perspective which emphasize the depth of the picture.

Pictures which are a combination of these two types tend to produce a peculiar feeling of vertigo in the viewer. For example, framing so that a parapet (which is in fact level) runs diagonally across the picture will make it difficult to decide 'which way is up', particularly if the other side of the frame contains a figure leaning over at an angle.

DIAGONAL DETAIL

▼ Choosing to show the pageantry of a military parade by detail rather than in an overall view, *Graeme Harris* picked an area dominated by a strong diagonal. As well as giving a feeling of movement, the slanting trumpet divides the frame into two balanced areas: one rich in colour, the other in detail.

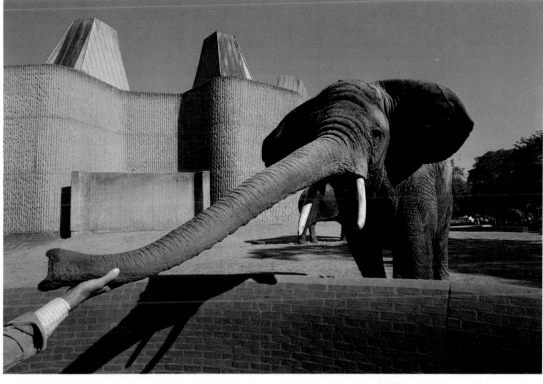

DIAGONAL PERSPECTIVE

▲ A wide angle (28mm) lens, which emphasizes perspective, exaggerates the way the elephant's trunk seems to slope out of the frame towards the viewer. *Per Eide* used a small aperture (f11) for good depth of field.

DIAGONAL PATTERN

▼ This bird's-eye view gives no feeling of perspective, concentrating on the pattern of chimney pots stacked in a builder's yard. *Mike Busselle* prevented the shot from looking too static by framing on a diagonal line.

◀ Far left: The way the shadow outline and the details on the ground combine, gives *Tessa Harris's* 'self portrait' its interest. Following the angle of her arm, the diagonal on the ground brings life to the figure.

◀ Though the steps must lead downwards away from the camera, *Robin Bath's* flat viewpoint reduces the shot to two dimensions, concentrating on the abstract effect of colour and texture based around diagonal lines.

▼ *Bob Davis's* shot of a transaction at the floating market in Bangkok falls into two sections, balanced around a diagonal gap. On the left it is the bright colour combination that attracts the eye: on the right it is the shapes of the green coconuts.

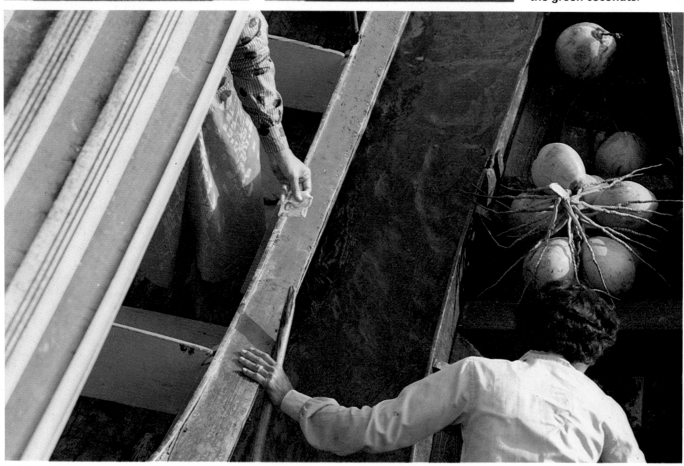

Two-dimensional pictures

Photographing a flat surface where there is no feeling of perspective places a great deal of emphasis on pattern. With no perspective to lead the viewer's eye further into the composition, it is vital to include striking colour combinations or strong intricate shapes to hold the viewer's attention. Where there is a diagonal line running across a picture like this, always try to include objects of equal interest on either side. In a photograph where a delicate wrought iron gate occupies one of the triangular areas of the frame, for example, a bright patch of coloured creeper in the other will balance the picture.

High views often produce two-dimen-

sional images and provide an excellent opportunity to experiment with diagonal composition. Tilting the camera sideways when the picture includes the horizon simply gives a peculiar result. From a high viewpoint looking down, there is no 'right way up', and you can frame your subject at any angle you choose. In a picture of sunbathers on a beach taken from the pier above, it would be just as logical to have their heads at the bottom of the frame as at the top.

Because there is no perspective, the balance of colour and shape becomes more important in a high viewpoint picture that contains a strong diagonal. Because it is more difficult to alter your

▲ Though in fact his model was lying flat, *Tino Tedaldi* turned his camera to give the impression that she was falling downwards out of the frame. He used a wide angle lens to exaggerate perspective on the bamboo.

viewpoint once you have found a good vantage point (it is often difficult, if not dangerous, to take that vital pace backwards) you may need to change the focal length of your lens to get a balanced picture. Using a zoom lens is the easiest way to do this.

Diagonals of perspective

Returning to ground level, the strong diagonal lines that lead from the fore-

◀ This square arrangement of Edam cheeses could have been photographed from the side. However, shooting from one corner with a wide angle lens exploits the diagonals to give a much more dynamic result. The strong diamond shape produced contrasts with the rectangular shape of the picture area. Travel photographer *Mike Yasmashita* took the picture in Amsterdam.

ground of a shot into the distance can have a very bold effect. In fact, from the photographer's point of view, the effect can sometimes be too strong: the ability of lines of perspective to draw the eye into the picture can sometimes overwhelm the rest of its contents, and it becomes crucial to maintain a good balance.

Landscapes which contain a road or river running away towards the horizon often pose this problem. The uneven contours of the ground and the foliage may help to soften the diagonal, but it often needs another strong centre of interest to balance the picture. A striking shape in the foreground or the middle distance, on the opposite side of the frame to the direction of the lines of perspective, will do this. A tree (because of its size and complicated shape) or a human figure (because of its personal interest) can be particularly effective. An active figure has a stronger impact than a passive figure simply contemplating the view.

A colourful object also has the power to draw the eye back from the distance and counterbalance the perspective lines. A piece of bright red farm machinery in the foreground, for example, could provide a strong alternative centre of interest.

With a wide angle lens, which both exaggerates perspective and emphasizes foreground detail, a careful balance of

▲ Tilting and *turning* the camera exaggerates this skyscraper's height. *Ron Boardman* balanced it with part of another building to prevent it from seeming to rush diagonally out of frame.

these two factors is even more important. City scenes are mostly made up of straight lines. Shots taken looking up at a tall building depend on diagonal composition because of the apparently converging vertical sides of the building. However, shots like this can often look

▼ Aiming to show the contrast between the sunlit field in the foreground and the dark storm clouds beyond, *David McAlpine* chose to fill the frame with the foreground, making sure that the track would lead the viewer's eye across the picture into the distance.

rather empty. By including, say, a red traffic light in the foreground you can both give the necessary feeling of scale and balance the strong attraction of the lines disappearing into an empty sky. The effects of diagonal lines of perspective—whether vertical or horizontal—are all the stronger if they run from one corner of the frame to another. Wrongly used, they can lead the viewer's attention straight out of the picture. By including a strong feature or colour in the diametrically opposite corner of the shot you can give it a satisfying feeling of balance.

To sum up
Successful pictures that feature a dominant diagonal line tend either to be two-dimensional, flat views, concentrating on pattern and colour, or pictures including strong lines of perspective.
● To achieve a balance in a picture which is cut in half diagonally, include strong colours or striking shapes in each of the matching triangles.
● Where the diagonal line is related to perspective, take care that you include some strong feature in the foreground to compensate for the way that the diagonals lead the eye into the distance.

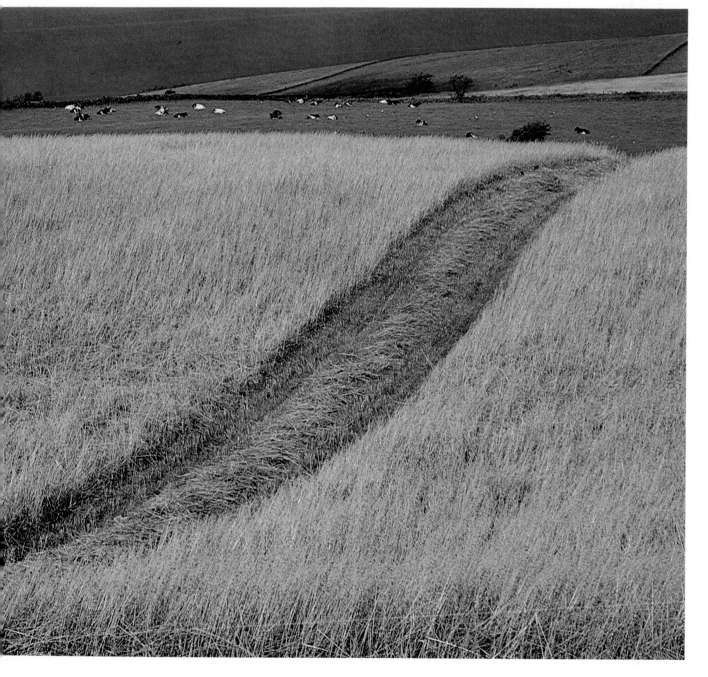

THE DETAILS THAT COUNT

So far this book has taken a very general view of picture-making, and looked at the factors that affect the photographic image as a whole. Now it concentrates on the specific details that can make or break individual images.

Almost every good photograph has at least one strong line running through it, providing an anchor that holds the picture together. The first section in this chapter shows how to use such lines to provide movement and direction to capture and hold the viewer's gaze. A strong pattern or a richly textured subject can have the same effect, and the chapter goes on to explain how you can use pattern and texture to produce interesting, vibrant photographs.

Since they lack colour, black and white photographs rely on light and shade to form the image. The tones in the picture, and the contrast between them, are therefore very important when working in monochrome. This chapter explains how to produce pictures that emphasize the tonal range and subject contrast, both in colour and black and white, and how to eliminate shadow tones to leave striking silhouettes.

The final section, which looks at the concept of the picture essay, shows by practical examples how two photographers use many of the principles which have been described in the preceding pages. They use a sequence of images to build up a more comprehensive picture than any one photograph could provide.

Awareness of line and shape

If you trace the main outlines of many successful photographs you will find the resulting images have a pleasing and balanced quality. This is because these lines represent the basic framework of the picture, and without a sound basis it is unlikely that a satisfying photograph will be produced.

Making tracings

With some photographs the main outlines are very clear but with others the main shapes and lines may not be immediately obvious. To discover which elements make up the basic framework

▲ A tracing of the main lines and shapes of the photograph below gives a well balanced and recognizable image. The tracing makes it

easier to see the basic composition of the picture—that is, a series of circles with a strong, carefully placed, diagonal which breaks the harmony of the circles.

▼ Bottom: the helter skelter is in partial silhouette so the picture has to rely on its strong shape for impact. Although simple, a picture like this needs careful composition: the tower must be placed within the frame in relation to the sun, so it adds interest and balances the composition.

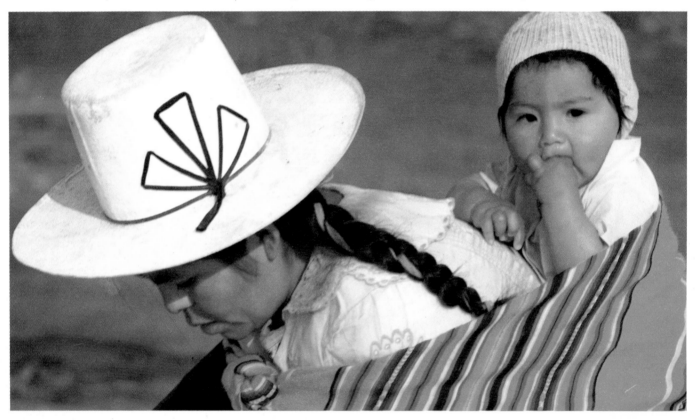

of a picture, trace the dominant lines and shapes of a couple of photographs you like and one in which you find the composition disappointing. Then compare the results; it should be quite easy to see why the one fails where the others are successful, and which elements influence the overall structure.

Dominant lines and shapes

These lines and shapes are created by a number of things:
1 The outline of the main subject.
2 When a picture includes a horizon or other equally strong division, the line it creates is usually very dominant and its position influences the overall balance strongly.

3 Boundaries between contrasting areas of tone or colour can be important elements in the composition.
4 Lines created by the effect of perspective can add to or detract from overall balance.
The effect of shape is most easily seen in photographs where the main subject is either silhouetted or boldly contrasted against the background.
Shapes created by lighting which causes strong highlights or casts shadows can be equally dominant. In hard directional light—midday sunlight, for example—contrast shapes and shadows can become more powerful than the subject. Once you start to look for them, these elements become easy to recognize. So ·

making a rough mental pencil sketch of the subject is the first important step in the process of composing your picture. Train yourself to notice these lines and shapes in your viewfinder long before you consider taking the picture. Without this awareness, creating well-composed pictures becomes a very hit-or-miss affair.

Contrast
The juxtaposition of the shapes and the way they react with each other is also important. Contrast is one way to make sure the subject gains the atten-

▶ It is not usually advisable to divide the interest of a picture down the middle. But in this case the dominant shapes are completely symmetrical and the strong central division enhances this effect.

▼ Horizontal lines emphasized by bands of colour produce a restful image. The photographer has taken particular care to position himself so that the trees are seen clearly in silhouette.

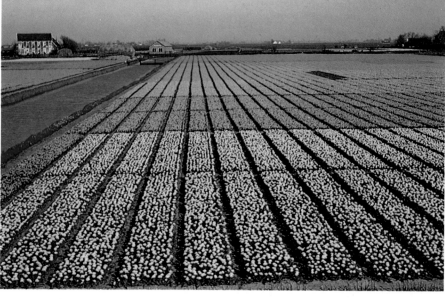

tion of the viewer, and a contrasting shape or line is an effective way of achieving this.

In a portrait, for example, the roundness of the face and eyes can be enhanced by using the model's arms and shoulders to create an angular contrast. The presence of even a small vertical line, such as a human figure or a tree on an otherwise uncluttered horizontal skyline also achieves this.

A contrast in shape alone is not always enough to achieve the desired impact; a contrast of tone or colour is usually needed as well. For instance, a red triangular sail on a blue horizon is much more striking than a blue sail would be.

Altering the mood

Quite apart from their role in composing pictures, lines and shape can have a marked effect on the mood of a picture. Where horizontal lines predominate, as in many landscapes, a relaxed and passive quality will be created. A strong diagonal line, on the other hand, is much more vigorous and assertive. Where a number of similar shapes exist within the image—the curves in a still life of a bowl of fruit, for example—the effect is usually restful and harmonious, while a variety of contrasting shapes or lines at different angles create a busy and a more exciting impression.

Controlling line and shape

With many subjects the photographer has a limited degree of control over these elements. In the case of portraits and still lives, shapes can be created at will but with landscapes it is only possible to control the choice of viewpoint and the way the picture is framed. It is often possible to minimize the effect of undesirable lines in a picture by choosing a viewpoint which allows foreground details to interrupt or obscure them. To introduce diagonal lines, photograph from a higher or lower viewpoint and tilt or angle the camera.

In a similar way, soften shapes which are too obtrusive by hiding part of their outline behind other details, or by cropping into the shape. A change of viewpoint often alters the lighting effect to reduce the tonal contrast between a shape and the background.

Once you can see which of these elements contributes to the picture and which detracts, it is usually possible to find a way of stressing the former and subduing the latter. And if no solution is possible, your awareness of the fact will spare you from a disappointing result and wasting your film.

▲ *George Rodger* climbed on top of a shed (about 6m high) to gain an elevated viewpoint—essential to capture the interplay of perspective on the repeated straight lines of this tulip field. Taken with a Leica 50mm lens with UV filter, on a bright but overcast day.

▼ The rhythm of curves and lines in the Sydney Opera House adds up to an exhilarating, almost abstract composition. When photographing buildings, look for repeated lines and see how they echo or conflict with the shape of the subject. *Gordon Ferguson*

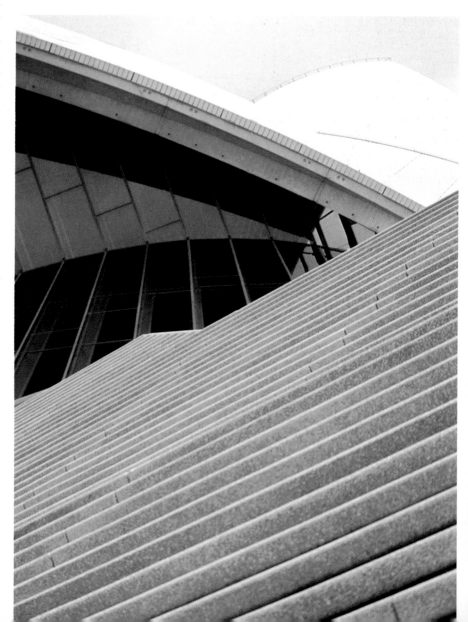

▲ Look for repeated curves or lines in haphazard arrangements.

► Contrast of colour and shape prompted Michael Busselle to take this picture. Try altering your camera position to make sure the contrast is most effective.

▼ Try looking at shapes from above (over a cliff, for example). The strong diagonal of this pier is emphasized by bright directional sunlight while under-exposure deepens the shadow.

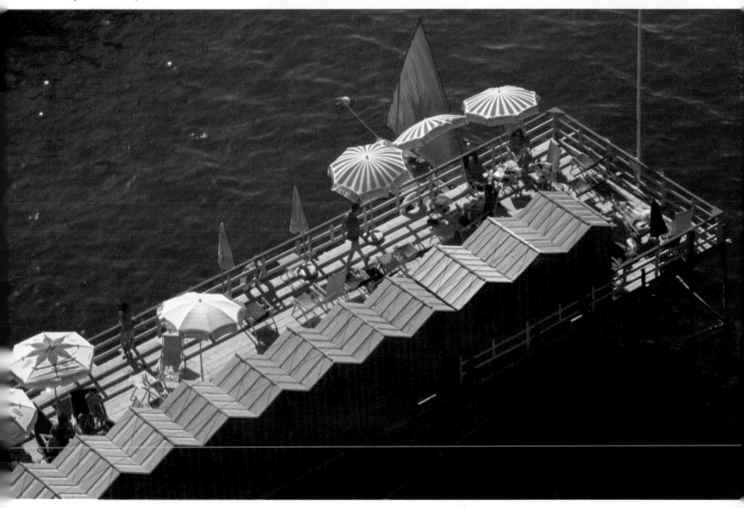

Discovering pattern

We live surrounded by pattern. In photography these patterns can tease, amuse or stimulate the visual imagination. Skilfully used, this repetition of shapes or lines within a photograph help create a rhythm and order that can make a particular picture memorable. The patterns the photographer uses need not always be exact geometric repetitions like the arches in a colonnade; they could be an impression of a pattern, such as the expanding ripples of water, or tracery of branches against the sky.

Where to find pattern

Finding patterns is very much a question of being aware. To develop your 'eye', look out for pictures with a strong element of pattern and see how they are formed.

Pattern can exist almost everywhere. There are two main types—transient patterns which exist only at a certain moment or from a particular viewpoint, such as the faces of a crowd at a football match, in a flock of flying birds or a parade of soldiers; and static patterns which are man-made or created by nature, such as the windows in an office block or a row of houses, the bark of a tree or the ripples left in sand after the tide has gone out.

How to use pattern

It is unlikely that a picture relying solely on pattern will have any lasting appeal—although it may have an initial impact—so pattern should be used only as a strong element of a picture and not as the sole reason for taking it.

A strong pattern can create a reassuring, restful and ordered atmosphere in a picture. But remember that patterns are usually quite busy and complex, so the main subject of the picture should be simple and bold, and placed in a strong position within the frame, otherwise it may be completely overwhelmed.

▶ REPETITION
A far more dynamic effect is created by this diagonal pattern of soldiers than by the usual straight-on rows. The build-up of repeated shapes, repeated angles, repeated details, all contribute to the overall result. The high position is important; at ground level the pattern would not have emerged as clearly. Notice too how the epaulettes separate the rows dramatically.
Bruno Barbey

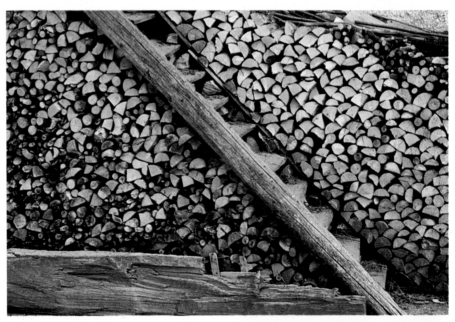

▲ This apparently higgledy-piggledy mass of beach huts is held together by the strong underlying repetition of the triangular roofs. *Michael Busselle* juggled about with the viewpoint until he found the most effective combination of colours, perspective and play of light and shade. Now approach the idea another way: if the huts had all been in straight lines—each shape, colour and angle identical— the picture would lose the interest created by oddities in the pattern.

Sometimes purely repetitious pattern can be boring—especially when the scale suppresses individual quirks and surprises—as in the picture of a pile of logs (right). But as a background to the strongly diagonal ladder the logs work well, throwing the ladder forward and not competing with its lines in the way a more varied background, such as a collection of farm implements, might have done.

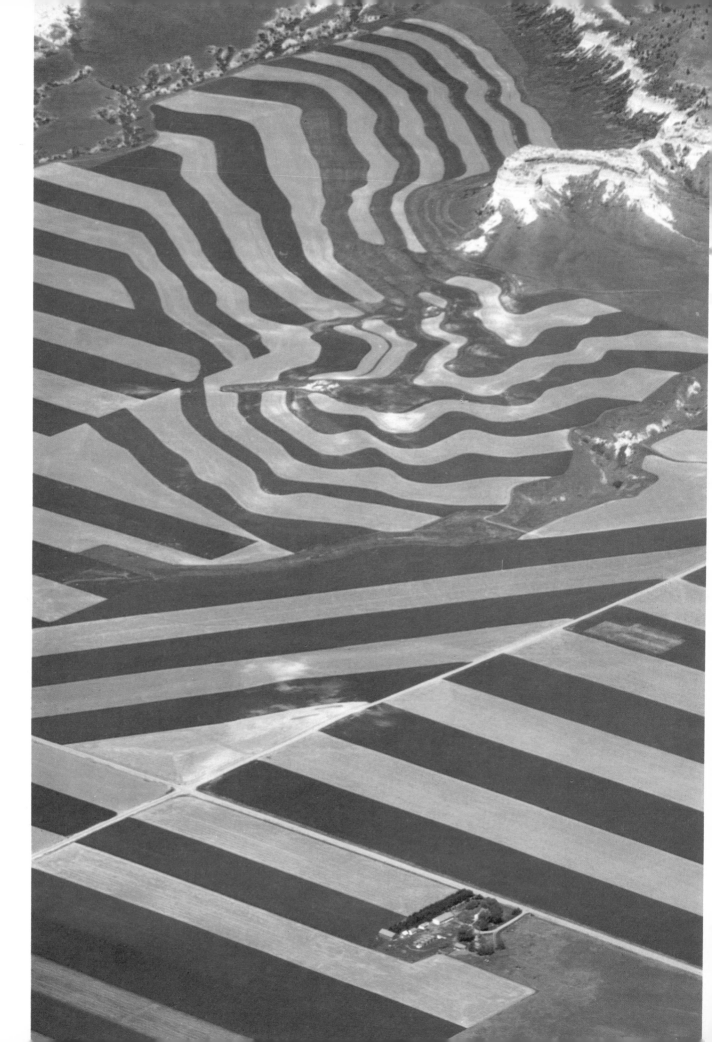

◄ Once you notice the farm building at the bottom, the whole picture acquires a sense of scale. You see the scene again in this context and suddenly it's not an abstract design, but a pattern created by the contour of the land and the ploughing of the field —a marriage of both man's and nature's influence.

How light affects pattern

A subject which has an inherent pattern, such as a pile of logs or a row of houses, may not be greatly affected by a change of lighting, but there are other images where the pattern is created or revealed by the nature of the light. A pattern of this sort may only exist for a short time. Take, for example, the patterns caused by sunlight on the ripples of water. It is quite easy to photograph a couple of dozen frames on a subject like this and

for each one to be quite different. In many instances it is the shadows which make a pattern, and a slight shift in the angle of light causes the pattern to disappear.

Pattern and colour

Pattern is made up of lines and shapes. In a black and white photograph these are formed by highlights and shadows and contrasting shades of grey. In colour photography, lines and shapes are often formed entirely of colour and

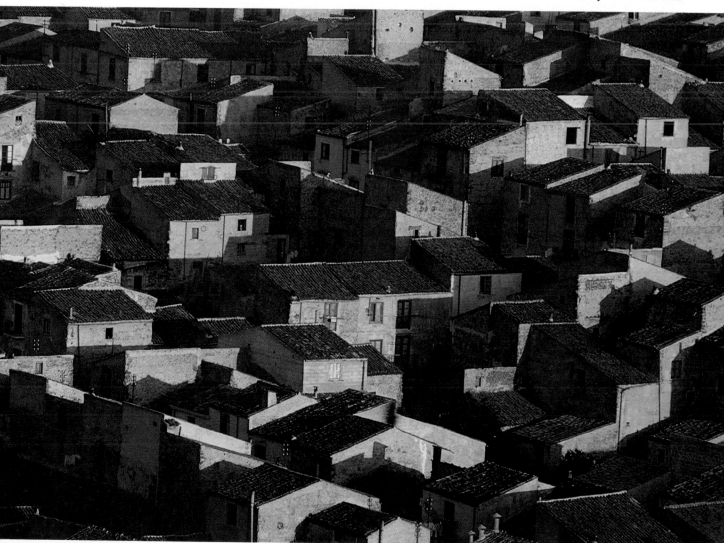

◄ This reflection of a colourful boat on rippling water makes a transient pattern which will change with the movement of water and the position of the sun.

▲ An Italian village, seen at late afternoon when the sun is at an angle. Very strong lighting has created dense shadows and strong highlights, making a pattern which would be equally obvious in black and white.

the colours of the subjects become as important as highlights and shadows. In many instances strong colours make a pattern obvious and it is quite possible for a pattern to be produced by colour alone. The colours in landscapes and woodland scenes often make strong patterns. Close-up photography often reveals beautiful patterns in the colours of flowers and insects, or in the rainbow patterns found in soap bubbles and oily water.

Patterns exist everywhere but the photographer must be prepared to look for them. It is really only a question of 'tuning in' visual awareness to uncover a limitless source of subject matter.

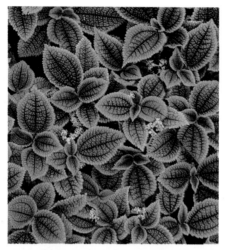

Pattern can be man-made or it can occur naturally. It can be revealed by lighting or colour or by a changed viewpoint. All these pictures contain strong patterns of one sort or another. Some are immediately obvious, such as the repeated shapes of the honeycomb, the sea urchins, the cars seen from above, or the house fronts. Others, such as the umbrellas or the stone wall, depend on the lighting to make the pattern obvious. Often going in close on a detail will show pattern more effectively than photographing the whole—for example, the pattern of leaves (top left) or the fir trees.

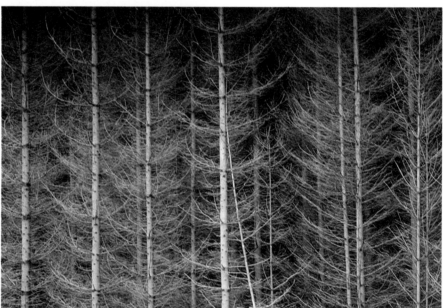

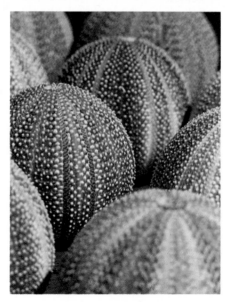

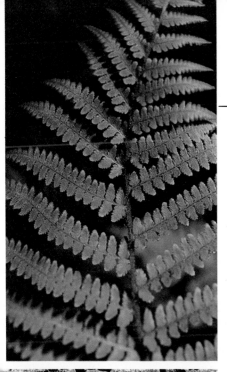

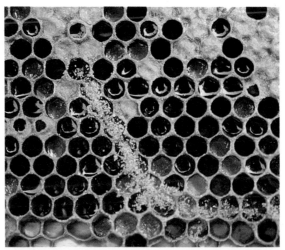

Emphasizing texture

One of photography's special qualities is its ability to convey texture so realistically that you can tell what objects would feel like just by looking at pictures of them.

The texture of a surface shows how it feels to the touch—whether it is rough or smooth, hard or soft. It is possible to take a picture of a group of objects——a piece of metal, an egg, some silk and an orange, for example—and give a really accurate impression of how each one would feel. Indeed, wood grains can be printed on laminates so convincingly that you have to touch them to tell genuine from fake.

Texture for realism

The ability to convey texture is vital for pictures that are intended to look particularly realistic. Some of the best examples are seen in food and still-life photography, where the photograph sometimes becomes almost more real than the product. And if you want an unreal quality, texture is the first thing to go—dream sequences in films are almost always shot with soft focus attachments, whereas to show texture the image must be as sharp as you can get it.

Professional still-life photographers often use large format cameras when photographing for texture but it i quite possible to get very effective results with smaller cameras. The must be accurately focused, and kep very still, and the aperture must b small enough for adequate depth o field. A fine grained film is usually bes for emphasizing texture.

How light affects texture

The way you light an object to revea texture most effectively depends largel

▼ A full range of textures, from fabric to metal, is reproduced here. *Michael Newton's* use of soft, low-angled lighting highlights the individual textures.

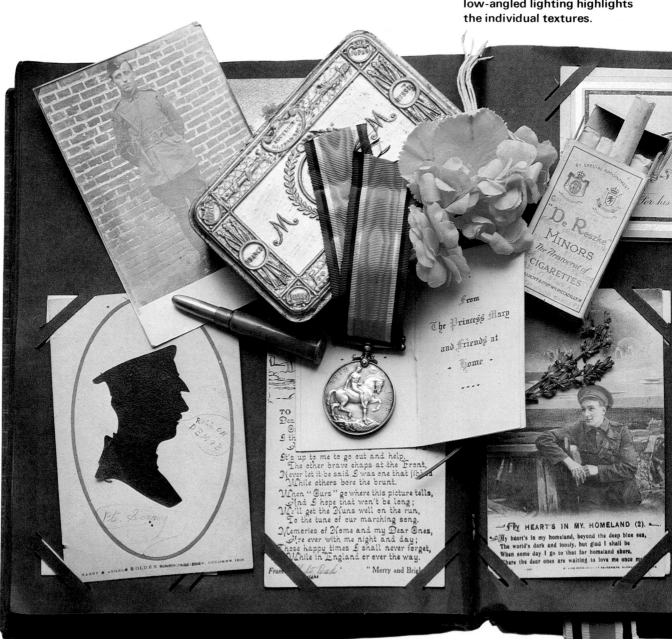

► *Paul Forrester's* skilful use of lighting picks out the texture in this food shot. Here the combination of lighting, fine grain film, small aperture and camera angle all contribute to the strength of the texture. Although shot on large format, high quality is possible with a slow 35mm colour film, such as Kodachrome.

▼ Right: close camera position and precise focusing isolates the detail of texture. *Eric Crichton*

on the surface you are photographing. A subject with a coarse texture and wide range of tones, like the bark of a tree, can be quite effectively photographed with just a soft (large source) frontal light. However, a surface with a subtle texture, such as an orange, which also has an even tone and colour, would need to be lit in such a way that highlights and shadows are created within the tiny indentations of its skin. This usually means that the lighting should be quite hard (fairly small source) and directed at the subject from an acute angle so that it literally skims across the surface.

With a subject which has a more pronounced texture, such as a stone wall, slightly softer lighting at an acute angle is preferable, otherwise the shadows created by the indentations become too large and dense.

Shape is also important: with a flat surface such as a stone wall lighting has the same effect over the whole surface whereas the lighting on a rounded surface, such as an orange, varies.

As a general rule, the more subtle textures require lighting which is harder and more directional than surfaces with a more pronounced texture. But to achieve the best results you have to be aware of the distribution of highlights and shadow tones, and the gradations between them, which the lighting creates on the surfaces of your subject. If you are going for textural quality above all else, you may find that the techniques used create undesirable effects in other elements of the picture. For instance, in fashion photography the lighting used to bring out the texture of cloth won't do much for the model's skin.

How to accent texture

One method of accentuating texture is to increase the contrast of the lighting, either by directing it from a sharper angle when it is controllable, like studio lighting, or by changing the camera position.

Photographing towards the sun is an effective way of doing this, especially when it is low in the sky. Don't point the camera directly at the sun but position it so that its angle to the surface being photographed is roughly equal to the angle at which the sun

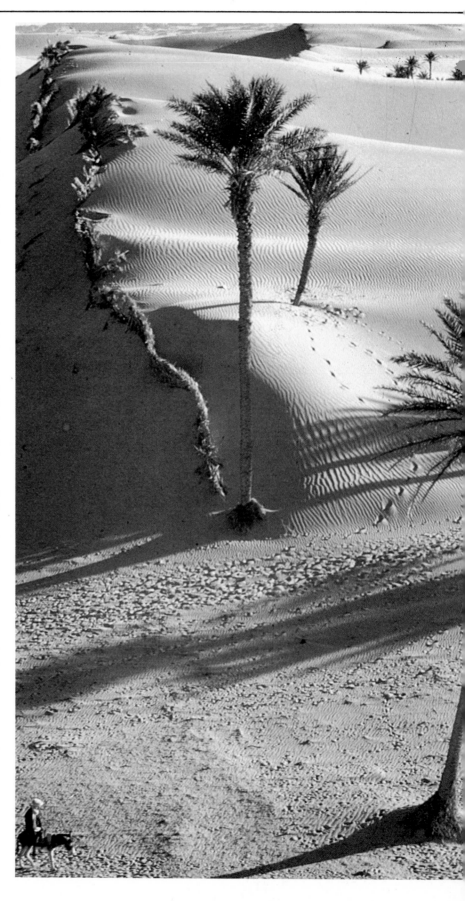

▶ The low sun will pick up the sand's texture but produce strong shadows, so it is wise to bracket exposures. Here the photographer has no control over the lighting. *George Rodger*

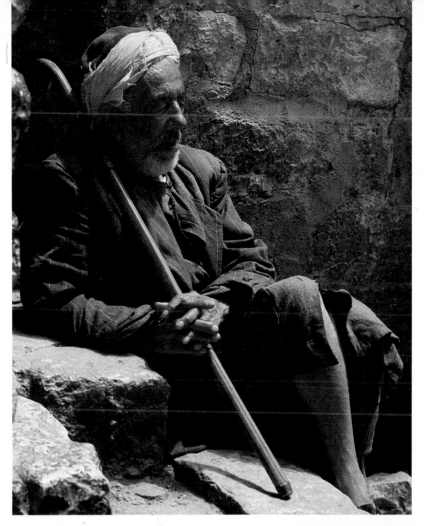

▲ Bark has a very pronounced texture which would be obvious in almost any lighting. Hard, directional light, here good for the texture, often creates dense shadow and loss of detail.

◀ Similarly, skin texture can be revealed by hard, directional lighting. This type of lighting is usually more effective on dark skins than on white, where it tends to be unflattering. *Michael Busselle*

▶ By taking the camera close in, *Eric Crichton* has emphasized the inherent texture of this cabbage. Here soft lighting is essential to record the delicate texture at the edges of the leaves, which would become lost in the shadows from a strong directional light.

▼ The problem is similar in *Colin Barker's* close-up of a leaf, where the texture is only made obvious by the extreme close-up.

▶ Below: texture like this peeling paint needs strong side lighting where there is no colour contrast to make it really obvious.

strikes it, so increasing contrast.

Contrast can also be increased by your choice of film: the slower the film the higher the contrast. In black and white photography (and with certain colour films) it is possible to increase the contrast by using special processing techniques. But although it is possible to create exaggerated effects in this way, it is at the cost of subtlety, and other elements of the picture may have to be sacrificed.

Exposure can quite often be used to accentuate texture, particularly if you use lighting with a reasonably high contrast range. In this situation a degree of under-exposure will often effectively increase the textural quality of the subject. Skin tones in a portrait, for example, will have a stronger texture when they appear darker than usual—the portraits of Karsh often display this technique.

The opposite technique is of course used to minimize skin texture, as in fashion and beauty photography, where a soft, frontal light creating a low contrast range is often combined with a degree of over-exposure to create a more ethereal effect.

But the key to a picture showing strong texture is a really sharp image. Although lighting, camera angle and exposure can all contribute, success ultimately depends on a really crisp picture with good definition. Make sure the camera is accurately focused and try and stop down to at least f8. If this means a slow shutter speed be sure to use a tripod.

▲ Slight under-exposure will often bring out skin texture in portraits, as in this *Karsh* picture. Use this technique with care as it can bring out unflattering blemishes as well as character.

◄ A picture which works as well in black and white as in colour (far left). Low back lighting creates strong highlights, shadow and sparkle. The strong highlights could cause under-exposure, so take a reading from a middle grey area or bracket exposures.

▶ Take away texture and you take away realism. Soft focus gives a dreamy, romantic image.

Tone and contrast

Tone is the difference in density between the lighter and darker parts of a photograph, ranging from white at the one extreme, to black at the other. In between lies an infinite variety of tones and it is tonal contrast (or the relationship between these tones) which gives three-dimensional form and depth to a picture. The tonal contrast of an image is affected by the lighting of a subject, its colour and its reflective qualities.

In colour, the same principle applies, although technically the darker tones—in the green of a leaf, for example—are called shades, whereas the lighter tones in a picture are called tints.

Tone and form

If a two-dimensional photograph is to imply a third dimension it needs to include the full tonal range with subtle variations. Much of the photographer's skill lies in recognizing these tones and recording them accurately. First, you need to become aware of them in your subject, even in something which is white. A cloud, for example, is very rarely white all over; it is usually a gradation of white and grey and it is these gradations which give the cloud form and depth.

► To achieve a full tonal range you need to balance the tonal quality of the subject with lighting, precise exposure and correct contrast in processing and printing.

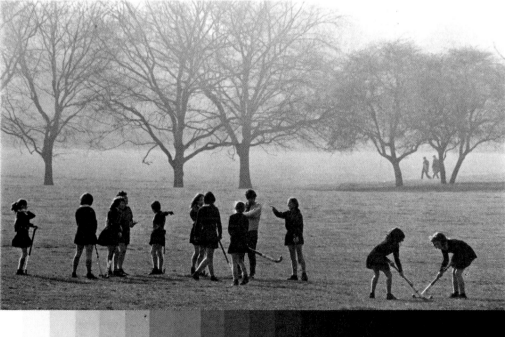

◄ Most of the tones in this picture are only a slight variation on mid-grey, as the grey scale below shows. This results from soft lighting accentuated by processing and printing. Higher tonal contrast in the picture could have made the overall effect too fussy. *Herbie Yamaguchi*

► Difference in tone between background and foreground add to the feeling of distance created here. The limited—but high —contrasting tonal range is the result of lighting conditions—mist and early morning backlighting— which produces the very pale background with the foreground almost in silhouette.
Herbie Yamaguchi

How light affects tone

If you photograph a white billiard ball (or an egg) and a disc of white card the same size, and light them from the front so that no shadows or highlights are created, there will be no visible difference between them. If you then move the lighting to the side to create shadows, the difference will immediately be obvious. The white ball will develop a full range of tones from white on the lit side through shades of grey to black in the deepest shadow, and so becomes three-dimensional. Light which creates shadows is also creating tone. You can see the relationship between light and the tones and shadows it creates virtually anywhere—from the window light on a fellow passenger's face in a bus or train to the sunlight on the landscape through which you are travelling. A hard (small source) light such as direct sun creates solid tones with clearly defined steps, whereas the soft light of a cloudy day produces gently changing tones and shadows with imperceptible edges.

How tone affects mood

There is a strong connection between the tonal range of a photograph and the mood it conveys. A picture which consists primarily of the darker tones in the range gives a sombre and serious atmosphere whereas a picture with a full range of tones, bright highlights and crisp shadows creates a lively and cheerful impression. A photograph

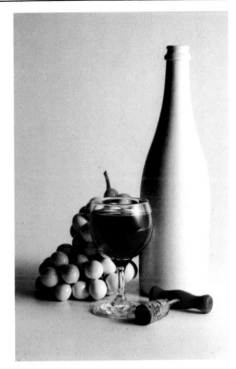

The two white bottle pictures show how lighting affects tone and how a large tonal range brings out form and distance. The same soft lighting is used for both but front lighting (below) has produced an almost shadowless image, which makes the picture look flat. Half-side lighting (above) gives strong, well-placed shadows, adding form and depth. *Michael Busselle*

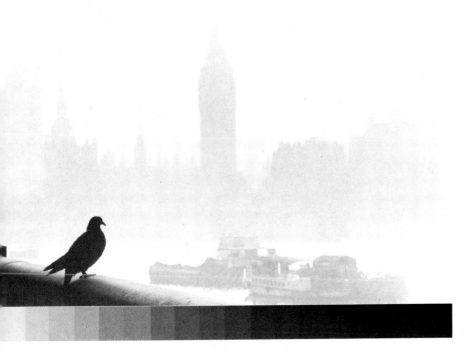

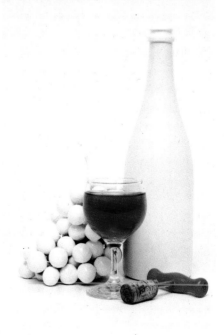

▲ Low key pictures are usually found, not created. The sombre, serious mood is helped by slight under-exposure. *Michael Busselle*

▼ A high key picture has light tones with little contrast, but there are usually areas of fine, bold detail in a darker tone, almost like a pencil sketch. *Robin Laurance*

made up of lighter tones has a delicate and often romantic quality.

So the tonal quality of your picture should illustrate the mood you want to convey—a dark-toned (low key) picture of children playing on the beach would be as inappropriate as a delicate light-toned (or high key) portrait to show the character of Count Dracula.

Tone and contrast

Contrast is the relationship between the darkest and lightest tones in a picture. A photograph which has a full range of tones with detail in all but the brightest highlight is considered to be of normal contrast. A picture dominated by very light and very dark tones, with little tonal variation between, is described as high contrast. Where there is only a small difference between the brightest and darkest tones you get low contrast image.

Contrast is partly controlled by lighting. A hard directional light such as bright sunlight tends to create a high contrast image while very soft light—a heavily overcast day, for example—creates a low contrast image.

Colour and contrast

Light and dark colours in a subject give it contrast which is independent of that created by lighting. For example, a bride in a pale wedding dress standing against a dark church door is a high contrast subject, whereas the same bride standing against a white wall would be a low contrast subject. You can also control the contrast in your photographs by the way you handle the lighting. Harsh sunlight will emphasize contrast, producing hard shadows and giving extremes of tone. If you want to reduce this contrast, wait until the harsh direct sunlight has become diffused by clouds.

Developing and printing

In black and white photography, and to a lesser extent with some colour films, it is possible to control contrast by varying the development times; the longer the time, the greater the contrast. Conversely, less development means less contrast. The choice of printing papers can also affect the contrast. Taking grade 2 paper as normal, using grades 3 to 5 will give a higher contrast picture and grades 1 to 0 will give a softer result.

To sum up

For a wide range of tones
- Wait for—or create—softer diffused lighting.
- Calculate your exposure carefully: if in doubt, bracket exposures.
- Develop and print according to manufacturers' instructions.

To increase contrast
- Use harsher, direct lighting.
- Under-expose by about 1 stop.
- Increase development and/or use a more contrasty printing paper.

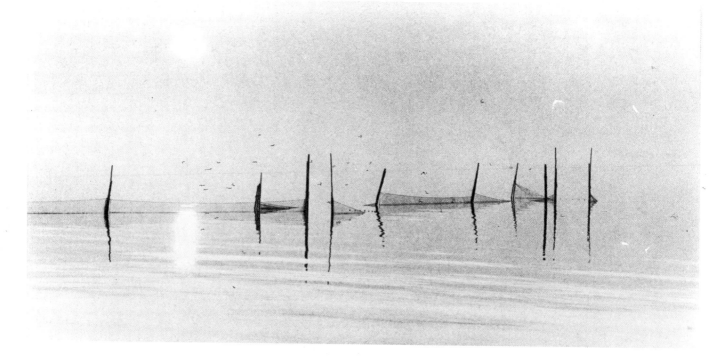

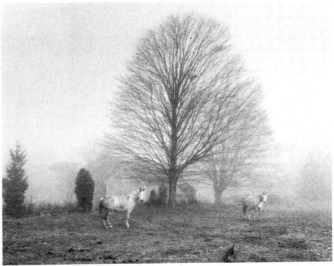

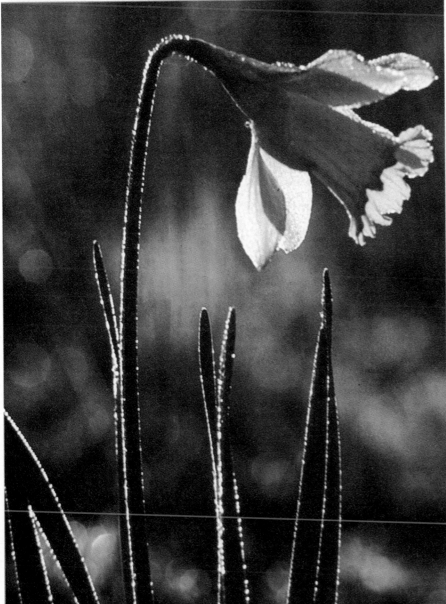

Top left: back lighting with a slight haze and high contrast paper gives a high contrast image. The exposure needs to be just long enough to keep the light areas clean without unwanted detail in the foreground. *Bob Kauders*

Left: the high contrast is totally a result of exposing for the very strong back lighting. *Richard Tucker*

Top right: this low contrast image is the result of very, very soft lighting and slight mist. A soft grade of paper should be used for this effect. *Jonathan Bayer*

Below: low contrast in colour. The tonal range here is lower than may at first appear because there is quite a large colour difference. *Michael Busselle*

Images in silhouette

A silhouette is the most elementary form that an image can take; in the true sense it is simply a black shape on a white background and the only interest it has is the outline of the shape itself. Yet silhouettes can tell a story in which the viewer mentally fills in the details. For example, the cut-out profiles which were popular in Victorian times often conveyed a strong likeness of the subject and revealed more than a little character.

Looking for silhouetted images is a good way to learn the basics of composition because the simple outline shows clearly how shapes within a frame balance each other.

Shape alone is enough to identify some things, while others need more elements to be recognizable; the silhouette of a banana, for example, would be enough to identify it, while the rounded outline of an orange would be less easy to recognize.

How to use silhouettes

A pure silhouette is rarely used in photography. There is usually a sug-gestion of other details included in the image, a little colour or tone, a suggestion of form or texture, or just some detail in the background. But the purpose of such an image remains the same—to concentrate the viewer's attention on the shape or outline of the subject. A silhouette showing subdued details, rather than one where the detail is completely blacked out, is an effective way of doing this. By using semi-silhouette conditions, something is left to the imagination and this in itself can bring a suggestion of mystery.

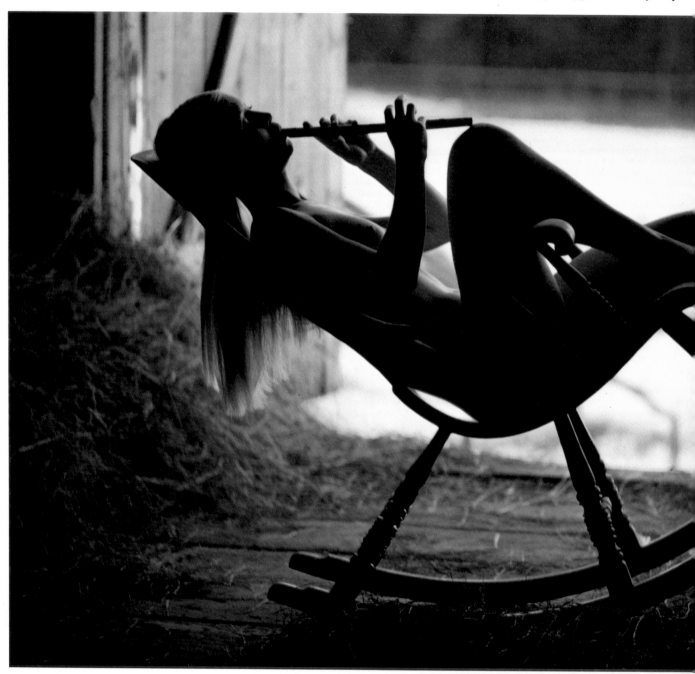

How to create silhouettes

Silhouettes can be created in several ways: you can use natural or artificial light, shoot into the sun, use foggy or misty conditions.

Natural lighting indoors: you can use controlled lighting to create a silhouette by lighting the background and keeping the subject in darkness. A simple way to do this in natural light is to place the subject in front of a window or open doorway, with the light behind it, and to take the photograph from inside. The subject will be boldly defined.

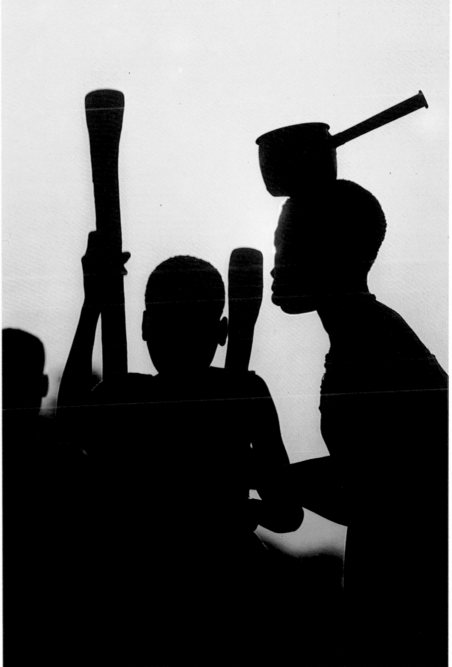

◄ The girl is carefully positioned in a doorway so that both she and the rocking chair present a clear, explicit outline. *Michael Boys*

▲ A silhouette created by shooting into the sun. *John Bulmer* positioned himself so the sun is hidden behind the figures and calculated the exposure from the sky to suppress unwanted detail.

► Silhouettes can frame a picture too: they can provide good foreground without competing with the main subject.

Studio lighting: with studio lighting it is, of course, possible to control the light even more finely, by directing the lamps at a white background. Any light straying on to the subject can be shielded by placing a piece of card round the light to limit it to the background only.

In all cases it is important that exposure readings should be taken from the light background areas only to ensure that the subject itself remains as an under-exposed dark tone.

The sun: shooting towards the sun is often the most convenient way of producing a silhouette, especially if the background has a light tone, like water or sand. Again, you need to expose for the highlight areas. It is also important to shield the camera lens from direct sunlight. Sun causes flare and lowers the contrast of the image, which in turn reduces the effect of the silhouette. Even an efficient lens hood is not always adequate protection when pointing the camera directly into the sun, and a useful trick is to throw a shadow over the lens by holding your hand, or a piece of card, a half metre or so in front of the lens, but of course out of its field of view.

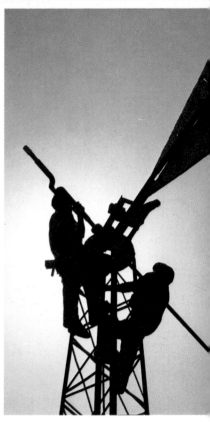

106

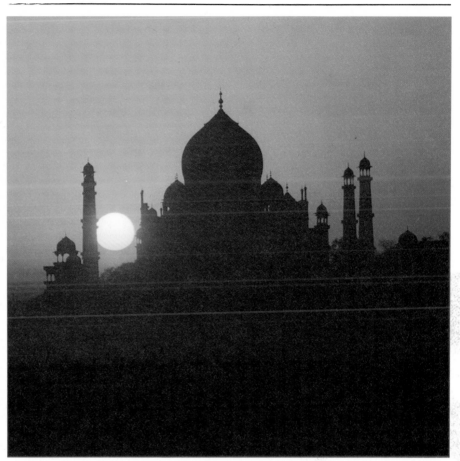

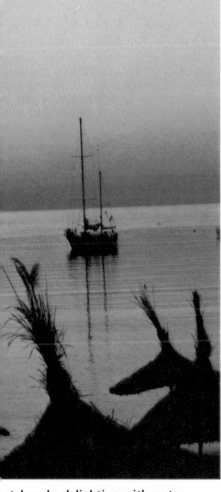

▲ Low back lighting with water can create interesting silhouettes against highlighted water. The light reading taken from the sky darkens the silhouette. *Peter Myers*

◄ Far left: good silhouette material can be found almost anywhere. A sunset framed by a pattern of leaves is more interesting than a sunset on its own. *George Rodger*

◄ Left: look out for unusual shapes. The dramatic diagonal is created by shooting from a low position and looking up. Hiding the sun behind the subject increases contrast. *Spike Powell*

► Above and below: when shooting towards the sun its position greatly influences the effect. With the sun just rising (above) the light is still quite strong, resulting in a high contrast and black silhouette. But before dawn (below) the softer light reflected from the sky creates less contrast. The top picture is exposed for sky and the lower one for the building. *George Rodger*

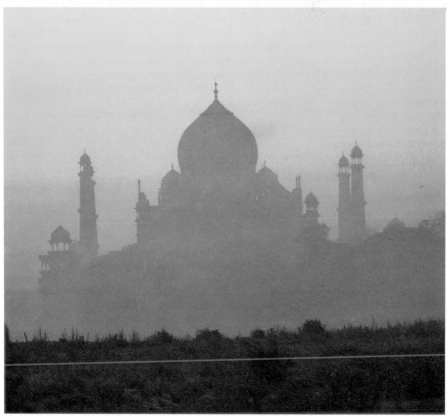

107

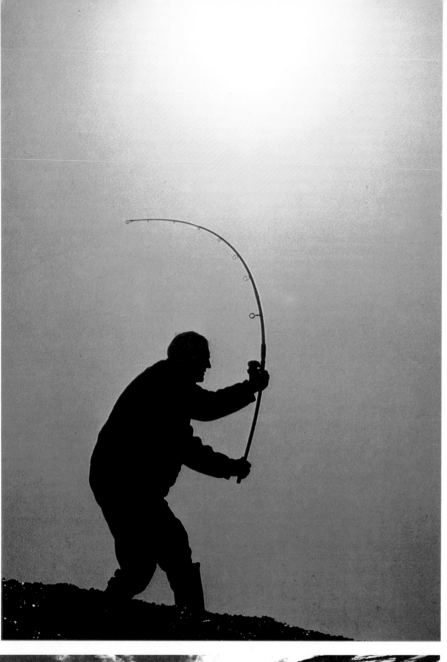

◄ A background of mist and low camera position create this bold image. The mist stops flare from the sun by veiling it. Note how silhouette conditions emphasize the tension on the rod and line.

◄ Below left: *Chris Smith* took this photograph into the sun which is masked by one of the figures. He had to crouch down low to make sure the cyclists made clean, clear shapes against the sky.

▼ Position here is all-important. *Michael Busselle* moved in slowly until the moment when the deer showed up clearly on the horizon.

Fog and night lights: silhouetted images can be produced in fog or mist by subduing background details so that only the objects in the immediate foreground are seen clearly. A fussy and complex subject like a woodland scene can be reduced to an image of stark simplicity in mist or fog, especially when combined with back lighting. Street scenes at night can also give bold silhouetted pictures under these conditions. Exposure for subjects like these is fairly critical; too little will produce muddy tones in the background and too much will weaken the silhouette effect. A useful method is to take an average from both the darker foreground and the brightest highlight in the background.

Silhouette and viewpoint

Choice of viewpoint is always one of the most vital decisions a photographer has to make. By finding a position which gives a silhouette effect to your subject, you are in fact achieving one of the main aims of good composition —separating the centre of interest clearly from the background. There are of course other ways of doing this, such as selective focusing or colour variation. But a viewpoint which gives a bold tonal contrast between the subject and its background is the most basic and often the most effective.

You may only need to move a metre or so to right or left to bring a highlight tone in the background behind the subject, and in the case of a portrait you can move the subject as well.

A low viewpoint allows the subject to be silhouetted against the sky; you can even shoot from ground level to increase this effect. But, quite apart from the silhouetting effect, a low viewpoint invariably adds impact to a picture. Conversely, a higher than normal viewpoint often removes unwanted background tone and details— as little as 30cm can make all the difference. This is why many professional photographers prefer rigid camera cases which they can stand on to give them a slightly higher viewpoint.

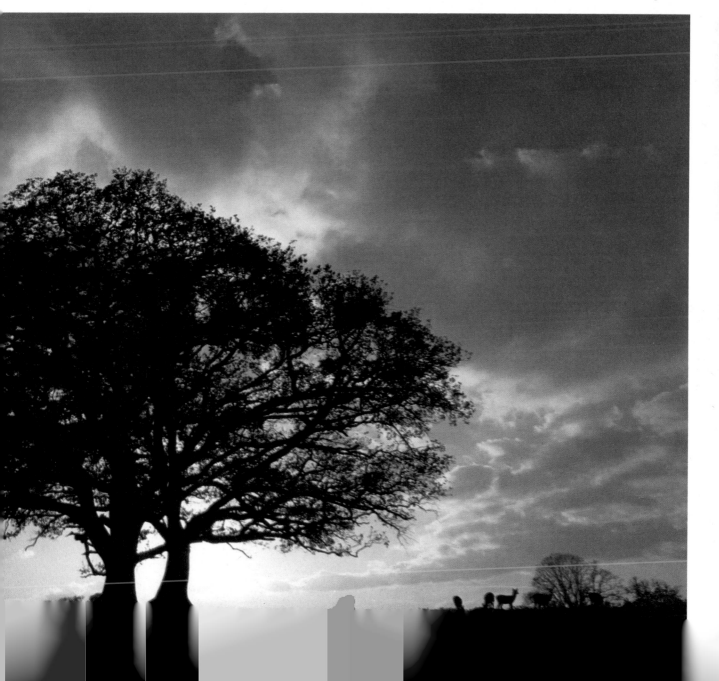

The picture essay

The idea of a picture essay is to link pictures together to tell a story or put across an idea, in much the same way as a feature or documentary film, keeping a sense of continuity all the way through. There are a number of ways of making a picture essay. One way of making a story about a person is to deal with it chronologically. You could start with your subject getting up in the morning, follow him through the day and end with his evening relaxation or even getting back into bed. Or, you may prefer to start halfway through the day and just cover significant moments of a particular event. But whatever approach you choose it is essential that the essay should be carefully thought out before you begin.

Choosing a subject

The first step towards the creation of a good picture story is the selection of a suitable subject. To start with it is best to pick something simple that can be shot in a relatively short time, probably not longer than a day, and without the need to travel too far afield with your camera. If you miss an essential shot first time out, you may need to go back for a reshoot!

Try to choose a subject that can be photographed by available light, as using flash or tungsten lights can destroy the natural atmosphere which is an important part of the story.

Broadly speaking, the most suitable subjects can be divided into four categories; people, events, places and themes. The main consideration is that they should be interesting enough to warrant a series of pictures about them.

People

People are always interested in the lives of other people, so there is no need to search out a public personality as your subject. In fact, you will find that a local character, or even a member of your own family, is more co-operative and probably more interesting than somebody famous.

Having chosen the person, the next step is to decide on an approach and roughly plot out a story before you begin. To give shape to the essay use a visit or a special occasion, such as a child's birthday party, around which to create a story line. If your subject is a craftsman, use the actual progress of the work as your base. Decide how much of the day, or the work, you wish to cover and make a list of what you think will be the most telling moments. These may well change

When planning a picture essay it is important to make a list of essential photographs, without which the story would be incomplete. For example, for an essay on glass blowing *Peter O'Rourke* knew that he must include a picture of the furnace (below), one of the molten glass being worked with a tool (above) and, perhaps most important, one of the glass actually being blown (right). Pictures like this provide the basic information—the framework on which to build the rest of the story. Details are then added to give it substance.

later but will give you a basis from which to work.

The most significant picture—when the child blows out his candles or the craftsman finishes his work—will probably be the climax of your story. But for an essay you must also record the important moments which lead up to that point. In the case of the party, putting up decorations, getting ready, greeting guests at the door and so on. Look for expressions and gestures which are particularly characteristic of your subject and take pictures immediately you see them.

You can take the same approach to a group of people, such as a choir or a football team, as to a single person, but of course a group is a larger and more difficult subject.

This type of photography means using up a lot of film, but if you try to economize you will probably end up with only half a story. It is better to take more pictures than you need and to edit them down later. This applies to all picture essays. The best pictures may only become obvious when you look at your prints or slides and start sorting them out, but if you have used plenty of film and planned the essay carefully in advance all the most significant moments will be there.

Events

When an essay is constructed round an event rather than a person the pictures can have much greater variety. Instead of concentrating on one person you can include relevant pictures of buildings and plants, signposts and cars as well as the people involved.

One of the most obvious—but also most rewarding—events to photograph in this way is a wedding. There are many other possibilities, such as a day trip to the races, a parade or a special festival. The first shot should probably be the one that sets the scene: a picture of the location before anyone has arrived, or an overall view from a high vantage point (if that is possible). Then try to get general shots of groups of people and close-ups of individuals as they arrive. Look for shots of objects or groups of objects that symbolize the event. For example, a line of expensive cars would convey something of the life-style of the players at a football match.

In any picture essay it is important that you have a key picture that sums up the event. At a sporting event it might be the moment of victory or the presentation of prizes.

That may be the final picture in the essay. Or if not, after the key picture

▲ A picture essay should have a definite ending and not just peter out. The last shot, like this glass, should be the climax of all that has gone before.

the essay must be brought quickly to a close. A good shot to end with could be the mess left behind when everybody has gone, if it is another general shot of the location, that will link the end of the story to the beginning.

As with stories of people, an essay of an event should be carefully worked out in advance. Before you start, plot out the things that you know are going to happen to form your beginning, middle and end. Make a note of any important people and anything else that you should include, like pictures of the scoreboard or close-ups that may be particularly relevant. Tick these off on your list as you go along, and you will be less likely to forget them in the heat of the moment.

In between those pictures you have planned there will be moments of humour and action that you could not have predicted. Keep your eyes open for these and be ready for them when they happen; pre-focus if possible and wind on ready for the next shot after every picture. Once again, use lots of film and edit it later.

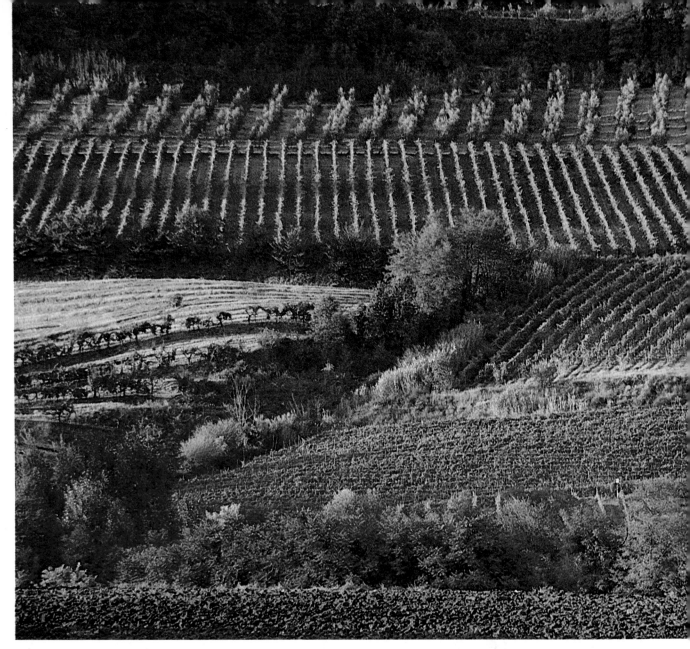

Places

An essay about a place, a village or an area of countryside, has a much less obvious structure than the two previous categories. It will also take you longer both to plan and execute. To create an essay that matches your ideas you will probably have to make several visits over a period of time.

Before you even start planning the essay it is a good idea of find out as much as you can about the place. If you merely rely on impressions you will miss a great deal and the result will be superficial.

Your initial research should include a visit to the local library to find the main points of interest and a talk with a shopkeeper or publican to discover who the local 'characters' are. Try to find out if there are any legends about the place, ask when market day is and if there are any local festivals. Armed with this information you will be able to work out which aspects to photograph.

Make a list of the pictures which you

believe will make an interesting story and check them off as you get the shots.

Themes

An essay based on a theme rather than a story is the most difficult of all to execute. Having chosen a theme—dogs, gardens or whatever takes your fancy—you have nothing but your own ideas on which to base the structure. It is easy for an essay of this kind to degenerate into simply a catalogue.

An essay about a theme is impossible to plan in detail in advance. It is likely that the 'story' will only begin to emerge once you have gathered together a sizeable collection of pictures. You may then get an idea of how to organize your approach to the theme, which may be from the point of view of historical development, or by colour, or size, or whatever. Once the pictures are organized in some way, any gaps will become immediately apparent, and you can try to bridge them by taking more pictures.

An essay of this type may take months, or even years, to complete.

Displaying the results

To do justice to your completed work you should exercise a little care with its presentation. This will depend to some extent on the number of prints that make up the essay.

If you have six prints it is a simple matter to mount them on a large piece of card. A larger number is better made up into a book, using either a loose-leaf binder or binding them together on card mounts yourself.

The size of the prints relative to one another is also important. The key shot should be the biggest with the others varying in size according to their significance. The key shot must be given the most prominent position. The layout should reflect the idea of the picture essay, that is, it should give a sense of continuity and coherence to the pictures while emphasizing the underlying story.

John Sims spent a month in the wine-making region of southern Italy and took hundreds of pictures for an essay on the subject. These he later edited to about 25 good photographs, 7 of which are shown here and on the following two pages. They were all taken in available light, which meant using long exposures and a tripod for the interior shots.

All picture essays need an introduction—a picture which sets the scene. In this case the vineyard from a high view-point (top left) does the job perfectly. The next step is to move in, perhaps changing lenses, and isolate important areas of detail, like the bunches of grapes and the man cutting them from the vines with his special knife.

113

The old and the new: the metal vats on the right are the modern means of storing the wine before it is bottled. Traditionally wine was stored in wooden casks like those below, now used only for wines of exceptional quality. Comparison pictures like these are interesting in a picture essay, so always be on the look-out for them, even if you hadn't planned for them in the initial stages. The picture below also shows old wine labels on the wall, and ancient tools of the trade are displayed on the table. Details like this all help to build up a comprehensive account of the subject covered by the essay.

◄ The making of a picture essay is no reason to forget all you know about effective composition. Remember that although the content of each picture is important, so is the quality. The higher the standard of the individual photographs the more impact the essay will have. This picture not only shows another stage in the wine-making process but also adds visual interest to the essay by introducing pattern and perspective.

▼ The final picture in an essay should sum up the story. For this shot John Sims left the vineyards and went into the town to find a shop selling the final product.

THE EXCITEMENT OF COLOUR

To the majority of people, 'photography' means 'colour photography'. The world around us is in full colour, and for most of us, the only pictures that we see in black and white are in the daily papers, and occasionally on the screen of a television. It makes sense, then, that our own photographs should be in colour.

This chapter looks at the many ways that we can use colour in our pictures. It starts off with an explanation of how colours react together, and how they can be combined most effectively, then goes on to catalogue six specific ways of using colour photography, which with practice and experiment we can refine into a more personal, individual style. The subsequent section explains how the camera can be used to make the most of the colours around us, and record them faithfully.

In a few circumstances, though, black and white pictures still have more power and impact than those in colour, and some photographers work exclusively with black and white film. They feel it provides a simplified view of the world, without the complication and distraction that colour can sometimes introduce. The end of the chapter looks at the best way of using monochrome, and shows how to recognize the situations that would reproduce better in black and white.

Colour awareness

The vocabulary of colour

When considering the effects of colour it is useful to know a little about why colours react with each other in the way that they do. Why, for example, does a green leaf look different when viewed in turn against a white wall, a blue sky and a red flower?

How colours react together

There are three basic ways in which colours react with each other: they either contrast, harmonize or clash and are discordant. These reactions are, to some extent, due to their position on the spectrum.

The colour wheel shown here is a simplified version of the spectrum, bent into a circle. From it you will see that those colours which tend to harmonize are close to each other and those which contrast—red and green, for example—are well apart. The other two wheels separate the primary from the secondary, or complementary, colours.

You will see that the primary colours of light differ from those of paint. Note that the colours of both wheels contrast, the primaries more sharply than the secondaries.

The green leaf, therefore, is seen most naturally when viewed against the neutral background of a white wall. It will, however, harmonize with the blue of the sky, appearing softer and more gentle, and contrast with the red flower, which will make it appear harsher and more aggressive.

Types of colour

Although the reasons for harmony, contrast and discord given here are generally true, you will find that at times—maybe on a hazy day—colours that would normally contrast appear to be in harmony. This is because the strength and brilliance of the colours are reduced and therefore more in accord, even if the colours themselves are not.

This strength of colour depends upon three factors: hue (basic colour), saturation (purity) and brightness (reflected light).

● It is the **hue** which distinguishes one colour from another—blue from red, for example.

● The **saturation** is the purity of hue. The hues in the colour wheels are fully saturated, pure colour. They become desaturated by the addition of either black (shadow) or white (light), white producing a tint and black giving a shade. (See diagram, centre right.)

● The **brightness** of a colour depends upon the amount of light reflected by the hue; yellow, for instance, is naturally bright, blue less so, and tints are brighter than shades.

Therefore, on a hazy day the light desaturates colour, the qualities are consequently weakened and harmony is more likely to be produced from contrast or discord. A very bright day can also have a similar effect. The strong light induces glare, is bounced off reflective surfaces and the colours of the subject become desaturated.

The pictures below and right illustrate the terms which will be used in the pages on colour which follow. Each aspect of colour will be dealt with in turn: the term will be defined and explained more fully, and guidelines will be given on the best way to make use of each when composing colour photographs. By the end of the chapter you should find that colour awareness comes more naturally to you. However, if at any time you feel you need reminding of what you should be looking for when you have a colour film in your camera, you can refer back to these pages and use them as a guide. These images have been chosen because they illustrate each point in the most simple way and are easy to remember.

► This chart demonstrates the principle of desaturation. The fully saturated band in the middle is seen in perfect lighting conditions. The desaturated areas (tints and shades) on either side are created by adverse light: bright light in the case of tints, and weak light or shadow in the case of shades.

Colour as the subject

Colour contrast

Colour harmony

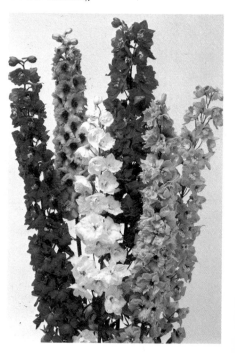

Red, blue and green are the *primary colours* of light. They differ from the primary colours of pigment (red, blue and yellow) but like pigment primaries they can be mixed to produce any hue.

The *complementary colours* of light are formed from a combination of two primaries. Magenta is formed from a mixture of red and blue, yellow from red and green and cyan from green and blue.

THE COLOUR WHEEL

Accent colour

Monochromatic

Polychromatic

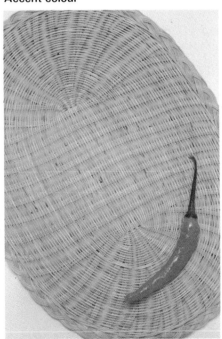

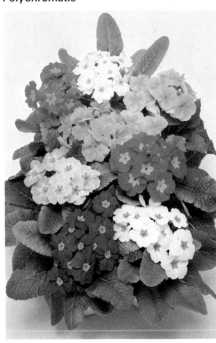

119

Colour as the subject

There may be times when the colour of an object makes a greater impact on you than the object itself—a pile of fruit on a market stall, for example. To capture this feeling it is quite legitimate to fill your frame with the colour, possibly losing all sense of form, and make the colour itself the subject of your picture. In the example of the market, you may take an overall view of the scene conveying the mood of the place, and then concentrate on some details—a flower stall, or a pile of oranges—which have no more 'meaning' than the impact of bright colours.

Limiting the colours

To take a successful picture of colour for its own sake you will often find it most effective to close in on the subject to eliminate distracting ideas from the viewfinder and use a neutral background (or foreground) for contrast. Strong colours especially will fight for dominance and tend to flatten form. So, although it *is* possible to produce a pleasing picture from a mass of mixed colour, you will achieve a more dramatic, and probably more satisfactory, result by restricting the number of hues to one or two. Isolating a couple of cars from a row, for instance, will emphasize the colour more than including the whole car park.

Strengthening colour

The strength of colour is important in these pictures; after all, it is the colour that you are trying to capture. There are various ways in which you can add strength without using special accessories.

▲ The striking contrast between the primary colours is the subject of this picture by *Ed Buziak*. The impact of the colours has been emphasized by excluding all other areas of interest.

● **Use neutral contrast.** Position yourself so that a neutral area (very pale or very dark) either frames your subject or provides the background. The lack of colour in the surroundings will emphasize the colours of the subject.
● **Close in.** The closer the camera is to the colour the stronger it will appear. Take care, however, not to lose the contrast with the surroundings.

Coloured objects do not
necessarily have to be very
interesting to make a good
photograph. In these three
pictures it is the colour,
and not the subject, which
has captured the imagination
of the photographer. In
each case they were taken
with an exposure of 1/125
at f5 · 6. This is a good
general exposure with which
to experiment with colour. It
gives sufficient depth of
field for most purposes and
eliminates camera shake. A
film speed of around 64 ASA
will give good colour ren-
dition for pictures like
this, and a wide angle lens
can give slight distortion
(right) if you feel that a
little more interest would
be an advantage.

▲ The neighbours might not like it but it makes a good picture! By limiting the number of colours, *John Sims* has stressed the liveliness of the painted red bricks.

▼ Glare from shiny surfaces can be reduced by careful choice of viewpoint. *Robin Laurance* has closed in on a detail of this car and cut reflection down to a minimum.

▼ By including only a small section of this church, *Bob Davis* has left the eye free to concentrate on the whole range of tones present in the blue on the walls.

▶ Contrast with the neutral background and the grey of the hats has made the colour of these capes stand out brilliantly in the subdued light. *Suzanne Hill*

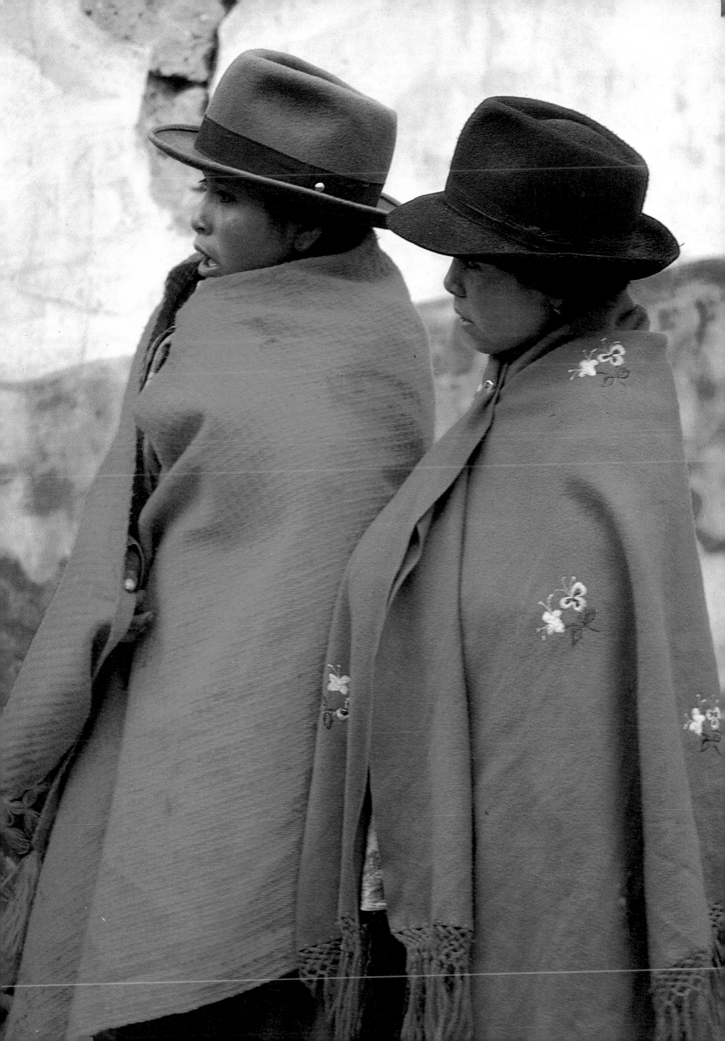

● **Use soft light.** Really strong, bold colours are most effectively captured by soft lighting. This eliminates strong highlight and shadow areas which desaturate the colour.

● **Eliminate glare.** Reflection or glare from subject surfaces will weaken the colour. Position the camera at an angle which reduces the amount of reflected highlights as far as possible to bring out the true colours.

To strengthen colour artificially you can use coloured filters to compensate for weak colour, and polarizing filters to eliminate glare and reflection. Slight under-exposure, about ½ stop, in bright light will also improve the saturation of colour when the picture is developed.

Keep the design simple

A mass of complicated images within the viewfinder is as destructive to the composition of a photograph of colour as the inclusion of too many hues. Each vies with the others for the centre of attention. When using colour as the subject it is therefore essential to strive for simplicity of design.

Sometimes this can be achieved by selecting scenes with one overall colour scheme and introducing variety through a range of brightnesses, as in a sunlit woodland landscape. Again, closing in on the subject can help to eliminate unwanted surrounding images and to keep the line and form as basic as possible. With practice you will become a good judge of an effective balance between colour and design. If the colours are simple, then the design can be more complicated than for a mass of different colours.

Experimenting with colour

Start with an uncomplicated image, the colour of which attracts you—a post box, for example. Photograph the whole of the subject from different distances and angles, in various lighting conditions and using different exposures. The results should give you a good idea of how best to capture colour with your camera. You can then draw on this experience when you come to the more challenging process of isolating an interesting area of colour from a more complicated scene.

◄ In amongst a whole group of upturned boats, *Michael Busselle* was struck by this one area of bright colour. To make the most of it, and to keep the design as simple as possible, he chose his viewpoint carefully and then closed in on the colours using a 200mm lens.

▼ Weak colour can be strengthened by fitting a coloured filter to the front of the lens. Here the photographer used a 4X orange filter to exaggerate the effect of evening sunlight on the colour of the water.

◄ When faced with a highly detailed subject there is always a danger that the complicated image will detract from the impact of the colour. For this picture *Michael Busselle* has reduced the amount of distracting detail by close framing with a 135mm lens.

▼ A polarizing filter to eliminate glare, and slight under-exposure to increase the saturation of the colours, has resulted in the deep blue of the sky and the rich red of the flowers on their branch. *Ron Boardman*

Colour contrast

Visual reaction to a colour can depend, not only on the colour itself, but also on colours that are next to it. Red, for example, looks brighter and warmer when placed next to blue, and blue appears colder and less active next to red. This reaction is called colour contrast, and is created when colours of opposite characteristics meet.

The impact of colour contrast is quite considerable and by controlling it carefully in your pictures you can achieve some dramatic results.

How colours contrast

Determining which colours contrast and which clash is largely a matter of personal taste. Generally, though, the more extreme the qualities of the colours the greater the contrast.

● Strong primary colours often contrast with each other. This is frequently seen in nature, as shown in the picture of the red poppy (below).

● Strong complementary colours contrast with each other. Blues and greens, for example, will contrast with their complementaries, yellow and magenta respectively.

● Bright or light colour contrasts with dark colour. Primrose yellow will make navy blue appear even darker, and the yellow itself will seem to shine out against the darkness.

● The contrast between warm and cold colours is strong, as shown by the example of red and blue given earlier.

● Strong colour contrasts with neutral colour. Green leaves provide an effective contrast against the neutral background of an overcast sky.

● Tones may contrast. A deep red, for example, will contrast with a very pale, pastel pink. The difference of tone provides contrast even though the colours themselves appear to be in harmony.

Using colour contrast

There are two main ways in which you can use contrast in your photographs. You can either create it, as when arranging a still-life, or it may already be present—in a landscape for example, and can be balanced in the viewfinder.

Colour contrast can be introduced in still-life by moving the objects around to achieve the best effects, either between the colours of the objects or the objects and the background. The same is true, although to a more limited extent, when taking shots of people. Even if you are photographing a group

▲ *John McGovren* has carefully balanced the contrast between the purple and the bright flash of the chrome of the car badge. Usually the lighting immediately after rain has an unexpected clarity, which helps to raise the contrast. Slight under-exposure will further boost the colour saturation and contrast of most colour films, and an exposure either side of the indicated reading will give a variation.

▲ Strong primary contrast adds to the dramatic effect of this picture. To reduce glare from the bright light and to maintain the richness of the colours, *John Sims* fitted a polarizing filter to his lens.

◀ Nature provides plenty of good examples of colour contrast. The idea being, in this case, that the bright red flower should stand out brilliantly in contrast with the softer green background, in order to attract birds and insects. *Bryn Campbell*

▶ In this picture by *Les Dyson* primary contrast is combined with contrast of tone—the bright subjects are set off sharply against the dark background.

dressed in identical clothing, you can choose a contrasting setting.

Although arranging a landscape is more difficult, you can give extra life to natural or urban scenes by finding some patch of colour that contrasts with the general tones, however small it may seem. A single wild flower can be contrasted with the tones and colours of a landscape if you take the trouble to find the right camera position. Or you can use a low viewpoint to contrast the subject against the sky.

Composing the picture

The normal rules of composition apply when dealing with colour contrast, and it is important to remember that the area of greatest contrast in the frame will act in the same way as a strong

highlight: it will take charge of the picture unless you control it carefully. So you must make sure that strong contrast either forms part of, or is related to, the main subject. It can then contribute to the composition without being a distracting influence.

You will also find that equal areas of strong, contrasting colours in a photograph will detract from each other and result in a confusing picture. You must therefore achieve a balance by varying the proportions of the colours which contrast. One red apple in a blue dish containing mostly green fruit, for example, will be more striking than the same dish holding half green and half red fruit. For landscapes you can vary the proportions by moving the camera until you reach the right balance.

▲ Choice of viewpoint is an important element of composition in any photograph, but especially so when dealing with contrasting colours. In this picture, *Colin Barker* has emphasized the warmth and purity of colour of the orange by choosing a low viewpoint, so as to bring in the blue sky as a background. Once again a polarizing filter keeps the colours rich.

◄ All the elements of contrast are here. The deep colours contrast with the pale background; the pink bracelet contrasts with the dark brown skin; neutral white contrasts with red and blue, which in turn contrast with each other.

► Imagine this picture in summer, when the snow has melted and contrast has given way to harmony. *Michael Busselle* used an aperture of f16 to maintain depth of field throughout the picture and capture the dramatic effect to its fullest advantage.

▼ If you feel there is a danger of the contrast of the subject being lost against the harmonious background, throw the background out of focus, or crop in closely round the subject.

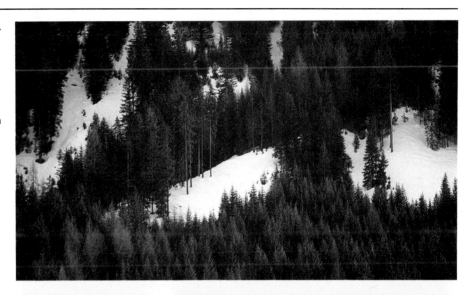

▲ Possibly the strongest contrast is that between a primary colour and its complementary—here, blue and its complementary yellow. The contrast between dark and light is also a feature of this picture by *Robin Laurance*. Notice how the yellow appears to shine out in contrast to the darkness of the blue. The absence of distracting detail increases the impact.

Colour harmony

Harmony is possibly the most subtle and evocative of all the reactions between colours, and can be used with great effect to create mood in your pictures. While contrast is dramatic and emphasizes the subject, often at the expense of mood, discord is aggressive and usually disagreeable, and often results in a confusing photograph. Harmony, on the other hand, is relatively gentle and certainly easier on the eye. Colour harmony in your pictures can evoke feelings of romance and of peace, but it can also reflect the gloom of an industrial landscape or the anger of stormy weather, the heat of the desert or the bleakness of mountains.

How colours harmonize

Harmony generally exists between those hues from the same section of the spectrum, or colour wheel—between yellow and green, for example. Colours with the same characteristics will also be in harmony when placed together. Orange-brown and yellow very often have the same warm quality and harmonize well. This combination is frequently found in nature—the reds and browns in an autumnal scene, for instance, or the yellow/green harmony of a spring landscape.

Harmony and viewpoint

One of the easiest ways a photographer can control his pictures is by being selective when aiming the camera. With most pictures it is choice of viewpoint which provides this crucial control, and this is particularly true with colour harmony.

In a landscape of green fields and blue sky, for example, a foreground of red flowers is intrusive and should be excluded from the picture if this is pos-

▼ Autumn often provides spectacular examples of colour harmony in nature. The trees, and the ground beneath them where the leaves have fallen, are resplendent with a harmonious mixture of oranges, reds, yellows and browns. For this picture, taken near Bedgebury in Kent, *Mike Burgess* used an 81EF filter (from Kodak's yellowish range) to bring out the warmth of the autumn colours. To maintain the depth of field he used a small aperture (around f22) and this, combined with the filter, meant a fairly long exposure, making some blur from the moving leaves unavoidable.

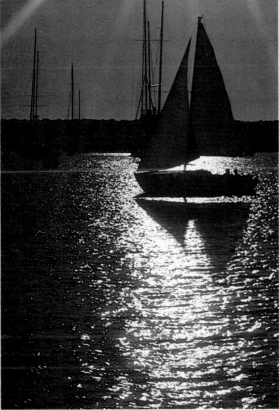

◄ Shooting into the light has a similar effect to under-exposure. The colours become desaturated and are more likely to be in harmony. In this scene the white sail was in contrast with the more subdued surroundings. By shooting into the light *John McGovren* threw the boat into silhouette and achieved the harmonious effect he was seeking. Glare from the lens in pictures like this can be reduced by using a small aperture (f22) and a fairly fast shutter speed.

▼ Blue sky, green trees and water that reflects the hues of both—colour harmony at work in nature. *Clive Sawyer*

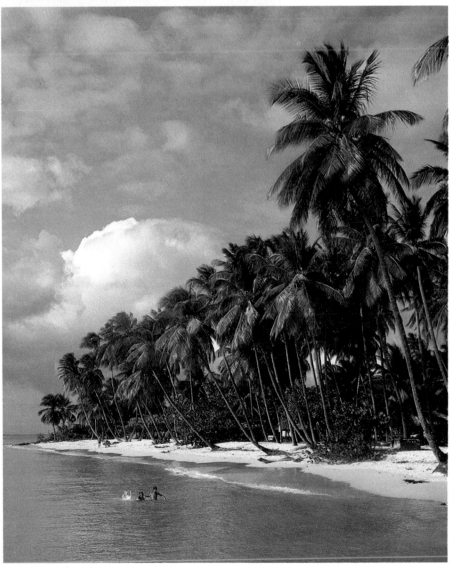

sible. By choosing the right viewpoint, or by changing your lens, you will be able to remove the flowers and restore the harmony. You can move forward to exclude them, or find a position higher and shoot over them. Similarly, a distracting area of colour can be removed from the middle of a picture by changing the viewpoint. A bright red tractor in the field, for instance, could be excluded by changing your position so that it becomes hidden behind a tree— providing, of course, that there is a tree conveniently at hand. You could always cheat by holding a sprig of leaves to obscure the tractor and shoot through them as if they were the natural foreground!

Creating colour harmony

If harmony is important to the composition of your picture but the scene you want to photograph consists of contrasting or discordant colours, you can sometimes weaken the offending colours artificially so that they blend together more easily. One way of doing this is by varying the exposure. Over-exposure will soften and lighten strong colours, while under-exposure will darken them. In either case the contrast is weakened and the desaturated colours should give a more harmonious quality to your picture. You will find that slight over-exposure is more suitable for dreamy, quiet pictures, while under-exposure will create a more sombre harmony suited to gloomy

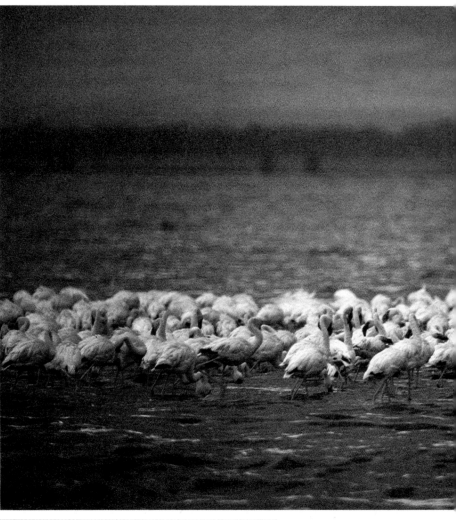

▲ The harmony of the colours in this shot has been achieved at the expense of detail. A high-speed film (400 ASA) and a 500mm long focus lens have had the same effect on the light as a soft-focusing attachment. The background has been thrown out of focus, the colours have become softened and the whole scene has assumed a pink cast which harmonizes with the colour of the flamingoes. *John Garrett*

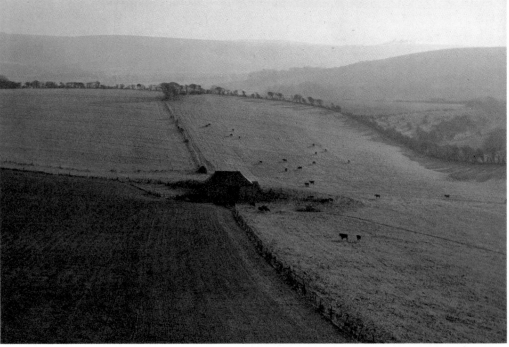

◄ Weather conditions can have a great effect upon colour relationships. In this picture the early morning mist has created a blue cast over the whole of the scene and all the colours are in harmony. The photographer has exaggerated the effect by using a blue filter.

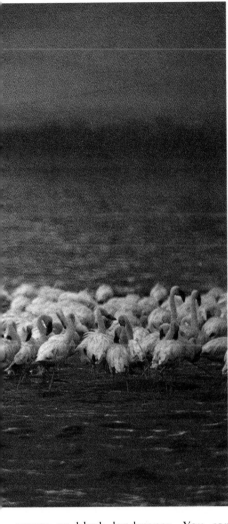

◄ A soft focus attachment fitted to the front of the camera's lens will diffuse the light, soften bright colours and create harmony to give your pictures a romantic quality. A similar effect can be achieved by smearing a light layer of Vaseline on a plain sheet of glass held in front of the lens, or by covering the lens with a stocking or some other transparent material. *Michael Busselle*

▼ A mixture of the soft, misty light and a small degree of under-exposure has combined to give the bleak harmony in this picture by *Gary Ede.*

scenes or bleak landscapes. You can experiment by bracketing around the normal exposure by one or two stops. Another way to create harmony by reducing the colour saturation in a picture is by shooting into the light. This induces flare as the light shines into the lens. The effect is similar to under-exposure but is a little more difficult to control.

You can also experiment with the use of colour correcting filters to produce an overall harmonizing colour cast. The method is to use a filter of the same colour as that which you feel predominates in the subject already. For example, a scene may look predominantly blue/green but include an offending patch of yellow. In this case a bluish filter will be most effective. It will have a relatively subtle effect on the blues and greens but will considerably tone down the yellow. Fog filters and soft focus filters can also be used to tone down colour and induce colour harmony in your pictures.

Accent colour

Unless the overall effect of a scene is particularly striking you will find that most pictures need at least one point of interest, some aspect to which the eye is immediately drawn, to ensure their success.

This is really a question of basic composition and is usually achieved through careful framing and choice of viewpoint. There may be times, however, when simply one spot of colour, in contrast with the surroundings, will provide the selective emphasis you are seeking and give your picture impact. The red clothing of the small boy on the steps, for example, provides a focus for attention in a basically monochromatic picture. He also gives depth and scale to the two-dimensional image, another advantage of accent colour.

The fact that the colour providing the accent is red in this picture is of some significance. As already discussed in previous sections, red is an aggressive colour, leaping out at you from its surroundings. You will generally find, therefore, that colours with this assertive quality (red, yellow, orange) will be

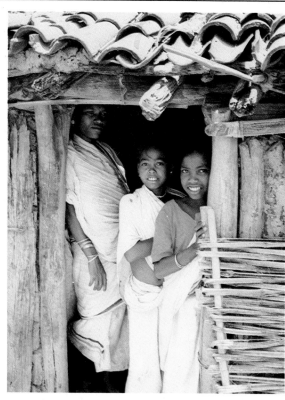

◀ The power of one small splash of colour in a monochromatic picture is quite considerable. Initially it draws attention to itself and then, if the photograph is carefully composed with the accent off-centre, it leads you into the more subdued areas of the main subject. *Libuse Taylor*

▶ It is something of a tradition that when taking pictures of historic interest the photographer waits until people have disappeared. But, as this picture by *Patrick Thurston* shows, one small patch of bright clothing can often add a sense of depth and scale as well as an initial point of interest.

▼ An accent of colour can be highlighted by careful exposure. This dramatic example is the result of exposing for the sky. *Ernst Haas*

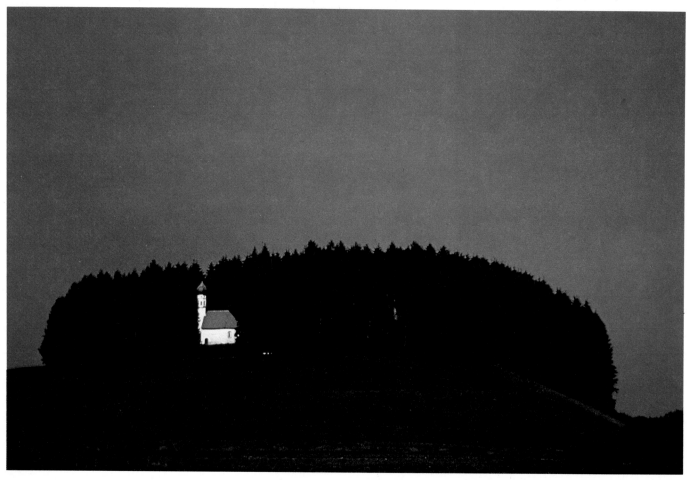

the ones most likely to provide the point of interest, especially if they are strong and bright. In dull surroundings, however, any bright colour will assert itself. If there is sufficient contrast in tone, bright blue or green may serve equally well as an accent.

Exposure and composition

An accent of colour is often useful for providing interest in a monochromatic setting, and for maximum colour intensity you should slightly under-expose the main subject. This will emphasize the brightness of the spot of colour and throw it into greater prominence. But be careful to keep it small, and choose a viewpoint where the eye is led from the point of interest to the rest of the picture. If the area of colour is too large or bang in the centre of the picture it will assume an importance out of all proportion to its function as an accent. Look at the pictures reproduced here and see how the eye is left free to explore the rest of the scene, having been attracted initially by the accent of colour.

Interiors

Although you will normally find accent colour enhancing an outdoor scene, you can also use it to add a point of interest to your interior shots. Here you have more control over the composition and can actually place the accent where it contributes most to the picture. A vase of roses, for example, strategically placed in this corner of a room, or a bowl of brightly coloured fruit on a table, will draw attention not only to that point but also to other details around it. In this way accent colour works along similar lines to the principle of a supermarket, where the goods are displayed so that you go in to buy a packet of tea and come out loaded with shopping! Having attracted your attention in the first place, the accent colour then interests you in the rest of the picture. Think of it in this way and you will never underestimate its value.

▶ A landscape is a much more difficult subject than most photographers think. Without a point of reference, what was a magnificent view seems to become puny and insignificant when seen through the viewfinder and the final results are a disappointment. In this picture *John Bulmer* has solved the problem by including the huntsman. The tiny red jacket immediately attracts attention and then puts the scenery into perspective.

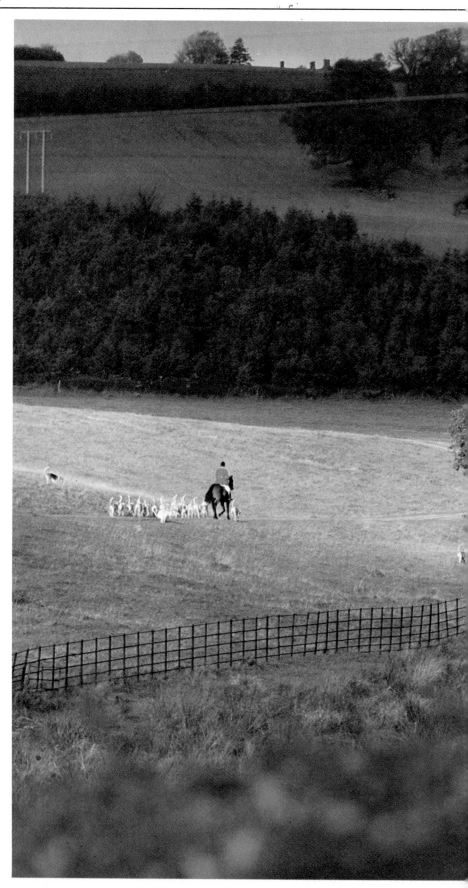

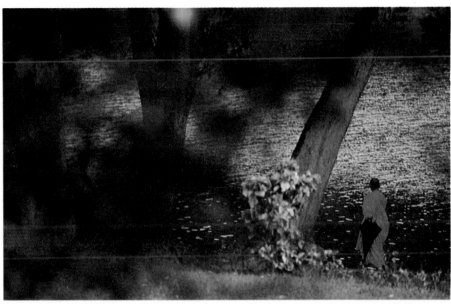

▲ Photographs of interiors are usually more fussy than exterior shots. A strategically placed accent of colour will provide a point from which to explore the detail. *Valerie Conway*

▲ To work well as an accent, the area of bright colour does not have to be near the centre of the picture. In fact the opposite is true and the best position is to one side. *Bryn Campbell*

▼ In this picture the yellow accent is used to balance the composition. Beware that you do not allow the accent to dominate the picture and so detract from the main subject. *Robin Laurance*

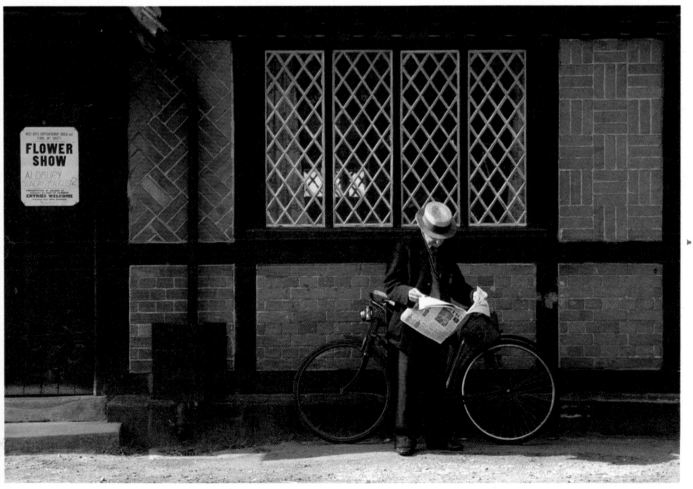

Muted colour

You may find it a temptation, when taking photographs, to overlook muted colour and to dismiss a monochromatic scene as being uninteresting. But, if you look at a number of successful photographs you will see that they do not have to be bright or full of colour to hold your attention.

A great deal, of course, depends upon the subject of the picture, but monochromatic and muted colour can be just as expressive as black and white, with the colour lending more feeling and atmosphere. The weathered stonework of an old building, for example, is muted and basically monochromatic, but even that single colour gives it a warmth and mellowness that

black and white could not convey. You will also find that muted colour is an advantage when photographing a detailed or highly textured subject. The eye can then concentrate on the detail in the picture without being distracted by areas of strong colour.

The effect of light

A monochromatic photograph is literally one that uses only a single colour. However, it is possible for a picture to appear monochromatic even if the subject is, in fact, multi-coloured. This usually occurs when the lighting is poor and the colours have become desaturated. The whole picture then assumes the quality of the light, and can some-

times make a more interesting photograph than one taken under more conventional conditions.

The diffused light of a misty morning, for example, is an ideal time to take dreamy, evocative pictures, before the brighter light of day strengthens the colours and destroys the mood. The scattered light from reflective surfaces such as water or sand will also desaturate colour and create soft, warm pic-

▼ The weathered stonework of this old building beautifully illustrates the subtlety of muted colour. It has a warm and gentle quality that neither strong colour nor black and white could possibly convey. *Eric Crichton*

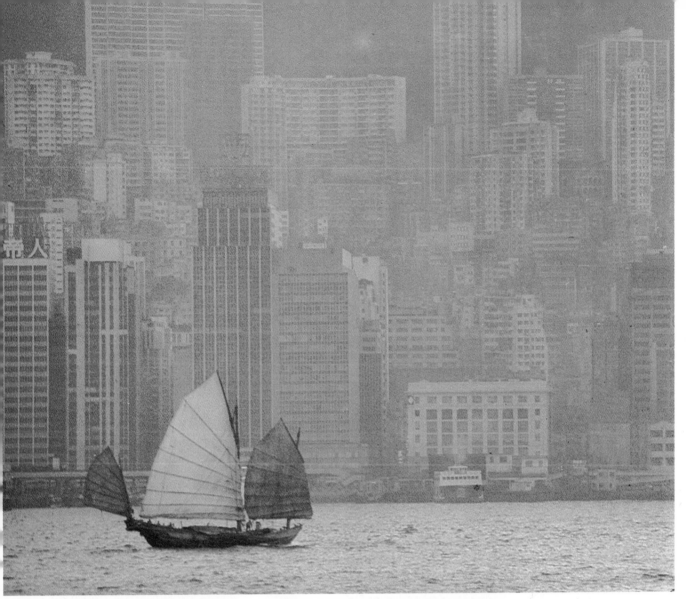

The diffused light of a misty morning (far left), or the haze at the end of a hot summer's day (above) are ideal conditions in which to take atmospheric pictures of muted colour. In the picture above *Graeme Harris* used a X5 red filter to increase the pink cast from the setting sun. For the shot of the wood *Michael Busselle* focused on the foreground to add to the effect of the mist in the distance.

◄ Without the distraction of bright colours the eye is left free to concentrate on detail. In this picture slight overexposure has muted the colour still further, but retained the cold, hard quality of the metal.
J. P. Howe

tures that might otherwise have been bright and hard. (Slight over-exposure—about ½ a stop—will exaggerate the effect by weakening the colour still further.) You must remember, however, that because of the lack of colour in pictures like this, the subject itself must be interesting. So, compose the picture carefully before taking the shot.

Artificial aids

You can experiment with muted colours by photographing a normally bright subject through material which will diffuse the light artificially. Try photographing someone through a net curtain, or a landscape through a rain-drenched window. The colours will be more muted if you focus on the curtain or the glass.

Soft focusing techniques will also give muted colour. The most conventional way of soft focusing is to use a soft focus filter, but if you don't have one you can either smear Vaseline on a UV filter or stretch a stocking over the lens to produce a similar effect.

For monochromatic pictures you can experiment with colour correction filters which produce a colour cast over the whole image.

▲ A rain-drenched window is an ideal medium through which to experiment with muted colour. Focusing on the glass, rather than on the subject behind, will subdue the colour still further.

▶ If you don't have a soft focus filter, smear a little vaseline on any clear filter and it will give the same results. Slight under-exposure adds to the softening effect. *Martin Riedl*

▲ When taking pictures of nature don't dismiss muted colour. What a subject lacks in brightness it very often makes up for in striking detail and texture.

▼ A cloudy sky in the early evening often produces a natural blue colour cast—perfect for taking moody monochromatic pictures. *Robin Laurance*

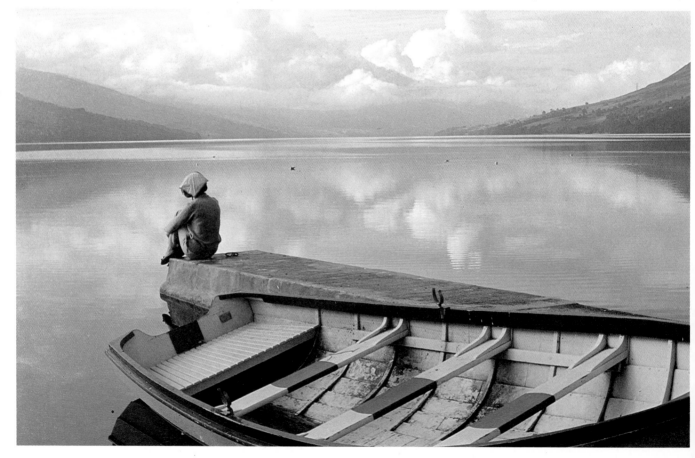

Successful multi-coloured pictures

Why is it that when your prints or transparencies come back from the processors, the beautiful multi-coloured scenes that so attracted you when you took the pictures sometimes look a bit of a mess?

The main reason is that a mass of mixed colour is one of the most difficult subjects to photograph successfully, and although it may look spectacular in its natural setting, it does not really work well within the confines of the viewfinder. Several bright, saturated colours placed together will fight each other for the centre of attention and a confused picture will normally result. However, this does not mean that from now on you must exclude multi-coloured (polychromatic) scenes and restrict your photographs to subjects containing only a few colours. There are ways of getting round the problem.

Viewpoint and lenses

There are two basic viewpoints from which to photograph a polychromatic scene effectively: from some distance away or from very close up.

The advantage of putting distance between your camera and a multicoloured subject is that you do not remove it from its setting, and although at the time you may not be conscious of it, both the setting and the background are tremendously important to a polychromatic subject.

Look at a multi-coloured scene in nature—the flowers in your garden, for example—and you will notice how important green is in this context, and how it contributes to the overall pleasing effect. Almost imperceptibly, in the form of leaves and stalks, it is interspersed throughout the bright colours, separating them from each other and creating areas of contrast and harmony. The larger areas of green, the grass and the trees, provide the background, and an important restful quality to counterbalance the liveliness of the bright flowers.

It would be impossible to imagine your garden without the moderating influence of green, but to get some idea of what it would be like, pick a bunch of flowers of assorted bright colours and take off all the leaves. Then arrange the blooms so that the stalks are not visible, and place your arrangement against a multi-coloured background—a lively poster, for example. You will then see why the expression 'a riot of colour' is so apt. The result will be confusion, and the value of a view-

◄ *John Sims* has isolated these two revellers from the rest of the crowd by using a long focus lens (200mm). This has the advantage not only of cutting out distracting detail from the side of the picture but also of flattening the background so that it does not conflict with the subject.

► Keeping bright colours in a subdued setting is important. Here the gentleness of the green off-sets the liveliness of the flowers and makes the whole picture easier on the eye. *Tsune Okuda*

▼ A close viewpoint has lifted this area of mixed colour out of a confused market background. *Alfred Gregory*

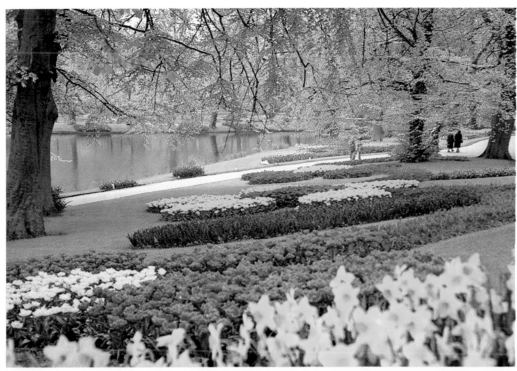

point from which you can include a more subdued background will be immediately obvious. However, if you can't change your viewpoint, then a wide angle lens, with its greater angle of view, may enable you to keep the confusion of colour to one small area, where it can become very effective.

The alternative to including the background of a polychromatic subject is to close in. Choose one or two particularly striking colours—an area of contrast, for example—close in on them and cut out the others. Although you will not get the same overall effect with one photograph, a series of pictures will combine to remind you of the scene, with the added advantage of the extra detail gained from a closer viewpoint. A long focus lens will help you isolate a small area if you can't get in close enough yourself.

Still-life and people

A still-life offers more scope for polychromatic pictures than landscapes, but the same principles still apply. For a successful picture you must reduce the competition between the colours, and between subject shapes and colours, and make use of a background with one basic colour to unite the separate elements of the subject. Neutral-coloured objects can be used to separate areas of contrast and harmony, and the table, or other support for the arrangement, can provide the unifying background. What you are actually doing is creating lots of little pictures of colour, brought together by the setting.

For pictures of people in brightly coloured clothing, bear the same points in mind. Choose your viewpoint carefully so that the background forms a unifying setting. You can also make use of areas of shadow to separate the various colour elements.

▲ The strength and brilliance of these colours have been accentuated by a low camera position, very close to the subject, so that the light is caught shining through the material, similar in effect to a stained glass window. *Colin Barker* under-exposed slightly to ensure good colour rendition.

◄ Selective focusing with a wide aperture has thrown both the background and foreground out of focus so that nothing interferes with the graphic image and strong colours of the parrot 'perched' in the bushes. *Michael Taylor*

▶ Multi-coloured subjects are much easier to handle in still-life or pictures of people. Still-life subjects (above) can be arranged so that there are no areas of harsh conflict between the colours, while people in bright clothes (below) can be taken against an uncluttered background.

Special techniques

Finally, if you find that the difficulties presented by a particular polychromatic subject are too great, you can use special techniques to reduce the saturation and brilliance of the colours. By doing so the fierce competitiveness between the colours will be greatly diminished and the subject will be much easier to handle successfully. These techniques have been covered in earlier pages and include image diffusion, under-exposure, over-exposure, using neutral density filters, colour correcting filters and special film or lenses.

Colour and the camera

The sections in this colour chapter so far have been concerned with developing an awareness of both visual and emotional responses to colour, and with how to use these most effectively when composing colour photographs. There is, however, one other aspect of colour photography that must be considered in order to achieve successful results: the effect of colour on the film you are using, and how to control the colour quality with the camera.

How film sees colour

Light has an enormous influence on colour, and especially on colour film. As discussed earlier, the visual colours of objects are affected by the colour quality of the light source which illuminates them, but in normal circumstances the brain makes a mental adjustment and generally we do not notice relatively slight changes.

Colour film, however, is not so accommodating, because any variation in the colour of the light source is faithfully recorded. Colour film is manufactured to give optimum results under very specific conditions, so these changes can be quite dramatic.

Take the page in front of you as an example. You know it to be white, and it will appear to be white whether you look at it in daylight, fluorescent light or tungsten light, because you are making a subconscious adjustment. But a colour film which has been balanced for use in daylight will see the paper as orange under tungsten light, and probably greenish under fluorescent light. Conversely, a film which has been balanced for tungsten light will record the page with a strong blue tint under daylight conditions. In photographic terms these are quite extreme variations in colour quality, but even slight changes will record noticeably.

For accurate colour rendering, it is vital that the colour quality of the light source exactly matches that for which your film is balanced, and any discrepancy must be adjusted by the use of colour correction filters. Even if you consider colour accuracy to be less important than producing a pleasing picture, you must still be aware of the colour quality of the light source if you want predictable results.

The time of day

Even when you use daylight film in daylight conditions you will still find a considerable degree of variation in colour between pictures taken at different times of day.

The available light sources in this kitchen were daylight through the door, tungsten from the spotlights on the ceiling and fluorescent from the strip underneath the cupboards. For all three pictures daylight film was used.

Far left: lit by all three sources, but an 80B blue filter used to correct the orange cast from the tungsten light. Accurate colour is recorded in all the areas lit by the spotlights but the daylight registers as blue and the

fluorescent light appears greenish. Above left: with the filter removed and the fluorescent strip switched off the orange effect of the tungsten lights is clearly shown. Above: lit by daylight only. *Gordon Ferguson*

▲ The green cast from fluorescent lighting is difficult to correct, but can be overcome to some extent by using a magenta filter. *John Walmsley*

◄ This picture was taken on tungsten balanced film as the light was falling. All artificial light—the bollard, car lights and inside the telephone box, have recorded as accurate colour, but the areas lit by daylight only have a strong blue cast.

► The blue cast in this picture is the result of using daylight film on an overcast day. Colour film tends to exaggerate the natural effect of light if there is any departure from the ideal conditions for which it is balanced.

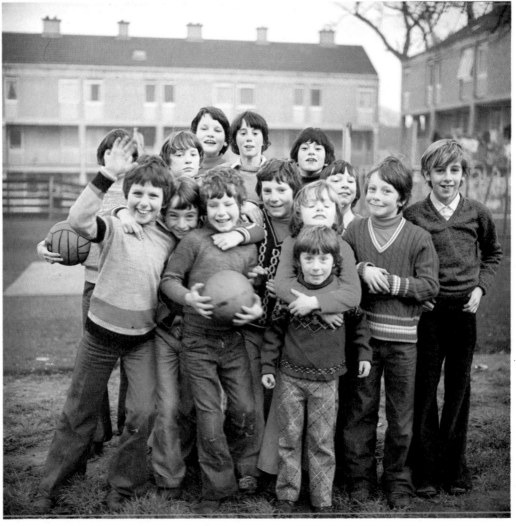

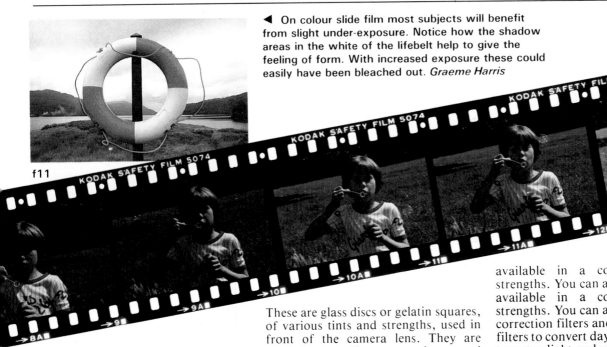

◄ On colour slide film most subjects will benefit from slight under-exposure. Notice how the shadow areas in the white of the lifebelt help to give the feeling of form. With increased exposure these could easily have been bleached out. *Graeme Harris*

f11

Daylight film is balanced for ideal conditions, which approximate to noon sunlight in summer. Any departure from this ideal will create a colour cast. For example, when the sun is lower in the sky, as in the early morning or late afternoon, there is a stronger red bias in the light it gives. This produces pictures with a warm orange cast, and the lower the sun is in the sky the stronger the orange cast becomes. When the sky is overcast, however, or when a cloud passes over the sun, there is a higher content of blue in the resulting light. This registers on the film and produces a corresponding blue cast or cold quality in the picture.

You will get a similar blue effect by shooting from open shade while the subject is partly illuminated by the light reflected from a blue sky. Pictures taken by the sea or at high altitudes will also tend to have a cool colour quality. This is because there is a high proportion of ultra-violet present in the light and, although you cannot see it, it does affect the blue sensitive layer of the colour film.

Correction filters

It is a relatively simple matter to correct unwanted colour casts by the use of weak colour correcting filters.

▶ For this picture *Michael Busselle* exposed for the bright colours of the boat. An overall meter reading would have washed out the highlight areas, so he closed down by 2 stops.

These are glass discs or gelatin squares, of various tints and strengths, used in front of the camera lens. They are graded according to colour and strength; for example, a CC05R is a pink filter half the strength of a CC10R.

To correct a colour bias you must use a filter of the opposite colour to the cast. A warm, yellow filter will correct a blue cast, for example, and a filter with a bluish tint will balance a reddish bias. For most normal situations, you will probably find a CC10Y or 10R, and a CC05B most useful, but both primary and complementary coloured filters are

available in a complete range of strengths. You can also buy ultra-violet available in a complete range of strengths. You can also buy ultra-violet correction filters and stronger coloured filters to convert daylight film for use in tungsten light and vice-versa.

One point to bear in mind is that not all colour casts are undesirable. The warm, mellow quality of evening sunlight, for instance, is often responsible for much of the atmosphere in this type of picture, and to correct it would be a mistake. There is also often a case for using a correction filter to *exaggerate* a colour cast to create a more dramatic effect. A sunset, for example, will often benefit from a little help provided by a yellow or pink filter.

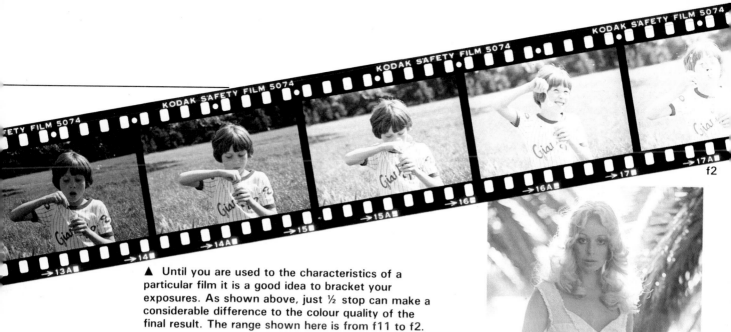

f2

▲ Until you are used to the characteristics of a particular film it is a good idea to bracket your exposures. As shown above, just ½ stop can make a considerable difference to the colour quality of the final result. The range shown here is from f11 to f2.

Exposure for colour

The choice of exposure can have a great deal of influence over the colour quality of a photograph. Over-exposure will weaken colour and under-exposure will strengthen and darken colour. The 'correct' exposure will adequately record highlight and shadow detail and reproduce the colours as accurately as the film allows. However, in many circumstances a departure from the norm will produce a colour quality more in keeping with the mood of your picture and give a more pleasing result than an accurate reproduction.

Skill in exposure assessment is mainly concerned with being able to visualize the effect you require and translating this in terms of shutter speed and aperture. An effective way of learning the technique is to experiment with alternative exposures, bracketing ½ stop, or even 1 stop, either side of the calculated setting. This may seem extravagant, but the experience gained in being able to study and compare the effects on colour will be invaluable. You will learn how your film responds and you can then use the characteristics of a particular film to your own advantage.

▼ Colour correction filters can be used to exaggerate a desirable colour cast as well as to correct an unwanted one. *John Bulmer* used a CC5Y filter to increase the yellow of this sunset.

▲ Over-exposure gives a pastel quality to colour and is especially suitable for colour prints. Under-exposure on colour negative film tends to result in rather murky colours. *Michael Busselle*

Seeing in black and white

Many photographers still prefer to use black and white because, although you cannot rival colour for realism, black and white is often more immediately expressive. Working in colour may be a distraction in certain circumstances, too—for example, in some documentary photography, or when the natural colours of the subject are not very pleasing. Without colour the image is simplified, allowing the shape, tones and texture to be emphasized.

Colour as black and white

To produce good black and white photographs the world of colour around us has to be seen as shades of grey. The change of approach is so marked that many experienced photographers find it difficult to shoot both black and white and colour pictures at the same time.

One of the main problems is that colours of the same intensity, which may look very different in colour, appear as the same tone of grey on black and white film. Take, for example, a scene of a boat with a bright red sail against a blue sea. This would look quite striking and have considerable contrast in colour but in black and white it would appear as

grey on grey and rather flat. When you start looking at the world in shades of grey you will see that what makes a good colour picture is very rarely as good in black and white.

If you have difficulty visualizing a scene in black and white, there are filters—Kodak Wratten No 90 and Monovue—which will help you judge its tonal values. These are dark, greyish-amber filters, made specially for monochromatic viewing. The Kodak also comes in a cheaper gelatin version. This can be placed in a transparency mount for protection and easier handling.

Light and black and white

Light changes tonal values and is of course vital to all photographic pro-

Right and below: you have to look carefully at the tonal values. These radishes show what happens to colours of the same intensity. The red and green give a strong contrasting image but in black and white the contrast in tone disappears.
Michael Newton

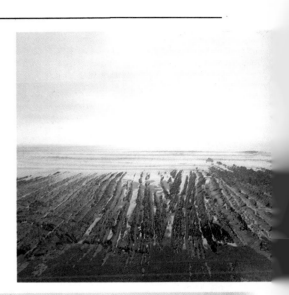

Left and far left: this garden is a complicated scene which depends on colour to separate the various elements. These colours look well together but there is not much tonal contrast. In black and white the tonal values emerge as a rather fussy, distracting arrangement of details. *Gunter Heil*

Right and below: this is a picture which works better in black and white; in colour it is rather flat. By increasing the contrast in the black and white print—using high contrast paper and giving the sky extra exposure—we have an image rich in contrast. *Michael Busselle*

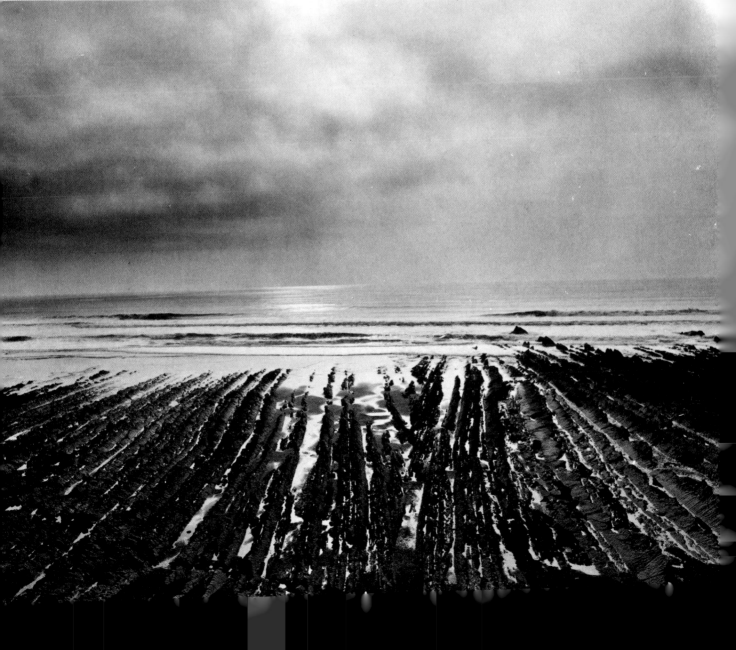

cesses, but it has a special importance in black and white photography. The example of the red-sailed boat on the blue sea, which looks flat and grey in black and white, could easily be converted into an exciting black and white image by a change of lighting. For example, if the picture was taken into the sun so that the grey sea became highlighted and recorded as a much lighter tone, the grey sail would in turn become silhouetted and record as a much darker tone. The resulting picture would then have impact and contrast.

So the tonal range of a scene becomes important, and to a large extent it is the lighting which creates the tonal quality of a picture. Taking photographs in black and white is an excellent way of learning how to understand and use light.

Filters

Modern panchromatic black and white films have quite a well-balanced sensitivity to each colour, which is why colours of the same brightness record as a similar tone of grey. But you can change the film's response to colour by using coloured filters which are designed to add contrast in black and white photographs.

These filters come in the form of discs or squares of coloured glass or plastic which are mounted in front of the camera lens. They work on the principle that they will pass light of the same colour as themselves but will hold back light of other colours. This effect depends on the strength of the filter. For example, a full-strength primary blue filter will pass blue light only and will prevent all red and green light from affecting the film. A pale blue filter, on the other hand, will only hold back some red and green, thus slightly reducing the contrast.

Colour filters give you considerable control over a black and white film's response to colour. Going back to the example of the red sail and the blue sea, you could use a strong blue filter to record the sea as a much lighter tone and the red sail as nearly black. With a strong red filter the sail would record as nearly white and the sea as very dark grey.

Few of the colours around us are pure hues, so the red sail may well reflect some blue and the sea some green. Even with a full strength filter the effect is therefore rarely total.

Once you have become aware of how to 'translate' the colour you see into black and white images, you can begin to create more powerful, dramatic pictures. You will be able to see when black and white would be more effective than colour. For example, the low-light situations where flash is out of the question, such as concerts, boxing matches, or social functions; here, colour would add very little and a fast black and white film is best.

COLOUR TO BLACK AND WHITE
The two sets of boxes give an idea of how colours come out in black and white. Look at the tones which appear the same in the bottom row and then compare them with the coloured versions.

▶ News photographs such as this one seldom gain impact in colour because their effect depends more on the emotional content from which colour would detract. *Don McCullin*

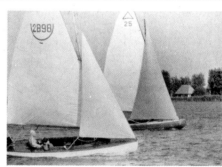

▼ As a colour picture the yachting scene has quite a strong composition largely due to the bold contrast between the orange sail and blue sea. In black and white (right) the sail becomes a medium grey and there is no longer a strong contrast. With a blue filter (below right) the sail becomes darker, the sea lighter. *Michael Busselle*

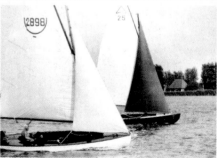

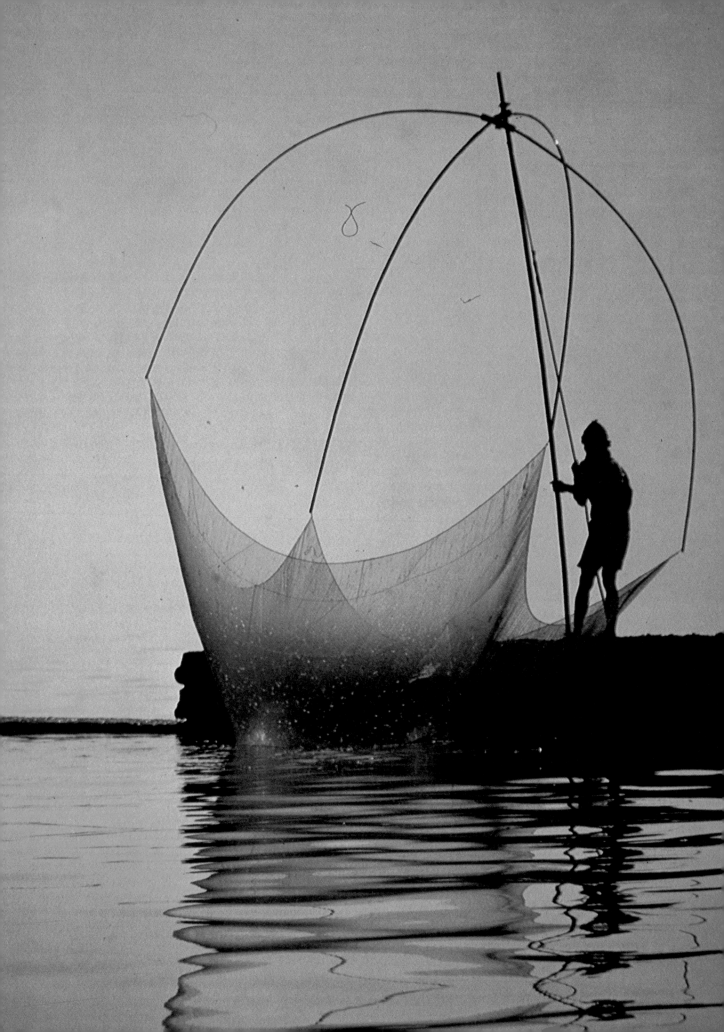

LIGHTING FOR BETTER PICTURES

In a successful photograph, quality of light is as important as quantity. Lighting affects the appearance of colours, textures and form while highlights and shadows can be a major element of composition.

Most cameras have elaborate devices to measure the amount of light reflected from the subject. The direction from which the light is coming, and the size of the light source, are equally important, though, and they cannot be measured by a meter.

This chapter explores the creative aspects of lighting, showing how it can be used to improve the quality of your pictures. The text begins by looking at different sources of light, and goes on to explain how they can be used, what kind of light is most suitable for each subject, and where it should be positioned for best results.

During the course of the day, the qualities of daylight can change dramatically: direction, colour and intensity all vary from the low orange sunlight of dawn to the hard, bright overhead light of noon. This chapter explains how to take advantage of these changes throughout the day, and the closing sections cover pictures at night: it isn't necessary to put away your camera once the sun has set, and since the night hides many things, a scene that looks cluttered by day can look picturesque during the hours of darkness.

Introducing light: the source

One of the main components of a successful or failed photograph is the lighting. The power of light is so great that the appearance of a person or object can be altered beyond recognition merely by changing the lighting.

Away from the studio, photographers tend to accept whatever lighting happens to exist, believing there is no alternative. After all, one can hardly shift the sun around or roll back the clouds. But there is in fact a great deal a photographer can do to gain control of existing light once the basic principles of lighting are understood.

Take an everyday example of a family on a beach, where the sun is out and every element throws complicated and hard-edged shadows which may be unflattering to the family group. The photographer can do several things to avoid this. A large beach umbrella, or any other large object, could be used to cast a shadow over the whole group to soften the hard-edged shadows. Exposure should be based on the areas which are now in shadow.

▼ Direct sunlight can be one of the trickiest light sources to handle: here *Clive Sawyer* uses it successfully by positioning himself so the main subject is 'spotlit' and all the potentially confusing cast shadows are lost in the dark background.

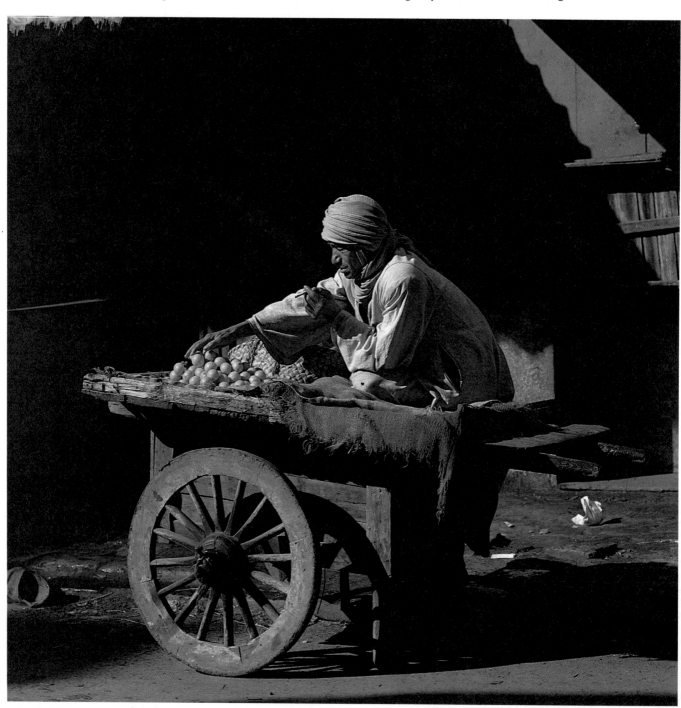

This is one solution and the person who understands the basic theory of lighting can quickly improvise many others, depending on the particular situation and the purpose for which the picture is intended. But first the photographer must think about what he wants to achieve in each individual case.

What is good lighting?

Good lighting for a passport photograph, a portrait, a prison record or an actor's publicity shot would clearly be different in each case. So good lighting has to be right for its particular purpose. The following four functions of lighting should be thought about, too.

The first function of lighting is simply to enable the photographer to see the subject, focus on it and expose the film. From this point of view, the more light there is the better: focusing is easier, there is greater depth of field and shorter shutter speeds are required, with less likelihood of camera shake. Slower speed film can be used, with finer grain and greater sharpness.

The second function is to convey information about the subject in terms of shape, size, colour, texture, and form, so that a two-dimensional photograph conveys the impression of 3-D. When eyes look at something, they see it in stereo. People can move their heads from side to side, enhancing the depth separation of the subject and clarifying the relative position of elements within the picture. Eyes can also concentrate on a small part of a scene and render it very sharply indeed. As a lens the eye-brain combination is of the finest quality.

Because the camera cannot operate in the same way as the eye, good lighting can help it to separate out these elements in a picture and communicate them to the viewer.

The third function of lighting is to comment by giving mood or atmosphere to a subject. It can imply the value or worthlessness of an object or suggest more indefinable qualities such as honesty or purity, happiness or misery. It can also subdue aspects and emphasize others. One has only to look at advertising photographs to see that these qualities can be attached to a subject or situation.

A fourth function is to give sensual pleasure. We enjoy looking at a high quality photograph in the same way as we enjoy hi-fi music and the way the lighting is handled is a vital element in such picture quality.

The danger with a 'small' light source such as the sun, is that it can create irritating highlights and confusing shadows (right). If you block out the sun and use light reflected from other surfaces, shadows and highlights become more gradual and less aggressive. This gentler lighting is more suited to the subject.

The type of light source

Many different terms are used to describe lighting: hard, harsh, soft, diffuse, flat . . . These terms are often loosely used and it is easy to be misled. The expression 'flat lighting' is commonly used to cover three quite different forms of lighting: light from an overcast sky, the light from a flash unit mounted on the camera, and the

light reflected into the shadows by white walls or equivalent reflectors.

A better system for talking about lighting is to refer to the nature of the *effective light source*, whether a reflector or diffuser, sun or flashgun. In the example of the family group on the beach, initially the sun is the light source. When the subject is put into shadow the effective light source becomes the sky, beach and whatever reflective surfaces now illuminate it.

This effective light source is important because *the nature of the light source determines the quality of the lighting*, and the size of the light source is the most important factor.

A large light source is where the light is coming from almost every direction. It barely casts any shadow. Examples are the beach umbrella combination already described, or an overcast sky, a

series of fluorescent lights on a white ceiling or any source large enough to make the light come from everywhere.
A small light source, at the other extreme, is directional and casts a hard-edged shadow. Examples are bright sun, a flashgun, a light bulb or a photoflood pointed directly at the subject. It may be a potentially large light source which is so far away that it appears small like bright sunlight.

Small light source

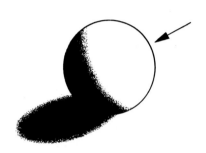

Medium light source. In between these two extremes there is an infinite range of light sources. But for the sake of simplicity just one intermediate size is defined here—a medium light source. This gives directional light but softer shadows than a small source.

The medium source is defined as being roughly as large as it is far away from the subject. For example, a window

acts as a medium source if it is, say, 1m wide and the subject is within a metre or two of it.

Medium lighting occurs indoors as well as outdoors. When sun strikes any light-coloured surface such as a wall, it becomes a medium light source. Sometimes, during heavily overcast weather, the clouds part to reveal a brilliantly lit cloud. This is an unusual and dramatic example of medium-source lighting. The same lighting is obtained artificially by reflecting (or diffusing) the primary light source by, or through, a piece of material, which should be roughly as big as it is far away from the subject.

Medium light source

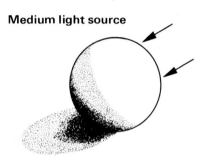

Large light source

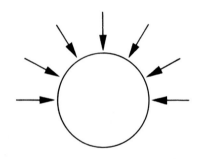

▼ An example of lighting from a large light source—an overcast sky—with scarcely any cast shadows. The colours stand out well and a basically complex picture is kept as simple as possible.

▲ The medium light source
—from the window behind—
gives better modelling and
softer shadows than a small
light source as shown in
the picture of a fruit seller
on the previous spread.

▶ Another example of
lighting from a medium
light source. But here
light from a window was
reflected on to the
subject by a sheet of
white paper.

Lighting different surfaces

When you look at your photographs you may feel that your lighting is not quite right but you don't know what to do about it. If so, you are not alone. Many photographers have the same problem. While there is no instant formula to make every picture come out perfectly, the photographer who knows what sort of lighting is produced by different sizes and angles of light sources, and how different surfaces respond to light, should be able to solve most lighting problems.

The last section defined the different types of light in terms of size. This section describes the three areas produced when light strikes an object—the highlight, lit and shadow areas—and how these areas differ according to the surface of the object—whether it is matt, shiny or somewhere in between. The next section will show the importance of the different angles or positions of the light source. An appreciation of these four aspects will enable you to get the lighting effects you want.

▲ A typical matt surface, with a minute, invisible highlight on each grain of sand. Colour appears in the lit area, while the edge of the shadow shows texture and form.

What light does

When directional light strikes an object three distinct areas are created: the highlight, the lit area and the shadow. (There may also be a cast shadow—but more about this later.) The combination of these areas provides the information which gives dimension, texture and colour to a photograph.

To see the character of each area, place an orange on a dark matt surface and light it from one side with a single, small light source such as an anglepoise lamp. Notice how the shape of the shadow and highlight show the shape of the object and that the colour comes from the lit area. Texture appears at the edges of the lit area where it merges into the highlight and shadow areas.

Types of surfaces

If you exchange the orange for a matt object such as a peach or a tennis ball, you will find that the highlight is practically invisible and that form and

texture are shown on the border of the shadow and lit areas. Now look at a shiny object made from glass or stainless steel, and you will notice the predominance of the highlight area and how the lit area merges into the shadow.

As these areas differ according to whether the object is matt, shiny or somewhere in between, surface will obviously influence your choice of

lighting and its position according to which area you want to emphasize.

For the sake of simplicity, surfaces are broken down into three main types: shiny, matt and semi-matt. In reality, there are very few truly matt or truly shiny objects and under these headings fall surfaces which have a tendency towards mattness or shininess. The effects of lighting will be modified accordingly.

What light does

Highlight

Highlight/lit
area border

Lit area

Shadow/lit
area border

Shadow

Highlight: shows colour of light source
Highlight/lit area border: shows shape and texture of shiny and semi-matt objects
Lit area: shows colour of object
Shadow/lit area border: shows shape and texture of matt and semi-matt objects
Shadow: shows nothing

▼ A medium source studio light illuminates a variety of fruit surfaces, ranging from the matt skin of the plum to the shiny, polished apple.
Now look at the fruit in conjunction with the diagram on the left. Notice the difference between highlight, lit area and shadow on the various surfaces, seeing especially which areas give the most texture and form, and which give the most colour. (On the semi-matt orange form and texture show up on the borders of the highlight/lit area and shadow/lit area, while on the apple only the edge of the highlight gives this information.)

▲ Dry pebbles are matt, while water adds shine so that both the highlight border and the shadow border show shape and texture.

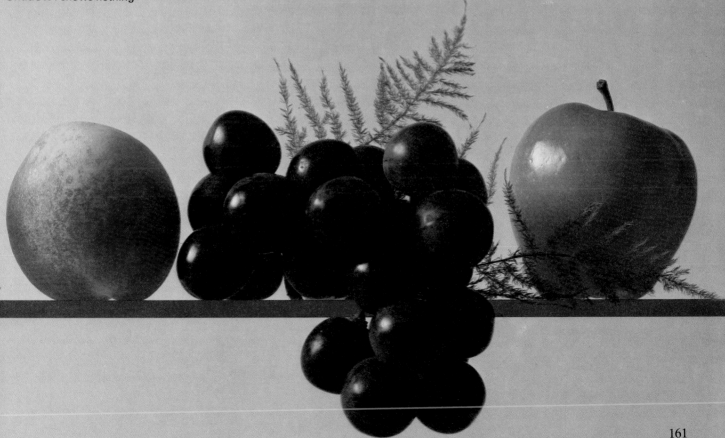

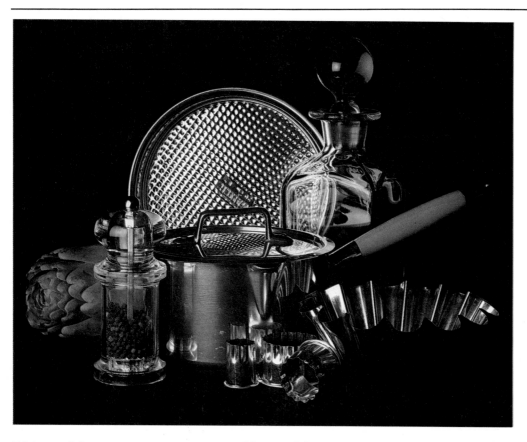

◀ The objects in this photograph are shiny apart from the artichoke and brushed aluminium saucepan. Notice that it is through the highlights that we realize the shape and texture of these shiny objects. The lighting used was a medium sized rectangular strobe (studio flash) and the shape of the light is seen clearly on the rounded bottle stopper. If a small light source had been used this picture would have been unreadable—just a confusion of tiny, hard highlights.

▶ The bread crock is a good example of a matt object where the highlight is not obvious and where texture is clearest on the shadow/lit area border. Compare this with the semi-matt onion which has a distinct highlight, and texture visible on both borders.

Shiny objects

In the case of shiny surfaces, such as tinfoil, mirror or glass, the highlight shows up very strongly while the lit area and shadow area tend to merge into one. For this reason, when lighting shiny objects the photographer needs to concentrate on the shape, size and position of the highlights. These highlights are reflections of the light source and do not show the colour of the object. But information comes from the reflection, which is distorted according to the shape of the object. The brain, seeing this distortion instantly recognizes the shape of the object.

The texture of a shiny object, or lack of it, appears at the border of the lit area and highlight.

Lighting suggestions: when small-source lighting is used a small highlight is produced. This does little to describe the shape of the object, so small light sources are not usually used with shiny objects. In fact, for many years photographers tended to construct the largest possible light source when photographing shiny objects such as cutlery or stainless steel kitchenware. More recently there has been a swing towards using a medium light source, particularly a source with a neat, clean shape such as a rectangle.

Matt objects

With matt objects, such as a brick or tennis ball, the surface is finely broken up in many directions and there is not just one highlight but thousands or millions of minute ones, usually too small to be seen as such. So the highlights are not much help to the photographer. (A comparison between the two still lives on this spread shows clearly the difference between the highlights of shiny and matt objects.) The lit area shows the colour of the object but is largely flat in appearance, while the shadow itself does not have any modelling or texture—if there appears to be some it is from a second light source, such as a nearby reflecting surface. It is the edge of the shadow, where the lit area and shadow merge, which is full of information.

Lighting suggestions: if it is texture that you want to emphasize you need a strong, well-placed lit area/shadow border. This means choosing a small, or medium, light source and positioning it so that the border falls on a prominent area of the photograph. Top, bottom or side lighting will put the border between shadow and lit area roughly in the centre of the object (the next section discusses lighting positions).

Semi-matt objects

Semi-matt (or semi-shiny) covers the majority of surfaces which are not predominantly·matt or predominantly shiny but a mixture of the two. Copper and brass (not highly polished), glossy paint, most plastics, human skin, oranges and many other fruit, are examples of semi-matt surfaces.

To a greater or lesser extent both the highlight and shadow areas are clearly distinguishable from the lit area. The highlight is the same colour as the light source, the shadow is black (unless light from another direction is shining on to the shadow area) and the lit area shows the colour.

Texture appears in both the highlight/lit area and the lit area/shadow border. The amount of texture revealed by either border will depend on the extent of the highlight or shadow.

Lighting suggestions: if you want to show up the subject's colour above all else, the lighting has to be arranged so that the maximum amount of lit area is visible. This means two things:

1 Keeping down the shadow area by using more frontal or half-front lighting (the next section will go into more detail on this).

2 Keeping down the size of the highlight by using a small light source.

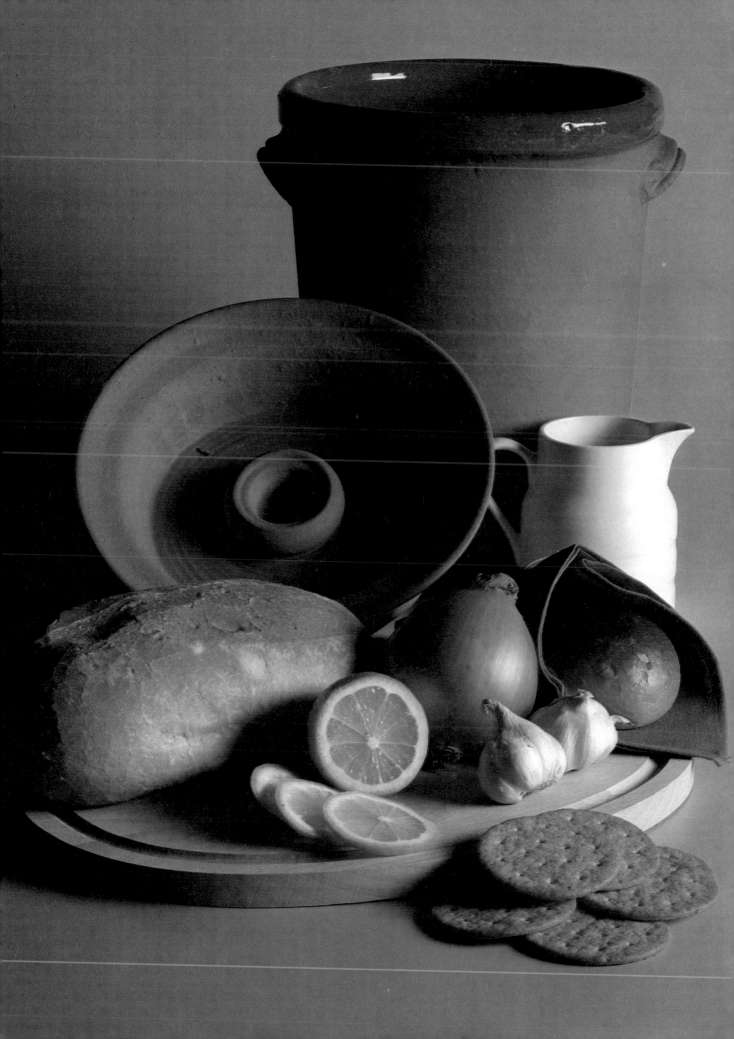

Positioning the light source

While the size of the light source is probably the main factor affecting the quality of lighting, its position is obviously also very important. A glance at the three photographs here, illustrating a scene at three different times of day, shows what a vast difference the angle of the light can make; notice the strong highlight in one, the shadow in another, the colour in the third, and how the details vary with the change of lighting for each of the pictures.

With small light sources, or with shiny objects, small changes in position can alter lighting significantly, but in most cases moving the light up or down a few centimetres does not have a very great effect. So it is usually more helpful to think in terms of five or six basic lighting positions, such as front, top, side, half-side, back lighting and perhaps lighting from below.

Choosing the angle

The position of the light has two quite separate effects. One effect is *subjective*; lighting from different angles can be associated with different situations and can carry definite emotive connotations. For instance, lighting a face from below with a small light source can look very sinister, while top lighting can create a reverential atmosphere.

The other effect of the position of light is *objective*; it concerns the amount and quality of information that lighting conveys. More simply, as the light moves round an object, so the viewer is presented with more or less shadow, more or less lit area, more or less highlight.

Your choice of angle will be determined by where you want the highlight, shadow or lit area to fall and what type of information you wish to convey about the subject.

With all shiny objects, for example, it is the shape and break up of the edge of the highlight which reveals the shape and texture of the subject. So a flat shiny surface such as a wet pavement or wet sand will not usually show much surface detail unless a highlight or highlights can be positioned to appear on it (look again at the examples of the seascape photographed at different times of the day).

Positioning the lit area

Since the lit area carries the colour of an object, front or half-front lighting, which shows the largest amount of lit area, shows the most colour.

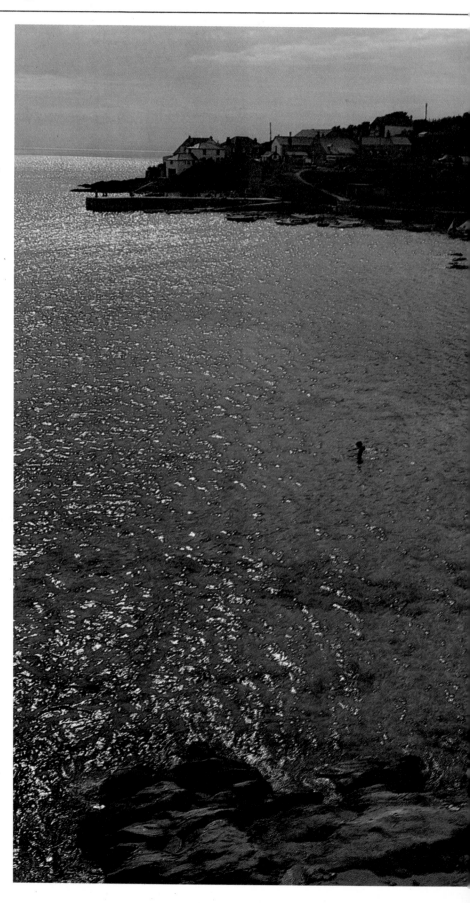

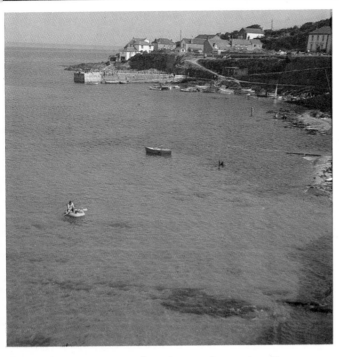

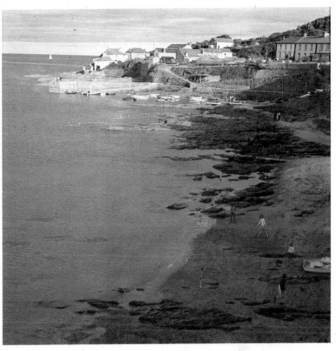

These three seascapes show how colour saturation, texture, modelling and tonal relationships (dark and light areas) change with the angle of the light.

The photograph on the left, with its small source back lighting, has the least overall detail but the light is in a position where it reflects on the shiny surface of the sea,

emphasizing the waves. The large source front lighting from a cloudy sky (right) gives good colour saturation on the headland (notice the greenery and red life belt). The side lit view (centre) has less colour saturation but more detail (see detailing on the pier, central steps and boats).

▶ The oranges show what happens when a semi-matt object is lit by small source lighting from five different angles.

TOP AND SIDE LIGHTING: half the object in shadow. Good for texture and modelling.

BACK LIGHTING: very large shadow area and small, but very strong, highlight. Lit area/shadow border indicates shape and texture well.

FRONT LIGHTING: good colour but little modelling or texture.

HALF-SIDE LIGHTING: strikes a balance between side and front.

TOP LIGHTING

SIDE LIGHTING

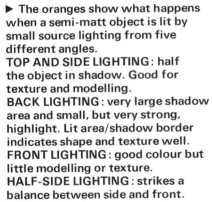

BACK LIGHTING

FRONT LIGHTING

HALF-SIDE LIGHTING

Positioning the highlight

The position of the highlight depends on the position of the light source. A rounded object will always have the highlight visible somewhere on it. A flat object may lose the highlight into its edge. But most objects are a combination of flat and rounded surfaces. With such objects the highlight can be placed deliberately to fall on an area where it is most useful.

For example, in portraiture you may want to emphasize furrows on the brow or wrinkles at the corners of the eyes with highlights.

The edges of dark objects photographed against dark backgrounds can be strengthened by altering the angle of your light source so that you run a highlight along them. Of course, this technique can only work when the highlight is strong enough to stand out clearly; that is, with a shiny or semi-shiny object.

Positioning the shadow

With matt objects, and to some extent with semi-matt objects, it is the positioning of the shadow which produces modelling of shape and texture—or rather the area where the lit area merges into the shadow. In exactly the same way as you position the edge of the highlight to fall across a flat surface of shiny material, so the edge of the shadow can be used.

For example, when photographing the front of a building the architectural photographer will usually wait for the sun to be in a position where the light is cutting across the surface, picking up all the fine detail. A few minutes earlier, the front may have been in shadow and the only light on it would have been large source light reflected from the surrounding area and the sky. A few minutes later the front would be completely in the lit area—good for colour but unlikely to yield fine detail in terms of fine shape and texture. But for a few minutes the whole facet sits on the edge of the shadow. Similarly, the still-life photographer turns the slice of bread until the edge of the shadow lies across it and the portraitist runs the edge down the wrinkles of his sitter's face, as shown here.

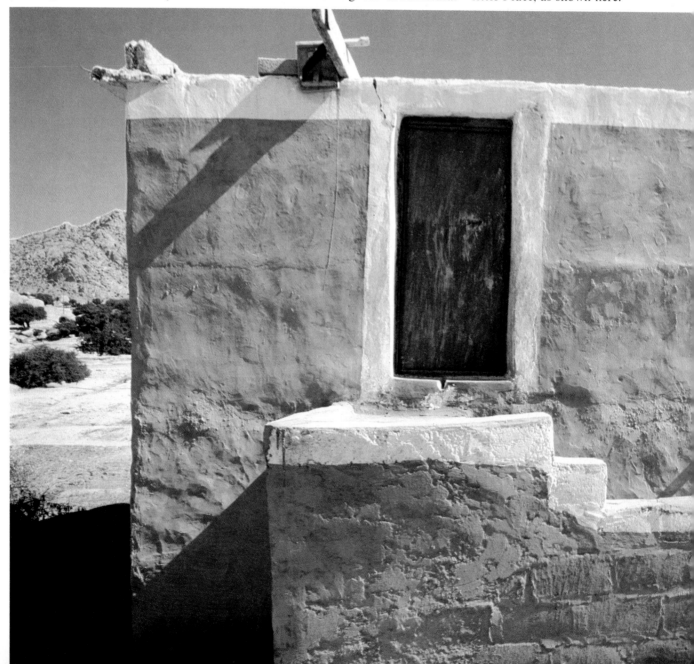

▶ The head is turned so that it is lit from the side. This causes the man's wrinkles to be emphasized by highlights.

▼ Right: this photograph shows street decorations reflected in a car. The position of the highlights could be changed by moving the camera from side to side.

▼ Left: the sun is just coming round the right side of the building, placing the whole façade on the edge of the shadow and picking up all the details on the surface.

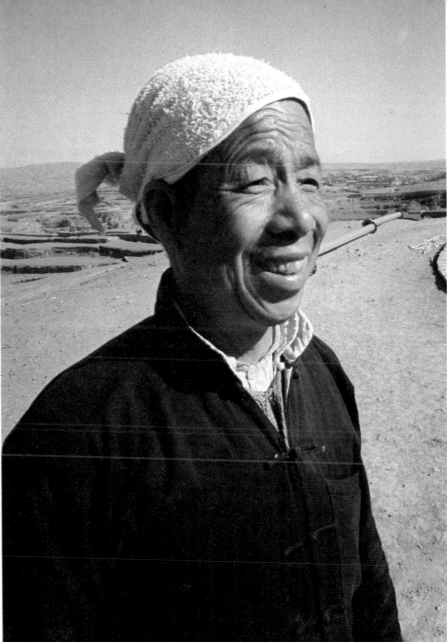

Side lighting

With side lighting the edge of the shadow tends to run down the centre of each object in fullest view of the camera and this is the most commonly used angle where texture is the main feature.

Half-side lighting

Half-side lighting keeps the edge of the shadow in a prominent view, while offering a little more of the lit area and less shadow than side lighting. This makes it a useful working angle, and probably more pictures are taken with half-side lighting than any other kind.

Front lighting

With front lighting there is virtually no shadow area and the edge of the shadow is almost out of sight. It thus gives very little texture or modelling to the subject, although it does give good colour saturation, as the lit area is well to the fore. The highlight is practically in the centre of each object, and this can be disturbing, especially with portraits, for example, where it appears almost in the centre of the eyes. This is the lighting given by on-camera flash (except where bounce-flash techniques are used).

Medical photographers use front lighting because the good colour saturation and absence of shadow ensure that pigmentation will show up well, and that no detail will be lost in shadow. They make do without texture and shape information. Press photographers use front lighting because it is simple to use under pressure.

▲ Half-side lighting.
◀ Far left : front lighting.
◀ Left : side lighting.

These three angles are the most common ones, and you will often find yourself having to choose between them. Even in a simple room setting the angle of the light makes a big difference to the overall result.

The front lit picture (far left) has the most colour saturation but looks a little flat. The side lit picture has less colour but more shadow and contrast while the half-side lighting is good for both colour and contrast.

Top lighting

Top lighting is really the same as side lighting from above: that is, the edge of the shadow tends to run across the centre of each object in fullest view of the camera, again leaving half the object in shadow.

While there is no general objective difference between top and side lighting there is a difference in the particular effects. For instance, people nearly always keep their heads upright, and top lighting does not seem to suit the layout of the human face too well: the eyes and jowl darken, the nose and cranium lighten and the result is not generally felt to be pleasing. This is particularly unfortunate because top lighting—from an overcast sky—is one of the most common forms of natural lighting.

Apart from tilting your subject over on his or her side, the best solution is to either add light in or take it out so that the lighting is no longer simply from the top. For example, a reflector such as a large white or shiny object could be used to add front lighting, or something dark such as an umbrella could be manoeuvred into position above the subject's head to reduce the lighting. However, with less overall light, you might find that exposure problems arise.

Back lighting

With back lighting most of the subject lies within the shadow area, which contains no information (unless a second light source, like a reflector, picks it up). The lit area is so small as to be overwhelmed by the intense highlight.

Although the highlight is small it becomes more dominant as the light tends toward back lighting. This is because any surface becomes more reflective when light hits it at a shallow angle. The effect is so powerful that even seemingly totally matt objects can acquire a highlight when back lit, so this angle is often used to bring life to a dull subject.

The double effect of obscuring a lot of unwanted detail while creating plenty of highlight has made back lighting a favourite among many photographers. It works like magic. But that is not all. Where there is a succession of shapes, one behind the other, receding into the distance—for example, ranges of hills, folds of fabric or wet sand—back lighting separates and spaces them out by placing each highlight against the shadow area of the shape beyond it; this in turn grades through lit area to highlight, and so on.

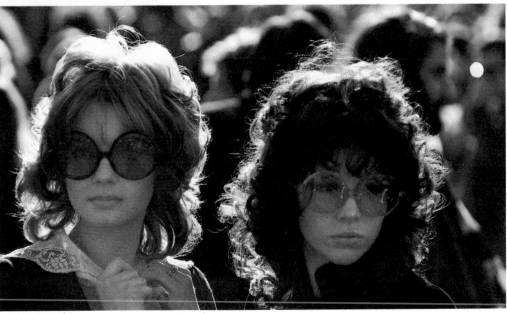

▲ Top lighting does not usually suit the human face in an upright position. The photographer has got round this problem by angling the model's face so that the lighting becomes more flattering.

▶ Back lighting outlines the heads, while highlights separate them from the crowd behind. The faces would be black if it were not for reflection from the surroundings which provides secondary lighting from the front.

Small source lighting

Lighting and the ability to use it well is important for successful pictures, and the size of the light source has probably more effect on the final lighting than any other single factor. The three basic sizes—small, medium and large source—have been described briefly already. The three sections which follow take each in turn, describing their advantages and disadvantages and how to overcome the different problems which may arise.

What it is

Small source lighting—also known as hard lighting—is recognized by its strong direction and hard-edged shadows. It is probably the most commonly found lighting because bright sunlight itself is small source.

In spite of the enormous size of the sun, it is so far away that it appears quite small from the subject's position. And the brightness of strong sunlight has the directional and shadow qualities of small source lighting.

Other small light sources are direct flash, domestic lamps and studio lamps, unless they are in large reflectors. Again, the test is: do they cast a hard-edged shadow?

What it does

Because of the strong well-defined shadows this lighting both casts and forms on the object itself, small light sources tend to make a picture more complicated. Highlights are small, bright and hard. The dividing line between lit area and shadow is abrupt, with little space for the subtle tones that give a feeling of roundness to an object.

But what it lacks in subtlety it makes up for in visibility. It also shows up every small flaw it illuminates.

The advantages

Though small source lighting may present some problems, it is ideal for certain situations.

Small simple objects respond well to it when the tendency to complicate subjects becomes an advantage. The sharp-edged shadows and pointillistic highlights inject some life into very simple subjects which might otherwise be boring.

Colour saturation is good and fine texture can be picked out, though medium source side lighting can often be as effective here.

Small source lighting can be projected considerable distances and its distribution is easy to control. Spotlights

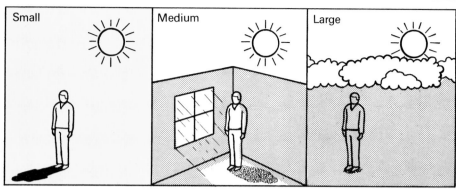

▲ The different types of light source can be distinguished by their shadows. To simplify the illustration, only cast shadows are shown but the lighting has similar effects on all shadows. A small light source casts a hard edged shadow, a medium light source a distinct, but soft-edged, shadow, while large source lighting produces almost no shadow.

▼ The jug was lit by a small-source, half-side lighting from the left. Note the small but distinct highlight, the hard shadow edge and good texture. *Malcolm Warrington*

◀ High bright sunshine from the left makes the most of the gloss paint and emphasizes texture on all surfaces. *Suzanne Hill*

▼ Strong directional sunlight results in masses of tiny highlights which break up the surface of the water rather like a pointillistic painting. The shadow edges on the ducks are softened by the feathers, producing a good contrast with the hard highlights. *Suzanne Hill*

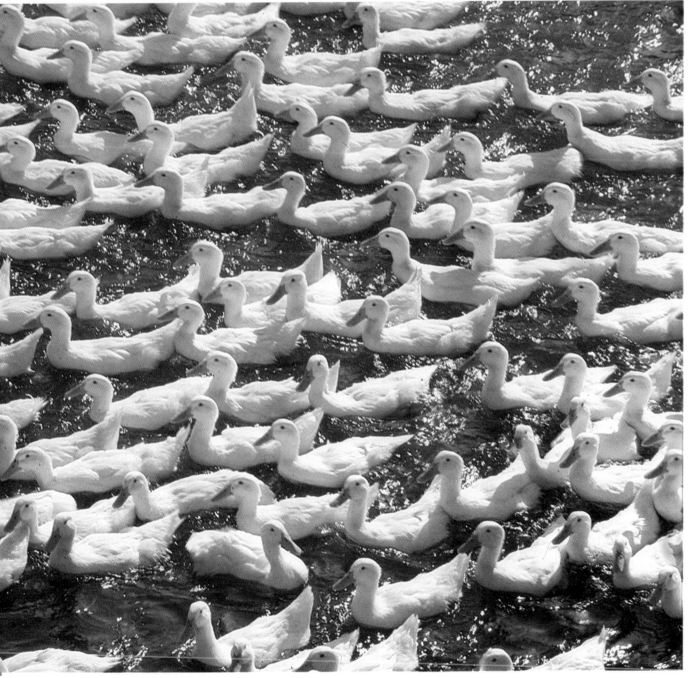

are always small source for this reason. Television studios use nothing else, although film lighting technicians have discovered medium source lighting.

Water-spray or rain can only produce a rainbow with small source lighting. Flare-spots can only be obtained with small source lighting. Medium or large source lighting produces flare which has no strong pattern, but simply 'whites out' the picture to some extent.

Disadvantages

Because of the complicated, hard-edged shadows and the ability to pick up every defect, small source lighting is not always the most flattering, especially for photographing people.

On the other hand, it is one of the easiest types of lighting to control. Take, for example, a sunny day on a beach where a photographer wants to take a picture of her husband and children. The hard shadow edge cuts across their faces. Stress lines are recorded mercilessly. If it is hot, any sweat on the face is picked out by thousands of tiny, hard highlights.

Because of the excellent colour saturation, a red nose appears redder than ever. Throughout the whole scene, there is a lack of modelling: the baby's podgy limbs are not attractive because there is no feeling of roundness.

Changing the lighting

One way to overcome this problem is to change from a small source to a medium or large source light. To do this, the photographer has to find something to block out the direct sunlight. Exactly how this might be done depends on the actual situation; a beach umbrella might be available to put over the group, or perhaps they

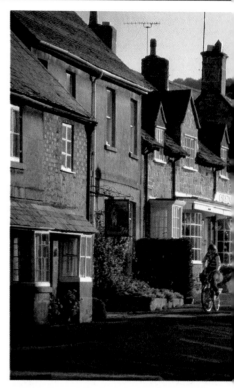

▶ **Strong shadows intensify the angles of the buildings and dramatize perspective. *Adam Woolfitt***

▼ **Provided there is enough reflected light, placing the subject in shade is a way of losing those harsh unflattering shadows. Here the wall on the left acts as a reflector. *Tim Megarry***

▶ The subject has her back to the hard sunlight, and her face is lit by softer light reflected from surfaces all round. *John Garrett*

▶ Below: strong directional light causes unflattering shadows under chin, eyes and nose and picks up every detail —even single strands of hair. *Richard Greenhill*

could be moved into the shadow of a cliff or awning.

Failing this, the photographer might just have to wait until the sun is diffused by a cloud or haze. In each case, the principle is the same—a change from small to large or medium source. The effect of this is detailed in the sections on medium source and large source lighting which follow.

Backlighting: a slightly different way of doing the same thing is for the photographer to move round until the subject is backlit. The camera will now be facing the sun so a good lens hood is needed—or somebody else could keep the sun out of the lens by casting a shadow on it with his hand. (This assumes that the sun is not so low as to be actually in the picture—if it is, it will cause severe flare, unless part of the subject can be manoeuvered in front of the sun to block it out.)

Now that the direct sunlight is only lighting the very edges of the subject,

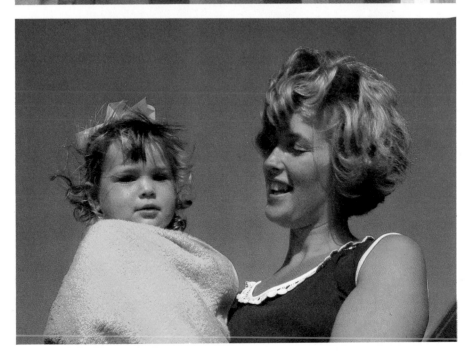

the faces and bodies are being lit only by reflected light from the surroundings or the sky. This is large source lighting. It is almost certainly not as bright as the primary (direct sun) light, so on a camera with adjustable settings the aperture should be opened up by about two stops.

The combination of small source back lighting and large source front lighting is extremely flattering—it makes almost any subject look angelic and idealized. The power of lighting is such that, by moving no more than a metre and using a wider aperture, a sweat-covered, red-nosed, line-ridden man and cross-looking children can be changed to a Greek god and cherubs.

Changing the picture

Instead of changing over from small source light to light from a larger source, the picture can be changed to suit the lighting characteristics.

In the example of the family on the beach, the photographer could move so that the sun is behind her. The subjects will then be more frontally lit, and the effects of the hard, sharp shadows reduced. (Care should be taken that the photographer's shadow does not obtrude into the picture area.)

The faces are now entirely in the lit area and are not so broken up as they would be with side lighting. Any stress lines will be there, but not so obviously. However, any sweat or redness of the

▼ Right: creative use of strong directional lighting; without the strong shadows this picture would be very dull indeed. *Jack Taylor*

▼ Strong side lighting clearly defines the fluting on the columns and the cast shadows add interest to the bare space between the rows of columns.

▲ The strong side lighting picks up every detail—the shallow ripples in the sand, individual blades of grass. Notice how the photographer has carefully chosen a position where the grass is shown against the sky. *Jack Taylor*

nose will still show up. One solution to these problems is to resort to a soft-focus filter to smooth everything out. The cruel shadows of side lighting can be lessened by lowering the lighting contrast. Any white or pale coloured material (except green or blue) can be used to reflect some light back into the shadows. This will make the lighting less stark. Reflectors often occur naturally, even within the picture area. For example, a hand or book may reflect light back into a face. This reflected light can even take over and become the principal lighting for a sizeable part of the picture.

Because small source lighting complicates a subject with shadow and revealing detail, the photographer can respond by simplifying the picture. You could try a more formal arrangement. And watch for irritating flaws: untidy hair, creases, and so on. Clean, flat surfaces, or elements such as the sky, can be brought into the picture instead of the complicated beach scene. Finally, take cast shadows into account. The cast shadows with small source lighting are hard-edged and so, unless they are filled in by other light, they show up very strongly in the picture—sometimes even more strongly than the

object which casts the shadow. While this can be an advantage in some situations, in an already complex picture the hard-edged shadows may be an unwanted extra element.

Unwanted shadows

Getting rid of shadows is not very easy. Still-life photographers often use a second lamp, but this produces its own, albeit weaker, shadow. They then move the second light to the front so that its shadow is hidden behind the subject, and in the edge of the existing shadow. But this in its turn produces a second set of highlights.

On the beach the problem is probably most satisfactorily solved by lowering the camera angle and shooting up slightly, so that the shadows on the ground are no longer in the picture. As the top half of most scenes is usually much simpler than the bottom half, this immediately simplifies the photograph. There are now no important shadow areas in the picture so it is a good idea to close down the aperture by about half a stop to improve colour saturation in the blue sky.

Using shadows creatively

The hard-edged shadows cast by small source lighting can be used to indicate the shape of another object which the shadow falls across. For example, the shadow of a telegraph pole on the snow dips and rises as it runs across a ditch. The shadows cast by clouds often define the shape of a hill.

Shadows can also have a symbolic effect and can be used to create photographs with a deeper level of meaning and mood. They can give a menacing, sinister effect—for instance, the strong shadow following a lone figure.

Cast shadows can also be very important in the composition of a picture, being used to form patterns and balance or offset the subject matter.

To sum up

Small source lighting will produce a:

Small highlight: results in good colour saturation but gives no shiny-object modelling.

Hard shadow edge: gives good texture visibility but may give little matt-object modelling.

Hard-edged cast shadow: can be used creatively but can complicate a picture. So while small source lighting works very well in some situations, in many others it needs imagination and know-how to quieten it down and make it work in the way you want it to.

Large source lighting

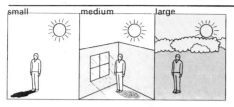

The last section covered small source lighting. At the opposite end of the scale is large source lighting where the effective light source is so large or close that it practically surrounds the subject. Light comes from almost every direction, and there are hardly any cast shadows at all.

The most commonly found large light source is an overcast sky. Buildings, such as supermarkets, with white ceilings and rows of fluorescent tubes provide large light sources. When flash is bounced off the ceiling it is often a large light source. A large light source

does not need to be bright. The test is, does the lighting cast shadows? With large source lighting the only cast shadows are from objects relatively close to the ground or other surfaces, and even these are very soft-edged.

What it does

Large source lighting tends to simplify a subject. Highlights spread out, often until they are invisible, and this desaturates the colour and markings of the subject. This happens because

◀ **Large source lighting produces a spread-out highlight and few shadows.** *Malkolm Warrington*

▼ **A busy scene with patches of strong colour makes an ideal subject for large source lighting.** *Richard Greenhill*

the highlight normally carries the colour of the light source rather than that of the subject, so if a large highlight spreads out through the lit area it will weaken the colour.

The great advantage of large source lighting is its simplicity and unifying effect. It may not help the subject to stand out well but, on the other hand, it does not carve it up as small source lighting can. So, though colour may be toned down, it often shows up well nevertheless, because it has less visual activity to compete with.

Shiny objects: we have already seen how the edge of the highlight can be used to define the shape of shiny objects. When the highlight spreads out the edge is weakened and, unless the object is of a dark colour, may be lost altogether. So large source lighting cannot generally be used in this way, though studio photographers do use a patchy or uneven large source to light shiny objects; this is, however, a rare and more specialized usage.

Matt objects: in the case of matt objects it is the edge of the shadow which gives modelling and texture. With large source lighting this edge is soft and gradual; the lit area slowly changes into shadow area but never quite becomes total shadow.

For this reason, large source lighting gives extremely subtle modelling—so subtle that it is often ineffective. Texture, too, is virtually invisible.

Using large source lighting

While a small source can be turned into a larger source, the reverse process is more difficult. Occasionally it is possible to get a medium source from large source lighting but, on the whole, the photographer has to learn to live with

it and turn it to advantage where possible. For example, suppose a photographer visiting a famous city wants to take some pictures of his family seeing the sights on an overcast day. What should he do?

Fortunately for the photographer, large source lighting from an overcast sky is usually easier to handle than small source, direct sunlight. All he needs to worry about is that he does not under-expose the picture, and that there is something in the composition to keep the colours lively.

Exposure for overcast sky

On a cloudy day the whole sky is the light source: though it may not look bright, there is unlikely to be anything around that is brighter. So the slice of cloudy sky at the top of the picture is deceptive and, if the camera has a built-in meter, this bright area will influence the reading; the camera 'thinks' the subject is much brighter than it really is so the sky comes out perfectly exposed but the rest of the picture is far too dark.

To get a correct exposure, take a reading by pointing the camera downwards to cut out some of the sky.

With a fully automatic camera, unless it has a memory lock, the only way to cope with this problem is to set the film-speed indicator half the actual ASA speed of the film being used.

With a simple camera the problem does not arise in the first place—just set it to 'cloudy' and all will be well.

Livening up the picture

Colour contrast: you can compensate for desaturated colours by adding a touch of very bright colour. For example, it would help if the sight-seeing

family put on their brightest clothes. Although the colours would be toned down a bit, if they are bright enough there should be plenty left—certainly enough to bring life to an otherwise colourless picture. Even if these colours only form a small part of the composition—a bright coat, for example—the picture has greater colour contrast as a result.

Lighting contrast is likely to be low as well. Small and medium source lighting can be of any contrast, but large source lighting is nearly always of low contrast. Some ingenuity may be needed to increase this contrast; it will, of

▼ Contrast is increased by including the veiled sun in the picture. Taking a reading from the ground in front of you makes the tree record as a mid tone. *Richard Tucker*

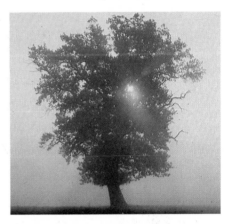

▼ Large source lighting reduces the three-dimensional effect of an image and emphasizes the outlines of the shapes in the composition. Slight under-exposure brings out the rich tones. *John Garrett*

course, depend on the particular situation.

The lighting on a large building is beyond the photographer's control, but if the family were grouped in the foreground quite near to another large building, or solid mass, this would at least cut off some of the light falling on them from one side, so increasing the lighting contrast. They would now be more or less lit by medium source lighting which would give the picture a tonal boost.

Subject contrast: increasing the subject contrast (that is, the tonal contrast of the subject itself, regardless of lighting) has a similar effect. For example, put a light-skinned person in light coloured clothes against a contrasting background such as a dark archway or entrance, and vice versa. Or include a bright light, such as a street lamp, car headlamp or some bright reflection, in the picture to extend the overall contrast. If it is in the background it will give a feeling of depth. It might even give a bit of back lighting to the main subject.

If the sun is dimly visible you could include it in the picture, either by choosing a suitable camera angle or by using its reflection in a window,

▲ Here the soft lighting suits the complex subject matter and several elements are combined to produce this lively photograph. Apart from the bright colour and strong subject contrast, notice how the large clump of trees cuts off some of the available light, so increasing the overall lighting contrast.
Ron Boardman

▶ Overhead fluorescent lighting, such as one finds in shops or offices, produces the typical shadowless image of large source lighting. Fluorescent lighting often produces a greenish tint and a strong magenta filter—CC20 or 30—is recommended. *John Bulmer*

puddle or other shiny surface. And, remember, shiny objects are usually more lively than matt objects as highlights increase the brightness range, so look out for shiny, wet surroundings, too.

Complexity. While complexity is a problem with small source lighting, it can be a positive asset with dull, large source lighting, and the answer to livening up the picture may be to make the composition as busy as possible.

▲ By placing the sun behind the girl, her face is lit by light reflected from the white sand all round her. The shadowless, large source frontal lighting produces a flawless complexion, noses melt away and attention is drawn to contrasting features like eyes, eyebrows and mouth. The light reading should be taken close up from a mid tone such as a shaded part of the shirt.

Other large sources

Fluorescent lighting is often large source and the same general principles apply. Bounce flash off the ceiling may produce a similar effect, but here you have a chance to act directly on the lighting. Turning the flash unit, or in some cases the flash head, on its side and bouncing light off the walls, usually changes the lighting to medium source (the use of flash is covered more fully later in the book).

The angle of the light

Top lighting: an overcast sky or overhead fluorescent lighting produces the problems of top lighting—see section on positioning the light for details.

Front lighting: if you are aiming to make your sitter's complexion flawless this is the lighting to choose. Texture and modelling are not wanted here. Spots and wrinkles are smoothed away as if by magic, noses lose their prominence; only colour and tonal diff-

179

erences remain—the eyebrows, lashes, pupils, nostrils and lips. This is the sort of lighting achieved by obscuring direct sunlight with, say, a hat.

If the sky is the main light source the picture is likely to have a bluish cast, but on a pale-coloured beach the sand should reflect enough yellowish light to balance this.

Sunlight filling a courtyard can have a similar effect. If the subject is placed in the shade the main light source is the sunlit walls and ground. This light can be strikingly beautiful, especially if the walls are a warm colour.

To sum up

Large source lighting has a:

Large highlight: sometimes useful to show the shape of shiny objects, but will not show up well enough unless object is very shiny and dark in colour. The large highlight obscures the colour of the lit area, producing desaturation.

Very soft-edged shadow area: keeps the subject simple. Produces very delicate modelling. Does not compete with colour or markings. Does not pick up texture. Produces low lighting contrast.

Very soft cast shadows: the cast shadows are so soft-edged that they almost cease to exist. They cannot complicate the picture, but nor can they be used to add contrast. In general, the problem with large source lighting is livening it up.

▲ Large source lighting in the shadow of a courtyard on a bright sunny day. *John Bulmer*

▶ Soft lighting flattens the forms and draws attention to the outline of the subject, giving it an unreal cut-out quality. This effect is heightened by the background being out of focus.

◄ A bright light provides contrast and becomes the focal point of the photograph. *Richard Greenhill*

▼ Soft lighting, with its spread-out highlights, tends to desaturate colour, producing in this instance a monotone effect. *Suzanne Hill*

▼ Bottom: spots of colour again used effectively to lift a picture. If you cover up the splashes of pink, this charming scene of a country rose garden becomes dull and lifeless. Care should be taken not to under-expose in these lighting conditions and a light reading should be taken by pointing the meter downwards.

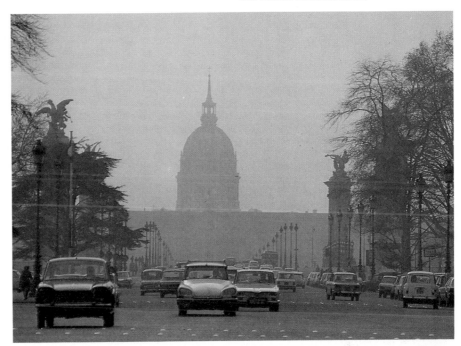

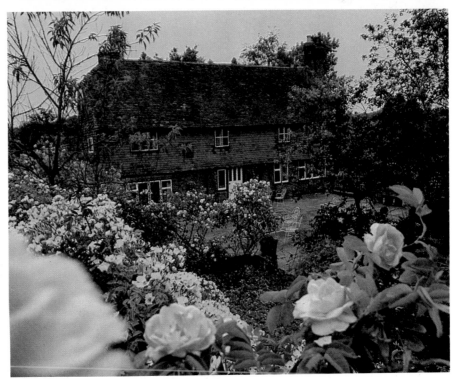

Medium source lighting

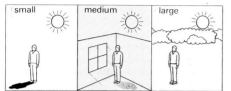

Medium source lighting is something of a universal remedy for most lighting problems, because it is suitable for the majority of subjects and requirements. It combines some of the virtues of small source lighting (texture and good colour saturation) with some of the virtues of large source lighting (relative simplicity). It also gives excellent modelling for shape, as well as a sense of depth, scale and solidity.

Though some very simple, or small, or pale-coloured, objects need the strength of small source lighting, and some very complex subjects need the simplicity of a large source, medium source lighting can cope with most situations.

What is medium source?

A whole range of lighting lies between large and small light sources, but for the sake of simplicity only one intermediate size is considered here: one which is midway between the two extremes in effect. A medium light source can be recognized by its soft-edged shadow area. Though, unlike large source shadows, the shadows are substantial, they do not have the hard edge of small source lighting.

The definition of a medium source is lighting where the size of the source is very roughly as great as its distance from the subject. For example, a window 2 metres across and 2 metres away from the subject would fit the definition precisely (so long as no direct sun hits the subject); in fact, it could still be called a medium light source at any distance up to about 4 metres.

A reflection, or a patch of sunlight on a wall, would be medium source if it was roughly as big across as it was far from the subject.

What it does

Medium source lighting gives excellent modelling for shape and roundness. The highlights are large but are usually definite enough to be clearly seen.

Although there is more colour desaturation than with small source lighting, it is not extreme, as the highlight is not so large as to obscure the lit area.

Medium source and shiny objects: if the subject has any shininess at all the well-shaped highlight can give a pleasant and sensuous appearance of roundness to it. Shape and surface information come across well.

Medium source and matt objects: the shadow/lit area border, which is so important in communicating shape and texture, is well-defined and yet gradual. With small source lighting this area is too abrupt and narrow to give much description of shape, and with large source it is too subtle and vague. Medium source is ideal lighting for matt objects. The graduation of tones from lit area to shadow gives tactile shape and texture to each element of a picture. Unlike the over-subtle transition of large source lighting which never quite reaches shadow, the shadow from medium source can, if there is no fill-in lighting, go right into blackness.

Outdoor medium source

Unfortunately, medium source lighting is not very common out of doors; if the sun is shining brightly it produces small source lighting; when it is cloudy the lighting is usually large source. But medium source lighting does occasionally occur out of doors: when a black and thundery sky folds back a little to allow a brilliant sunlit cloud to act as a medium light source, for example. The cloud acts as a giant floating reflector.

▲ Medium source lighting gives good modelling for shape. Note the distinct but soft-edged shadows and compare with photographs on pages 170 and 176. *Malcolm Warrington*

▶ The medium source in this picture is the open doorway. The shadows are the soft ones characteristic of medium-source lighting, and the white walls reflect light which lightens the shadows further. *Anthony Blake* took three exposures, bracketed at one stop intervals (shutter speeds of 1/15, 1/8 and 1/4) to ensure that he got a picture with the best possible balance, retaining detail in both the highlight areas and shadows.

(This lighting should not be confused with the effect of sunshine coming *through* slight cloud or mist, which is actually a combination of small source and large source light.) If you want to use medium source lighting outside you usually have to create it or look hard to find it. You may find it in the shadows, especially on a sunny day.

Changing small source to medium: look for a situation where the direct sunlight is blocked, so that the subject is in cast shadow, and where some light-coloured surface is acting as a reflector.

Alternatively, it may be possible to block the sunlight by using a beach umbrella, hat or similar object (see earlier).

The result will not necessarily be medium source: if light is coming from the sky and surroundings, rather than from one main direction, the lighting is large source; but if a light-coloured surface reflects light on to the subject so that it is directional, with soft-edged shadows, then you have medium source lighting.

You may find that only a small area within a potential photograph is lit by medium source lighting. The overall scene is lit by small source light, perhaps from the back or side, but an area—a face, perhaps—is in shadow and lit by light reflected back from a surface such as a hand or a book. You can produce very romantic lighting by over-exposing a picture of this sort. The area lit by direct, small source light becomes burnt-out white, while the face, lit by medium source, is correctly exposed.

Changing large source to medium: large source lighting from an overcast sky can sometimes be changed to medium source by using large objects such as buildings or trees to reduce the size of the light source (see earlier).

Indoor medium source

Here the *level* of lighting brightness is often a problem—there isn't enough to

give a short exposure or much depth of field. But this is often more than compensated for by the *quality,* which can be marvellous. This is particularly true of daylight coming through a window.

Natural lighting: light coming through a window, provided it isn't shining directly into the window is usually medium source. (The exception is a tiny window, very far away, which might fall into the category of small source.)

The light coming from the sky will tend to have a bluish cast and it is a good idea to use an 81A filter to compensate for this.

Contrast is sometimes rather high. You could remedy this by using a bounced flash, or you could use a reflector to lighten shadows. But this is only practicable for small set-ups such as portraits. Even if the reflector does not seem to have a very great effect, it can prevent the shadows from becoming completely black. Another way to lower contrast is to open a door, or pull back some curtains to allow light in from a different direction. It all helps.

If sun is shining into a room and striking a white wall the patch of light created is medium source. Its colour will usually be slightly warm or golden. But remember that if the direct sunlight strikes a strongly coloured surface, it is liable to give the picture an overall cast of that colour. To avoid this, position a white sheet or piece of paper or newspaper in the patch of light to act as a reflector.

Direct sunlight coming through a window can be changed to medium source by fixing a diffuser, such as tracing paper, over the window. A white roller-blind or fine net curtains *may* give the same effect, or they may allow some direct, small source sunlight through—it depends on the fabric. If this happens, a combination lighting similar to that produced by hazy cloud or mist is produced. To find out if the lighting is medium source or combination, look at the cast shadows. If they are sharp-edged, though pale, the lighting is combination. If they are soft-edged it is medium source.

Artificial lighting: medium source lighting is not often provided by lighting indoors, except under studio conditions. In fact, in the past 15 years or so photographers have tended more and more to use medium source and have a battery of equipment to produce it, like special white or silver umbrellas and large box-lights covered with dif-

fusers. Strip lighting is usually large source, and most tungsten lighting tends to be small source or a combination lighting.

Some large lampshades do give medium source lighting, as do lamps which are designed to bounce light off a wall. But with these sources you need a fast film, or to use a large aperture, or a slow shutter speed with a tripod. Colour transparency film needs to be tungsten type to avoid an orange colour cast.

Bounce flash can produce medium source lighting and, as it does not require special film, large apertures or long exposure times, it is often the most practical solution.

Some flash units come with a bounce board which can be attached to the flash head. Although this gives some variation from the small source frontal lighting produced by direct flash on the camera, it is not nearly big enough to give the quality of medium source lighting, unless the subject is within a metre of the flash. A better solution is to fix up, or ask someone to hold, a larger reflector such as a sheet of newspaper and bounce the flash off this.

It has been suggested that putting a handkerchief or paper tissues over the

flash will give a softer result. This will diffuse the flash and contrast may be reduced. But this method does not make the source any bigger; it does not create medium or large source lighting and in fact it may do nothing except cut down the power of the flash.

To sum up

Medium-sized highlights: ideal for showing shape of shiny objects. Not so much loss of colour through desaturation as large source but more than small source. If colour saturation is paramount, a smaller source may be necessary.

Moderately soft edge to shadow area: produces full, rounded, deep modelling on matt objects. Reasonably good texture, but not as strong as with small source. Where texture is paramount, a smaller source may be necessary. Conversely, for very complex subjects, or to subdue texture, a larger source may be best.

Soft-edged cast shadows: give a good sense of the mass and scale and depth of the elements of the picture but do not compete with the subject matter.

Conclusion: one cannot usually go wrong using medium source lighting.

▲ If you look at the wooden egg you can see how the full range of tones and soft shadow edge of the medium source lighting convey the form of the object. *Michael Boys*

► The shadows show the nature of the light source. Although these are pale they have a very distinct edge and the lighting is a combination of small and large source from the sun and cloudy sky.

▲ *Richard Greenhill* diffused direct sun by putting tracing paper over the window. In a similar situation, remember not to include the window area when you calculate exposure as the photograph will be underexposed.

▼ Medium source lighting coming through a window on the left produces high contrast even though some light is reflected back into the shadows. Take an average reading for the exposure with this type of shot. *Clay Perry*

185

Photographing into the light

For most of us, the first piece of photographic advice we hear is to keep the sun behind our left shoulder. This is to ensure reasonable modelling, to keep exposure determination simple and to avoid the pitfalls caused by including the light source in the picture. However, if photographs could be made simply by following the book of rules there would either be no great photographs or all of our pictures would be masterpieces.

Edward Steichen said that there were only two problems to be solved in photography, to capture the right moment of reality as you release the shutter, and to conquer light. One step towards the latter is to disregard the rules occasionally and to take your pictures facing towards the light rather than away from it.

Shooting into the sun

A photograph taken into the sun, called *contre-jour* by Henri Cartier-Bresson, makes the subject stand out against large areas of shadow and this in turn creates a greater feeling of depth and richness of tone, particularly in colour work. For example, a picture of trees and flowers taken against the light has a high colour saturation because the amount of white light reflected from the surfaces of the leaves and petals is reduced to a minimum. With light at normal angles the surface reflection of white light is far greater and the colours become desaturated.

Working with colour film out-of-doors, however, while giving us greater freedom, also brings more problems to solve. Daylight colour film is balanced for average 'over the shoulder' lighting and this is usually expected to be sunshine with small white clouds in a blue sky. Where the sunlight falls the light will be apparently normal and in the shadows light reflected from the blue sky by more or less cloud will show as more or less blue.

Photographing into the sun, therefore, means that we are exposing all the shadowed areas by predominantly blue light. Our eyes will adapt and try to correct this blueness—the film will not, and some form of filter must be used to compensate. A skylight filter is ideal for this purpose, its pinkish hue warming the shadow colour to the point where we will accept it as being correct.

Starburst filters

When a small point of light source is included in the picture you may find

▼ By shooting into the light, the main subject can be made to stand out in bold contrast to the areas of shadow in the foreground. *Homer Sykes*

◄ The light in this shot is in front of the camera but slightly to one side of the family group. This creates a kind of rim lighting on the right-hand side of the figures and also gives greater detail than if the sun had been directly in front. Notice how the film has recorded the much bluer light of the shadowy area in the foreground of the picture. *John Garrett*

► The rich, saturated green of the leaves in this picture could only have been achieved by shooting into the light. By doing so the light is transmitted through the translucent leaves, rather than reflected from the surface as it would have been with the more conventional over-the-shoulder lighting. To keep the colours deep and to prevent the over-exposure that would have resulted from a reading taken from the bright burst of light, *Timothy Beddow* used a very small aperture (f22) and a fast shutter speed.

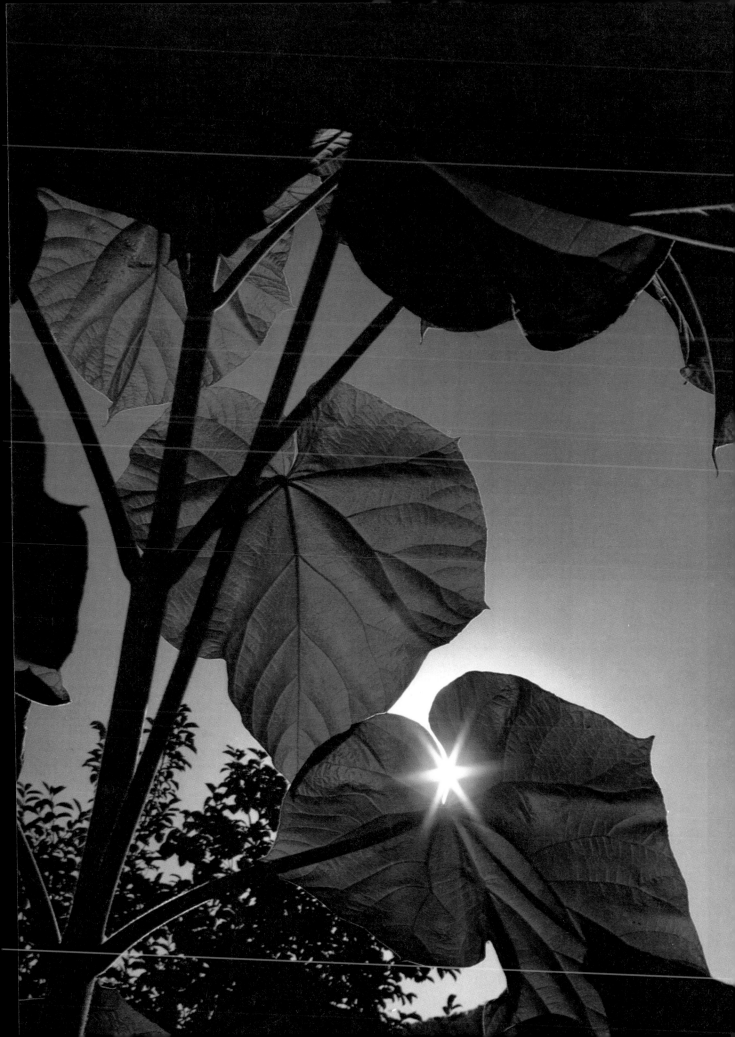

that as well as the ghost diaphragm shapes there are lines of light radiating from them. It is possible to turn this defect to advantage with the starburst filters currently available. These comprise fine lines in a square pattern, etched or moulded on to a clear piece of glass. Their function is to exaggerate the radiating lines from lens flare. They also diffract the light into bright rainbow colours and produce beautiful and dramatic emphasis on backlit subjects with many small highlights. Ripples on water or speckles of light through leaves are ideal subjects to photograph with starburst filters.

Determining exposure

With conventional backlighting one of the biggest problems is calculating exposure, especially if the subject is a landscape with a low sun. The meter will respond to the brilliant highlights, which in effect means that it will read the light source and not the subject. The subject will then be heavily underexposed. A good rule of thumb for many subjects against the light is to give four times the exposure indicated by the general meter reading, but this will depend on the size and importance of the highlight areas in the frame.

Another solution is to measure the exposure from the sky directly above your head. This is the equivalent of a mid-tone in a more conventionally lit subject and should give acceptable detail in the shadow areas. Once again, bracketing the exposure will increase the chances of a perfect result.

Interiors

For pictures taken indoors the photographer can exercise a considerable degree of control over the light source and can use the technique of shooting into the light to achieve a planned result and extend the creative lighting possibilities.

The major problem here is that a backlight behind the subject may spill over into the studio area to grey the shadows or reflect back on to the front of the subject as light of a different colour, having been bounced off the walls behind the camera. For studio flash you can use a snoot, a tube over the source which minimizes spill, but tungsten spotlights will give a similar result with greater control. For small subjects you can prevent light being

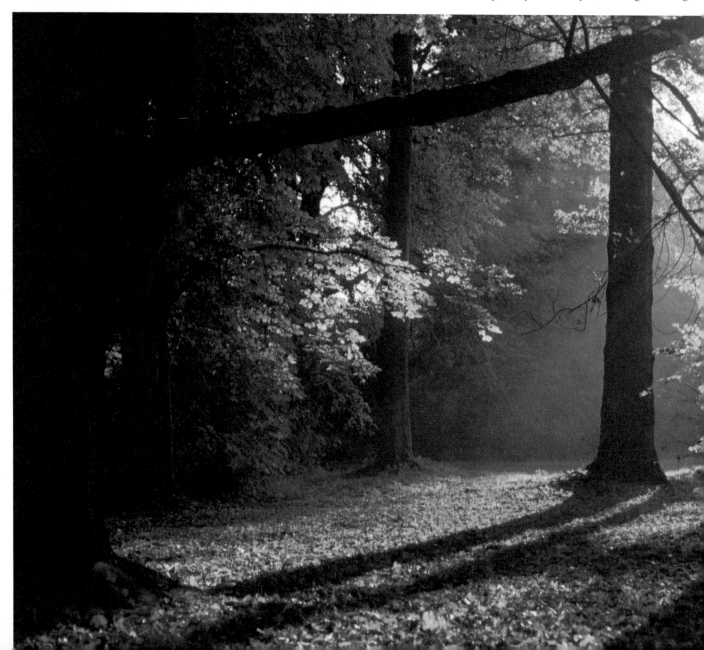

bounced back on to the front by placing a piece of black card upright and below the camera so that it is not included in the picture. For larger subjects the wall behind the camera should be blacked off.

Backlighting in the studio need not always be harsh or with hard-edged shadows. A large source, such as an umbrella flash or a large reflector, can be used to give the richness of unlit shadow areas, with the tonal quality that comes with soft lighting.

So, although it does present its own problems these can be overcome, and being courageous enough to break the rule of not shooting into the light should reward you with some outstanding pictures or, at the very least, some interesting effects.

▲ If the light is just outside the picture area, it is possible to prevent flare from stray light by casting a shadow over the lens with your hand (top). However, as *Michael Busselle* shows above, including some flare can add to the picture.

Lens flare

When a light shines directly into a lens it not only forms the image but scatters generally between the various glass surfaces, creating fogging and lack of contrast. It also creates 'ghost' diaphragm shapes of different sizes and colours. These are superimposed on to the image and known as lens flare.

This problem has become more acute with the increase in complexity of lenses. The effect is most often found with zoom lenses which can have as many as sixteen component glasses and up to a dozen surfaces, some elements being cemented together.

To see what the effect of flare may be, point an SLR towards (not at) the setting sun. Sometimes *including* limited flare can add to a picture. Fit a lens hood or shade the lens with your hand (just out of shot) if you want to modify the effect. If you are using a modern lens the effect will be reduced anyway, as multi-coating is now a feature and this greatly minimizes the effects of light scatter.

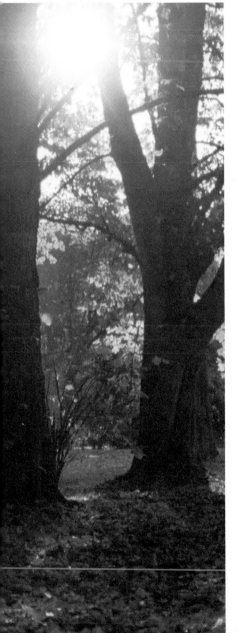

◄ The full effect of the sun in this picture has been reduced by the trees, but it is still fairly bright. To capture the light shafting into the wood, *Clive Sawyer* took the exposure reading from the lightest part of the scene, although not from the sun itself. Because the subject is naturally high in contrast the slight flare which has resulted serves to add to the picture rather than to spoil it. Had the sun been more obviously in view the exposure would have to have been calculated from that part of the picture farthest from the light.

▶ Working in a studio gives the photographer greater control over the light source. Here, *John Garrett* has combined strong back lighting, to outline the girl's head, with soft front lighting to bring out the detail.

Sunsets

One of the most popular subjects for photographs which include the light source is the sunset. This occurs at any time from two hours before the sun disappears below the horizon until about 30 minutes afterwards. During this time the light drops rapidly, perhaps as quickly as one f stop a minute. You will therefore have to check the exposure every 30 seconds. You will notice when looking at sunsets that as the sun sinks lower in the sky it appears to grow larger and the light it gives gets progressively redder. For these reasons a longer focal length lens will give the most effective representation of the sun and, of course, an extreme telephoto gives those dramatic shots of a huge red ball touching the horizon.

As with most landscapes, foreground objects can be included in sunset pictures to great advantage. They should be chosen for their shape in silhouette, as well as for their contribution to the overall scale of the image. A meter reading taken from the sky when the sun is below the horizon will turn backlit forms into silhouettes.

Boats on water highlighted by the sunlit sky, trees and recognizable structures such as famous buildings all benefit from the simplification that a sunset silhouette gives, allowing the photographer to concentrate on shape and pattern. Using a wide angle lens has the effect of making the sun smaller and the foreground correspondingly more prominent.

▼ The most spectacular moment in a sunset is often only seconds before the sun disappears below the horizon. It is well worth waiting for. *Timothy Beddow*

► This picture includes two elements of composition, either of which can turn a rather ordinary sunset into an extraordinary photograph—a dramatic silhouette and a reflection of the sun in the foreground. *David R. MacAlpine*

Below right: as the sun sinks in the sky it seems to become larger. One of the most effective ways to capture this in a photograph is to use a fairly long focus lens. If the sun is also thrown slightly out of focus, as it is here, the lack of a sharp outline will make it appear bigger still. *Alexander Low*

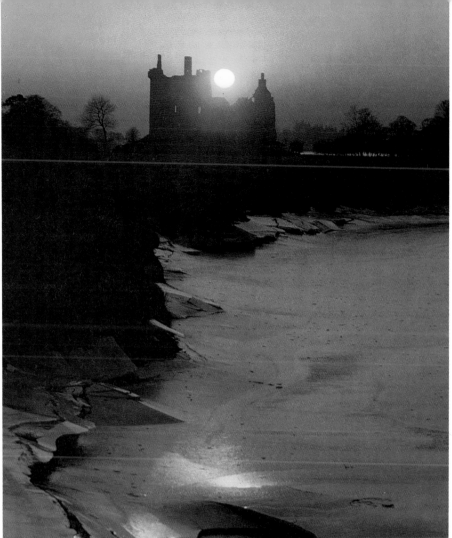

Dawn till dusk

Light changes its colour, as well as its direction, as the day passes. The change is so slow and subtle that the eye adjusts to it without noticing. Yet the light's colour at any given moment is very apparent in a picture. Colour film is balanced for a particular colour of light, so light of a different colour produces a colour bias in the picture.

An evening scene, for example, may not appear particularly warm. The only qualities that many will notice are shadow length and the amount of light. But a picture of the scene will be obviously warm in colour because the colour of the light is redder in the evening.

The colour of natural light is not necessarily the same as that of the sky. Evening portraits may be red, but shots taken at noon under a cloudless sky are not necessarily blue.

Light changes its colour according to the angle that rays from the sun pass through the atmosphere, and to how much water and dust there is in the air. The greater the angle and/or the less clear the air, the more the light is scattered and absorbed.

Some wavelengths of light are more quickly absorbed and scattered than others. Those which are not deflected from their path give the light its characteristic colour.

Colour and time

Time creates the most regular changes in the colour of natural light. A typical shift can be demonstrated by photographing the same object, usually from one angle, many times during the day.

Choose an object that is not going to move or be obscured by shadows or people during daylight hours. The best objects are white or pale grey, and fairly large. A white building, a light cream caravan or hut is a suitable subject.

Take a series of pictures at various times, preferably from just before sunrise to after sunset. It is possible to show the changes by taking a shot about every four hours. A series taken at more frequent intervals is much better. The most rapid changes in the colour of light take place at the start and end of the day. It may take only a few minutes for the setting sun to transform from a dull colour into an exciting one. Another few minutes may destroy the excitement for another day.

It is impossible to describe exactly how light will change with time for all situations, because there are so many variables. But a typical day could affect a light coloured object in these ways.

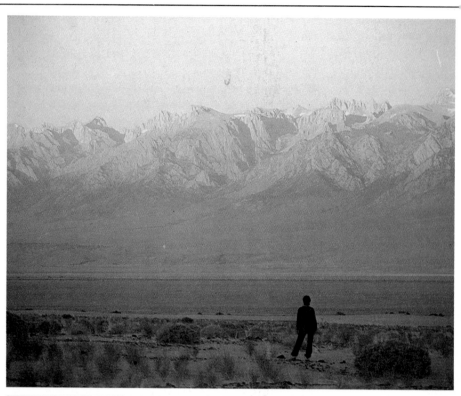

EARLY MORNING

▶ Just before sunrise, this tree appears delicate and fragile in silhouette. There is little variation in colours at this time of day. The light is cold and blue. *John Garrett*

◀ As dawn arrives, the sun brings warmth to the distant mountains. (Here the sun is rising behind the photographer.) In the valley bottom, the light is still cold and rather blue. *John Garrett*

▼ The sun rising behind these hot air balloons clearly outlines their shape. The warmth of the sun's light at the moment of sunrise adds to the interest of this picture. This light quickly changes to the neutral colour of daylight. *Rémy Poinot*

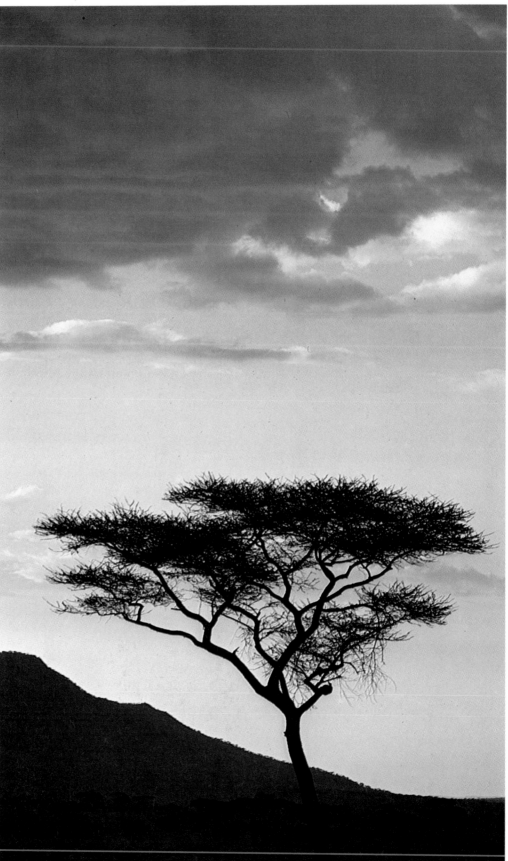

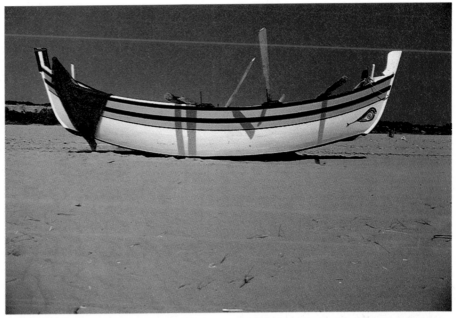

MID-DAY LIGHT

◀ In the middle of the day the light is neutral. That is, the colour balance of daylight film matches it correctly. In this typical picture, there is light from the sun, from the clear blue areas of the sky, and reflected from the white clouds. Together they produce a neutral balance where the colours of the subject reproduce fairly accurately. Distinctions between colours are quite clear, but the light gives little form or modelling. In this picture, for example, the subject has become an almost abstract pattern of shapes and colours. *Lisl Dennis*

▲ The sun was at it's height when *Raul Constancio* took this picture in Italy. The lighting shows very little of the texture in the sand. The shadow under the boat is solid black. It is only the shadows of the oars on the side of the boat which make the picture.

▼ The sun was almost directly overhead when this shot of Serengeti tribesmen was taken in Kenya by *John Garrett*. The harsh, contrasty quality of the light gives a dramatic effect in what might otherwise look a pastoral setting. The figures appear almost as silhouettes, and their shadows are dark and sharp.

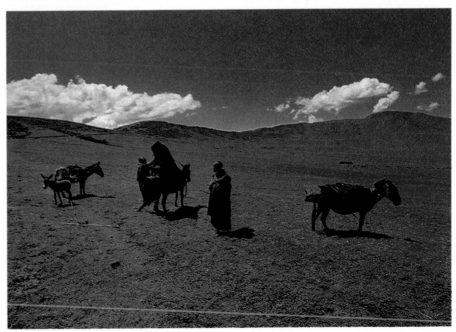

Before sunrise there will be no apparent colour anywhere. A subject may appear in silhouette against a dark grey sky as the sun begins to shine over the horizon. **Sunrise** itself will make a deep red light that could turn the subject a dark brown. After sunrise the light is often blue and cold. This can last well into the morning.

One hour after sunrise sometimes sees a yellow or golden tint to the light, but the predominant colour is still blue. The warmer tint is often most obvious in any early mist or subject highlights.

Mid morning, or a few hours after sunrise, and the white subject is beginning to look white, especially if it is lit by

direct sun. If the subject is in shadow, the predominant colour may still be blue.

By midday this blue should have disappeared. The light will be neutral in colour or, put another way, its colour temperature will match the characteristics of daylight colour film.

Early afternoon will see little change in the colour of a white subject. By this time there may be dust and moisture in the air, depending on local conditions. This may make the light slightly warmer.

Mid afternoon will see a definite shift towards red in the light.

By late afternoon or early evening, the light is a pronounced red or yellow. This warmth goes on increasing in intensity.

About sunset the light changes rapidly. As the sun goes down a white subject may well darken into silhouette again. This time, however, the silhouette will

be seen against a very deep blue sky. The changes may vary according to the weather. If, for example, the whole day is overcast, every shot may be too blue. Sometimes, also, very strange colours can appear—purple or orange, for example. These are usually short lived and associated with storms or other unusual weather conditions.

Using colour

It is possible to use filters to correct the colour of the light to match the film. A 5CC yellow or 81A filter used in the morning will make flesh tones appear warmer. Warm evening light can be corrected with a weak cyan or blue filter. But for most purposes filtration is unnecessary except within an hour or two of sunrise and sunset.

Early morning or evening light can be so strongly coloured that it is virtually impossible to correct. However, it is

▼ **In the evening light objects become silhouettes again. The purple and orange in the sky are typical of stormy conditions. The low light meant a long exposure (2 seconds) was used.** *R. Bath*

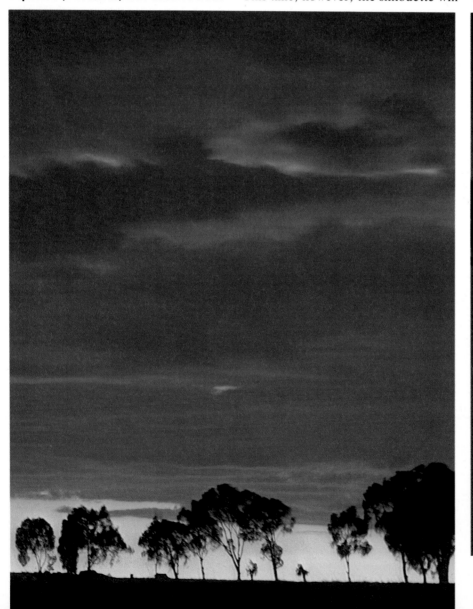

unlikely that you would want to do so. The attraction of a sunrise or sunset is the warm red colour cast, so there is no point in filtering this out.

Make use of the colours that appear early and late in the day. They often add an emotional appeal that turns something ordinary into a good picture.

SUNSET AND AFTER
▶ **As the sun sinks towards the horizon it's light becomes warmer and it hits the landscape at an acute angle. Here the sun has already set on parts of the road.** *Colin Molyneux*

▼ **After sunset, the light becomes cold and blue as darkness comes. In this shot taken in St. Moritz, Switzerland, the only warmth comes from the electric lights of the ski cabin. This gives yellowish colours with film balanced for daylight use.** *Michael Friedel*

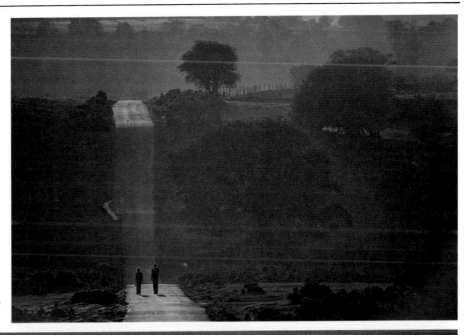

Night photography

Taking your camera out at night can be more exciting and challenging than photographing by daylight, even—perhaps especially—when you leave your flash gun at home. The night photographer uses the lights that man and nature have devised to illuminate the darkness, which are more diverse and colourful than daylight. And photography thrives on variety.

During the day our eyes see clearly and we expect the camera to reproduce what we see. At night most people's eyes not only see a bare minimum, but often see it in less brilliant colour, less detail and with less clarity. The camera, however, can see colours which we cannot see at night, and look into dark shadows which our eyes cannot penetrate. One bright light in the darkness can prevent the human eye from adjusting to darker areas. The camera has no such limitations, and this is the beauty of night pictures.

Light sources

With a minimum exposure, the camera will only reproduce light sources: street lights, for example, car headlights (still or moving), lighted windows, signs, the moon and stars, reflections on water and so on. Fires, fireworks, TV screens and decorative illuminations are also all light sources. These subjects give us pictures of the colour, shape and movement of the lights themselves rather than any scenes they illuminate. Light sources can be photographed with fairly short exposures and there is often a choice between freezing moving lights or letting them make streaks of light on the film, as happens with moving car tail-lights.

The human eye does not normally see just the light sources: as well as all the neon signs at Piccadilly Circus or Times Square, we expect also to see detail of the buildings and streets. You can set your camera's highly selective exposure to leave out all this.

Lighted subjects

When photographing lighted subjects at night, minimal changes in exposure have more effect than on light sources. With more exposure, detail in the darkest areas becomes visible, while often the detail in lighter areas remains good as well. Moonlit scenes often look as bright as day, with blue skies, good colours, shadows with soft edges, and full detail—though the object with such pictures is usually not to simulate daylight but to go halfway to producing a night effect with good detail.

▲ Backlighting makes the most of this fountain by day, but its own lights give a far better effect by night. Note how long night exposure turns drops of water into a stream. *Dan Budnik*

▼ With a hand-held meter, *Robert Glover* had already worked out an exposure for a candlelit face (1/30 at f2 on 200 ASA film) so that for this shot he was free to watch for the right moment.

Light and subject

For some pictures you will want to show both the light source and the subject which it illuminates. The closer your subject is to the light, the better the result. Normally you will have to accept that the light will be slightly too bright while the subject is rather too dark, but an exception is where you use a reflective surface—a window or a wet street—to reflect the light source. A face has a slightly shiny surface and reflects better if you photograph it with the light behind it and slightly to one side—even including the light in your picture—than with the light coming over your shoulder. Instead of a dim, full-face portrait you will have a brighter, rim-lit profile, leaving the rest of the face in semi-silhouette.

Exposures

Exposures for night photography vary considerably, and the exposure you choose will depend on the scene and the effect you want. This makes it difficult to give precise guidelines for exposures though you may find the table of rough exposures overleaf useful as an initial guide. The table takes account of one complicating factor, known as reciprocity law failure.

▶ On 50 ASA daylight film, this shot was exposed for 30 secs at f22. Longer would have shown more detail on the tower but may have spoiled the balance, making the whirling lights too bright.

Reciprocity law failure refers to the fact that, with very long exposures, halving the aperture no longer has the same effect on exposure as doubling the shutter opening time. For exposures faster than 1/10, there is no problem. For exposures between 1/10 and 1 second, you should allow half a stop extra, and for exposures between 1 and 100 seconds allow between one and two stops extra. Always bracket exposures to be certain, preferably by altering the aperture setting rather than the shutter speed.

To complicate matters further, if you are working with slide films the density contrast and colour will change with different exposures. Trial and error is your best guide: take readings from different parts of the picture, allow extra time, make plenty of different exposures and keep notes on each one so that you can learn by experience.

With slide film, to get black shadows you must expose for the highlights: with negative film—colour or black and white—you need make fewer exposures because you can vary the effect by printing darker or lighter later on. Expose to give detail everywhere and then print to make the shadow black or detailed as you wish.

Meters

Most modern hand-held meters are of the CdS or silicon type and can get a reading in a lit night scene, but few TTL meters will. Even with the better TTL meters—Canon EF or Olympus OM-2—you should ideally use a hand-held meter as well. A few good hand-held meters will actually give a reading in moonlight.

As a general rule, if you want to record clear detail, measure the brightest part of the scene and allow three f stops more exposure, or eight times the shutter opening time, This method is equally effective with a hand-held meter or with a TTL meter used close up to the subject. TTL meters which take an average reading or are weighted towards the centre of the frame—but not spot meters—are also accurate for working out the exposure for neon signs and other light sources: move close enough for the sign to occupy one-third to half the picture and use the resulting setting from wherever you shoot the picture. Even with the best possible exposures, you should expect colour to change slightly, but your results will generally be creatively acceptable. Our own eyes do not see colours correctly at night.

Subject	Type of lighting	Effect	Settings (400 ASA film)
Street scene	strong city centre lighting, sodium or mercury vapour	dark	1/125 f4
		bright	1/60 f2·8
	small town, modest lighting	dark	1/60 f2·8
		bright	1/30 f2·8
Shop window	small store	normal	1/30 f2·8
	spotlit items	normal	1/60 f4
	very bright	normal	1/125 f4
Street lights Christmas lights	mixed	lights only	1/125 f8
		lights only	1/125 f5·6
		street as well	1/60 f4
Bonfire	wood	just fire	1/125 f4
		fire and faces of onlookers	1/60 f2·8
Fireworks	mixed	light source	1/60 f4
	sparklers	to illuminate face of holder	1/30 f2·8 45cm away
Car lights (rear)		light source	1/30 f2
		streaks	10 secs f8 50 mph
Neon signs		light source	1/60 f4
Floodlit buildings	various	normal	1/30 f2·8
Moonlit landscape	full moon	normal	20 mins f5·6
	half moon	normal	2 hrs f5·6
	full moon	moonlight	4 mins f5·6
	half moon	moonlight	20 mins f5·6
The Moon	clear night	detail surface	1 sec. f4 200mm lens

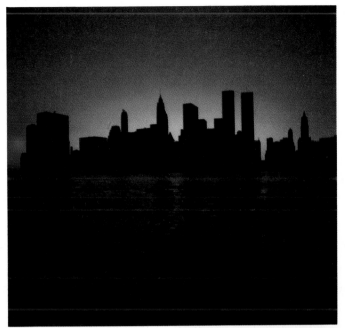

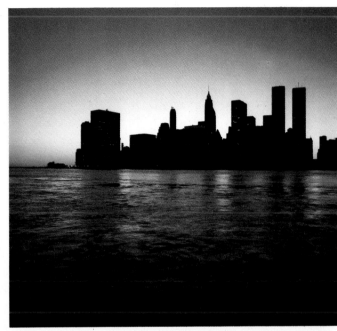

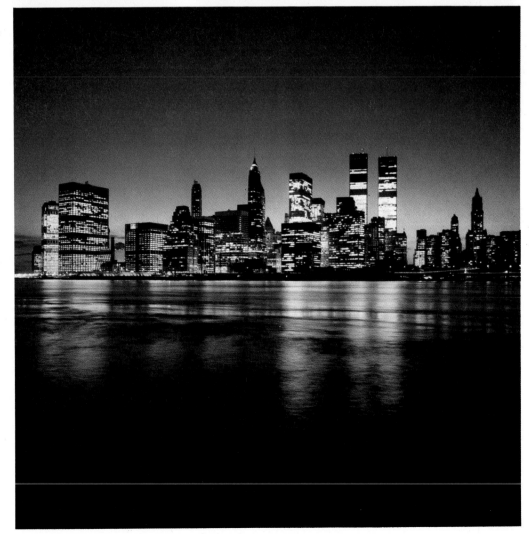

These photographs of the Lower Manhattan skyline were taken over half an hour in rapidly falling dusk light. *Clive Sawyer* kept an aperture of f4 for all of them, adjusting only his shutter speed to deal with the changing lighting conditions.

The first shot (above) was exposed at 1/30, too fast to show anything but a dim silhouette with barely any artificial lights visible.
The second (above right) was taken at 1/8, long enough for the lighted windows to begin to show, and incidentally boosting the lingering sky light.
The third shot (right) was exposed for the city lights and their bright reflections in the water: in this case the shutter was left open for 5 seconds.

◄ A powerful light source will require only a short exposure. Using a 200mm Nikkor lens to isolate this Tokyo shop sign, *Alfred Gregory* set an exposure of 1/60 at f4 with type B (tungsten balanced) 200 ASA Ektachrome. The slight flare across the picture is caused by reflections from glass in front of the sign.

Film

You will get the greatest latitude for night photography by using a fast film, preferably 400 ASA film of any type. Fast film tends to be rather grainy, but it is better to get results with grain than no results at all. If you need still shorter exposures, all types of 400 ASA film can in fact be pushed to higher speeds: 800 ASA or 1600 ASA and in rare cases to 3200 ASA. With black and white film you can do this yourself by increasing the development times. Note: all exposures on the same film will be affected. With colour film, the enthusiastic experimenter can sometimes get good results from push processing, but processing laboratories offer special services which may be more reliable, though they cost two or three times the normal processing cost. Of course if you are using a tripod and can accept a blurred subject, you can use a slower film. For most night photography the make and type of film is not important. With colour slides, however, you may prefer to avoid the warm, rather orange tones that daylight film gives with floodlit shots, shop windows and other artificial lighting. To compensate for this use a blue (D to A) filter and give an extra stop on exposure, or load your camera with a tungsten balanced film—Agfachrome 50L, for example, or Ektachrome 160 Tungsten.

Equipment

A tripod is almost essential when photographing at night: choose one that is easy to set up with gloves on (some are very awkward indeed).

Avoid small locking screws or adjustments. Never fix your camera to the tripod in the dark: fix it first in your car or indoors to avoid the risk of failing to thread it correctly without realizing it.

Keep your camera in your car or under your coat as much as possible. If it gets too cold the shutter may become sluggish, and very cold weather can make the film brittle. Avoid loading film in the dark, or changing lenses (unless they are of a good bayonet type, with

locating warts). Never take your camera indoors from cold conditions with the lens removed: contrary to popular opinion, cameras do not mist up out-of-doors, but when they re-enter a warm, moist atmosphere. If misting does occur, leave any filter in place and never remove the lens or try to clean the mirror. Misting does no harm if allowed to evaporate normally. There are some useful aids to night photography: though only available light photography is discussed here, you may find a flash gun with illuminating dials useful for emergency viewing. A small torch is valuable, and so is the illuminating dial of an LCD watch: you can also buy inexpensive ballpoint

▲ *Eric Hayman* arrived at the exposure for this shot by taking a TTL meter-reading from the sky and then under-exposing it by 1½ stops to get the motorway in silhouette. With 64 ASA film this gave him 1 sec at f11.

◄ For a correct balance between the artificial light sources and the vestige of sky light, *Dan Budnik* had to bracket exposures—particularly as he was using Kodachrome which allows no leeway for adjustment in processing.

► *Robert Estall* took this shot of Piccadilly Circus on a 17mm lens open at f8 for 10 secs. This was long enough for a car to complete a right turn leaving a trail of yellow flashes.

▼ Mixed artificial lights can give un-predictable results: here *Laurie Lewis* used tungsten balanced film which has a bluish bias but copes well with lights ranging from floodlights to lasers.

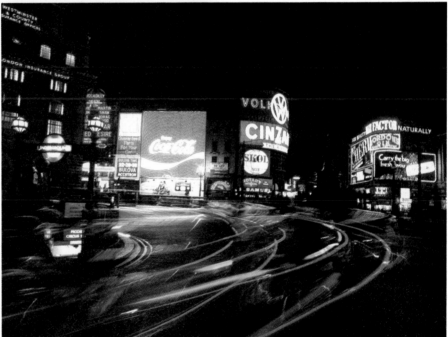

pens which incorporate a torch for writing at night.

Few other accessories are needed. A watch—preferably with a second hand—is more important than any photographic extras. Some cameras have shutters with speeds up to 30 seconds, but most only go up to 1 second, and you will often need far longer exposures. One rather useful idea for night photography is the focusing light—a small torch fixed to your camera, aimed at the centre of the viewfinder's picture so that you can use the focusing screen at night. Another useful new idea is the auto-focus camera: some will not work at night, but others, particularly those with a light beam, can cope with darkness. The subject must be fairly central.

At night the world changes: scenes which are dull by day come alive, backgrounds disappear into darkness and insignificant details, well-lit, become whole pictures in themselves. On rainy nights the streets dance with reflected colour, and lamp posts which spoil attractive old alleyways by day throw the light that makes them all the more picturesque by night. All the photographer needs is plenty of film to experiment with—to try out unusual subjects or original ideas. The table on page 200 gives a rough guide to the exposures for different lighting conditions in night photography.

City nightlights

Cities at night take on a different aspect. Something as prosaic as the head of a parking meter, shot with a wide angle lens with a wide aperture to blur the street behind, can be transformed by night lighting. Dull daytime weather can detract from the colour and texture of remarkable buildings: floodlighting can pick out the one exceptional building in a busy street from all the more mundane frontages that surround it.

A city's wealth of detail provides a picture on every street corner, and people strolling the evening streets—not expecting a photographer—rarely see the camera aimed at them. Shop windows and cafés which by day reflect the street are illuminated from within, often very skilfully to pick out magnificent displays. Occasionally a passerby may pause long enough to give a sharp silhouette against the lighted window. Or you might catch a preoccupied expression on a face lit by window lighting: photograph it in the same way as you would a face lit by sunshine coming through a window into a dark room.

Street lights, except where they cast an overall orange glare, are like small suns—but suns which it is safe to include in your composition. No street light is too bright to be photographed: together, a row of street lights can illuminate a street scene quite adequately. A cross screen or starburst filter can turn commonplace lamps into sparkling points of brilliance, creating a pattern of light to overlay the main subject of the picture.

Light and motion

Besides street lights there are signs, displays, signals and car lights, some changing, some moving. With your camera mounted on a tripod, any mov-

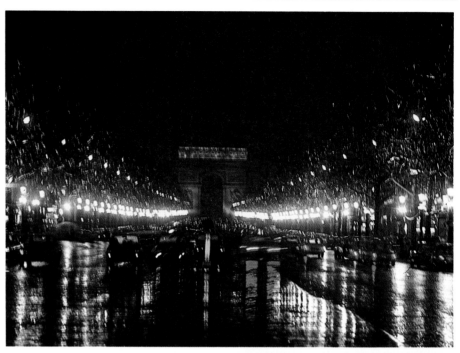

▲ Sacrificing film speed for quality, *Alfred Gregory* used a 25 ASA tungsten balanced film for this shot. Wet roads helped to boost the street lights and, choosing a moment when the traffic was still, he propped his camera on a bollard and exposed for 5 secs at f2·5.

ing light is recorded as a streak of brilliance: if it halts, the brilliance increases on the film; if it speeds up, the effect is dimmer. Cars streaming under a bridge are fascinating to photograph. Concentrate on the tail lights which have a more interesting colour than the modern tungsten headlights, which may also be too bright to balance the rest. Flashing indicators leave an intermittent trail of dashes across the frame, and stop lights temporarily thicken and brighten the light trail as the cars brake.

From your own car, so long as you are not doing the driving, you can open your lens to about f8 (with a 400 ASA film) and point it through the windscreen at the traffic approaching you. The result will be a spectacular burst of lights diverging past the camera. Or try travelling up an escalator holding the camera still with the shutter open so that the escalator steps are sharp and the surrounding scene blurs with movement. People crossing a square at dusk turn into ghosts if you use a long exposure: with a very long exposure, moving figures will not even appear unless they pause for a significant length of time in one place.

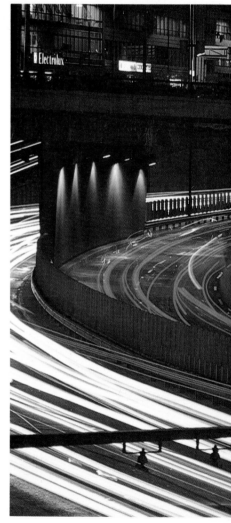

▲ To show both the detail and the dazzle of these street decorations, *Giles Sholl* experimented with double exposure. Overriding the automatic TTL meter on his Canon A1, he compensated for twice the amount of light reaching the film by stopping down half a stop. For the first exposure he focused at 15 metres to get the lights sharp: for the second he focused at 3 metres to superimpose a blurred image of them.

▶ One way to draw patterns with lights is to move them in a zoom lens, taking care to align the centre of the image with the centre of the frame. At f16, *Giles Sholl* exposed for 1½ secs, at the same time zooming from 80 to 200mm.

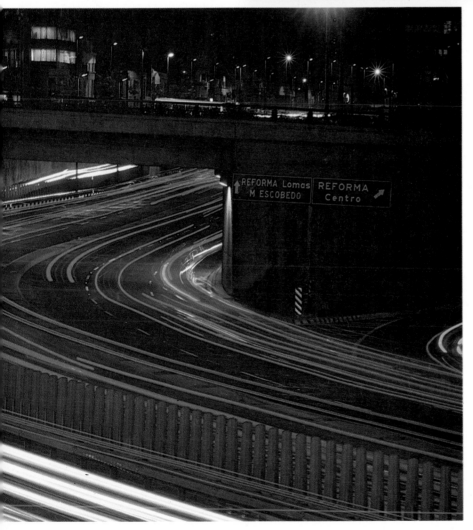

◀ Photographing at twilight on Kodachrome 64 (daylight) film, *Tom Ang* took about a dozen shots for four successful results. This shot was taken at f16 with an exposure of 8 secs, with his camera and 135mm lens supported on the parapet of a bridge.

Lighting displays

Festive decorations strung across the streets are best photographed at dusk when shop lights are on and the street lights just beginning to warm up. The decorations can then be picked out against a deep blue sky. Many of the best night shots of every type are taken between sunset and true darkness, when a vestige of natural light remains to offset the man-made brilliance. Ornate decorations often start to swing at the slightest breeze, so use the shortest possible shutter speed.

If you intend to project your pictures and are able to make dissolve shows, in which each slide fades into the next, try photographing animated lights, where the patterns change. The exposures you take of the different effects can be run in series to reconstruct the actual event, with lights winking on and off in the same continuous sequence.

Funfairs

Seaside resorts and fairgrounds are made for night photography, with thousands of lights, and many bright images. There is enough light cast by the coloured lights around a fairground stall for hand-held shots if you

use a 400 ASA film. Moving carousels will record beautifully on film: always try to keep the camera shutter open long enough for the lights to pass all the way across your field of view—one half-turn for a roundabout. A spotlit performer will give you some real action shots. Following the spot, you can use speeds of 1/125 to 1/250 with a fast lens and 400 ASA film.

Lights on water
Reflected in water, night scenes take on a double impact. Rivers or lakes usually have moving surfaces, and by night these become fluid expanses of blended reflection. Reflected lights are multiplied infinitely by choppy water, or drawn into long strands of colour. Even wet pavements double the amount of light and put detail into places which would otherwise be dark.

Wet cobblestones, particularly, make superb images, as do wet roof tiles on old buildings.

Supplying your own light
In the country, night photography is more difficult: you will generally have to bring your own light to your subject. Car headlights are a reasonable light source, but remember always to use tungsten balanced colour film. Flash will also give some light outdoors, but it is rather weak because most flash guns are designed to work indoors where the light is reflected from walls and ceilings. If you use flash outdoors, allow an extra stop on the recommended settings, or use computer flash which will automatically take care of your exposures. The furthest distance limit of your own flash will not be as great outdoors as the flashgun's scale

indicates: halve the distance for safety. At dusk use a combination of flash and natural daylight. Electronic flash, particularly, has a very short duration and will give a hardcore of sharpness even if there is some camera shake.

Special effects
Night photography is ideal for trying out trick ideas. If the background of your shot is completely dark, you can

▼ Some of the best 'night' pictures are taken at dusk while there is still some light and colour left in the sky but when it is dark enough to show pinpoints of artificial light. *Ray Tannen* took this picture on a spring evening with a 35mm Nikkor lens on Kodachrome 64, exposing for the sky at 1/125 and f4 to get the figures on the merry-go-round in silhouette.

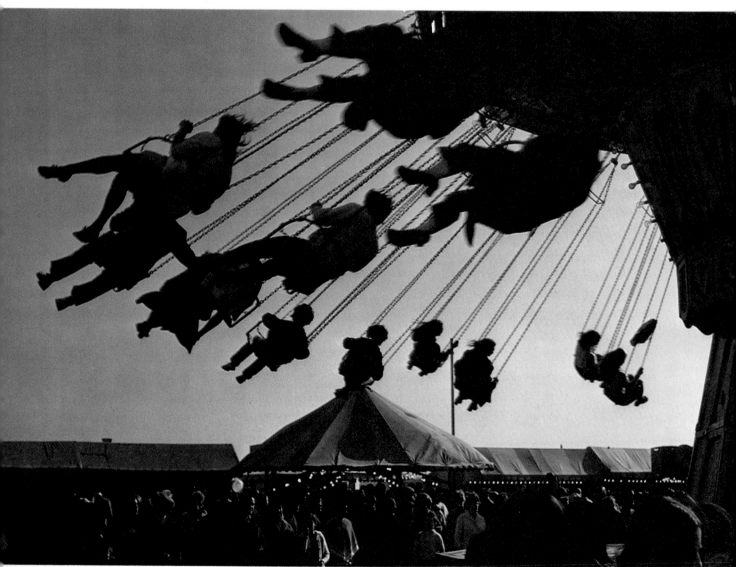

use flash and multiple exposures on the same frame to include a person's portrait several times in the same picture. Don't worry if the images overlap. You can record movement in a series of images in the same frame if you have multi-flash or motor-drive flash. It is worth working out your pictures beforehand: though you may not get the effect you intended, your results will be interesting at the very least.

▼ This picture of Disneyland's fairy castle makes a virtue of the normally problematical contrast between white mercury vapour floodlighting and the tungsten light of the castle's lanterns. Using a Nikon F2 and a standard lens, *Pete Mackertich* set a remarkable hand-held shutter speed of 1/8 — not to be recommended but possible because of the camera's gentle shutter release.

For both these pictures *Tino Tedaldi* used a Vivitar flash unit fitted with an 85B (orange) filter.
◀ On daylight film the figure has an orange cast against a normal night sky.
▲ On tungsten balanced film the orange cast vanishes, but the sky is a deeper blue. *Tedaldi* exaggerated the effect by setting the shutter at 1/15 — four times the normal exposure for flash.

To 'write with light' you need a box of sparklers and plenty of film. With his camera on a tripod *Clive Sawyer* focused on his helper from far enough away to include the whole word. He set his shutter on B at f5·6 with 64 ASA film. He opened the shutter as she began to write—normally, and the shot was later reversed—closing it when she finished.
▲ By setting up a flashgun at the right distance for your aperture, you can catch the helper in the act at the moment the flash is fired.
▶ For a picture of the word alone make sure there is no other stray light.

Fireworks and bonfires

Fireworks, either at big displays or around the family bonfire at Hallowe'en and Guy Fawkes' night, are ideal photographic material. You can show both their spectacular colours and their movement: a roman candle, for example, projects a coloured ball, but to the camera it draws a coloured line across the sky. A standard lens (f2·8, f2, or, best of all, f1·4) is most suitable for photographing fireworks. With a wide angle lens you would need to get dangerously close to the fireworks, and telephoto lenses have limited f stops. If you use 400 ASA film, you will be able to take most of your shots without a tripod.

For photographing bonfires, use the exposure recommended by your TTL meter if the bonfire occupies about half the picture: if it fills most of the viewfinder—with, say, just one figure silhouetted against it—give an extra stop. If the fire is only about one quarter of your image, give one stop less exposure.

Only the brightest fireworks are difficult to handle, tending to burn out the film with a brilliant magnesium flare, giving glaring white highlights with little detail. On the other hand, if the fireworks throw too little light to give a reading on an automatic camera you can 'push' your film by two or four times—set 400 ASA to 800 or 1600—and get results from the camera's normal readings.

Night portraits

If you want to include people in your bonfire night pictures, try to catch them in semi-profile against the fire or the light from the fireworks. A narrow rim of light will pick out the face to give a recognizable result. Full-face portraits are seldom successful because any light is very directional and will leave part of the face in shadow. By far the easiest way to photograph people at a bonfire party is to pick them out in solid black silhouette against a bright fire.

The only type of firework which can be used to illuminate faces is the sparkler. Sparklers have a fairly constant light output—they do not flare up or die down—and they are quite safe to hold. Held 45cm away from a face, a spark-ler will give enough light for a hand-held shot with most cameras. By stopping down a couple of stops—to f4 or f2·8—the image from the sparkler it-self can be used to draw pictures on the film. Get someone to hold the sparkler and move it in a steady action, drawing shapes or even letters on the film (but backwards in a mirror image of the desired effect). The resulting picture shows line traces with sparks flying off all round them.

Your pictures of people at night may well show some very unusual effects. Fires and fireworks cast flickering red highlights over their faces, and lights from odd angles throw peculiar shadows. A face lit from beneath will have upward shadows, giving the well-known 'horror' effect.

◀ With fast black and white film you avoid the problems of colour distortion. *John Garrett* used HP5 pushed to 800 ASA, shooting at f1·4 and 1/30 by the light of a bonfire and skyrockets.

▶ In reality, this picture never existed. It required a long exposure to pick up consecutive bursts of fireworks (the lights in the foreground show how far the boats have moved) with the lens covered over between each burst.

MOVEMENT AND MULTIPLE EXPOSURES

Movement has preoccupied photographers since the earliest pictures were taken. The first photographs were still lifes and landscapes, and showed no moving objects, because it took several hours to make the exposure. As materials were improved, it became practical to photograph people, first standing still, and then in motion.

Still photography at its best can capture in a single image the whole essence of an action. To make an effective picture, movement doesn't have to be frozen with a short exposure, it can be spread across the frame in an elegant sweep of colour, or it can appear in a sequence of individual images, each one slightly different. In this last chapter, we look at a number of ways of using movement to produce interesting pictures, both movement of the camera, and of the subject.

However, besides these vibrant and exciting representations of motion, a moving image can also be used as an expressive medium in its own right. This chapter shows how a moving light source can form abstract patterns that owe nothing to reality, and explores the many ways that multiple exposures can be used: to suggest movement in the subject, certainly, but also to show two aspects of the same subject simultaneously, or to add the moon and stars to pictures taken on an overcast night.

Expressing movement

Of all the pictorial arts photography has the advantage when it comes to capturing and recording movement. A moving subject, or even a moving camera, can be used to convey the impression of speed. Alternatively, the action can be frozen on film. Other techniques can make crowds disappear or even reveal what the unaided eye would not see.

The effect or feeling of movement in a photograph is dictated by the degree of sharpness or blur and is controlled by the choice of shutter speeds. In addition, there are techniques like panning and zooming that provide other ways of expressing movement with the camera.

The use of fast shutter speeds or electronic flash will result in pin-sharp, frozen images (specially designed shutters have captured atomic explosions, and the use of a flash can

appear to halt the beat of an insect's wing), and this will be dealt with in a later section. But it is not necessary to freeze all movement, particularly if you want to suggest speed.

Blur—friend or foe?

Blur is a streaked image caused by the subject moving an appreciable distance while the shutter is open. This can suggest movement and may add to the atmosphere in a photograph but it may also be a nuisance if it has not been planned.

Shutter speeds of 1/500 or 1/1000 will freeze the movement of most everyday events, but the appearance of blur is strongly connected with a subject's movement relative to a steady camera. A cyclist, for example, riding directly across the angle of view may photograph blurred at 1/250. However, a cyclist riding at the same speed towards

the camera may be acceptably sharp even at 1/30. For a given shutter speed, a moving subject appears less blurred the more it approaches 90° to the camera. Distance also affects blur: a subject will cross a camera's field of view more quickly, and therefore be more blurred on the film, the closer it is to the camera.

Panning

Panning, or swinging the camera steadily to follow a passing subject, can keep a moving image in one place on the film. Of course, everything that is not moving as the subject does—like the foreground or the cyclist's wheels —will have a shifting image on the film. The result is a relatively sharp subject and blur everywhere else on the photograph.

When panning, it is important to remember to follow the subject

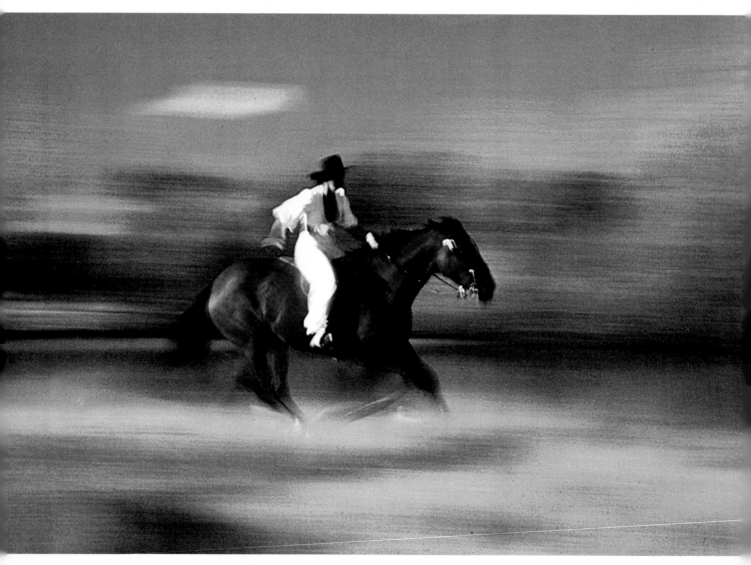

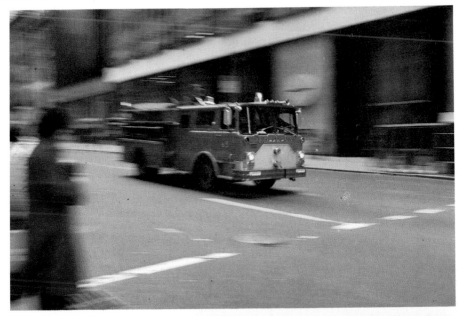

through after you have released the shutter. Failure to do so may halt the camera's swing while the shutter is open and blur the subject too. Another common fault is to pan too fast for your subject. This results in the image appearing to go backwards and, to avoid this, care should be taken to keep the subject in the centre of the viewfinder throughout the pan.

A useful aid

Both SLR and 6 x 6 TLR cameras have disadvantages when used to pan. The 6 x 6 viewfinder image is reversed left to right and moves confusingly in the opposite direction to the pan. The SLR mirror blacks out the subject as the shutter opens.

If you find panning difficult with a reflex camera, a frame or sports viewfinder (a wire rectangle and a viewing frame) can replace the camera view-

These pictures, all taken at similar shutter speeds (about 1/30), show how the degree of blur is effected by the angle at which a moving subject crosses in front of the camera.

◀ Panning with a subject travelling straight across the lens creates a blurred background enhancing the feeling of speed. The horse's legs and the rider's arms were moving faster than the rest of the subject and therefore appear more blurred. *M P L Fogden*

▲ Although actually moving faster than the horse, this fire engine, crossing at 45° to the lens, appears to be slower. The background is clearer and the impression of speed greatly reduced. *Norman Tomalin*

▶ Head-on to the lens, this go-kart could almost be stationary. It is only the driver's expression and the low viewpoint which convey any sense of movement. *Robert Estall*

finder. Sports viewfinders are available for most 6 x 6 cameras and a simple one for an SLR camera can be made out of two pieces of card. A strip of card is folded into a rectangle with a negative-shaped hole; this is positioned in front of another piece of card punched with a viewing hole. Tape the viewfinder to the top of the camera, and experiment to get sizes and angles right. A simple accessory like this makes life simpler for anyone who wants to take panning shots with an SLR, but it will not be as optically accurate as the camera's viewing system. (One camera designed specifically to pan is that used for photo-finishes. In this the film, rather than the camera, follows the subject, which is why the pictures appear distorted).

Experimenting with blur

A busy zebra crossing is a good subject for experimenting with blur. People are walking briskly, the background stripes make movement apparent and cars offer stationary points of reference. Shoot a series of pictures using the camera's fastest speed down to its slowest (include exposures of 1, 2 and 3 seconds). Use slow film. This may make it impossible to use the fastest speeds, but will mean that you can use the slowest. The results should show blur increasing as shutter speeds become slower. (Remember to compensate exposure by stopping down the lens as you change the shutter speed.)

Tungsten balanced 160 ASA Kodak Ektachrome film with an exposure at 1/4 at f5·6 was used by *Clive Sawyer* to capture the movement of these balls on a snooker table. Because these pictures were taken in close-up, the direction of movement in relation to the camera makes little difference to the amount of blur recorded, and in this case the balls which moved first appear most blurred.

▲ Careful choice of viewpoint, as well as blur, has contributed to the effect of motion in this picture. Notice also how the highlights on the red balls add to the effect of the blur.

▶ The colour of the red balls is desaturated. Slight under-exposure helps this weakening of colours which often happens when photographing moving subjects.

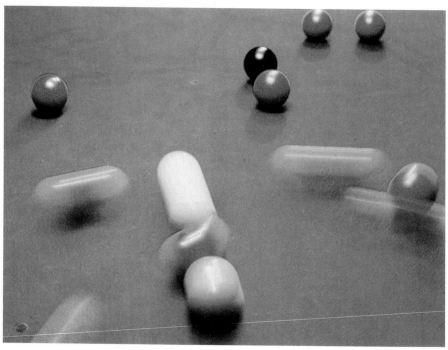

Taken with slow film (Kodachrome 25), this sequence of pictures illustrates the effect of different shutter speeds on recording a moving subject. At 1/60 (left) only the fastest-moving parts of the people (hands and feet) are blurred. At 1/15 (below left) the whole subject is blurred, but still recognizable, and the fastest-moving areas have now disappeared, making these girls seem one-legged. At 1/4 (below right) only the vaguest impression of the people remains, producing a ghostly effect. At 1 second (bottom) they have almost totally disappeared, only feet staying still long enough to register on the film. Remember that during a long time-exposure the lens must be stopped down to avoid over-exposure.
Homer Sykes

Pedestrians, sharp in photographs taken at higher speeds, become more and more indistinct. Sometimes only a foot may remain still long enough to be recorded, while its owner, moving too fast for the shutter and film, has almost disappeared. Very long exposures will make the pedestrians disappear altogether. This technique can be used to remove crowds and traffic from whole streets, landscapes or interiors. However, cover the lens while any bright light, such as a car's headlamps, passes at night otherwise there will be strange lines crossing the photograph. Also, cover the lens if you think something is going to remain still long enough to register on the film. During long exposures in daylight you may also need to use neutral density filters. These restrict the light and prevent over-exposure.

Panning and long exposures

Perhaps the strongest impression of movement is obtained by combining

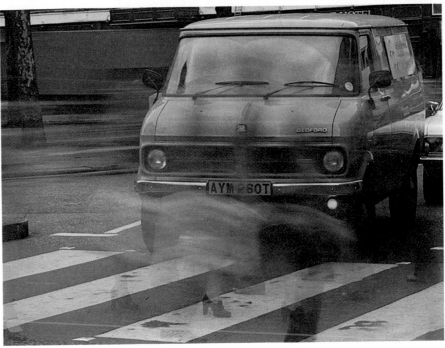

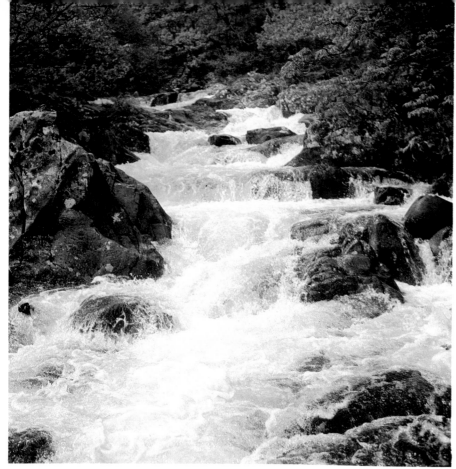

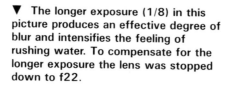

▲ To capture fast-moving water this sharply you will need a fast film, a fast shutter speed and a wide aperture. This was taken on Ektachrome X film with an exposure of 1/500 at f2·8.
Eric Crichton

▼ The longer exposure (1/8) in this picture produces an effective degree of blur and intensifies the feeling of rushing water. To compensate for the longer exposure the lens was stopped down to f22.

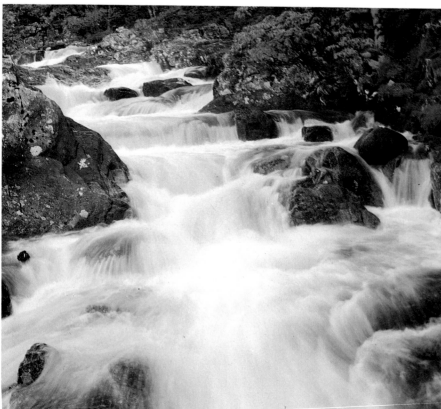

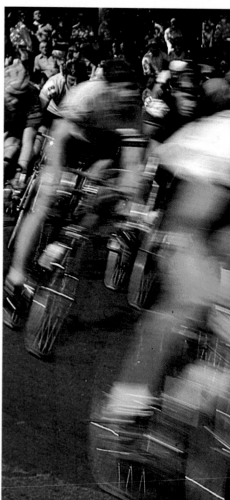

◄ To achieve this degree of blur an exposure of 2 or 3 seconds would be needed, in conjunction with either a neutral density or polarizing filter to avoid over-exposure. However, the sense of speed in this water has been destroyed and a shorter exposure would have been more effective.

► *Gerry Cranham* used a combination of a long lens (200mm) and panning to convey the speed of this motorbike. He used a slow film (25 ASA) and a shutter speed of 1/125 at f8 to maintain the sharpness of the image.

▼ A sharp background contrasting with a blurred subject creates an impressive picture of movement. When the subject has plenty of highlights, as with these cyclists, the blurred image is more effective because of the pattern created. *David Overcash*

both panning and long exposure. This technique is most suitable for fast-moving subjects and more effective in colour than black and white, as the entire image will be blurred and colour helps to· distinguish the shapes. It is also important to have your subject in focus to ensure that the effect looks deliberate and not like a badly taken photograph. This is of course true for each of the movement techniques.

Abstracts

Moving lights and long exposures used together will make abstract patterns. A time exposure on black and white film of, say, a Ferris wheel at night is likely to record as a repetitive tangle of lines. The effect in colour will be very different, especially if background lights appear. The rhythmical tangle will remain, but colours will be laid over other colours to achieve further lines.

Abstract effects also occur (especially in colour) when both camera and subject move. For example, camera shake may be added (accidentally or by design) to a pan. Mood, atmosphere and appearance will vary according to whether the film used is black and white or colour, the shutter speed and amount of movement. Usually, the photographer has little or no say over subject movement, and sometimes has to accept camera movement. For example, when jostled by a crowd or when working from a moving vehicle.

Using movement

As the previous section on photographing movement showed, composition, shutter and film speeds and camera angle all combine to produce a controlled degree of blur in a photograph. Blur is certainly an effective device for recording movement but it is by no means the only one available to the resourceful photographer when an action shot is required.

Stopping subject movement

Freezing the subject in mid-movement will often produce a dramatic picture, and the resulting image will be sharp: an advantage if you want an accurate record of the event.

Though fast shutter speeds are normally used to freeze movement, fast-moving subjects do not necessarily need especially fast shutter speeds to halt them. Most movement is rhythmical, with points of stillness or reduced speed: cars slow at bends, a child on a swing reaches its highest point and stops, then accelerates downwards, a football boot halts as the kick's power is transferred to the ball. Timing and anticipation can capture these movements, often with a relatively slow shutter speed.

Flash will also stop movement. The discharge from an electronic flash gun may last just 1/5000 second (maybe less with an automatic gun), much faster than most shutters, and only that instant will register on the film. There is a danger, however, that when slow shutter speeds are used in daylight with a flash a blurred second image, recorded by the sunlight, will also register.

Imagine, for example, a child playing football on a dull day. The flash will give a correct exposure at, say, f8; a daylight reading shows 1/30 at f8. Experimentation suggests that the child will appear blurred at speeds of 1/30 or longer. Shooting with flash at 1/30 and f8 will give a double image: one frozen by the flash and the other a blurred image recorded by daylight and a slow shutter speed. (This will not occur with leaf shutters which synchronize with flash at all speed settings, but most focal plane shutters will only synchronize at speeds of 1/60 or less.)

This apparent problem can be turned into an advantage, so that the double image becomes an effective way in which to express movement. However, work like this is best carried out against a black or very dark background, as a light background will usually prove stronger than the second image.

◄ Split-second timing has caught this bike at the height of its leap. Here *Duncan Laycock* used 64 ASA film with an exposure of 1/150 at f5·6 to stop the movement, and a 200mm lens to give the shallow depth of field. He pre-focused on the track before the rider arrived as there was no time for this later when taking the shot.

► A natural pause in the dance, rather than a very fast shutter speed, has stopped the movement of this dancer. Careful framing and timing are most important for shots like this and the exposure should be pre-set.

▼ For this picture *Michael Busselle* used a shutter speed of 1/1000 and Ektachrome 200. To retain the sharpness throughout the picture the lens was stopped down to f22. In poorer light, depth of field would have been sacrificed in order to keep the fast shutter speed.

► Freezing all but the fastest movement, flash is especially useful for natural history pictures like this owl by *Hans Reinhard*. Electronic flash can be as brief as 1/5000 second, depending on the gun, so an especially fast shutter speed is not needed.

Double exposure

A double image can also be obtained with a greater degree of control, by taking double exposures. This can be done using daylight only or with tungsten/quartz iodine studio lights, but to ensure that the first and second images are in register you will normally have to mount your camera on a tripod.

To experiment with this technique, first photograph your subject—a ping pong ball, for example—as you would for a normal exposure. Then, without winding on your film and this time using a slower speed and wider aperture, fire the shutter again as the ball is moved, perhaps blown gently away. The same method is used when panning or moving the camera during double exposure.

It must be remembered that for double exposures you need a camera which can release the automatic wind-on mechanism that normally limits each frame to a single exposure.

Writing with light

The word photography means to write with light, and it is possible to make this translation from the Greek literal. Ask someone to write his name (or any other word) in the dark, fairly slowly with a pen torch or sparkler. Have your camera mounted on a tripod and set for the correct subject distance. Open the shutter just before the person starts writing (see page 208).

When the word is finished fire a flash gun to close the shutter. Set the aperture according to the gun's flash factor, and if you are photographing a sparkler wait until it is lit before opening the shutter.

Alternatively, you can draw outlines with light. Draw your pen light round an object, perhaps a chair, in the dark. Keep the torch facing towards the camera, and move it at a constant speed, then remove the object before firing the flash and closing the shutter. Separate exposures can be made for the writing or drawing and for the flash.

Regular patterns can be drawn by a pen torch suspended as a complex pendulum, of three or more cords, over a camera. Focus between the top and bottom of the torch's swing. Swing the lighted torch in the dark and open the shutter for a few seconds (try about f5·6 for a 400 ASA film). The result will be regular rhythms of lines, forming a complex symmetrical pattern. For coloured patterns you can place coloured filters over the camera lens.

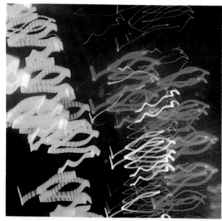

◄ This abstract pattern of lights has been created by camera movement during a 1 second exposure. The stripes in the light are caused by the alternating current of mains electricty. *Colin Barker*

▼ The double exposure of this runner was taken by *John Garrett* with Ektachrome X film. The subject was lit with tungsten light for the first blurred image, during an exposure of 1 second, at the end of which the flash was fired, independently of the camera, to give the sharp image.

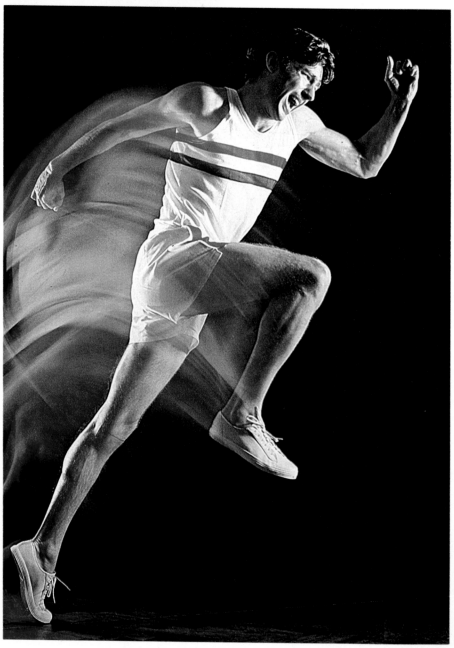

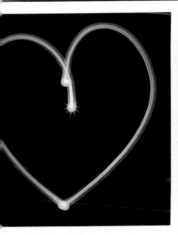

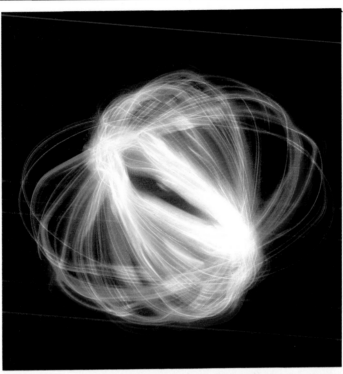

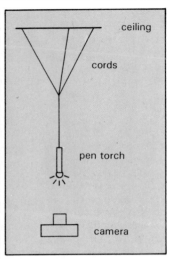

Car lights (below) are a traditional subject for long exposures with subject movement. More unusual is drawing with a pen torch (above) or using a physiograph (right) with coloured filters placed over the camera's lens.

▲ The arrangement of a physiograph. Focus the lens, switch on the torch, swing the cord and begin the exposure. Switch off the torch before changing the coloured filter.

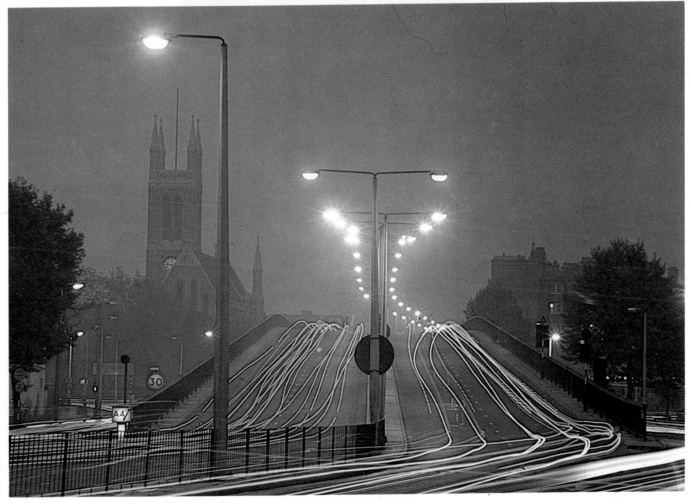

Zooming

How to use the zoom lens

The modern zoom lens offers more creative scope for blur effects to the ambitious photographer than any other lens currently available. Almost any subject matter is suitable for zooming, but in order to avoid the photographic cliché the special effects of the zoom lens are best used to illustrate compositions that would normally appear dull or uninteresting. By introducing the characteristic 'streaking' a visual excitement and feeling of motion is communicated. This works particularly well in sports photography, though many a static or pedestrian subject has been dramatically transformed into an exciting image by using the technique.

Recommended zoom lenses

The medium telephoto zooms of 80–200mm are the ideal focal lengths to use. The majority of zooms in this range are light and have a combination focus/focal length collar which make them very easy to operate for special effects. The longer zooms are bulkier and were originally designed for the sports and wildlife photographer, whilst the shorter zooms in the 35–85mm category are somewhat limited in focal length.

Exposure

Exposures are calculated in the usual manner and films in the medium speed range of 64 ASA are ideal to facilitate the slow shutter speeds at which you will be working. Some under-exposure is recommended to enhance the density of streak and is particularly effective when working in colour.

Zooming technique

The characteristic 'streak' of the successful zoom shot is achieved by changing the focal length of the lens whilst the shutter is open. In order to do this the lens and body are best mounted on a tripod (or monopod if you are working in a confined position). The most important points to remember are *slow* shutter speeds (1/30 second should be the fastest and 1/15 or 1/8 second is the generally accepted norm) and a *smooth* continuous hand movement in sliding (or twisting if your zoom has two separate collars) the focal length collar up and down the range. These are the two factors that determine the degree of streak imparted to the film.
Focusing is not critical in zooming as you are trying to communicate an impression. But some focal point must be maintained, otherwise the image will dissolve into an unrecognisable blur.
The two basic methods of zooming are *up* the focal length (that is to say, going from 80mm to 200mm) or *down* the range (200–80mm). Each produces a different effect and you will need to experiment to determine which is visually most acceptable for your particular subject. The generally accepted method is to zoom down the focal range.This has two distinct advantages in that the image in the viewfinder will be large initially, thereby aiding focusing, and you will avoid the occasional ghosting effect of double exposure that zooming up the focal range imparts. It is important to expose several pictures of your chosen subject at different zooming rates, as exact results are difficult to predict.

Advanced zooming techniques

One of the most pleasing zoom effects is achieved by applying a small degree of streak. This technique retains most of the primary image but 'paints' small brush marks at the edge of the picture. It is executed by either pre- or follow-focusing on a particular spot and then sliding the collar fractionally. Another method of achieving the same result is to double expose your subject. One exposure would be shot 'straight' and the second exposure zoomed slightly. Multiple exposure zooming can also work using different focal lengths in the range; however, this technique can only be applied to still-life subjects.
Finally, when you feel that you have mastered the basics of zooming try taking the assembly off the tripod and pan and zoom at the same time, as was done for the picture below.

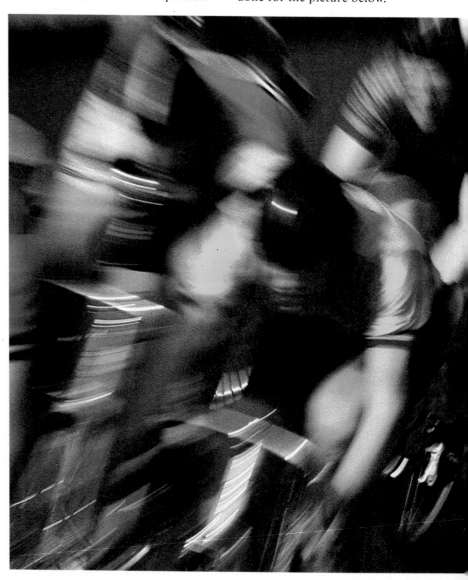

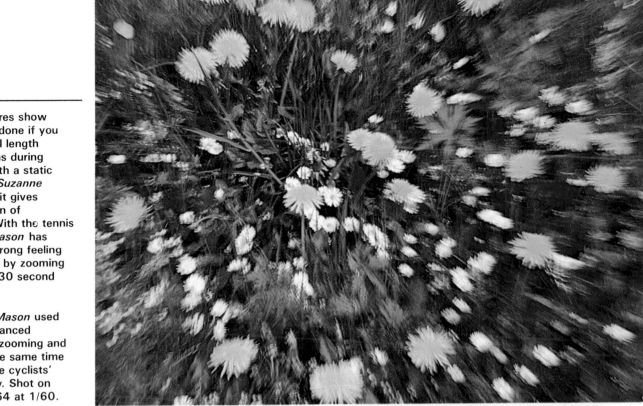

▶ Both pictures show what can be done if you alter the focal length of a zoom lens during exposure. With a static subject, like *Suzanne Hill's* flower, it gives the impression of movement. With the tennis player, *Leo Mason* has achieved a strong feeling of movement by zooming during the 1/30 second exposure.

▼ Here *Leo Mason* used the more advanced technique of zooming and panning at the same time to express the cyclists' frantic energy. Shot on Ektachrome 64 at 1/60.

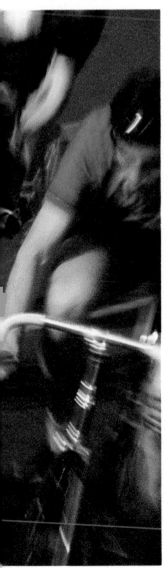

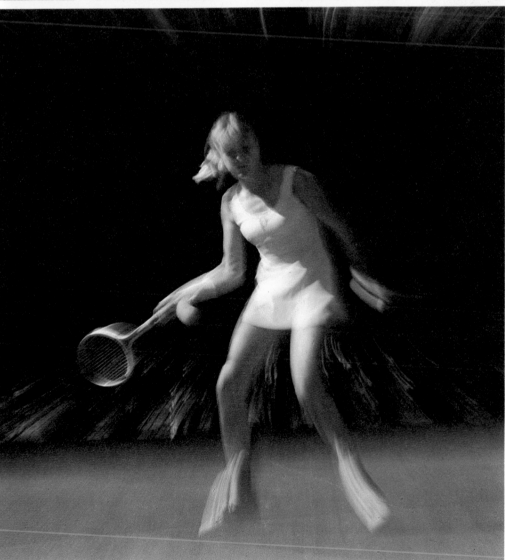

Techniques in movement

The pictures on these pages illustrate the different ways of photographing movement that have been described in this chapter. Looking at pictures like these, and knowing why and how they succeed, is one step towards mastering these techniques—another is to go out and try them. Mastering the various blurring, panning and zooming techniques is part of the answer. The rest of the story behind these successful pictures is deciding exactly when to take the picture, choosing the right camera position and having the right lens on the camera. Obviously in sports pictures knowledge of a particular sport is helpful when it comes to judging the right moment to take the shot, but generally patience and careful observation are essential. Here some photographers find an autowinder is useful as it leaves you free to concentrate on the moving subject. It is all too common for an intentionally blurred picture, that has not quite worked, to be mistaken for one of those basic errors—camera shake or a simple out of focus image.

With photographs of a still subject you can be fairly sure that your photograph will resemble what you saw when you took the picture. You can plan ahead and will probably need to take only one shot. But with a moving subject, the camera records the subject in an entirely different way from the human eye. When watching movement you do not see blur, nor do you see frozen action. You cannot, therefore, rely on your eyes to tell you what the result of your photograph will be. Because of this always be prepared to take a series

of shots, experimenting with shutter speeds and various apertures. Each of the slower shutter speeds below 1/30 will record movement in a slightly different way—and the more you experiment the greater the chance of an interesting picture.

Preventing over-exposure

Because long exposures are often used when photographing movement, there is the danger that your pictures will be over-exposed. So bear in mind the following points.

● Slow film, on which the light registers less readily, allows a longer exposure time and is therefore more useful for recording blur than fast film.

● A small aperture lets in the least light, so, to allow long exposures, you will need a lens which stops down to at least f16.

● Grey, or neutral density, filters will reduce the amount of light entering the lens, effectively downrating the film (making it slower). The denser the filter the longer exposure time you can get, so carry one or two with you.

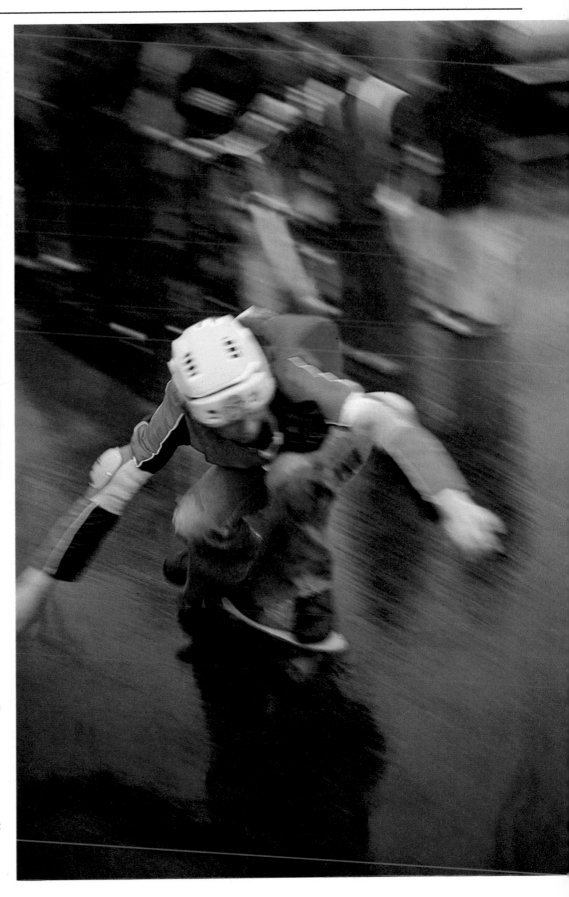

▲ The swiftness of this bird skimming past the trees has been beautifully conveyed by *Ernst Haas*. Because of the lack of colour, the picture depends very much on the patterned background, created by panning across the leaves, for its success.

◄ This trick picture is a self-portrait (!) of *Ed Buziak*. He used a 20mm lens at f3·5 and made his head vanish by moving it up and down unceasingly during the 10-second exposure.

▶ Almost nothing is sharp in this picture of a skate-boarder by *Robert Ashby*. The technique would have been a disaster for a still life or a landscape but expresses the movement of this subject perfectly. The film used was Kodachrome 25 and the subject was panned during an exposure of 1/8 at f16.

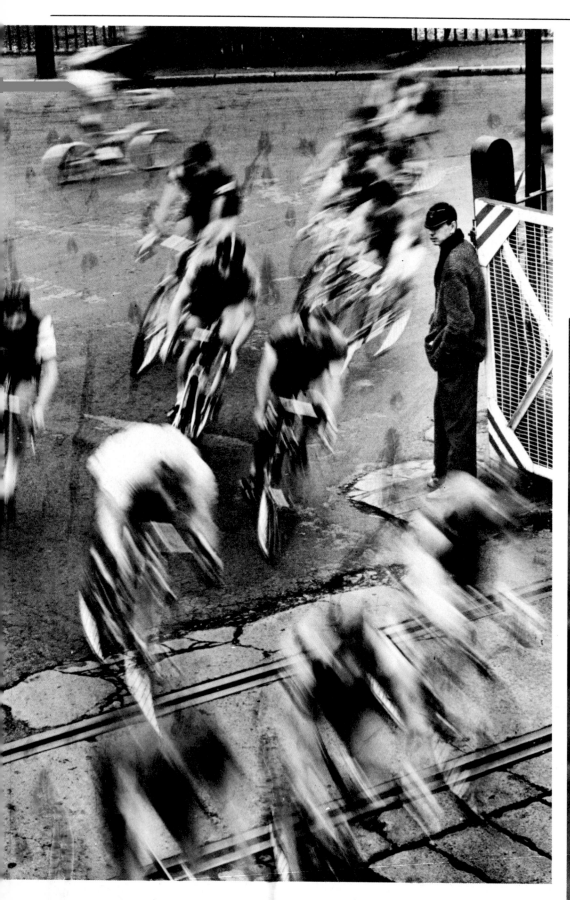

The still figure of the spectator is an important feature of this picture by *Ron Chapman.* His casual slouch is in direct contrast to the purposefulness of the cyclists whizzing past, and without him some of the momentum of the picture would have been lost. Place your hand over the figure and notice the change in the speed at which the bikes appear to be travelling. The slow shutter speed (about 1/15) and the high viewpoint have controlled the amount of blur. The camera was pre-focused on the road so the photographer was free to concentrate on the timing.

◀ An exceptionally fast shutter speed would be needed to freeze the beat of this humming bird's wings, and even if it were managed the impact of the movement would be lost. This picture uses blur to give an idea of just how much effort is going into keeping this tiny bird hovering in front of the flower while it feeds. *Charlie Ott*

▼ To get perfect framing for a shot like this you would have to take anything up to 20 exposures. For this degree of blur experiment with a shutter speed of around 1/60. *Tony Duffy*

Unless your camera is mounted on a tripod during a long time exposure, some camera movement is almost inevitable. This is especially true if a long focus lens is used, as in the picture above taken by *Victor Robertson* with a 200mm lens. He used Kodachrome 25 with an exposure of 1/15, at f16. The picture below by *Tom Nebbia* was also taken with an exposure of 1/15, and both illustrate how camera shake can be used to advantage to add atmosphere to a moving subject. For the train on the right, however, camera movement would have been inappropriate, as it relies upon the sharp static foreground, as well as split-second timing. With a time exposure of 1/8, *John Sims* used a tripod to ensure that the camera was not moved.

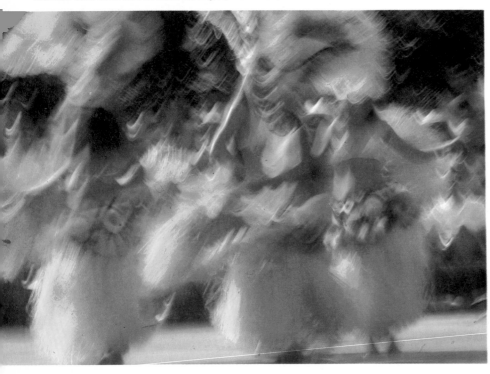

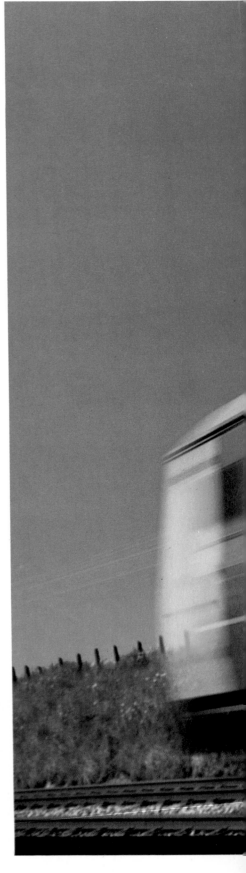

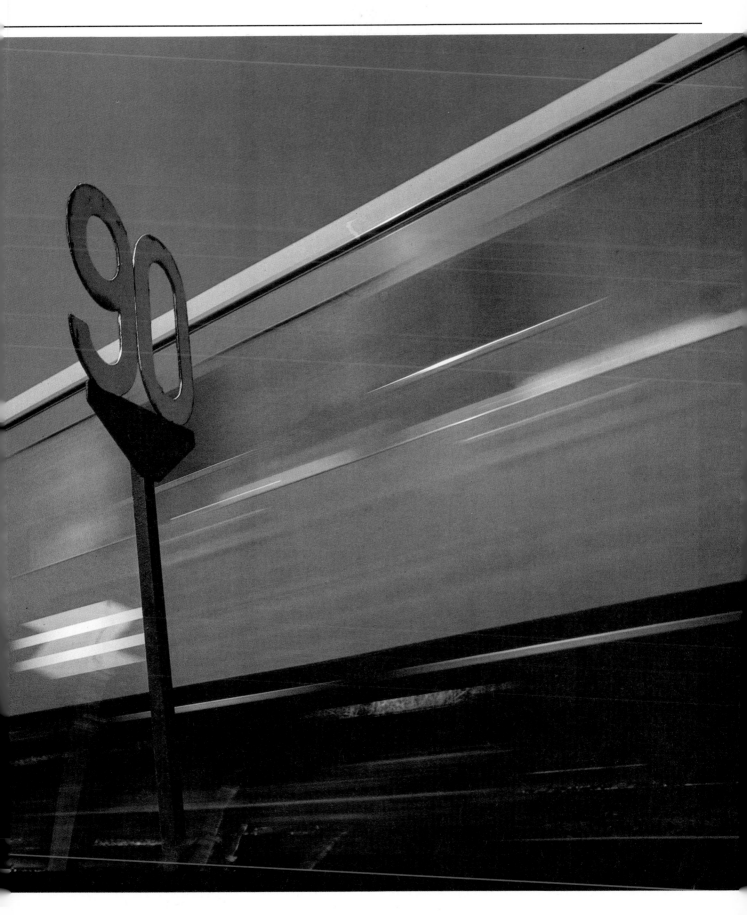

Pictures from a moving vehicle

Most of us spend a great deal of time travelling in cars, trains and coaches, particularly on holiday. Much of that time is spent looking out of the windows. If you have been tempted—by a spectacular view or an interesting building—to photograph the passing scene, you will have discovered some of the problems:
● camera shake, due to vibration;
● blur from the forward motion;
● reflections;
● image quality degraded by the glass.
Like many photographic problems, these can be overcome, and even turned to creative use. Movement, for example, can be either a hurdle or an asset: it depends on the impression you want to create. For candid shots, you have the advantage that no one expects to be photographed from a passing car or train. Nor do fellow passengers: most will assume that you are simply checking or adjusting the camera.

So, provided you are aware of the problems it is worth having your camera with you during a journey.

Motion and distance

Next time you are travelling at speed, look at the foreground. The road, near-by verges and fences appear to rush by. The background, on the other hand, stays relatively still. In the distance movement will be scarcely noticeable, but all objects in the foreground move. This is the effect of parallax.

In photographic terms, if you are moving at 60mph, then photographing

something 3 metres away is like shooting a car passing at 60mph at the same distance. It will appear to move much more quickly than something passing at the same speed a mile away.

Stopping movement

All the rules for stopping movement still apply. You must either use a very fast shutter speed—to match the effective speed of the vehicle in which you are travelling—or pan.

When you pan from a moving vehicle, you must start to frame the subject when it is in front of you. Press the shutter and swing round in one smooth action, following the subject as you pass. As with normal panning shots, the subject will be sharp but the background blurred.

If you want your picture to be as sharp as if it had been taken from a static viewpoint, use the fastest possible shutter speed and avoid any foreground intrusions. There are two reasons for avoiding the foreground. Firstly, as explained, close objects move apparently very fast and are likely to record as a distracting blur. Secondly, if there is no foreground, you will need less depth of field, and can use the wider apertures that fast shutter speeds require.

Even when using fast shutter speeds, try to follow the subject by panning, keeping it static in the viewfinder. Squeeze the shutter gently as you pan. It is best to pre-focus on a subject at a similar distance. Also, you may find an autowinder or motordrive useful if you have any doubt about getting precisely the right viewpoint and angle with only one shot. Never assume that speeds like 1/125 and 1/250 are fast enough to stop movement. It is far safer to use 1/500, 1/1000 or even faster if your camera provides for that.

Even so, any really close object like a pole which may leap unexpectedly into view will still appear as a blur.

Travelling alongside another vehicle at the same speed, you can easily stop its motion—but the background will reproduce as a blur. Do not use too slow a shutter speed for this, however, since you still have to avoid camera shake from the vibration of your vehicle. To photograph a vehicle travelling in the opposite direction you must add together your speed and the speed of the other vehicle when calculating the required shutter speed.

▼ MOTION AND DISTANCE
At 1/8 sec, *Suzanne Hill* emphasised the speed of this boat along a Thai canal. Ahead the scene is sharp: close to, the foreground in her 28mm lens is blurred.

▶ **PANNING**

From a stationary viewpoint, you pan by swinging round in the direction your subject is moving. From a moving vehicle, you swing to follow the apparent backwards motion of your subject. Since the apparent speed of what you see varies from foreground to background, only objects you select in this way remain sharp. *Ed Buziak*

▼ **STOPPING MOTION**

All these motorcycles, including the one on which *David Simson* was riding pillion, were travelling at roughly the same speed, so a shutter speed of 1/250 was fast enough to stop their motion. At the same time the blurring of the road in the foreground and the exaggerated tilt produce an impression of speed.

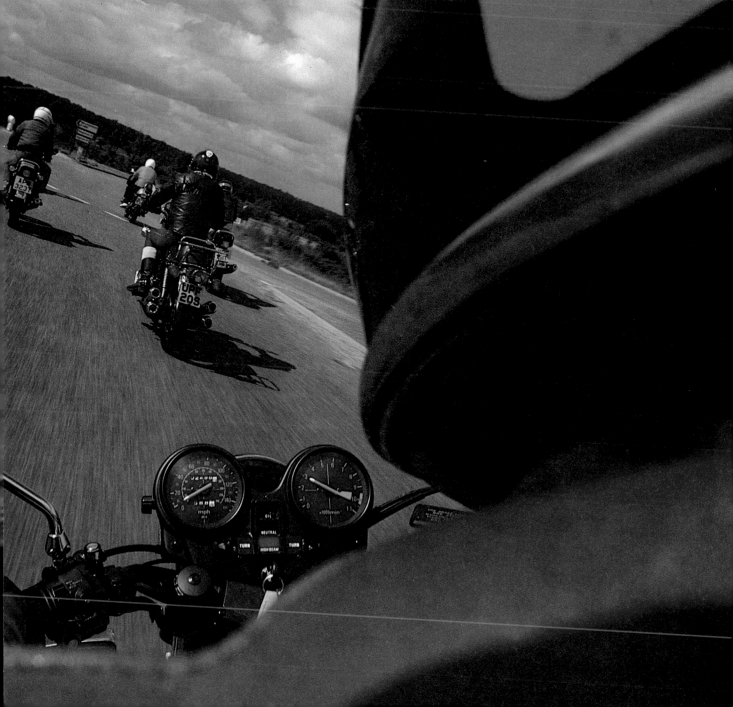

Creative effects

Blur is not always a disadvantage; it can provide a range of creative effects.

Firstly, there is straightforward blur, which "streaks" the whole scene in one definite direction. To use this effect well, choose a graphic form as your subject. Any fine detail will be lost in the motion blur.

Another effect is distance related blur, in which the background seems sharp and the middle distance and foreground become progressively more blurred. With a very wide angle lens you can include the foreground almost next to the vehicle and get an effect similar to zooming during exposure, with the image rushing out of the edges of the frame.

If you are on a train which is curving round a bend, you can (with care) lean out of the window and take in the curve of the other carriages, keeping them sharp with a relatively slow shutter speed while allowing the foreground to be streaked with motion blur.

Sunsets can be taken from moving vehicles: the sun is so distant that it does not appear to move at all if your vehicle is travelling in a straight line. A jumble of blurred foreground detail, like poles and rail edges, can make an interesting contrast to a sharp, clear sunset.

Look down for shots of white lines in a road or the rush of railway lines.

One interesting effect of shooting from a moving vehicle at high shutter speeds is that the scene might be distorted into a parallelogram, especially with a shutter that runs vertically. As the shutter slit moves across the film—effectively scanning the picture from top to bottom —the view is moving, so that the top of the scene is recorded at a different angle to the bottom.

Camera mounts and optics

For some shots from cars you may be tempted to mount your camera on a clamp fixed to the dashboard or door frame, particularly if you are using long exposures. However, unless your vehicle has superb suspension, these mounts are not to be recommended. Long periods of vibration from the car body can ruin your camera.

Car and train windows are optically very poor. Apart from tints, curves, stress patterns (revealed by polarizing filters), changes in the refractive index in laminated screens, double glazing and dirt, the average vehicle has windows that tilt upwards slightly so that if you rest the lens against the glass to avoid reflections you have to tilt the camera up. Experiment with a big collapsible rubber lens hood: press it against the glass and let half of it collapse. You may be able to cut out the reflections and at the same time avoid any problems with vibration transmitted from the glass. But be careful that the lens hood doesn't bend over and obscure part of the picture.

Pictures inside your vehicle

For shots inside a vehicle, you will need fast film and a wide angle lens. A 35mm lens is wide enough to take in the seated figure of the person opposite you.

If you choose exposures to record full detail in the vehicle, the view through the windows will burn out through over-exposure. Or you can record the view and have dark, shadowy figures picked out by natural rim-lighting.

Use flash if not trying to get candid shots, but take care with reflections. Depending on your vehicle, you will have to work out which panes of glass might reflect the flash back into the camera.

Night shots

Try driving along at night with the camera shutter on B to pick up the tail lights of the cars in front and the oncoming headlights. Use a whole range of exposure times and apertures—f8 may be suitable with 125 ASA film and f16 with 400 ASA film, but see what happens when you open up two or three stops in succession. The headlights which seem to burst around the camera as they pass can have a dynamic effect. Dusk shots aboard a boat with deck lighting can take advantage of the motion. Secure the camera firmly and use a long exposure so that any harbour

▶ Designed for cine cameras, clamps like this can be adapted for still photography from a moving vehicle. Though they may be useful for long night exposures and motordrive shots, however, your camera may suffer damage from vibrations if you leave it mounted like this for long. If you try to take pictures from the driving seat, it may well be you who suffers.

▼ Windscreens are a problem if you want sharp pictures: tints, curves, reflections and dirt can spoil a clear image. *Ed Buziak* used this rainwashed windscreen to add to the atmosphere.

lights, lighthouse beams or navigation lights on other ships form streaks in the background.

Most artificial light (apart from headlights) is usually of low voltage and records a strong orange cast on daylight film. For more accurate colour at night use tungsten balanced film.

Safety and consideration

Finally, whenever you shoot pictures from a moving vehicle, keep safety very much in mind. *You* may be quite safe, but by distracting a passing driver who sees a camera trained on him you may be the cause of an accident. So don't hang out of the window. Also, remember that a camera around your neck can cause a nasty injury in the event of a sudden jolt. It is therefore better to put your arm, not your head, through the strap.

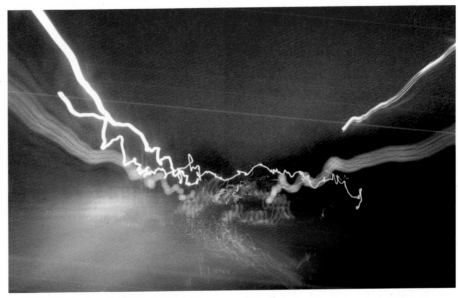

▲ At night, time exposures through the windscreen can be impressive. *David Kilpatrick* used a 24mm lens and 200 ASA film at f8, holding the shutter open for 10 seconds along a bumpy road.

▼ Exposing for the scene outside may mean leaving the interior foreground in silhouette. On Kodachrome 64, *John Sims* exposed at 1/125 and f5·6 with a 20mm lens for this winter sunrise.

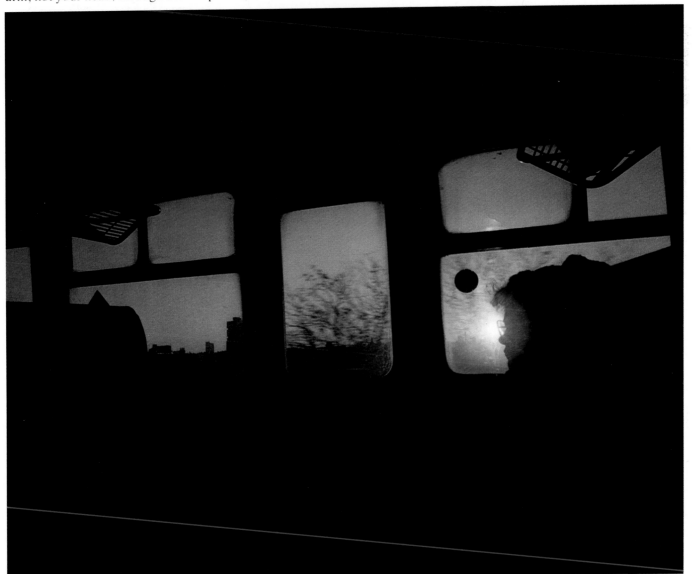

Double and multiple exposures

The technique of multiple exposure, superimposing two or more images on a single frame, is one of the most rewarding, if at times frustrating, aspects of photography. It enables you to combine elements of different sizes, from different places and at different times of day, or even year, in a relationship that would be impossible in any other way. A multiple exposure is not the easiest way of taking a picture, but you should enjoy trying. It offers great scope for imagination and with practice will give you some spectacular photographs.

You can take multiple exposures with most SLR and TLR cameras. The shutter mechanism has to be wound up, without advancing the film in the camera. This can usually be accomplished as follows:

● Take the first picture.
● Take up any slack by turning the rewind knob.
● Press in the rewind button to disengage the wind-on mechanism.
● Operate the wind-on lever in the normal way. It will still cock the shutter, but will not move the film.

The camera is now ready to make another exposure on the same frame. Some twin lens reflex cameras have a double exposure prevention lock. With such cameras, the shutter cocking and film wind-on mechanisms are separate and you simply disengage the safety lock, reset the shutter and expose again on the same frame of film.

Exposures and shutter speeds

Taking several images on top of each other effectively multiplies the time exposure by the number of images. For example, two exposures at 1/60 will equal one at 1/30. You cannot simply take each shot at the exposure you have calculated for the complete shot. The result would be badly over-exposed. Therefore, if your exposure for a particular shot is f8 and 1/125, for instance, the total of all exposures on that frame must not exceed 1/125. You will have to make two exposures at 1/250 or four at 1/500. Overlapped, they build up to the correct exposure. The aperture is usually chosen according to the depth of field you want for the subject in hand. Stick with that choice and vary the shutter speeds.

With automatic aperture priority camera systems, work is made rather easy. Some can be set to under-expose by one stop for two exposures, or by two stops for four exposures. With others, simply set the film speed dial to double or quadruple the 'correct' film speed. If your film speed is 50 ASA, for example, set the meter at 100 ASA for two exposures and at 200 ASA for four exposures. An automatic camera will then take care of the shutter speeds required.

Check that the shutter speeds you will need are within your camera's capability. If you quarter your exposures it is easy to arrive at a time shorter than 1/1000 of a second. This will probably mean that you have to limit the number of exposures to three or even two. It is really not all that complicated, provided that you take a little care to get the planned sequence carried out correctly.

Wind and water

One of the most elusive subjects to capture in photography is the effect of the wind. A fast shutter speed retains detail but freezes all movement, while a slower speed gives a sense of movement but at the expense of detail. With a multiple exposure you can retain both detail and the feeling of movement. Leaves can appear to dance on a tree and a flower to bend and sway in the grass.

Multiple exposures such as this need to be made using a tripod. This is to ensure that there is no overlap at the edges and that those parts of the image which you want to be stable stay in place—parts such as tree trunks, stones or the horizon. In these cases it will be the wind blowing through the grass or leaves which will place most of the subject matter in a different position during each exposure.

When photographing water, such as a stream, you will often be in a heavily shaded area where there is just not enough light to freeze the motion of the water and have enough depth of field for the shot. Again, a multiple exposure provides a solution. A series of short exposures will build up the light and still give a sharp image.

Moving the camera

A field of flowers or a patch of grass may look very appealing to the eye, but when seen through the viewfinder of your camera the whole thing seems patchy. Possibly there are not as many

◄ When the overlap of images is only slight, as it is in this picture by *Michael Busselle,* the calculated exposure need not be halved. An exposure of f5·6 at 1/500 was used for both these images and the camera was moved up slightly for the second.

► Above: the details of one image will always appear most strongly in the shadow areas of the other. For this picture *Brian Rybolt* has placed the image of the bush in the shade of the girl's hat so that it is clearly seen and appears like hair. The exposure for each image was f11 at 1/250, half that needed for the complete picture.

► To create the impression of leaves blowing about in a storm, while keeping the whole image sharp, *Ekhart Van Houten* took four exposures at 1/500 and f4. The camera was mounted on a tripod for the whole shot.

flowers or grass tips as you thought there were. Here, too, multiple exposures can help. Just imagine having four times as many flowers in the frame area.

You can do this by varying the camera position very slightly for each of the four exposures. Each flower can then be used more than once to provide you with a rich spread.

Alternatively, you can add interest by varying the distance of the camera from the subject. In this way you will get a number of different sized images superimposed on each other. Another method of achieving this effect is to leave the camera where it is and change lenses for each exposure. This is the technique used for the statue picture on this page.

▶ The first exposure in this picture by *Chris Alan Wilton* was of the waves. He used a 105mm lens, shaded the sky area and exposed for the highlights. The second exposure was of the sun, very heavily under-exposed and taken using a 20mm wide angle lens. There is an element of trial and error.

▼ For the first exposure of the statue *Sergio Dorantes* used an 85mm lens. The second, more dramatic, exposure was taken from the same spot (the camera was mounted on a tripod) but with a 500mm lens and a red filter.

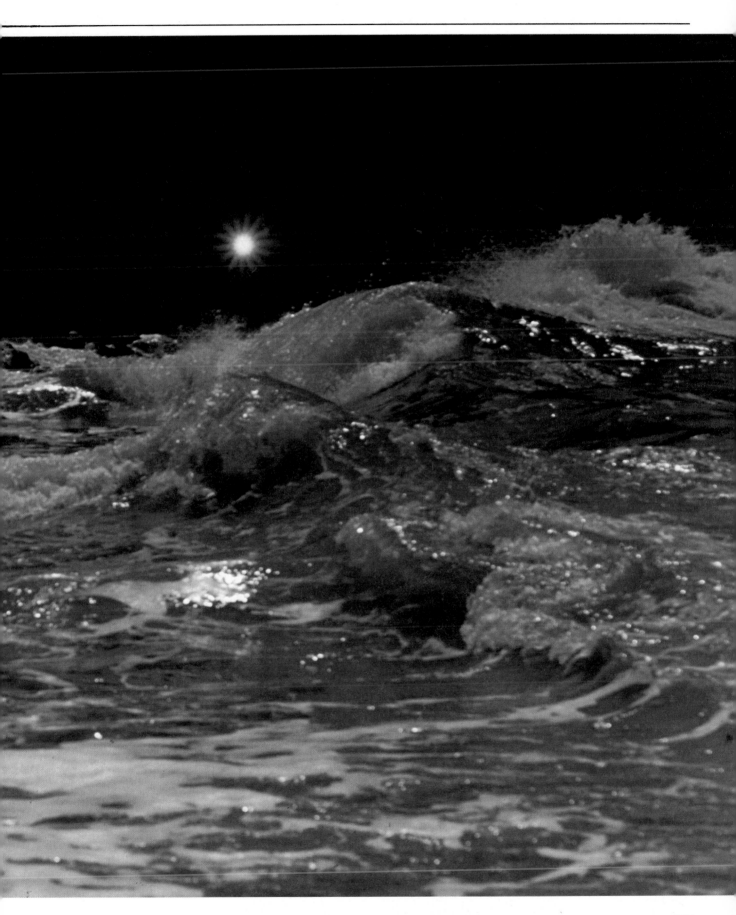

Helpful hints

Multiple exposures *can* be taken without using a tripod. Where there is no particular point of reference and the exposures are short enough, by all means try some shots with a hand-held camera. Usually, however, a tripod is very necessary. Once the camera is fixed on a tripod, make sure that the rewind button, which is often underneath the camera body, can be reached without disturbing the whole set-up.

On some motor-drives, the rewind button or lever can be held while making exposures. These levers are usually spring loaded and have to be held while making the exposures on one frame of film. This can, in practice, be quite awkward.

Some camera manufacturers are beginning to note that a multiple exposure facility is a desirable feature, and many recent models (including the Cosina CSR, the Voigtländer VSL3-E and the Canon A-1) have a lever especially for this purpose. Another useful feature is a frame counter which only records the film that has been wound oh.

It should be realized that results are not all that predictable. Some perseverance may be necessary, especially with shots containing a slow exposure with some movement. A good result could be considered something of a fluke. But, if you can work out the result you want and you have some idea of what you are doing and how to go about it, results do eventually become predictable. So be prepared to use up some film and effort.

Remember that light backgrounds and light or light-reflecting surfaces tend to obscure detail and are generally unsuitable for multiple exposures. Make sure that highlights do not build up too rapidly and result in 'burnt out' areas. Carefully placed shadow areas can be very useful to counteract this.

Experiment to see if you can master this technique, but don't then overdo it. Always ask yourself if a multiple exposure is really all that necessary. Are four blinks better than one? Sometimes yes, then use the technique as a means to get the end result and not just to show that you can get two pictures for the price of one.

In theory making double exposures by putting the film through the camera twice should be a relatively simple business. But, as the frames on the left and below show, you can end up with some disappointing results if you are not careful. In this case the photographer first exposed the film for the landscape. Then, having rewound the film, he waited for a clear night with a full moon. He then reloaded the film and tried to photograph the moon on to the sky area. Not having made a registration mark on the film the first time round, he could only rely on luck to achieve the positioning he wanted. The result was a disaster.

The diagram above shows where to make the registration mark before exposing the film for the first time and so avoid a similar mistake. When the film is reloaded for the second exposure you simply line up the mark with the same upright guide (indicated above by the dotted line). This ensures that each frame falls within the same area of the film for both exposures. A slight overlap can be cropped after processing.

Exposing the whole film twice

Multiple exposures using this technique can only be taken with cameras that use 35mm cassettes. This is because after taking the first lot of exposures the film has to be wound back into the cassette ready to be loaded for a second time. However, if you do have a 35mm camera, the principle if not the practice is quite straightforward.

● Expose your roll of film once, shading the part of each frame you do not want exposed.

● Wind the film back.

● Reload the film and take a second exposure of another subject, exposing those areas previously shaded. This second exposure can be weeks later and miles from the subject of the first.

● To minimize frame overlap, take care when loading the film. When the film sits nicely on the take-up spool, take the slack out by tightening the film gently inside the cassette, just hand tight. Make a registration mark on the film against one of the upright guides between the shutter and take-up spool. Close the camera and wind on to the first frame. When the film is loaded for the second time use the same procedure and set the registration against the same reference point.

Using this technique you can simulate a moonlit landscape, for example, to rather better effect than the real thing. When you find a particularly striking landscape, photograph it in daylight using the whole film. At a later date, on a clear night with a large moon, reload the partially exposed film and photograph the moon.

To simulate the moonlight for the daylight shot, use low sunlight at sharp angles to the camera and under-expose by about one stop. You can shade the sky area with a strip of black card in front of the lens hood. The moonlight effect can be further enhanced by using unfiltered tungsten light film to give an overall bluish, night time impression, plus a polarizing filter to maximize the highlights over other areas. Rotate the filter until the picture looks right.

Keep notes on the subject of each exposed frame and the height of the horizon line. If the landscapes are taken with a normal lens, try to photograph the moon with a telephoto lens to enlarge its size.

▶ Having exposed a roll of film for shots of the moon, *Chris Alan Wilton* later reloaded it to photograph the girl in the studio. Pinpoints of light through black card represent the stars.

Multiple images: movement and light

It is more than likely that at some time or other you will have seen one of those pictures which show a golfer surrounded by a hundred images of his club as he swings at the ball. This effect is created by a multiple exposure technique which uses strobing flash lights (see page 244). The final multiple image not only makes a dramatic and unusual photograph but is also an accurate representation of each stage in a sequence of movements.

The strobe equipment is expensive and therefore not readily available to the average photographer, but it is possible to achieve similar results using much simpler lighting—even by available daylight.

Tungsten and flash

One way to suggest movement is by recording a blurred image. A multiple exposure which combines *several* blurred images and one short exposure, to produce a sharp image at the climax of the action, gives an increasingly dramatic effect. This works well for the photography of people executing a particular movement.

Any such sequence is best carried out in a studio and should be carefully planned. The first thing to determine is the amount of space required to show the sequence from start to finish. The space is usually fairly large. If you ask a person to move even one or two steps, and allow a small margin on either side of the sequence, you will note that 4 metres is about the minimum area required. Your camera will therefore have to be fairly far from the subject in order to take in the whole area.

The next step is to set up the background. This will have to be large enough to cover the entire area of action and should be black. The reason for this is that any light falling on the background will appear through the images of the figure, giving a ghostly see–through effect. A black or deeply shaded background will reflect no light. You can now begin the exposures. For the blurred images you will need an exposure of about 1/8 or longer. To light your subject for this length of time you will probably have to use tungsten lights. The final, sharp exposure can be made with flash.

This combination works well on black and white film, but with colour film you have the problem of matching the colour temperature of the two light sources. This can be overcome by fitting the tungsten lights with daylight conversion filters and using daylight

▲ A combination of one brief flash exposure plus a ½ second exposure lit by tungsten light was the method chosen by *Ray Daffurn* to capture the movement of this popcorn. To match the colour temperature of the flash he used an 80A blue filter over the lens during the longer tungsten exposure. Using 64 ASA daylight film he set the aperture at f16 for the flash. For the more subdued light of the tungsten shot he widened the aperture to f8.

◀ A single exposure, taken by flash alone, makes an interesting picture but does not convey the same sense of frantic movement as the double exposure above.

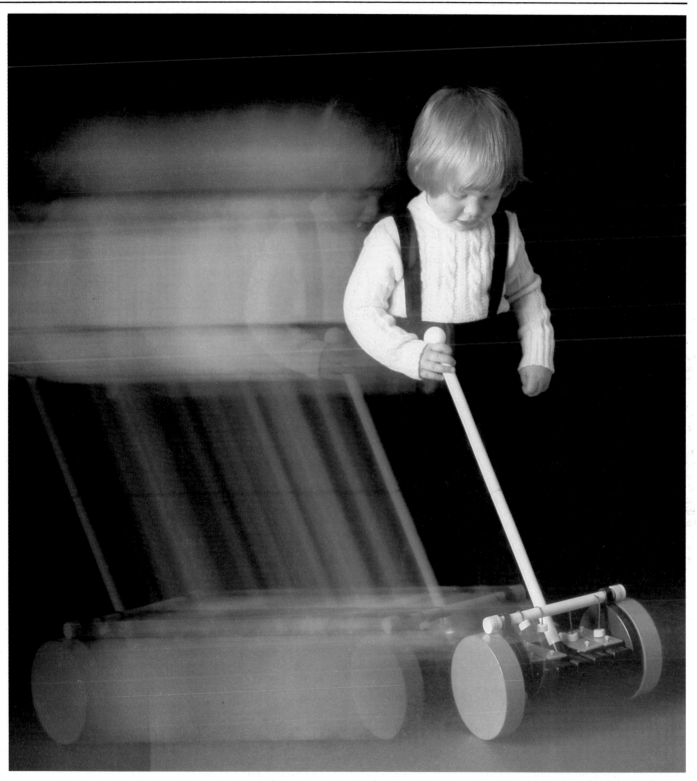

film. An easier, cheaper and more convenient method, however, is to fit a conversion filter to the camera lens, shoot the slow exposures using the normal tungsten lights and remove the filter for the flash exposure. You can even avoid a filter altogether and de-

cide to have your blurred shapes in an orangey colour.

Measure the light for each exposure separately, using an ordinary, or TTL, meter for the slow exposures and either flash factors, a self–regulating flash gun or a flash meter for the flash exposure.

▲ **This picture comprises four exposures—three taken using tungsten light, the fourth with flash. Because the orange cast from the tungsten light appears to complement the colours in the flash exposure *Howard Kingsnorth* decided not to use a correction filter.**

Use normal exposure in each case—for although you are recording several images, they are each in a different part of the picture area.

It is best to record such a sequence several times, and you will need the close co–operation of the person executing the movement. Carefully explain what you envisage so that he or she has a good idea of what is involved.

Be careful about overlapping areas, for these tend to over–expose. Some overlap can look effective, whereas a lot would spoil the sequence.

Studio flash

Another method of breaking down movement for multiple exposures, and this time without the disadvantage of mixing the light sources, is to use studio or other photographic flash lights for the entire sequence. In this case each exposure will be short (the duration of the flash) and each image sharp, more closely resembling the strobe effect but with fewer images. The lighting arrangement and the sequence of exposures is shown opposite.

▼ If you have a B setting on your camera you can take multiple ex–posures like this. With the shutter open *John Haw* produced these three images by firing his flash three times, once for the full face and once each for the profiles. The shutter was closed only after the third flash had been fired.

▲ This picture, taken by *Robert Estall* using studio flash, shows how interest can be added to a simple multiple exposure by using a different coloured filter for each image. For the first, brighter exposure he set the aperture at f8 and took the shot without a filter. For the next three exposures he stopped the lens down to f16. For each of these secondary, less distinct images he fitted a different coloured gelatin filter to the lens. Obviously, this technique can only be used if your subject can stop at each stage in the sequence and can hold the pose for the length of time it takes to change the filters. Once again, a black background is essential.

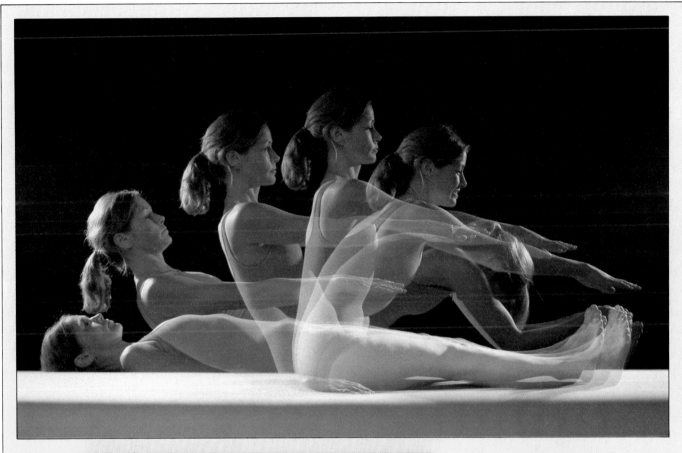

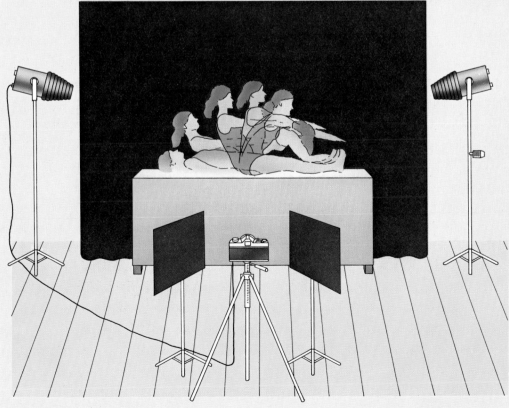

Multiple exposures of a moving subject not only combine to form an interesting image but can also be useful for accurately recording the sequence of events within a given action. *Michael Busselle* took this picture of a yoga exercise using the studio flash method. After each exposure the wind—on mechanism was released and the shutter re—cocked. The set—up of subject and equipment is shown in the diagram. The two studio flash units, above and to each side of the subject, were synchronized by a slave unit. The pieces of black card in front of the camera were positioned to prevent any stray light from reaching the lens. The curtain behind the model was black velvet.

Strobing flash lights

A stroboscopic unit emits a great many flashes in a very short space of time. It is ideal for breaking down really fast movement and for showing every stage rather than just part of a sequence. Unlike with other types of multiple exposure, the camera shutter stays open for the duration of the entire movement, and the number of flashes determines the number of images recorded. The rate of flashes per second can be adjusted to suit the speed of the action involved.

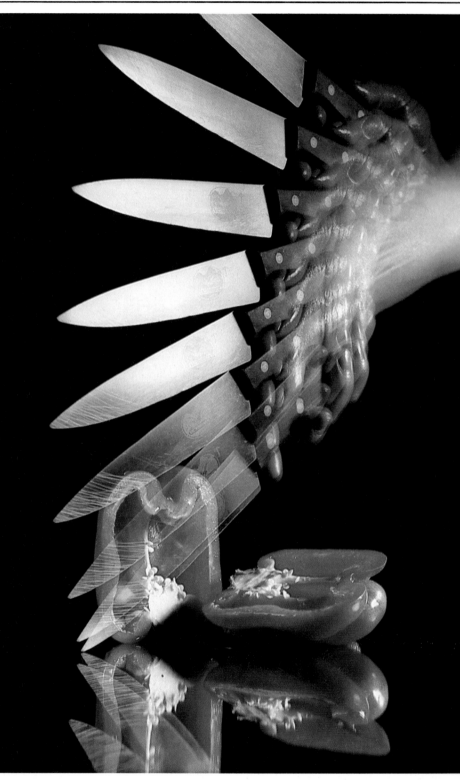

▶ Stages in the movement of a knife as it slices through a red pepper. This clear breakdown of movement is typical of a picture taken using lighting from a stroboscopic flash unit. The system used by *Ray Daffurn* for this photograph was one of the smaller disco–type strobes. These have a limited output and although they are perfectly adequate for pictures of small subjects like the knife, they are not powerful enough for outdoor action or for movement which has to be executed over a large area.
For the smaller picture above a static tungsten light was also directed at the knife; this has given the orange blur between the images which increases the sensation of movement. More sophisticated stroboscopic systems are used in industry where they appear to slow down the motion of fast–moving machinery so that it can be examined for possible defects without closing down the whole plant.

Equipment of this type, powerful enough for the photography of sportsmen, birds and acrobats for instance, is complex, expensive and not generally available. You can, however, hire smaller strobe units of the type used in discotheques. These are much less powerful but can be used close to the subject to compensate for the lack of power. In this way small subjects can be quite adequately lit—a magician's sleight of hand or the flight of a dart, for instance. Once again it is necessary to work with a dark background.

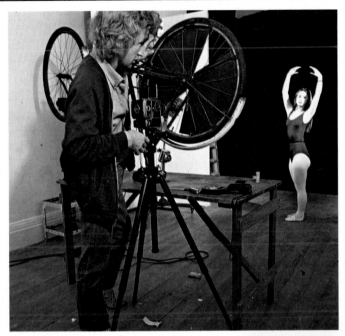

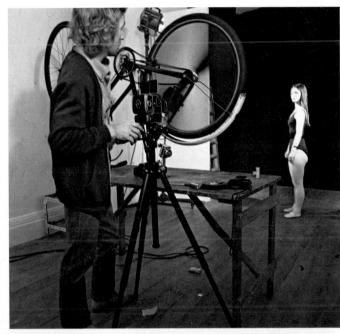

▲ Left: the back wheel of a bicycle is covered with black paper, leaving two small gaps. Make sure that all of the subject can be seen through the gaps. This set–up is in a studio, but the same results can be achieved outside, using daylight with the subject against a dark background. Right: the wheel is spun, acting as a chopping shutter.

▶ The final image, taken using an exposure of 1½ seconds. *Peter Lavery*

A chopping shutter

If you want to create a strobe–type effect of a movement out of doors you can do this by using the available daylight and what is in effect a chopping shutter. This is basically a disc or wheel covered over with black paper or card but with open slots. The wheel is then revolved in front of the camera lens (see above). In this way the slot, or slots, spinning in front of the lens provides the number of exposures. How many exposures depends on how fast the wheel is turning, how long the camera shutter is left open and how many slots there are in the disc.

A moving subject photographed through such a chopping shutter will appear as a number of overlapping images, rather similar to the proper stobe effect.

Be sure that your background is dark and that the angle of the lens takes in the entire area in which you estimate that the action will take place. Keep the revolving disc close to the lens hood to keep out flare.

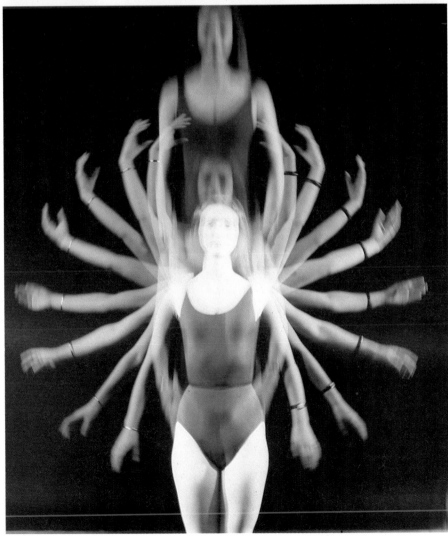

Using your camera

Throughout the book there are references to technical terms like 'film speeds', 'stopping down', 'wide angle lenses', 'bracketing exposures', etc. These have so far been unexplained as the book is primarily concerned with the act of taking better pictures. This section on using your camera covers the basics of lenses, exposures and choosing film and together with the glossary covers the technical terms used in the book.

EXPOSURE

To control exposures so that you take good pictures you must control the amount of light reaching the film. In dim light film needs plenty of exposure for a good result. In brilliant conditions a small exposure is all that is needed. The amount of exposure given to the film depends on a combination of two things: the brightness of the light reaching the film and the time for which the film receives the light.

Aperture

An aperture is a hole of variable size inside a camera lens. The size of the aperture controls the brightness of light reaching the film: a large aperture letting through plenty of light and a small aperture a small amount. Apertures are also called f stops, hence the term 'stop down' which means reducing the aperture.

Aperture numbers

The aperture ring on a lens usually has click stops at regular intervals which are marked with a scale of numbers. The numbers are called f numbers or f stops. A typical aperture scale might be f1.4 f2 f2.8 f4 f5.6 f8 f11 f16 and f22. (On the aperture ring the 'f' is ommitted to save space.) As the numbers get bigger the aperture size it refers to gets smaller. Each aperture on the scale lets in half as much light as the one before it — eg f2 lets in half as much light as the largest aperture f1.4 and twice as much as the next number on the scale f2.8. When you set f22 on the scale the aperture is very small in area.

f2	f2.8	f4
25mm	18mm	12.5mm

▲ This shows the relation of f numbers to aperture. If the area of f2 is halved the diameter goes down from 25mm to 18mm — giving an aperture of f2.8. Aperture f2.8 in turn is twice the area of f4.

Shutter

The shutter inside the camera body is the second half of the exposure team. It controls the time for which the film is exposed to light. A slow shutter speed lets plenty of light reach the film while a fast shutter speed lets through only a small amount of light.

Shutter speeds

The shutter speed dial on a camera is marked with a scale of numbers. These are the shutter speeds. Each step up in the series of numbers is roughly double the one before. The numbers represent fractions of one second. So 500 on the dial represents 1/500th of a second — often written simply as 1/500 or 1/500 sec.
A typical range of speeds is from 1 second to 1/1000. This is marked on a shutter speed scale as follows: 1 2 4 8 15 30 60 125 250 500 1000. The bigger the number (as it is marked) the faster the shutter speed. A fast speed lets through less light than a slower one.

When set at 60 (1/60) the shutter is open for twice as long as when set on 125 (1/125) and half as long as when set on 30 (1/30).
This doubling and halving of the amount of light is given the same name as when using the aperture to control light. There is one stop difference between the numbers just as there is between aperture steps.

How the shutter works

Most 35mm SLR cameras have a shutter just in front of the film called a 'focal plane' shutter. It is made up of two blinds which move over the film when you press the shutter release. Whatever speed you choose the blinds always move at the same speed. The time for which the film receives light is controlled by the width of the gap between the two shutter blinds. For example, selecting 1/1000 sets a tiny gap between the blinds. The film is exposed by a slit of light moving across it. When you choose 1/125 there is a much wider gap.
For speeds as slow as 1/60 the slit would have to be bigger than the picture frame area allows. For very slow speeds the first blind completely uncovers the film to flood it with light all over. The second blind is held back for a little while, depending on how slow the set speed is, then released to cover up the film again and block off the light.

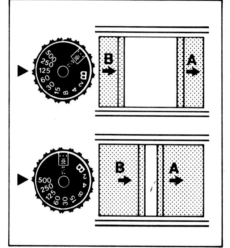

▲ This diagram of a focal plane shutter illustrates how shutter speeds work. Notice the difference in the gap between the shutter set at 1/125 (top) — written as 125 on the camera — and 1/500 (below).
The slower the shutter speed the later the second blind starts its journey across the film and therefore the bigger the slit between the first blind (A) and the second blind (B).

Controlling exposures

The amount of exposure you give for any subject depends on the brightness of light (through aperture) and the length of time light reaches the film (through shutter speed). You could use a big aperture and a fast shutter speed to photograph a subject. You could also use a small aperture and a slow shutter speed for the same subject. Both exposures would be correct.
With fast shutter speeds you need to use bigger apertures than with slow shutter speeds and vice versa.
Bracketing If, after taking a meter reading, you are not sure of the best exposure to use you can take several shots as insurance. Taking several pictures at different exposures is called bracketing. Giving one stop more then one stop less than the metered or estimated exposure almost guarantees a usable picture without wasting too much film. If you have no idea at all of what the exposure should be you can shoot a whole roll of film varying exposures by half a stop as you go. One will be perfectly exposed. This is a waste of film though, so only be extreme in your bracketing if the picture is important and unrepeatable.

Why are there two variables?

You probably chose a 35mm camera to improve the quality of your pictures. Controlling exposure level is one way of doing that. Having control over image sharpness is another.
Even though the exposures would both be correct a picture taken at f1.4 would look very different to one taken at f22. In the same way a subject photographed at 1/30 can look completely different when photographed at 1/1000. The aperture controls one aspect of picture sharpness, while the shutter speed controls another.

Depth of field

The aperture controls depth of field. The 'field' in this case is a crisply focused zone or band in the photograph. The 'depth' is how deep into the subject the crisply focused band starts and ends.
If you take a picture from close to the subject using a big aperture, this band of sharpness (depth of field) is very shallow. The foreground and background are fuzzy and out of focus while a narrow strip of the subject is clear and sharp.
If you use a small aperture, the band of sharpness (depth of field) becomes much deeper. As long as you are not too close to the subject the whole picture could come out sharp when you use a small aperture.

Making aperture the priority

You can decide how much or how little of the subject you want to come out sharp. To make a subject stand out in the frame surrounded by a blurred backdrop use a big aperture like f2. The background and foreground go out of focus and make the main subject dominate the picture. This is ideal for a

Aperture scale

Each step in this typical scale of apertures represents a change of one f stop. Imagine that f22, the smallest aperture, lets through one unit of light. F16 would allow through 2 units of light, f11 4 units and so on. The widest aperture f1.4 lets through 256 times more light than f22.

aperture	f1.4	f2	f2.8	f4	f5.6	f8	f11	f16	f22
units of light passed	256	128	64	32	16	8	4	2	1

Shutter speed scale

Each step in this typical scale of shutter speeds represents a change of one f stop. Imagine that 1/1000, the fastest shutter speed, lets through one unit of light. 1/500 (half the speed) lets through 2 units of light, 1/250 4 units and so on. The slowest speed here, 1/4, lets through 256 times more light than 1/1000.

shutter speed	1/4	1/8	1/15	1/30	1/60	1/125	1/250	1/500	1/1000
units of light passed	256	128	64	32	16	8	4	2	1

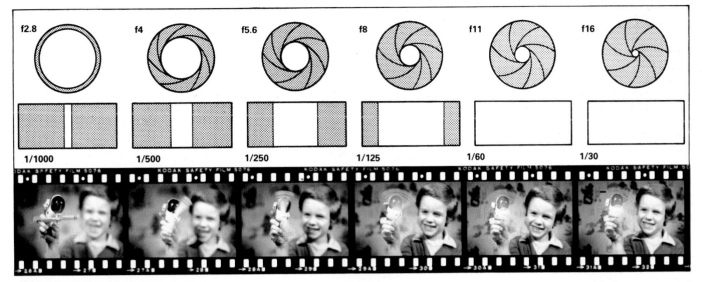

f2.8	f4	f5.6	f8	f11	f16
1/1000	1/500	1/250	1/125	1/60	1/30

▲ For any one subject there are many 'correct' exposures; a big aperture with a small slit between the shutter blinds letting through the same amount of light as a small aperture and a large gap between the shutter blinds. The resulting photographs show how depth of field and movement vary with the change of shutter speed and aperture.

picture of a single bloom surrounded by a mass of distracting leaves, for example.

Sometimes you want as much depth of field as possible to get everything clear and sharp in the picture. Perhaps you want to show a flower bed in full sharp detail from front to back. For extensive depth of field a small aperture like f16 is needed.

Estimating depth of field

Experience helps you to predict the most suitable aperture to get the depth of field you want. But you don't have to guess all the time. There are two main ways of judging depth of field.

Depth of field preview It is easier to compose and focus pictures with the lens at its widest aperture. This allows you to see a bright image in the viewfinder. Some cameras have a button or lever which closes the lens aperture down to whatever you have chosen on the aperture ring to give you a correct exposure. The viewfinder becomes much dimmer because you are reducing the amount of light passed through the lens. But you are then seeing in the viewfinder approximately the same image as the lens will project on to the film during exposure. You therefore have a visual idea of how much of the subject will come out sharp.

Depth of field scale Most lenses have a depth of field scale marked near the aperture ring to guide you. In the example shown some of the apertures on the aperture ring (4, 8, 11 and 16) are repeated on another scale. These figures and the lines that go with them are the depth of field scale. You use it to find the closest and farthest points in the subject (in feet and metres) which will be in focus in the photograph with the aperture you have chosen. The depth of field scale cannot work on its own, it relates to the aperture ring and to the focusing scale.

How to use a depth of field scale Set the correct focusing distance for the subject by turning the

▲ Using a wide aperture allows you to choose which part of the picture you want to be in sharp focus. In the picture on the left, focusing on the tree throws the flowers in the foreground out of focus. In the picture on the right the reverse effect is achieved by focusing on the foreground.

▶ The depth of field scale on the lens indicates how much of the scene will be sharp at a given aperture. In these examples there is barely any depth of field when you use a wide aperture like f2 and the subject is 2 metres away.

At f5.6 the depth of field increases dramatically. Here it extends from 1.6m up to 2.8m away from the camera when the lens is focused on 2 metres. (The total depth of field is therefore 2.8m minus 1.6m, which is 1.2m.)

At f16 the depth of field is extensive. Here total depth of field is 6.8m (8m minus 1.2m) and starts 1.2m away from the camera. As a general rule about two thirds of the sharp zone (the depth of field), is seen behind the point on which you have focused.

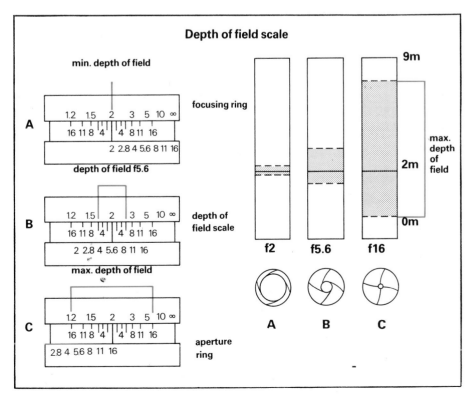

Depth of field scale

focusing ring until the subject looks sharp in the viewfinder. Set what you think is a suitable aperture for the subject and which also gives a correct exposure with the shutter speed you have chosen on the depth of field scale. Find the aperture you have set on the aperture ring. There are two marks for all apertures to either side of the lens's biggest aperture mark. Then read off the two distances opposite these marks on the focusing ring. The two distances show you the depth of field.

Choosing apertures

If the depth of field is the most important aspect of your picture choose the aperture you want to use first. Use a big aperture to throw a confusing background out of focus, or to get rid of an obstruction (like wire netting) in front of the subject. Use a small aperture if you want to show detail in the whole of the picture.
Then use your light meter to find out the shutter speed you will need to go with the aperture you have chosen. The shutter speed will vary according to the film speed you are using and the amount of light on the subject.

Movement blur

Shutter speeds affect the sharpness in your pictures but in a very different way to apertures. The shutter controls movement blur: whether caused by movement of the camera or movement of the subject.

Camera shake

If you are using a slow shutter speed and the camera moves during the exposure then the picture is

▲ Avoid camera shake by standing correctly. Stand firm with your legs slightly apart. Tuck your elbows in tight and hold your breath while you squeeze in the shutter release.

▲ Support the camera in the palm of your left hand, leaving your fingers free for focusing. Your right hand should grip the side of the camera firmly while your index finger works the shutter release. For extra support lean the camera against a tree or wall.

spoiled. The amount of blurring caused depends on how much you move the camera and what shutter speed is used. Most people can take sharp pictures when using shutter speeds of 1/60 or faster with a standard lens on the camera. At 1/30 or slower it is difficult to hold the camera steady enough to prevent shake. You should either avoid slow speeds altogether or steady the camera during the exposure.
Keeping still Holding your breath, standing firm and trying hard not to move while you squeeze the shutter release gently helps prevent camera shake. You can also steady the camera by leaning against a solid upright (like a tree) or rest the camera atop a wall or other flat surface. Pistol grips and rifle stock attachments all help to steady the camera by using your own body as a stabilizer. The most reliable support is a sturdy tripod.
Longer focal lengths With longer focal length lenses than your camera's standard lens, 1/60 is too slow to prevent camera shake. Long focal lengths magnify the subject and with it even tiny movements of the lens. To avoid the shakes set the shutter speed to match or be faster than the focal length number on the lens. With a 105mm lens set 1/125 or faster. With a 200mm or 500mm lens use a 1/500 or faster.

Panning

A sharp image against a blurred background gives a strong impression of movement. To achieve this move the camera in the same direction and at the same speed as the subject while the shutter is open. This is called panning. The best results happen with fairly slow speeds like 1/60 or slower. First focus on the spot where you want to take the picture. (If it's an empty space ask someone to stand there while you focus.) Pick out the oncoming subject in the viewfinder. Follow its motion with the camera, keeping it in exactly the same spot in the viewfinder all the time. Press the shutter release when the subject gets to the point on which you have focused. But don't stop moving the camera — follow the movement through all the while the shutter is open, and a little after you think it has closed just to make sure. The background comes out as if it, and not the subject, had moved across the picture frame. It looks streaked and blurred just as if you had viewed a still subject from a moving vehicle.

Cameras and exposure systems

There are several types of exposure systems available in modern SLR cameras. Most cameras, even the cheapest ones, have a built-in light meter. The meter measures light from the subject directly through the lens (TTL). TTL metering is convenient and generally reliable.
Manual exposure cameras You can adjust the aperture ring to get whatever effect you want. A moving needle or a coloured lamp in the viewfinder signals whether or not you will get a good exposure with the combination you have chosen. You can choose to ignore the viewfinder signal to deliberately under or over-expose.
Automatic exposure cameras Automatic exposures give slightly less control but enable correct exposures to happen much more quickly and easily. There are several automatic exposure systems:
● **Aperture priority**: the photographer chooses an aperture to control depth of field. The camera automatically provides the correct shutter speed for the lighting and film speed. Many of these cameras can be turned into manual exposure cameras by moving a switch (called 'manual override.')
● **Shutter priority**: the photographer sets an appropriate shutter speed to control movement blur. The camera automatically sets an aperture to give a correct exposure for the lighting conditions and the film speed in use. All current models in this group can be switched to entirely manual exposures.
● **Multi-mode cameras**: a few automatic cameras can be used as shutter priority and aperture priority as well as manual exposure cameras. There is often a programmed exposure setting too where the photographer has no control at all. The camera sets the aperture and shutter speed according to available light and film speed.

FILM

Types of film

The shelves of your local dealer may seem to display a bewildering range of different films. However, once you have decided which brand you prefer, there are only three main types of film — colour negative, colour slide and black and white negative.
Colour negative film or colour print film produces a negative image and is used to make colour prints.
Colour slide film or colour reversal film produces a positive image in the form of colour transparencies used for projection and reversal-type prints.
Black and white negative film produces a negative image and is used to produce black and white prints.

Daylight and tungsten film

Slide film is balanced for use in daylight and with electronic flash. Tungsten slide film should be used to give true colours with artificial (tungsten) light and special photographic lamps.

▲ Tungsten film and tungsten light: tungsten film is exactly balanced for the red bias of tungsten lights.

▲ Daylight film and tungsten light: if you use tungsten lights and daylight film the effect is usually too red.

Film speeds

On an SLR camera you will notice a dial with 'ASA' and numbers, perhaps between 12 and 1600, or the equivalent in DIN, with numbers 12 to 33. This dial has to be set so that the marker corresponds to the ASA/DIN number of the film you are using.
All three types of film are made in a range of film speeds. The term "film speed" describes how sensitive a film is to light. A slow speed (25-50 ASA) is not very sensitive to light while a fast film (200-400

ASA and over) reacts much quicker to light. Each speed is appropriate for a different lighting condition and has different advantages and disadvantages as the speed affects colour saturation, grain, image quality, etc.

Choosing the right film speed
Medium film speeds (64 to 125 ASA) are probably the most used and can cope with a great range of subjects and conditions, though they may not be the perfect choice for the job in hand. They give good colour, fairly fine grain and have a good latitude to exposure error. They are really only inadequate in very dim lighting conditions.

> **Medium is best for**
> ● good quality ● medium grain size ● good image sharpness ● wide subject range ● landscapes ● portraits ● the widest choice of correct exposures ● on holiday ● using as an all-round film ● for fairly big print sizes

Slow films (25-50 ASA) being less sensitive to light require wider apertures or longer shutter speeds to give more exposure. They give the best sharpness and detail, the finest grain and are the most suitable for making enlargements. However, because of the increased exposure they require, there is more risk of camera shake and less potential for action shots in poor light. In low light you may prefer to use a slow film and a tripod rather than a fast film.

> **Slow is best for**
> ● highest quality ● finest grain ● sharpest images ● intricate detail ● close-ups ● very bright light ● when you need slow shutter speeds ● when you need wide apertures ● for very big prints ● for purest colour (slides)

Fast films (200-400 ASA and over) Pictures which cannot be taken with slow or medium film are often possible with fast film, which can be used in low lighting conditions. The fast shutter speeds used are good for stopping action. However, fast films are more grainy.

> **Fast films are best for**
> ● photographing in low light ● when you want large grain effects ● preventing camera shake ● sport and action ● fast motor-drive sequences ● when you want fastest shutter speeds ● when you want smallest apertures ● for modest print sizes ● when up-rating to 800 ASA and beyond ● getting a picture at all costs.

How speed affects exposure
Imagine you are photographing the same subject with a range of film speeds. The lighting level stays the same all the time. As the film speed increases the exposure needed for a good result decreases.
You can decrease exposure by using a smaller lens aperture which reduces the brightness of light reaching the film. Alternatively, you can set a faster shutter speed which reduces time of exposure. For a large change in exposure you can combine a smaller aperture with a faster shutter speed. Each time you double the film speed you need only half the exposure, as long as the lighting conditions stay the same.

Re-rating films
You don't always have to expose films at the speed rating shown on the box. If there isn't enough light to give a good exposure with the film you have loaded, you can up-rate or push the film, that is expose it as if it were a faster film. There is a limit, though, to the amount a film can be up-rated.
Similarly, you can down-rate a film if there is too much light for the film you are using.
If, for example, your camera is loaded with 200 ASA and you need a film which is twice as fast, then you can expose it at 400 ASA. All you do is set the film speed dial to 400 ASA . The meter will indicate that there is enough light for your picture. However, you have to expose the film at the same ASA throughout; you cannot switch between two or

▲ The film speed dial must be set to the ASA rating of the film on cameras with automatic exposure control. Check the film speed dial each time you load a new film.

more different ratings. Uprating the film alters the developing times and it is essential to tell the processing firm that you have done so and what new speed you have used. This is called push-processing.
You can use the re-rating service if you expose a film at the wrong ASA by mistake.
Quality of re-rated film Changing the film's speed also affects the quality of the image. For example, a 50 ASA up-rated to 400 ASA will lose its fine grain and take on the coarse grainy appearance of a 400 ASA. So up-rating is always at the expense of quality.

What processors can do for you
When you take a slide film to be processed the charge usually includes normal development and mounting into 5cm square slide mounts. When you are having colour print film developed the price

usually includes developing of the film and printing of the negatives. The prints are usually around enprint size, which is 85 x 125mm, and you usually have a choice of lustre or gloss finish.
If you want anything unusual to happen to your pictures you have to (1) find a processor who will help you and (2) pay rather more than for a straight developing and printing job. The table below outlines the more popular special processes or treatments that a good processor can carry out for you followed by a list of things no processor can do.

What you can and can't do with your films after exposure
YOU CAN
Re-rate films and have them processed accordingly
Have prints made from slides
Have big prints made; anything up to poster size
Have a small area of a negative enlarged (called selective enlargement)
Have different print surfaces (canvas, linen, matt, silk, gloss etc.)
Have many prints made from one negative (or slide)
Have slides duplicated many times over
Have slight colour inaccuracies corrected
Have exposure faults compensated for during processing/printing (to a limited extent)
Have marks retouched out
Have contact (same size) prints made of your negatives
Have slide film returned uncut and unmounted
YOU CAN'T
Correct really bad exposures
Correct poor focusing
Increase or decrease depth of field
Change movement blur
Improve composition (except by cropping)
Include the very edges of the frame
Include something that is not in the picture
Remove scratches from slides or negatives

Speeds and film type

film type	speed					
	slow		medium		fast	
	ASA	DIN	ASA	DIN	ASA	DIN
black and white print	25	(15)	64	(19)	400	(27)
	32	(16)	100	(21)		
	50	(18)	125	(22)		
colour print			80	(20)	400	(27)
			100	(21)		
colour slide	25	(15)	64	(19)	200	(24)
	50	(18)	100	(21)	400	(27)

How film speed affects image quality

film type	speed group	grain size	colour purity
black and white print	slow	small	
	medium	medium	
	fast	large	
colour print	medium	small	good
	fast	large	acceptable
colour slide	slow	small	excellent
	medium	medium	good
	fast	large	acceptable

All films can be expected to produce good photographs. The comments here are made in comparison to one another.

How film speed affects exposure

When the aperture is pre-set (to control image sharpness)
Exposure example: f8 at 1/15 gives correct exposure with 25 ASA

correct exposure for 25 ASA	f8 at 1/15	new ASA	50	100	200	400
		exposure required	f8 1/30	f8 1/60	f8 1/125	f8 1/1250

LENSES

One of the biggest advantages of SLR cameras is that you can change the lens to use the most suitable type for the subject and the effect you want to create. You need to know a little about lenses in general before you can decide on the correct lens to use.

Focal length

Focal length is the distance between the lens and the film when the lens is focused on infinity. But because modern lenses are so complex in the way light travels through them, a lens can be physically longer or shorter than its marked focal length suggests. Focal length is measured in millimetres and is always written as a number followed by millimetres — 24mm, 500mm, 135mm and so on. The most important aspects of focal length are that it affects (a) the size, or magnification, of the image in the viewfinder and on film and (b) how much of a subject is included in the picture, that is the angle of view.

Magnification The longer the focal length of a lens, the more it magnifies a subject in the picture. A 400mm lens produces a bigger image of a subject than a 135mm lens. A 135mm lens in turn gives a bigger image of the same subject than a 24mm lens when photographed from the same spot. If the focal length is doubled, the magnification doubles too, and so does the size of the image.

Angle of view You cannot change the picture area produced on film by a 35mm camera; it is always 24mm by 36mm. Lenses for a 35mm SLR (except for fisheye lenses) all give an image which completely fills this picture area. Because a long focal length magnifies a subject, it appears closer than it really is when you look through the viewfinder. You can therefore only see a small part of the subject in the picture. It is as if you are looking through a long, narrow tube which stops you from seeing the area surrounding the subject. Long focal lengths cut down the area you see around the subject and they therefore have a small 'angle of view'.

Short focal lengths give much smaller images of a subject than long focal lengths. A small image of a subject looks much farther away than it really is. The whole subject can be seen in the picture as well as a lot of the area around it. A short focal length lens gives a wide view and is called a 'wide angle'.

Speed

When you hear of a 'fast' or 'slow' lens this is a reference to its maximum light gathering power. As a big aperture can collect a lot of light a lens with a big maximum aperture is called a fast lens. A slow lens has a much smaller maximum aperture. The maximum aperture is the biggest setting on the aperture ring. A lens with a large maximum aperture of f1.4 is a fast lens. An f3.5 maximum aperture on a lens of the same focal length is a slow lens. With some focal lengths it would be too difficult, and therefore expensive, to make a wide maximum aperture of f1.4. So a 500mm lens with a maximum aperture of f4.5 may seem slow, but it is fast because many other 500mm lenses may only start at f8. A 400mm f3.5 lens is 'fast' and so is a 50mm f1.2 lens, but a 50mm f2.8 lens is comparatively 'slow'. The bigger the maximum aperture the more expensive is the lens. The longer the focal length the smaller the maximum aperture possible.

Depth of field

Focal length also affects depth of field. A short focal length (wide angle) lens gives much more depth of field than a long focal length (telephoto) lens. With some wide angles it is almost impossible to get a foreground or background *out* of focus.

A telephoto lens gives a shallow band of focus which gets narrower as the lens focal length gets longer. With some telephoto lenses it is impossible to get a foreground or background *in* to focus. You should therefore take extra care in focusing when using a long focal length lens, especially when you are taking a picture at a wide aperture.

Minimum aperture

Most lenses stop down to at least f16 and often to f22. Longer telephoto lenses may have f32 and f45 settings, perhaps smaller. But because depth of field decreases as focal length increases, f32 in a 300mm lens does not give more depth of field than f22 in a 50mm lens with the same subject.

Taking pictures at small apertures also means that you need a correspondingly slow shutter speed to give the film enough exposure. With a long telephoto lens set on f32 you have to be careful that the shutter speed doesn't drop below the safe speed to avoid camera shake. This may mean using a fast film.

Focusing

All general purpose lenses focus on distant subjects. This is called infinity and usually means 30 metres away and more. The closest possible focusing distance varies from lens to lens. 50mm lenses can focus on about 45cm, a 24mm lens may let you get to 20cm from the subject and a 300mm lens may stop you going any closer than 4 metres. If you try to photograph a subject closer than the minimum focusing distance of the lens allows, then it will be unsharp in the picture.

Performance

Lenses rarely give their best quality when used to take pictures at their maximum aperture. The picture edges may look a lot less clear and crisp than the middle part. Stopping down two or three stops from maximum (f5.6 rather than f2 for example) often gives better all-over quality. Smaller apertures (like f8 and f11) can improve picture sharpness by increasing depth of field.

With smaller apertures you only use the centre part of the lens to make the picture. The centre of a lens performs better than the edges, and this too helps improve picture quality. However sometimes you can see a reduction in quality when you use very small apertures (f16, f22 and f32). This is because light rays are scattered and moved a little off course as they pass by the edges of the aperture blades. You would usually only notice the difference in big prints.

Which lens to choose

The standard lens focal length for 35mm SLR cameras is from 40mm to 58mm. With a standard lens the angle of view and image size you see in the viewfinder is 'normal'. It is the sort of impression you would get if you looked at the subject with one of your own eyes.

For a first lens many people decide on a standard lens when they buy an SLR camera. This is a good choice because standard lenses are usually inexpensive, of good quality for the price and extremely versatile. It is not long though before most photographers want to try the effects of other lenses. There is a large number to choose from.

Wide angle lenses Anything less than 40mm in focal length (for a 35mm camera) is a wide angle lens. As the focal length gets shorter the image size (magnification) gets smaller.

When you use a wide angle lens the depth of field is so great that you can get everything in focus from close to the camera to far off in the distance. The subject area close to the lens will look much bigger than that in the distance and you can use this quality to exaggerate perspective. If you get very close to something in the foreground and use a wide angle lens the feeling of depth in the picture is increased.

Telephoto lenses Anything greater than 60mm in focal length for a 35mm camera is a long focus lens — most are called telephotos. As focal length increases the image size produced gets bigger. The angle of view gets smaller as the focal length gets longer. An extreme telephoto may only see 3° of the subject. Such lenses are expensive and have limited uses.

Zoom lenses You can change the focal length of a zoom lens. A zoom always has a limited focal length range: from 24 to 38mm or 100 to 300mm for example. Use any setting between the two limits to suit the subject. The obvious advantage is that you have many focal lengths in one lens. This can reduce cost and minimizes the number of items of equipment you have to carry around. Zooms are also convenient because you do not have to change lenses to use a different focal length.

Sometimes it is impossible to change your viewpoint to improve a picture; but with a zoom you

Telephoto lenses		
lens type focal lengths available	**maximum apertures**	**typical uses**
portrait 85mm 90 and 100mm	f1.2 to f2.8 f2 to f4	portraits; greater magnification than standard; to slightly flatten perspective; general purpose
medium telephoto 105, 120, 135 and 150mm	f2.5 to f4	general purpose; candid photography; separating subject from surroundings; details; flatter perspective; reduced depth of field
telephoto 200mm to 300mm	f2.8 to f4.5	candid portraits; sports; distant detail; wildlife
long telephoto 400mm 500mm	f4.5 to f6.3 f4.5 to f8	sports; wildlife especially birds; extremely flat perspective; picking out distant subject at large magnifications
extreme telephoto 600mm 800mm 1000mm	f4 to f8 f5.6 to f8 f8	motor and water sports; wildlife; air shows; astronomy; special effects

Zoom lenses		
lens type common focal length ranges	**maximum apertures**	**typical uses**
wide angle 21 to 35mm 24 to 35mm 28 to 50mm	f3.5	landscapes; large groups of people; in confined spaces; travel; all wide angle effects
mid-range 35 to 70mm 35 to 85mm 35 to 100mm 35 to 105mm 35 to 140mm	f2.8	good general purpose lenses; many views of one subject; effects from wide angle to medium telephoto possible; three lenses in one; weight, space and money saver
telephoto 70 to 160mm 70 to 210mm 75 to 260mm 80 to 200mm 100 to 200mm 100 to 300mm	f3.5 to f5	portraits; sports and action; wildlife; candids; precise framing from one viewpoint; most telephoto effects; many have macro setting for close up pictures

can zoom in and out to get the exact image size and framing that you want. Disadvantages include the extra bulk and weight of zooms over a single (or fixed) focal length lens. There is also some loss in quality when compared with the performance of a fixed focal length lens of the same focal length. As you might expect buying a zoom lens can cost much more than buying one fixed focal length lens.

Looking after lenses

If you want clear, sharp pictures then take care of all your lenses. They are too expensive to mishandle. Keep the front element clean. A skylight or UV filter fitted permanently to all your lenses keeps out dust and moisture. It also prevents you from touching the delicate lens with dirty or greasy fingers. A filter is much easier to clean than a lens and much cheaper to replace in case of damage.

● Keep the lens cap on when not using the lens. If you are storing or carrying a lens off the camera then fit a rear lens cap to the back end. Dust can do as much damage if it gets inside the back.

● Keep water off your lenses. Don't let rain or spray get on to the lens. It may get inside and cause damage.

● Handle, carry and store lenses carefully. A drop or a knock may cause irreparable damage.

● Don't attempt to service a lens yourself and never oil moving parts.

● Store lenses somewhere cool and dry. In warm, humid conditions fungus might grow on or inside the lens and it's difficult to remove. As an extra precaution keep a bag of silica gel inside the storage container if you won't be using a lens for a long time.

● Clean the lens from time to time. Always use special lens cleaning materials: a soft brush, a lint-free cloth, lens tissues and lens cleaning fluid or distilled water. Never use a solvent liquid and don't rub or you may scratch the glass.

How focal length affects magnification (all compared with a 50mm lens).			
focal length	magnification	focal length	magnification
50mm	1x	50mm	1x
35mm	0.7x	80mm	1.6x
28mm	0.56x	100mm	2x
24mm	0.48x	200mm	4x
21mm	0.42x	300mm	6x
15mm	0.3x	400mm	8x
		500mm	10x

A 50mm lens does not produce a life size image. The table shows *relative* image sizes taking 50mm as the starting point.

A

45°

B

90°

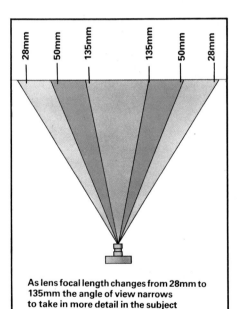

As lens focal length changes from 28mm to 135mm the angle of view narrows to take in more detail in the subject

▲ Diagrams A and B above show the approximate angle of view of a 50mm lens (A) and a 24mm (B). Because the 24mm is half the focal length of the 50mm, it has twice the angle of view.

1000mm 2.5°

300mm 8°

135mm 18°

85mm 29°

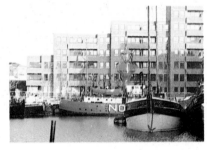

50mm 46°

35mm 62°

▲ All these pictures were taken from the same camera position and illustrate how a change of lens gives a changed angle of view. The lenses used range from a 1000mm telephoto (top) to a 35mm wide angle (bottom).

Wide angle lenses

lens type focal lengths available	maximum apertures	typical uses
extreme wide angle 15 16 17 18 19 20 and 21mm	f2.8 to f4	wide angle distortion; dramatic landscapes; very steep perspective; extensive depth of field
wide angle 24 25 28 30 and 35mm	f2.8 to f4	landscapes; steep perspective; good depth of field; interiors; large groups; travel

Glossary

Words in *italics* appear as separate entries.

A

Additive colour A method of mixing light where virtually any colour (except the pure spectrum colours) can be produced by adding various proportions of the primary colours—blue, green and red. The additive colour mixing system was used for early colour photographs, such as autochrome and Dufacolour and is used today in colour television.

Angle of view This is the maximum angle seen by a lens. Most so-called standard or normal lenses (for example 50mm on a 35mm camera) have an angle of view of about 50°. Lenses of long focal length (200mm for example) have narrower angles and lenses of short focal length (eg 28mm) have wider angles of view.

Aperture The circular opening within a camera lens system that controls the brightness of the image striking the film. Most apertures are variable—the size of the film opening being indicated by the f number.

ASA American Standards Association. The sensitivity (speed with which it reacts to light) of a film can be measured by the ASA standard or by other standards systems, such as DIN. The ASA film speed scale is arithmetical—a film of 200 ASA is twice as fast as a 100 ASA film and half the speed of a 400 ASA film. See also *ISO*.

Automatic exposure A system within a camera which automatically sets the correct exposure. There are three main types:
1 Aperture priority—the photographer selects the aperture and the camera selects the correct shutter speed.
2 Shutter priority—the photographer selects the shutter speed and the camera sets the correct aperture.
3 Programmed—the camera sets an appropriate shutter speed/aperture combination according to a pre-programmed selection.

Auto-winder In the strictest sense an auto-winder is a unit which can be attached to many SLRs for motorized single frame film advance. After each exposure the auto-winder automatically advances the film to the next frame and cocks the shutter. Many units, however, are capable of modest speed picture sequences. Some cameras have an auto-winder built into the main body.

B

B camera setting A shutter set to B remains open as long as the shutter release is depressed. To avoid camera shake it is advisable to use a cable release when making long exposures using the B setting.

Blur Unsharpness in the image caused by a number of factors, including camera or subject movement, or inaccurate focusing. Also, those parts of the image outside the depth of field zone are blurred. Blur can be deliberate to produce unusual pictures; for example, long exposure times can produce blur patterns that are soft (seascapes) or exciting (bullfighter).

Bracketing To make a series of different exposures so that one correct exposure results. This technique is useful for non-average subjects (snowscapes, sunsets, very light or very dark toned objects) and where film latitude is small (colour slides). The photographer first exposes the film using the most likely camera setting found with a light meter or by guessing. He then uses different camera settings to give more and then less exposure than the nominally correct setting. An example of a bracketing series might be 1/60th sec f8, 1/60th sec f5·6, 1/60th sec f11, *or* 1/60th sec f8, 1/30th sec f8, 1/125th sec f8.

C

Cadmium sulphide cell (CdS) A type of cell used in some hand-held light meters and some built-in camera meters. The resistance of the cell to a constant electrical voltage (supplied by a battery) changes as the light falling on the cell varies. The resulting current is either used to move a pointer on a scale or employed directly to alter the camera's shutter speed or aperture. CdS cells are more sensitive than selenium cells and are ideal when photographing in dim lighting conditions.

CC filters These are 'colour correcting' or 'colour compensating' filters which may be used either in front of the camera or when printing colour film, to modify the final overall colour of the photograph. Their various strengths are indicated by nusbers usually ranging from 05 to 50. Filters may be combined to give a complete range of colour correction.

Colour cast A local or overall bias in the colour of a print or transparency. Colour casts are caused mainly by poor processing and printing, the use of light sources which do not match the film sensitivity, inappropriate film storage (high temperature and humidity), and long exposure times.

Colour temperature Different white light sources emit a different mixture of colours. Often, the colour quality of a light source is measured in terms of colour temperature. Sources rich in red light have a low colour temperature—for example, photofloods at 3400 (Kelvin)—and sources rich in blue light have a high colour temperature—for example, daylight at 5500K. Colour films have to be balanced to match the light source in use, and films are made to suit tungsten lamps (3200K) and daylight (5500K).

Complementary colours These are pairs of colours which, when mixed together, give a grey (neutral). For example, a grey is formed when yellow and blue light are mixed together; therefore, yellow is complementary to blue and vice versa. Other complementary colours include green and magenta, red and cyan.

Contrast The variation of image tones from the shadows of the scene, through its mid-tones, to the highlights. Contrast depends on the type of subject, scene brightness range, film, development and printing.

Conversion filter Any filter which converts one light from one standard source to the colour of light from another standard light source. For example, a Wratten 85B filter converts daylight to photoflood type illumination. This filter, when placed in front of the camera lens, enables a camera loaded with tungsten colour film to give correct colour photographs in daylight. To compensate for the light absorbed by the filter, it is necessary to give extra exposure. This is determined by the filter factor.

Cropping The selection of just a portion of the original format of a negative or print so as to modify the composition. Cropping can take place at both the enlarging stage or later when the print is trimmed.

D

Daylight colour film A colour film which is designed to be used in daylight without or with electronic flash and blue flash-bulbs. This film type can also be used in tungsten or fluorescent lighting if a suitable filter is put in front of the lens or light source.

Depth of field The distance between the nearest and furthest points of the subject which are acceptably sharp. Depth of field can be increased by using small apertures (large f numbers), and/or short focal-length lenses and/or by taking the photograph from further away. Use of large apertures (small f numbers), long focal-length lenses, and near subjects reduces depth of field.

Depth of field preview A facility available on many SLR cameras which stops down the lens to the shooting aperture so that the depth of field can be seen.

Depth of field scale The scale, usually surrounding the lens barrel, which gives an easily read indication of depth of field.

Diffused image An image which has indistinct edges and appears 'soft'. Overall- or partially-diffused images can be produced in the camera by using special lenses and filters, or by shooting through various 'filmy' substances such as Vaseline, sellotape, and fine stockings.

DIN Deutsche Industrie Normen. A film speed system used by Germany and some other European countries. An increase/decrease of 3 DIN units indicates a doubling/halving of film speed, that is a film of 21 DIN (100 ASA) is half the speed of a 24 DIN (200 ASA) film, and double the speed of an 18 DIN (50 ASA) film. See also *ISO*.

Double exposure The process of exposing two separate images on one piece of film or paper.

E

Electronic flash A unit which produces a very bright flash of light which lasts only for a short time (usually between 1/500-1/40000 second). An electronic flash tube will last for many thousands of flashes and can be charged from the mains and/or batteries of various sizes.

Exposure The result of allowing light to act on a photosensitive material. The amount of exposure depends on both the intensity of the light and the time it is allowed to fall on the sensitive material.

Extension rings (tubes) Space rings which fit between the camera body and the lens, and allow the camera to focus on subjects closer than the nearest marked focusing distance of the lens.

F

Fast films Films that are very sensitive to light and require only a small exposure. They are ideal for photography in dimly lit places, or where fast shutter speeds (for example, 1/500) and/or small apertures (for example, f16) are desired. These fast films (400 ASA or more) are more grainy than slower films.

Film speed See *ASA*, *DIN* and *ISO*.

Filter Any material which, when placed in front of a light source or lens, absorbs some of the light coming through it. Filters are usually made of glass, plastic, or gelatin-coated plastic and in photography are mainly used to modify the light reaching the film, or in colour printing to change the colour of the light reaching the paper.

Fisheye lens A lens that has an angle of view greater than 100° and produces distorted images—lines at the edges curve inwards. Fisheye lenses have an enormous depth of field and they do not need to be focused.

Flare A term used to describe stray light that is not from the subject and which reaches the film. Flare has the overall effect of lowering image contrast and is most noticeable in the subject shadow areas. It is eliminated or reduced by using coated lenses (most modern lenses are multi-coated), lens hoods and by preventing lights from shining directly into the lens.

Flash See *Electronic flash*.

f numbers The series of internationally agreed numbers which are marked on lenses and indicate the brightness of the image on the film plane—so all lenses are focused on infinity. The f number series is 1·4, 2, 2·8, 4, 5·6, 8, 11, 16, 22, 32 etc—changing to the next largest number (for example, f11 to f16) decreases the image brightness to $\frac{1}{2}$, and moving to the next smallest number doubles the image brightness.

Focal length The distance between the optical centre of the lens (not necessarily within the lens itself) and the film when the lens is focused on infinity. Focal length is related to the angle of view of the lens—wide-angle lenses have short focal lengths (for example 28mm) and narrow-angle, lenses have long focal lengths (for example, 200mm).

Focal plane The plane behind the lens that produces the sharpest possible image from the lens—any plane nearer or farther from the lens produces a less sharp image. For acceptable results the film must be held in the focal plane.

Focal plane shutter A shutter that is positioned just in front of the film (focal plane). The exposure results from a slit travelling at constant speed across the film—the actual shutter speed depending on the width of the slit. As a focal plane shutter is built into the camera body, it is not necessary for lenses to incorporate shutters.

252

Focusing screen A ground glass screen on to which the image is focused. Focusing screens may also incorporate a variety of focusing aids; a split-image rangefinder or microprism rangefinder, for example. Some cameras have screens that can be interchanged with others, according to the subject matter and the preference of the photographer.

Format Refers to the size of image produced by a camera, or the size of paper and so on.

G

Grain The random pattern within the photographic emulsion that is made up of the final (processed) metallic silver image. The grain pattern depends on the film emulsion, plus the type and degree of development.

H

High key A photograph that consists of mainly light tones, a few middle tones, and possibly small areas of dark tones. The overall impression is of lightness and delicacy. A high key photograph is achieved by using diffused lighting and a subject that is predominantly light in tone.

Highlight Those parts of the subject or photograph that are just darker than pure white eg. lights shining off reflecting surfaces (sun on water, light shining through or on leaves). The first parts of a scene or photograph to catch the eye of the viewer are likely to be the highlights—it is therefore important that they are accurately exposed and composed.

Hue The colour of an object is described in terms of its brightness (light or dark), saturation (purity), and hue—the hue being the colour name, for example, red, blue, green.

I

Interchangeable lens A lens which can be detached from the camera body and replaced by another lens. Each camera manufacturer has its own mounting system (screw thread or bayonet type) which means that lenses need to be compatible with the camera body. However, adaptors are available to convert one type of mount to another.

ISO International Standards Organization. The ISO number indicates the film speed and aims to replace the dual ASA and DIN systems. For example, a film rating of ASA 100, 21 DIN becomes ISO 100/21°.

L

Leaf shutter A type of lens shutter which is usually built into a lens and operates by several metal blades opening outwards to reveal the diaphragm aperture and then closing when the exposure time is completed. Leaf shutters have the advantage of being able to synchronize with flash at any speed but only have a top speed of 1/500 second.

Lens hood (shade) A conical piece of metal, plastic or rubber which is clamped or screwed on to the front of a lens. Its purpose is to prevent bright light sources, such as the sun, which are outside the lens field of view from striking the lens directly and degrading the image by reducing contrast (flare).

Long focus lens Any lens with a greater focal length than a standard lens, for example, 85mm, 135mm and 300mm lenses on a 35mm camera. These long focal length lenses are ideal for portraiture, sports and animal photography.

Low key This describes any image which consists mainly of dark tones with occasional mid and light tones.

M

Monochrome A monochrome picture is the one which has only one colour; the term is usually applied to black and white prints or slides.

Motor-drive A motor-drive provides motorized film advance, both single frame and sequence. Motor-drive units are generally capable of much faster sequence rates (given in frames per second-fps) than auto-winders.

Multiple exposure The process of making more than one exposure on the same piece of film, thus allowing one image to be built on top of another.

N

Neutral density filter A filter which, when placed in front of the camera lens, reduces the amount of light reaching the film without altering its colour.

Normal lens A phrase sometimes used to describe a 'standard' lens—the lens most often used, and considered by most photographers and camera manufacturers as the one which gives an image most closely resembling normal eye vision. The normal lens for 35mm cameras has a focal length of around 50mm.

O

Over-exposure Exposure which is much more than the 'normal' 'correct' exposure for the film or paper being used. Over-exposure can cause loss of highlight detail and reduction of image quality.

P

Panning The act of swinging the camera to follow a moving object to keep the subject's position in the viewfinder approximately the same. The shutter is released during the panning movement.

Parallax error The difference between the image seen through the viewfinder of a camera and the image seen by the lens, which results from the fact that the two view from slightly different positions. For distant subjects parallax error is negligible, but the effect increases as subject distance decreases. Parallax error only occurs when cameras have separate viewfinder and taking lenses, not with single lens reflex cameras (SLRs) where viewing is through the taking lens.

Pentaprism An optical device, used on most 35mm SLR cameras, to present the focusing screen image right way round and upright.

Polarizing filter A polarizing (or pola) filter, depending on its orientation, absorbs polarized light. It can be used to reduce reflections from surfaces such as water, roads, glass and also to darken the sky in colour photographs.

Primary colours See *Additive colour.*

R

Reciprocity law failure Failure of the reciprocity law (which states: exposure = image brightness at the focal plane x shutter speed) manifests itself in loss of sensitivity of the film emulsion and occurs when exposure times are either long or very short. The point of departure from the law depends on the particular film, but for most camera films it occurs outside the range 1/2-1/1000 second, when extra exposure is needed to avoid under-exposure.

Reflector Any surface which is used to reflect light towards the subject, and especially into shadow areas.

Rim light Light placed behind the subject to give a pencil of light around the subject's outline.

S

Saturation The purity of a colour. The purest colours are spectrum colours (100% saturation and the least pure are greys (0% saturation).

Scattering of light The bending of light caused by interaction of light waves with small particles of matter. Scattering occurs in the atmosphere and within photographic emulsion.

Selective focus The technique of choosing a particular part of a scene to focus on. The aperture setting determines whether this selected portion of the scene alone is in focus or whether it is simply the centre of a zone of sharp focus.

Self timer A delayed action mechanism which causes the shutter to fire about ten seconds after the release is depressed. This can be used so the photographer can place himself in the picture or to minimize camera shake at slower shutter speeds.

Shutter The device which controls the duration of exposure.

Single lens reflex (SLR) A camera which views the subject through the 'taking' lens via a mirror. Many SLRs also incorporate a *pentaprism*.

Skylight filter A filter which absorbs UV light, reducing excessive blueness in colour films and removing some distant haze.

Slave unit A light-sensitive device which triggers other flash sources when activated by the light from the camera-connected flash.

Snoot Cone-shaped lamp attachment which concentrates the light into a small circular area.

Soft-focus lens A lens designed to give slightly unsharp images. This type of lens was used primarily for portraiture. Its results are unique and are not the same as a conventional lens defocused or fitted with a diffusion attachment.

Standard lens See *Normal lens.*

Star filter When placed in front of the camera lens, a star filter gives a star-like appearance to strong highlights.

Stop Another term for aperture or exposure control. For example, to reduce exposure by two stops means to either reduce the aperture (for example, f8 to f16) or increase the shutter speed (1/60 sec to 1/250 sec) by two settings. To 'stop down' a lens is to reduce the aperture, that is, increase the f-number.

Stopping down The act of reducing the lens aperture size ie, increasing the f-number. Stopping down increases the depth of field.

T

Telephoto lens A long focal-length lens of special design to minimize its physical length. Most narrow-angle lenses are of telephoto design.

Through-the-lens (TTL) metering Any exposure metering system built into a camera which reads the light after it has passed through the lens. TTL metering takes into account filters, extension tubes and any other lens attachments. These meters give only reflected light readings. See also *Cadmium sulphide cell (CdS).*

Tonal range The comparison between intermediate tones of a print or scene and the difference between the whitest and blackest extremes.

Tripod A three-legged camera support.

Tungsten film Any film balanced for 3200K lighting. Most professional studio tungsten lighting is of 3200K colour quality.

Tungsten light A light source which produces light by passing electricity through a tungsten wire. Most domestic and much studio lighting uses tungsten lamps.

Twin lens reflex (TLR) A camera which has two lenses of the same focal length—one for viewing the subject and another lens for exposing the film. The viewing lens is mounted directly above the taking lens.

U

Ultra-violet radiation Invisible energy which is present in many light sources, especially daylight at high altitudes. UV energy, if it is not filtered, causes excessive blueness with colour films.

Underexposure Insufficient exposure of film or paper which reduces the contrast and density of the image.

V

Viewfinder A simple device, usually optical, which indicates the edges of the image being formed on the film.

Viewpoint The position from which the subject is viewed. Changing viewpoint alters the perspective of the image.

W

Wide-angle lens A short focal-length lens which records a wide angle of view. It is used for landscape studies and when working in confined spaces.

Z

Zoom lens Alternative name for a lens having a range of focal lengths. One zoom lens can replace several fixed focal-length lenses, but results are likely to be inferior.

Index

A

Abstract effects, 217, 220, 221
Accent colour, 119, 134-7
 exposure and composition, 134, 136
 interiors, 136, 137
Action pictures *see* Movement
Auto-focus cameras, 203, 248
Automatic aperture priority, 234, 248

B

Background(s), 26-9, 100
 competitive, 26, 27, 28
 false attachments, 26, 27
 intrusive light or colour, 28
 neutral, for colour contrast, 120, 123
Backlighting, 103, 107, 164, 165, 169, 173-4, 188, 189, 198
Bird's eye view *see* High viewpoint
Black and white film, 152, 202, 208
Black and white photography, 150-3
 colour as black and white, 150
 filters, 70-1, 74, 150, 152
 light and, 150, 152
 pattern, 91
 tone and contrast, 100-3
Blur, 212, 213, 216, 217, 218, 224, 226, 227, 232
 creative effects with, 232
 distance-related, 232
 experimenting with, 214-15
 multiple exposure and, 240
 zooming, 222, 223
Buildings, photographs of
 diagonal perspective, 80, 81
 edges, 40
 frames for, 44-6
 lines and shapes, 86
 shadows, 166-7, 172-3

C

Camera mounts, 232
Camera shake, 157, 217, 230, 248
Car tail-lights, moving, 198, 203, 204, 232
Chopping shutter, 245
Clamps, 232
Colour(s), 116-49
 abstract effects, 217
 accent, 119, 134-7
 as black and white, 150, 152
 brightness, 118
 changing colour of light, 192-7
 complementary, 118, 119, 126, 129
 desaturated, 119, 138, 177, 181, 214
 diffused, 138, 139
 exposure for, 149
 film and, 146-8, 248
 filters, 125, 127, 133, 146, 147, 148
 how we react to, 12
 hue, 118
 intrusive, in background, 28
 monochromatic, 119, 138-40, 150
 to emphasize mood, 12, 14
 multi-coloured pictures, 142-5
 muted, 138-41
 pattern and, 91-2
 polychromatic, 119, 142-5
 primary, 118, 119, 126, 127, 129
 reactions with each other, 118
 saturation, 118, 165, 168, 170, 172, 182, 186, 187
 time and, 192-6
Colour as the subject, 118, 120-5
 close in, 120, 124
 eliminating glare, 122, 124, 125
 experimenting, 124
 limiting colours, 120, 122
 neutral background for contrast, 120, 123
 simple design, 124
 soft lighting, 124
 strengthening colours, 120
Colour casts, 140, 147, 148, 149
Colour contrast, 86, 118, 120, 122, 126-9, 177

Colour film, 248-9
 changing colour of light and, 192-7
 correction filters, 148, 149, 186, 196
 effect of colour and light, 146-8
 night photographs, 200
 shooting into the sun, 186
Colour harmony, 118, 130-3
 exposure, 132-3
 filters, 133
 shooting into light, 131, 133
 viewpoint, 130, 132
Colour slides, 200, 202, 205
Colour wheel, 118-9, 130
Complementary colours, 118, 119, 126, 129
Composition, 16-49
 background, 26-9
 creating depth, 58-63
 diagonal, 76-81
 edges of the picture, 40-3
 foreground, 30-3
 frame within a frame, 44-9
 horizon, 22-5
 intersection of thirds, 36
 seeing and analysing subject, 10
 using viewfinder, 18-21
 where to put subject, 34-9
 see also Colour; Light; Perspective
Contrast, 107
 black and white, 151
 colour, 102, 118, 120, 126-9, 177
 developing and printing to control, 102
 increasing, 102
 lighting, 177-8
 lines and shapes, 84, 85-6, 87
 neutral, 120, 123
 subject, 178
 texture and, 96, 99
 tonal, 100-3
Contre-jour, 186
Converging lines, 52-4
Converging verticals, 44, 81
Cropping (edges of picture), 19, 40-3
 at the top, 40
 changing the meaning, 42
 emphasis in printing, 43
 finished print, 43
 making a point, 42
 sides, 42

D

Depth, creating, 58-63
 diagonal perspective emphasizing, 76
 diminishing shapes, 62-3
 filling the mid-ground, 62
 high viewpoint and, 68
 lead-in lines, 60
 overlapping forms, 58, 60-1
 scale, 58, 60
 selective focusing, 58, 62
 texture, 58, 62
Depth of field, 27, 30, 31, 32, 48, 129, 246-7
Depth of field preview button, 32, 246
Diagonal composition, 76-81, 86, 87
 detail, 77
 pattern, 76, 77, 88-9
 perspective, 76, 77, 79-81
 silhouette, 106
 two-dimensional, 76, 78, 79
Diminishing shapes, 62-3
Dissolve shows, 205
Double exposure, 205, 220, 222, 234-9, 240
Double exposure prevention lock, 234

E

Edges of picture *see* Cropping
Exposure(s), 246-8
 colour and, 121, 132, 134, 136, 149
 double, 205, 220, 222, 234-9, 240
 movement and, 214, 215, 216, 217, 221, 222, 228, 232
 multiple, 207, 222, 234-45
 night, 109, 198-200, 202, 203, 204,

Exposures cont
 205, 208, 209, 232
 reciprocity law failure, 198, 200
 subjects against the light, 188
 sunsets, 190
 tonal contrast and, 100, 103
 zooming, 222
Extension tubes, 73

F

Film, 248-9
 effect of colour on, 146-8
 night photographs, 202
Film speeds, 121, 202, 204, 234, 248
Filters
 for black and white photos, 70-1, 74, 150, 152
 colour correction, 133, 145, 146, 148, 149, 186, 196
 cross screen, 204
 fog, 14, 133
 graduated effect, 74
 multiple exposure, 240, 241, 242
 neutral density, 145, 215, 216, 224
 night photos, 202, 204
 polarizing, 70, 73, 74, 125, 127, 216, 232
 skylight, 186
 soft focus, 14, 133, 140, 175
 starburst, 186, 188, 204
 UV or haze, 70, 148
Fireworks and bonfires, 198, 200, 208, 209
Flare, 65, 106, 108, 172, 188, 189, 200
Flare-spots, 73, 172
Flash, flash guns, 158, 188, 198, 232
 bounce, 168, 176, 179, 184
 illuminated dials, 203
 movement and, 212, 218, 219, 220
 multi- or motor-drive, 207
 multiple exposures, 240-3
 outdoors, 206, 207
 strobing, 240, 244
 umbrella, 189
Flash meter, 241
Fluorescent lights, 146, 147, 158, 176, 178, 179
Focusing light, 203
Fogging, 189
Food photography, 94, 95, 183
Foreground, 30-3, 100
 constructive use of, 30
 creating depth, 30
 framing with, 32, 33
 losing the, 32
Frames within frames, 44-9
 buildings, 44-6
 mirrors, 48, 49
 people, 46-7
 unusual, 48
Funfairs, night photos of, 205-6

G

Glare, eliminating, 122, 124, 125, 131

H

Haze, 70, 139
Highlights, 188, 214
 on different surfaces, 160, 161, 162, 177
 light sources and, 164, 166, 169, 170, 171, 172, 175, 176-7, 180, 181, 182, 184
High viewpoint, 68-81, 109, 226
 changing lenses, 71
 creating pattern, 69
 filters, 70-1
 lighting and, 68, 70
 line and shape, 86
 perspective, 68, 70
 two-dimensional diagonals, 79
Horizon, 22-5
 horizontal or vertical photos, 22, 76
 intersection of thirds, 22-3, 36
 viewpoint and, 54

Hue, 118

I

Interiors, indoor photos
 accent colour, 136, 137
 medium light source, 183-4
 shooting into the light, 188-9
Intersection of thirds, 22-3, 36

K

'Keyhole effect', 45

L

Landscapes, 10
 accent colour, 136
 colour contrast, 126, 128
 colour harmony, 130-1
 composing in viewfinder, 18-19
 creating depth, 58-9
 diagonal perspective, 80-1, 86
 effect of lines and shapes on mood, 86
 emphasizing space, 38
 foreground, 30
 horizon, 22
 intersection of thirds, 36
 moonlit, simulated, 239
 patterns, 90
Large source lighting, 158, 165, 170, 176-81
 angle of light, 179-80
 bounce flash, 176, 179
 changing to medium source, 182
 colour contrast, 177
 complexity, 178
 exposure for overcast sky, 177
 fluorescent lighting, 158, 176, 178, 179
 lighting contrast, 177-8
 matt objects, 177
 overcast sky, 158
 shiny objects, 177
 subject contrast, 178
Lead-in lines, 60
Lens hood, 106, 173, 189
 collapsible rubber, 232
Lenses, 250-1
 fish-eye, 72
 flare, 189
 multi-coloured pictures, 142, 144
 portraits, 65-6, 250
 telephoto, 41, 58, 71, 72, 190, 250
 viewpoint and, 65-6, 71, 72, 250
 zoom, 70, 189, 205, 222-3, 250
 see also Wide angle lenses
Light, lighting, 18, 84, 154-209
 black and white photos and, 150, 152
 changing colour of (dawn till dusk), 192-7
 complementary colours of, 118, 119
 contrast, 177-8
 different surfaces, 160-3
 effect on colour film, 146-8
 'flat', 157-8
 fluorescent, 146, 147, 158, 178, 179
 functions of, 157
 high viewpoint and, 68, 70
 intrusive, background, 28, 29
 moving, 198, 203, 204
 muted colour and, 138
 night photos, 109, 198-209
 patterns and, 91
 photoflood, 158
 primary colours of, 118, 119
 rim, 186, 198, 232
 shooting into the, 186-91
 silhouettes and, 105-6, 107
 soft, for strong colours, 124
 spotlights, 147, 170, 172, 188
 subjective or objective, 164
 sunrise, 193, 196
 sunset, 196, 197
 texture and, 65, 94, 96, 97
 tone and contrast, 100, 101, 102, 103
 tungsten, 110, 146, 147, 148, 188, 248

Light, lighting cont
 viewpoint and, 64-5
 see also Flash; Light sources; Sun
Light meters, 200, 241
Light sources, 156-85
 back lighting, 164, 165, 169, 173-4
 189
 effective, 158
 front lighting, 164, 165, 168, 179-80
 half-side lighting, 164, 165, 168,
 179-80
 large, 158, 165, 170, 176-81
 medium, 158, 159, 162, 170, 182-5
 multiple exposures, 240
 night photos, 198, 206
 positions or angles of, 164-9,
 179-80, 192
 side lighting, 164, 165, 168, 174
 small (hard lighting), 157, 158, 162,
 164, 170-5
 top lighting, 164, 165, 169, 179
Lines and shapes, 84-7
 altering the mood, 86
 contrast, 84, 85-6, 87
 controlling, 86
 diagonal, 86, 87
 dominant, 84-5
 tracings, 84
Low viewpoint, 72-5
 action pictures, 74
 choice of lens, 72
 silhouettes, 72, 74, 109
 small subjects, 74

M
Medium source lighting, 158, 159, 162,
 170, 182-5
 artificial light, 184
 changing small or large source to,
 172-4, 182
 indoor, 182, 184, 185
 natural lighting, 184
 outdoor, 182
 shiny or matt objects, 182
 see also Light; Light sources
Mirrors, 48, 49, 72
Misting, 203
Monochromatic colour/pictures, 119,
 138-40, 150
Monopod, 222
Movement, 212-29
 abstract effects, 217, 220, 221
 blur, 212, 214-5
 double exposure, 220, 222
 expressing, 212-7
 freezing subject, 218
 low viewpoint action pictures, 74,
 75
 multiple exposure, 240-5
 night photos, 198, 203, 204, 232-3
 panning, 212-3, 217, 224, 225, 230,
 231, 248
 panning and long exposures, 215,
 217
 preventing over-exposure, 224
 sports viewfinder, 213-4
 'streaking', 222, 232
 using, 218-29
 writing and drawing with light, 220,
 221
 zooming, 222-3, 224
 see also Blur; Shutter speeds
Moving vehicle, pictures from, 230-3
 blur, 232
 camera mounts and optics, 232
 creative effects, 232
 inside vehicle, 232
 motion and distance, 230
 night shots, 232-3
 panning, 230, 231
 stopping movement, 230, 231
Multi-coloured pictures, 142-5
Multiple exposures, 207, 222, 234-9
 changing lenses, 236
 chopping shutter, 245
 exposing whole film twice, 238, 239
 exposures and shutter speeds, 234

Multiple exposures cont
 filters, 240, 241, 242
 movement and light, 240-5
 moving the camera, 234, 236
 strobing flash, 244
 studio flash, 242-3
 tungsten and flash, 240-2
 wind and water, 234, 236-7
Muted colour, 138-41
 artificial aids, 140
 effect of light, 138
 soft focusing, 140

N
Neon signs, 75, 200
Night photography, 198-209
 city nightlights, 204
 equipment, 202-3
 exposures, 198-200, 202, 203, 204
 film and filters, 202, 204
 fireworks and bonfires, 208, 209
 funfairs, 205-6
 light and subject, 198
 light on water, 206
 light sources, 198, 199, 206
 lighted subjects, 198
 meters, 200
 moving lights, 198, 203, 204,
 232-3
 portraits, 208
 silhouettes, 104, 109
 special effects, 206-7
 street lighting displays, 205
 supplying your own light, 206
 'writing with light', 208

O
Over-exposure, 14, 132, 139, 140, 145,
 149, 224
Overlapping forms, 58, 60-1

P
Panning, 212-3, 214, 225, 248
 long exposures and, 215, 217
 pictures from moving vehicles, 230
 zooming and, 222, 223
Parallax effect, 230
Patterns, 88-93
 colour and, 91-2
 diagonal, 76, 77, 88-9
 effect of light on, 91
 repetition, 88-9
 static, 88
 transient, 88
People, photographing, 74
 colour contrast, 126, 128
 cropping, 40, 41, 42, 43
 frames for, 46-7, 49
 multi-coloured, 142, 144, 145
 picture essay, 110-11
Perspective, aerial or atmospheric, 52
Perspective, linear, 52-7, 84
 converging lines, 52-4
 converging verticals, 44, 81
 diagonal, 76, 79-81
 high viewpoint and, 68, 70
 horizon, 22-5
 low viewpoint and, 72
 shadows to dramatize, 172-3
 using grid, 56, 57
 vanishing points, 54, 55, 56
 viewpoint and, 53, 54, 56, 65
Photoflood, 158
Physiograph, 221
Picture essays, 110-5
Polychromatic colours, 119, 142-5
Portraiture, 38
 contrast, 86
 cropping, 40, 41, 42
 highlights and shadows, 166, 167
 longer lenses for, 65-6
 night, 198, 207, 208
 self-portraits, 78, 225
 see also People
Primary colours, 120
 contrast, 126, 127, 129
 of light, 118, 119

Primary colours cont
 of pigment (paint), 118, 119
Printing papers, 102, 103, 151
Push processing, 202

R
Reciprocity law failure, 198, 200
Reflectors, 158, 189

S
Selective focusing, 58, 62, 109, 144
Shades, 100
Shadows, 101
 cast, 156, 158, 160, 170, 174, 175,
 176, 180, 184
 different surfaces and, 160, 161,
 162
 high viewpoint, 68, 70
 shooting into the light, 186, 189
 unwanted, 175
 using creatively, 175
 see also Light sources
Shooting into the sun/light, 186-91
 colour harmony and, 131, 133
 exposure, 188
 interiors, 188-9
 lens flare, 189
 silhouettes created by, 105, 106, 107
 108
 starburst filters, 186, 188
 sunsets, 190-1
Shutter speeds, 212, 214, 215, 218,
 219, 222, 224, 226, 227, 230, 234,
 246-7
Side lighting, 164, 165, 168, 174
 half-, 164, 165, 168
Silhouettes, 21, 32, 84, 100, 104-9, 196,
 203, 233
 fog and mist, 104, 108, 109
 frames within frames, 44, 45
 natural lighting, indoors, 105
 night lights, 104, 109
 semi-, 104
 shooting into sun, 105, 106, 107,
 108
 studio lighting, 106
 sunset, 190-1
 viewpoints and, 72, 74, 109
SLR cameras, 72, 213-4, 234
Small source lighting (hard lighting),
 157, 158, 162, 164, 170-5
 backlighting and, 173-4
 changing the picture, 174-5
 changing to medium or large source
 lighting, 172-4, 182
 unwanted shadows, 175
 using shadows creatively, 175
Snoot, 188
Soft focusing, 140, 141
 filters, 14, 133, 140, 175
Sports photography, 38, 74, 111,
 216-7, 218, 220, 222-3, 224
 see also Movement
Sports viewfinder, 213-4
Spotlight, 147, 170, 172, 188
Starburst effect, 73, 74
Starburst filters, 186, 188, 204
Still-life photography, 94, 126, 144,
 145, 166, 175, 222
Streaking, 222, 232
Street lights, 198, 200, 204, 205
Strobing flash lights, 240, 244
Subject:
 colour as the, 118, 120-5
 contrast, and large source lighting,
 178
 emphatic alternatives, 38, 39
 freezing in mid-movement, 218
 intersection of thirds, 36
 leaving space around, 38, 39
 night photos, 198
 picture essays, 110
 seeing and analyzing, 10
 where to put, 34-9
Sun, sunlight, 156
 as small source lighting, 156, 157,
 158, 170-1, 172

Sun, sunlight cont
 shooting into the, 105, 106, 107,
 108, 186-9
Sunrise, 193, 196, 233
Sunsets, 107, 148, 190-1, 196, 197
 from moving vehicles, 232
Surfaces, lighting different, 160-3
 matt, 160, 161, 162, 163, 166, 177,
 182
 semi-matt, 160, 161, 162, 163, 166
 shiny, 160, 161, 162, 164, 166, 177,
 182

T
Telephoto lenses, 41, 58, 71, 72, 190,
 250
Texture, 58, 62, 78, 94-9, 140
 contrast, 96, 99
 for realism, 94
 how to accent, 96, 99
 lighting and, 65, 94, 96, 97, 160, 161,
 162, 164, 166, 168, 171, 177,
 182
 photographing toward the sun, 96
 skin, 97, 99
 under-exposure and, 97, 98, 99
Tints, 100
TLR cameras, 72, 213-4, 234
Tone(s), 58, 122
 black and white, 150, 152
 and contrast, 100-3, 126, 127
 creating mood by, 101-2
 effect of light on, 101
 form and, 100
Tripods, 202, 204, 220, 222, 228, 234,
 236, 238
TTL meters, 45, 74, 200, 203, 205,
 241
Tungsten film, 147, 202, 203, 204, 206,
 207, 214, 233, 248
Tungsten lights, 110, 146, 147, 148,
 188, 220, 240, 241, 244

U
Under-exposure, 97, 98, 99, 102, 125,
 127, 177, 203, 214, 222, 234
 colour and, 132-3, 141, 144, 145, 149

V
Vanishing points, 54, 55, 56
Viewfinders:
 composing in the, 18-21
 right-angle attachment, 72
 sports, 213-4
 waist-level, 72, 73
 where to put subject, 34-9
Viewing frame, 18, 20, 21
Viewpoint, 28, 64-7, 109, 130, 132,
 136, 214
 changing, 18, 20, 21
 changing lenses, 65-6
 diagonal, 76-81
 framing, 66
 high, 21, 22, 53, 55, 68-71, 77
 lighting, 64-5, 68
 low, 21, 53, 55, 72-5
 multi-coloured pictures, 142-4
 perspective and, 54, 56, 65

W
Waist level cameras, 72, 73
Waist level finder (SLR), 72
Wide-angle lenses, 48, 63, 66, 70,
 71, 72, 74, 77, 80, 121, 144, 190,
 232, 250
Worm's eye view see Low viewpoint
Writing and drawing with light, 208,
 220, 221

Z
Zooming, zoom lenses, 70, 189, 205,
 212, 222-3, 224, 232, 250
 double exposure, 222
 exposure, 222
 focal lengths, 222
 multiple exposure, 222
 panning and, 222, 223

Photographic credits

Julian Calder 1, 8; Eric Crichton 6; Anthea Sieveking/Vision International 2, 3; Chris Thomson 4, 5.

Why Take the Picture?
Michael Busselle 12, 13; Colour Library International 10, 11; England Scene 14 (bottom); John Garrett 15 (top right); Ernst Haas/Magnum 15 (top left); Suzanne Hill 15 (bottom); Alec Langley/Aspect 14 (top).

Composing the Picture
Malcolm Aird 44; Caroline Arber/Lynch 49; Stephen Ballantyne/Eaglemoss 27 (right); Colin Barker 18-19 (centre bottom); Colin Barker/Eaglemoss 27 (left), 29 (top); John Bulmer 24 (top right and bottom); 32, 33 (bottom right); 36 (top); 38 (top); Michael Busselle 43 (top); Bryn Campbell/John Hillelson 37; Bill Coleman 40, 42 (bottom); Anne Conway/Eaglemoss 46 (bottom); Eric Crichton 16-17, 34 (bottom); Robert Estall 34 (top); Andrew Evans 45 (top); Jon Gardey/Robert Harding 31; John Garrett 48 (bottom); Thomas Höpker/Magnum 41 (bottom); Ken Kirkwood/Eaglemoss 20-1; Robin Laurance 33 (bottom left); Laurence Lawry 46 (centre); Barry Lewis 25, 33 (top); Barry Lewis/Eaglemoss 22-3; Roland Michaud/John Hillelson 38 (bottom); Ed Mullis/Aspect 48 (top); Martin Parr 35; Spike Powell 24 (top left); Chris Schwarz/Mudra 43 (bottom); Tomas Sennett/John Hillelson 29 (bottom), 39 (top), 41 (top left); Eric Stoye 36 (bottom); Homer Sykes 26 (top); Homer Sykes/Eaglemoss 26 (bottom), 28; Patrick Thurston 30, 45 (bottom); John Walmsley 42 (top); Patrick Ward 39 (bottom); William Wise 41 (top right); Wilf Woodhead 47; ZEFA 18-19.

Perspective and Viewpoint
Robin Bath 75 (top right); 78 (top right); Timothy Beddow 69 (top); Ron Boardman 80 (bottom); Jane Burton/Bruce Coleman 75 (top left); John Bulmer 53 (bottom left); Michael Busselle 57, 74, 77 (bottom); Michael Busselle/Eaglemoss 70-1; Bryn Campbell 60 (top); Jo Clark for Kenneth Griffiths 58-9; Anne Conway 65, 73 (top); Bob Davis/Aspect 69 (bottom), 78 (bottom); Per Eide 77 (top); Roy Emerson 50-1; Robert Estall 63; John Garrett 75 (bottom); Ashvin Gatha 68; John Goldblatt 62 (centre); Graeme Harris 76; Tessa Harris 66, 78 (top left); Steve Herr/Vision International 52; Suzanne Hill 73 (bottom); David Kilpatrick 72 (bottom); Paolo Koch/Vision International 53 (top), 72 (top); David MacAlpine 81; Lisa Mackson 53 (bottom right), 62 (top); Mike Newton 55 (bottom); Clay Perry 61; Van Phillips 67; Clive Sawyer/ZEFA 55 (top); Tomas Sennett/John Hillelson 62 (bottom); Tino Tedaldi 60 (bottom), 79; Patrick Thurston 64; Adam Woolfitt/Susan Griggs Agency 56; Mike Yamashita/Aspect 80 (top).

The Details that Count
Ardea 93 (top right); Bruno Barbey/John Hillelson 88; Colin Barker 93 (centre right), 97 (bottom left); Jonathan Bayer 103 (top right); Michael Boys/Susan Griggs 104; John Bulmer 105 (top); Michael Busselle 84 (bottom), 85 (bottom), 87, 89, 92 (centre right, bottom left, bottom right), 93 (top left, centre left), 97 (top left and right, bottom right), 99 (bottom right), 100 (top), 102 (top), 105 (bottom), 109; Michael Busselle/Eaglemoss 101 (top); 103 (bottom right); Bill Colman 98, 99 (bottom left); Cressida 93 (bottom right); Eric Crichton 92 (top), 95 (bottom), 97 (centre); Michaelangelo Durazzo/Magnum 91 (centre); Gordon Ferguson 86 (bottom); Paul Forrester 95 (top); Georg Gerster/John Hillelson 90; Alfred Gregory 84 (top); Suzanne Hill 91 (bottom), 92 (centre left); Eric Hosking 82; Karsh/Camera Press 99 (bottom); Bob Kauders 103 (top left); Robin Laurance 102 (bottom); Peter Myers 106 (top); Mike Newton 94; Peter O'Rourke 110, 111; Spike Powell 106 (bottom right); George Rodger/Magnum 86 (top), 96, 106 (bottom left), 107; John Sims 112-5; Chris Smith 108 (bottom); Patrick Thurston/Woodfin Camp 108 (top); Richard Tucker/Eaglemoss 103 (bottom left); Herbie Yamaguchi 100 (bottom), 101 (bottom).

The Excitement of Colour
Aspect 128; Colin Barker 128 (bottom left), 144 (right); Ron Boardman 125 (bottom right); John Bulmer 136, 150 (bottom); Mike Burgess/The Picture Library 130; Michael Busselle 124, 125 (top and bottom left), 129 (top), 133 (top), 139 (bottom left), 148 (bottom), 150 (centre) 151 (top right and bottom), 152; Ed Buziak 120, 121 (bottom); Bryn Campbell 126, 137 (top right); Colour Library International 128 (bottom right), 132 (bottom); Raul Constancio 121 (top); Valerie Conway 137 (top left); Eric Crichton 138, 140 (top left); Bob Davis/Aspect 122 (bottom right); Les Dyson/Aspect 127 (bottom); Gary Ede 133 (bottom); Gordon Ferguson/Eaglemoss 146, 147 (top left and right), 149; John Garrett 132 (top); Alfred Gregory 143 (bottom); Ernst Haas/John Hillelson 134 (bottom); Graeme Harris 139 (top), 145 (top), 148 (top left); Gunter Heil/ZEFA 150 (top right), 151 (top left); Suzanne Hill 123; J P Howe 139 (bottom right); Paolo Koch/Vision International 116; Robin Laurance 122 (bottom left), 129 (bottom right), 137 (bottom), 140 (bottom); Don McCullin/Magnum 153; John McGovren 127 (top right), 131 (top); Mike Newton 118, 119, 150 (bottom left and bottom right); Julian Nieman/Susan Griggs 147 (bottom right); I Okuda/Aspect 143 (top); Martin Riedl 141; Clive Sawyer 131 (bottom); John Sims 122 (top), 127 (top left), 140 (top right), 142; Libuse Taylor 134 (top), 145 (bottom); Michael Taylor 144 (left); Patrick Thurston 135; John Walmsley 147 (bottom right).

Lighting for Better Pictures
Tom Ang/Robert Harding 205 (bottom); Robin Bath 196; Timothy Beddow 187, 190; Anthony Blake 183; Ron Boardman 178 (top); Michael Boys/Susan Griggs 169 (centre), 184; Dan Budnik/John Hillelson 198 (top centre and right), 202; John Bulmer 178 (bottom), 180 (bottom); Michael Busselle 166; Michael Busselle/Eaglemoss 189 (top); Colour Library International 179, 199, 209; Raul Constancio 195 (top); Ray Daffern/England Scene 180-1 (centre bottom); Lisl Dennis/Image Bank 194; England Scene 181 (bottom), 184-5 (centre bottom); Robert Estall 203 (centre); Michael Friedel/Image Bank 197 (bottom); Jon Gardey/Robert Harding 160 (top); John Garrett 173 (top), 177 (centre), 186 (top), 189 (bottom), 192 (top), 193, 195 (bottom), 208 (bottom); Robert Glover 198 (bottom); Greek National Tourist Office 174 (right); Richard Greenhill 157, 159, 164, 165 (top), 167, 173 (bottom), 176 (bottom), 180 (top), 185 (top); Richard Greenhill/Eaglemoss 165 (bottom); Alfred Gregory 200, 204; Robert Harding 158, 169 (bottom); Eric Hayman 203 (top); Suzanne Hill 171, 181 (top); Laurie Lewis 203 (bottom); Alexander Low/John Hillelson 191 (bottom); David R MacAlpine 191 (top); Pete Mackertich 207 (bottom); Tim Megarry 172 (bottom); Colin Molyneux 197 (top); Alasdair Ogilvie/Eaglemoss 162, 163; Clay Perry 185 (bottom); Remy Poinot 192 (bottom); Spike Powell 161; Clive Sawyer 156, 188, 201; Clive Sawyer/Eaglemoss 208 (top); Giles Sholl 205 (top and centre); Homer Sykes/John Hillelson 186 (bottom); Jack Taylor 174 (left), 175; Ray Tanner 206; Tino Tedaldi 207 (top); Richard Tucker 177 (centre); Malcolm Warrington/Eaglemoss 160-161 (bottom), 168, 170, 176 (top), 182; Adam Woolfitt/Susan Griggs Agency 172-173 (centre); Mike Yamashita/Aspect 154.

Movement and Multiple Exposures
Robert Ashby 225; John Barker 220 (top); Timothy Beddow 216 (top right); Steve Bicknell/Eaglemoss 232 (centre); Michael Busselle 219 (bottom), 221 (top centre), 234; Michael Busselle/Eaglemoss 243; Ed Buziak 224 (bottom), 231 (top), 232 (bottom); Julian Calder 238; Ron Chapman 226; Gerry Cranham 217 (top); Eric Crichton/Bruce Coleman 216 (top left and bottom left); Ray Daffern/England Scene 240, 244; Sergio Dorantes 236; Tony Duffy/Allsport 227 (bottom); Robert Estall 213 (bottom), 242 (top); M.P.L. Fogden/Bruce Coleman 212; John Garrett 220 (bottom); Ernst Haas/Magnum 224 (top); Robert Harding Associates 221 (bottom); John Haw 242 (bottom); Eric Hayman 210-11; Suzanne Hill 219 (centre), 223 (top), 230; Ekhart van Houten 235 (bottom); David Kilpatrick 233 (top); Howard Kingsnorth 241; Peter Lavery/Eaglemoss 245; Duncan Laycock 218; Leo Mason 222, 223 (bottom); Tom Nebbia/Aspect 228 (bottom); Mike Newton/Eaglemoss 221 (top left); Charlie Ott/Bruce Coleman 227 (top); David Overcash/Bruce Coleman 217 (bottom); Hans Reinhard/Bruce Coleman 219 (top); Victor Robertson 228 (top); Brian Rybolt 235 (top); Clive Sawyer/Eaglemoss 214; Homer Sykes/Eaglemoss 215; John Sims 229, 233 (bottom); David Simson 231 (bottom); Norman Tomalin/Bruce Coleman 213 (top); Chris Alan Wilton 237, 239.

Using Your Camera
Steve Bicknell/Eaglemoss 248 (left); David Kilpatrick/Eaglemoss 247 (top); Jack Taylor 247 (bottom left and bottom right); Michael Taylor/Eaglemoss 251; Con Putbrace/Eaglemoss 249; John Sims/Eaglemoss 248 (top right and bottom right).